DIGITAL ENCOUNTERS

Envisioning Connectivity in Latin American Cultural
Production

# Digital Encounters

*Envisioning Connectivity in Latin American Cultural Production*

EDITED BY CECILY RAYNOR
AND RHIAN LEWIS

UNIVERSITY OF TORONTO PRESS
Toronto  Buffalo  London

ISBN 978-1-4875-0868-5 (cloth)     ISBN 978-1-4875-3881-1 (EPUB)
                                   ISBN 978-1-4875-3880-4 (PDF)

Latinoamericana

**Library and Archives Canada Cataloguing in Publication**

Title: Digital encounters : envisioning connectivity in Latin American cultural
   production / edited by Cecily Raynor and Rhian Lewis.
Names: Raynor, Cecily, editor. | Lewis, Rhian (M.A.), editor.
Series: Latinoamericana (Toronto, Ont.)
Description: Series statement: Latinoamericana | Includes bibliographical
   references and index.
Identifiers: Canadiana (print) 2022040027X | Canadiana (ebook)
   20220400296 | ISBN 9781487508685 (cloth) | ISBN 9781487538811 (EPUB) |
   ISBN 9781487538804 (PDF)
Subjects: LCSH: Latin American literature – 21st century – History and
   criticism. | LCSH: Literature and technology – Latin America. | LCSH:
   Art, Latin American – 21st century. | LCSH: Art and technology –
   Latin America. | LCSH: Digital media – Latin America. | LCSH:
   Internet and activism – Latin America.
Classification: LCC PQ7081.A1 D54 2023 | DDC 860.9/98–dc23

We wish to acknowledge the land on which the University of Toronto Press
operates. This land is the traditional territory of the Wendat, the Anishnaabeg, the
Haudenosaunee, the Métis, and the Mississaugas of the Credit First Nation.

This book has been published with the assistance of a Social Sciences and Humanities
Research Council Insight Development Grant and a Grant for Emerging Scholars through
the Fonds de Recherche du Québec – Société et culture (FRQSC).

University of Toronto Press acknowledges the financial support of the Government of
Canada, the Canada Council for the Arts, and the Ontario Arts Council, an agency of
the Government of Ontario, for its publishing activities.

 **Canada Council** **Conseil des Arts**
**for the Arts** **du Canada**

Funded by the   Financé par le
Government   gouvernement
of Canada   du Canada

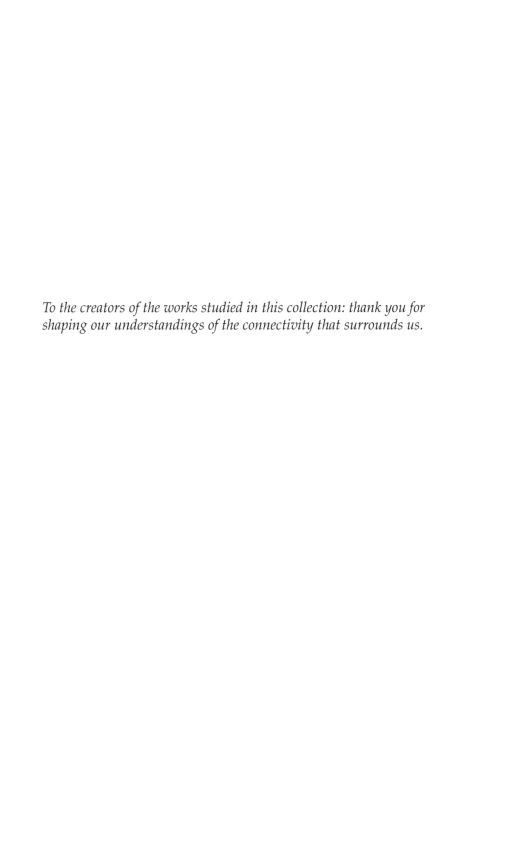

*To the creators of the works studied in this collection: thank you for shaping our understandings of the connectivity that surrounds us.*

# Contents

*Acknowledgments*   ix

Introduction   3
CECILY RAYNOR AND RHIAN LEWIS

1 Translating (Publishing) Networks from Print to Pixel   15
NORA C. BENEDICT

2 The Networked Search: Nation, Identity, and Digital Literary
Content in Chile and Argentina   38
CECILY RAYNOR

3 Print *Then* Digital: Material Reimaginations in *Anacrón*
and *Tesauro*   61
ÉLIKA ORTEGA

4 (404) Page Not found: Technology, Failure, and Disconnection
in Alejandro Zambra's *Mis documentos*   87
MARÍA JOSÉ NAVIA

5 C$U%B#A#+53: Glitches, Viruses, and Failures in Cuban and
Cuban-American Digital Culture   107
EDUARDO LEDESMA

6 The Poetics and Politics of Code: An Analysis Based on Chilean
Digital Literature   139
CAROLINA GAINZA CORTÉS

7 Cyborg Citizenship in Keiichi Matsuda's "Hyper-Reality"
(2016)   157
KATHERINE BUNDY

8  Eva Rocha: Digital *Desaparecido* in the Postinternet   178
   NORBERTO GOMEZ, JR.

9  PretaLab: Afro-Brazilian and Indigenous Women's Digital
   Autonomy   200
   EDUARD ARRIAGA

10  Encountering Virality in Latin/x American Tactical
    Media Works   223
    THEA PITMAN

11  "Todas tenemos una historia": Networked Storytelling in
    #MiPrimerAcoso   256
    RHIAN LEWIS

Epilogue   273
   CECILY RAYNOR AND RHIAN LEWIS

*List of Contributors*   279

*Index*   281

# Acknowledgments

All essay collections are collaborative processes, and this book in particular has relied upon many people, groups, and institutions. We would like to begin by thanking the Languages, Literatures, and Culture Department and the Anthropology Department at McGill University, particularly the faculty and chairs whose support has been crucial to the existence of this volume. We are also tremendously grateful to the digital humanities community in Montreal, particularly Stéfan Sinclair at McGill and Michael Sinatra at the Université de Montréal, whose guidance and encouragement as senior scholars have been fundamental. As co-editors, we are so thankful for the sources of funding that have enabled us to work together for the past four years, including grants from McGill's Arts Internship Office and GREN (Groupe de recherche sur les éditions critiques en contexte numérique), and the generous support of the Fonds de recherche du Québec – Société et culture (FRQSC) and the Social Sciences and Humanities Research Council of Canada (SSHRC). This funding has allowed us to grow our expertise and research interests through collaboration on numerous projects with scholars from across the Americas and Europe, ultimately resulting in rich relationships with the contributors to this book.

We are so grateful to Thea Pitman for sparking the idea for this volume and continuing to believe in its success, and to Carl Fischer at Fordham University for his eagerness in supporting our ideas and his intellectual companionship. We would like to thank Gabriella Coleman and her Bits, Bots, & Bytes digital research group for their keen editorial advice – and pizza – in the early stages of writing. To Mark Thompson, our editor at the University of Toronto Press, whose consistency and professionalism are unmatched: we have loved working

with you. To the reviewers who gave us insightful feedback on the manuscript, thank you.

Numerous members of our extended academic communities played a crucial role in developing and working through many of the concepts of this collection. Along with several contributors, we presented some of the book's key arguments at the Northeast Modern Languages Association Convention in 2017; the Latin American Studies Association Congress in Lima, Peru, in 2017 and later at its 2018 Congress in Boston; at DH2018 in Mexico City; and at the Electronic Literature Association Conference in 2019 in Cork, Ireland, and its virtual iteration hosted by the University of Central Florida in 2020. We would like to thank our co-panelists and our peers who took their time to attend our talks, ask questions, give feedback, and engage with themes that pushed this volume in new directions. We would like to thank our students at McGill, both undergraduate and graduate, and particularly those in digitally engaged courses, for providing sites for experimentation that would help to drive some of the ideas of this book forward.

At the heart of this volume are our contributors, whose expertise, creativity, and generosity in sharing their knowledge has made this book possible. Putting together this book allowed us to build communities that transcend disciplinary boundaries, institutional frameworks, and time zones. This collection spans many geographies from across the Americas and Europe and is the product of collaboration with researchers in multiple stages, from graduate students to junior faculty and to senior members of the academy, in fields as diverse as digital culture, electronic literature, new media studies, contemporary Latin American literature, and anthropology. We are so grateful for the knowledge that our authors have brought to this book and to the communities they engage in their own spheres of influence. To Eduard, Nora, Kate, Carolina, Norberto, Eduardo, MJ, Élika, Eduardo, and Thea: it has been a joy to learn from you all. Thank you for your brilliance, perseverance, and patience, and for teaching us about what connects us.

To these folks and other friends, family and colleagues, you have been a constant source of energy and inspiration to us both. A big thanks to everyone at Lili & Oli (especially Pat, Joe, and Allen) for keeping this book going with a steady supply of coffee and conversation. To Vincent Simboli, Kit Mitchell, Diana Nguyen, Campbell Veasey, Rodrigo Zepeda, Sara Birenbaum, and Paprika Lewis: your moral support and good humour kept the writing process going. A big thanks to Jennifer Sawdey and Alice Driver for late night and early morning conversations

and just enough adventure to keep sane while working on this book. Much gratitude also to Leila Bremer, for more than a decade of support. A special note of dedication can be extended to our families, Andrew C. Raynor and Janice Raynor, and Petra and Lionel Lewis, whose faith in our work and research has been limitless, and to our siblings, Kate, Andrew, and Alicia, whose presence in our lives enriches and inspires. And finally, to the person who grew with this book from digital simulacrum into joyful, jumping toddler: Xavier, thank you for coming along for the ride.

# DIGITAL ENCOUNTERS

# Introduction

CECILY RAYNOR AND RHIAN LEWIS

Jala hashtag aquí.

(Drag hashtag here.)

Above the prompt, a set of hashtags sit expectantly: choose #*poesía* and #*sufrir*. After a brief pause, a set of elastic tendrils germinate and unfurl a chaotic foliage of thumbnail images and text snippets. One reads,

Ya sabías que la poesía también nos enseño a sufrir.

(You already knew that poetry also taught us to suffer.)

Clicking the fragments yields a username, hyperlink, and timestamp, and the snippets become recognizable as tweets. Trading "poesía" for "poeta" causes the poem to jostle merrily and release a fresh volley of interlaced words and images.

Uno en la vida, como se gana tanto … quizá el destino de un poeta es sufrir?

(In life, one earns so much … maybe it's the destiny of the poet to suffer?)

In Karen Villeda and Denise Audirac's *POETuitéame* (2014), the reader summons unwitting Twitter poets into a web of serendipitous enjambments, instilling an inescapable awareness of other voices and other places. Reflections on digital culture often use the term *unprecedented* to discuss the connectivity that characterizes everyday life, and justifiably so: how else can we understand a historical moment in which all cultural production appears situated within ever-expanding networks? Indeed, it seems that, in almost every facet of media, users are traversing the same digital paths: executing code written by other people, following hypertextual links embedded in interactive poetry, or using hashtags to link their personal narratives to public discourses. This volume examines the ramifications of such a networked state within Latin American cultural production.

Reflecting on the connective infrastructure rendered visible through *POETuitéame,* Angelica J. Huizar (2020) writes,

> The "poets" are real individuals reachable via Twitter where the conversation can continue … We are enjoying a cyber-zen moment of mindfulness; we are all interconnected, and we are all part of that same thought process. If everything is indeed composed of energy, the information on Twitter is then a universe of the energy of human awareness composed of snapshots of life, thoughts, and reflections. We become complicit in the tweets of these voices and can deduce a philosophical understanding of what eventually leads to a Big Bang of global meta-consciousness: What is the general consensus on suffering? How do we conceive of poetry? (89)

Huizar's closing questions speak to the ambient awareness of digital connectivity that increasingly figures in human perception. Today, our surroundings are increasingly digitally conscious of us, and we are always conscious of each other: at the material level, this phenomenon takes shape through social media plugins, public spaces converted into "hybrid spaces" (de Souza e Silva 2006) through the availability of a wireless network, and an entire ecosystem of connected devices in the Internet of Things. As Rosa Elizalde (2019) reminds us, "la vida on line y off line no van separadas, son una continuidad, forman parte de un solo cuerpo, y que la red puede ser muchas cosas menos un mundo aparte intangible y etéreo" (111; life online and offline are not separate, they are continuous, composing a single body, and the internet can be many things other than a world apart, intangible and ethereal). Even life offline is saturated with the connective impulse of the digital, and even seemingly solitary online gestures invoke a hubbub of voices and actions that collide along the lines of identity, experience, and desire.

As a thematic point of departure, connectivity allows us to address changes in the fabric and prominence of digital technologies in Latin America. The term "connectivity" is generally interpreted as the level of internet access in a region, and thus provides an ideal jumping-off point for this new reflection on the Latin American digital encounter. In the second half of the 1990s, internet connections in Latin America surged from half a million to nine million users by 1999 (International Telecommunications Union 2000; see also Corrales 2002). This boom continued through the first decades of the new millennium to reach nearly half a billion users in 2019.[1] While there are substantial differences among countries with regard to the rate of information communication technology (ICT) adoption and percentages of connectivity, the portrait of Latin American internet use in the past twenty years shows

an indisputable tidal shift in access accompanied by substantial changes in modes of interaction with digital technologies. Thinking in terms of connectivity allows us to link the materiality of internet access – for example, the speed of a connection, the memory of a device, the presence (or lack) of a camera or microphone – with questions of power and the social situatedness of communication technologies. When Claire Taylor and Thea Pitman published *Latin American Cyberculture and Cyberliterature* in 2007, the dominant model of web access in Latin America was community-based *telecentros* and *cibercafes*. Although the increase in internet penetration over the past decade has accompanied a rise in fixed broadband connections, Latin Americans' internet use has also become fervently mobile in recent years: the region had nearly 420 million unique mobile subscriptions in 2018, of which approximately half were mobile internet users (GSMA 2019). Concurrently, internet studies of the region have transitioned from a focus on communal internet use in semi-public spaces[2] toward explorations of the privacy and ultra-portability afforded by an internet-enabled mobile device,[3] and explorations of the impact of algorithmic intuiting of human activity.[4]

Among these areas of study, perhaps the most expansive field examines the rate of internet adoption in Latin America.[5] The notion of the "digital divide" in the Global South is often invoked by development initiatives, policymakers, and telecommunications strategists alike to describe a situation of inequitable access, often rendered as the number of people in the region without an internet connection. We are all implicated in the structures that distribute inequitable benefits from the advancement of digital technologies: as Carlos Scolari (2018) commented in *Hipermediaciones*, "Nos guste o no, de un lado del muro u otro, todos vivimos en una Tijuana digitalizada" (13; Whether we like it or not, from one side of the wall or the other, we all live in a digitized Tijuana). Beyond the question of access to the web or lack thereof, digital inequities manifest in terms of users' ability to make authoritative claims to internet spaces and to appropriate technology for their own purposes – in other words, to engage with connectivity on their own terms. In this light, the push to close the digital divide can also be understood as an initiative for greater extension of networks of data capitalism. While the population of internet users in Latin America has skyrocketed, much of the profits from users' digital activity is funnelled out of the region: indeed, of the ten most-visited sites in Latin America, half are owned by companies based in the United States or Europe.[6] Recent scholarship on digital colonialism explores the power imbalances perpetuated as multinational corporations scramble to capture the user data of emerging markets in the global South. Of this digital colonization, Renata Avila

Pinto (2018) writes, "the public and private sectors are merging in joint ventures in a quest for global domination, penetrating every govern-ment, every citizen movement, mediating every action in every con-nected person's life through digital devices and data collection" (16).

In her writing on epistemologies of data colonization, Paola Ricaurte invokes the supranational "capture of life" (Couldry and Mejias 2019b) perpetuated by the harvesting of user data: "In this view, life itself is nothing more than a continuous flow of data. The pervasiveness of technologies and data regimes in all spheres of existence crowd out al-ternative forms of being, thinking, and sensing. The commodification of life and the establishment of an order mediated by data relations limits the possibility of life outside the data regime: refusing to generate data means exclusion" (Ricaurte 2019, 352). Ricaurte's critical stance with respect to the colonial project of big data recalls earlier cautions against the expansion of hegemonic and imperialist digital infrastructures in the Global South. As multinational digital conglomerates hone their ability to "optimize" streams of information and maximize the data harvested from users' online activities, the internet that Carlos Mon-sivaís described in 1999 as "el símbolo y la práctica de la globalización" (21; the symbol and practice of globalization) has become the funda-mental sustaining mechanism of global neoliberal capitalism through ever-accelerating extractive processes.

These power relations compel us to approach connectedness as a context in which Latin American subjects, localities, and narratives are increasingly yet disparately networked. Each configuration of human-digital contact implies a specific set of use limitations, cost dif-ferentials, and – most significantly for the present volume – relational and creative capacities. Our contributors mobilize a diverse array of cultural artefacts to position connectivity as a defining concern of Latin American cultural production in the early twenty-first century, among them, digital literature, online activism, glitch and multimedia art, transnational short films, and programming languages. The chapters in this book explore canonical elements of Latin American digital culture alongside less-studied cultural forms, at times revisiting tactical me-dia works from the early 2000s and at others contemplating the digital "translation" of twentieth-century print artefacts. By examining these works together, we cross-pollinate several well-developed scholarly dialogues, including a wealth of writing on Latin American electronic literature and poetry by Claudia Kozak, Leonardo Flores, Scott Wein-traub, Carolina Gainza, and Luis Correa-Díaz; Claire Taylor and Thea Pitman's explorations of identity and politics in net art and new me-dia; and recent studies of online activism and technopolitics by Hilda

Chacón, Francisco Sierra Caballero, and Tommaso Gravante. This volume is particularly interested in how works of art and literature reflect changes in perception wrought by digital connectivity: in this respect, our contributors continue a dialogue with Angelica J. Huizar, Matthew Bush, and Tania Gentic on the interconnected consciousness and networked subjectivity articulated by contemporary Latin American cultural production.

Despite the affordances of connectivity as a thematic gravitational centre, it nevertheless poses a challenge for geographically situating cultural artefacts, a question that compels us to consider our positionality as editors writing from Canada about a field of digital cultural production interpreted as "Latin American." In understanding the "Latin American-ness" of the works our contributors analyse in their chapters, we follow Scott Weintraub in expanding on Taylor and Pitman's interpretation of Latin American cultural production as that which originates "from a specific cultural, linguistic, and geographic cartography that is marked and transected by 'the Latin American' in a particular way" (Weintraub 2018, 13). In turn, we heed Alberto Moreiras and Daniel Mato's critical perspectives on the presumptive regionalism of Latin American area studies while attending to the significance and malleability of digital constructions of place and cultural territory.[7] The chapters in this collection focus primarily on works created by Latin American authors and artists, while also exploring the appropriation of Latin American settings and narratives into streams of cultural production that extend to anglophone North America and Europe. Although transnational creative networks and cultural appropriation are by no means unique to the digital age, the ease of arranging collaborative relationships and exchanging source material online allows "the Latin American" to be taken up and reworked in particular ways by creators from within and outside of the region. In this respect, our contributors investigate the motifs and tropes that are strategically employed to demarcate a digital work as "Latin American," as well as the implications of connectivity for practices of sampling and remixing cultural material.

The volume begins by exploring questions of format and adaptation at the convergence of digital and analogue spheres. However, before turning towards "digital born" (Hayles 2007) works and those that incorporate aspects of digital technologies, this volume reflects on "digital born-again" works to examine the changes that occur when analogue materials are carried into the digital space. In chapter 1, Nora Benedict explores the implications of digital translation by constructing social networks from evidence of literary encounters gathered from written

correspondence, contracts, magazines, and books of Argentine publishing giant Victoria Ocampo. By translating literary connections that are difficult to see in print into the digital space, Benedict nuances our understanding of print artefacts and pre-digital collaborative processes through a networked reimagining of Victoria Ocampo's contributions to creative circles and literary canons.

The relationship between print and digital forms continues to shape the platforms of well-established analogue enterprises such as national newspapers. In chapter 2, Cecily Raynor considers readership pathways to digital literary and cultural content produced by two prominent Chilean and Argentine online newspapers. As a medium whose offline presence has long been linked to the boundaries of the nation, newspapers provide important spatial lessons for readers in the transnational and trans-Hispanic web. Through distant, "medium," and close readings of the arts and culture sections of *La Nación* (Argentina) and *La Tercera* (Chile), Raynor finds that writers and readers of digital literary content connect on planes that destabilize the geographical parameters of national newspapers. Raynor's study of online cultural writing illuminates the networked nature of web readership, in which readers gather in the territories and pathways of shared search terms to find content ranging from the hyperlocal to the national and even global.

Continuing this exploration of readership in the contact zone between analogue and virtual planes, in chapter 3, Élika Ortega contemplates the blurring of the boundaries between digital and print formats in literary works whose linked components remediate print features through clickable motifs, pop-ups, superimposed text, and animations. Ortega examines Karen Villeda's *Tesauro* (2010) and Augusto Marquet's *Anacrón: hipótesis de un producto todo* (2009/2012) to explore how compositional and aesthetic hybridity manifests differently according to authors' literary intentions and the specific digital media paired with the print text. Following Ortega's exploration of remediation, María José Navia, in chapter 4, delves into Latin American authors' textual engagement with digital technologies. In her study of the short stories of Chilean author Alejandro Zambra, Navia finds that computers often signify something *other*, with their presence more akin to the intimate discomforts and long-term obligations of a family relationship than the expected speed and efficacy of a technological aid. By exploring the social life and materiality of digital technology in *Mis documentos*, Navia finds that Zambra's overheated, cumbersome computers are altogether *human* – and thus prone to error, misuse, and misunderstanding.

The burdensome and costly technologies discussed in Navia's chapter set the stage for further exploration of the power of failure and disconnection to offer a critical commentary on the pervasive connectivity of everyday life. In this vein, in chapter 5, Eduardo Ledesma analyses works by two Cuban and Cuban-American visual artists that employ a glitch aesthetic to disrupt the established digital order by undermining the proper functioning of digital media, acceptable use of the web, or "correct" algorithmic outputs. Thus, a slow connection or digital malfunction can either be read as a matter of inequitable access hardwired into local material and physical realities or, alternatively, be deployed as a disruptive aesthetic challenge to techno-political hegemony.

The capacity to intervene into digital architecture sparks an investigation of the programming languages that scaffold networked connectivity. Building on her previous examinations of hypertextuality and manipulation – forms of "cultural hacking" (*hackeo cultural*) integral to a digital aesthetic – Carolina Gainza in chapter 6 interrogates the aesthetic and linguistic properties of computer code. By examining code as a language, Gainza identifies a potential for intervention that the reader perceives through their interaction with a digital work, a venue of connection that instils in the reader a desire to delve into the programmatic infrastructure of that work. Gainza's discussion extends to questions of intellectual property and what she entitles "cultural hacking" of other users' code – a reminder that discussions of digital connectivity are inevitably entangled in uneven politics of intellectual property.

The ever-more intimate links between algorithms and human activity pose questions about algorithmic surveillance – particularly the constant monitoring of user interaction with mobile and wearable devices – at the level of perception. Here, our contributors investigate the changes in the fabric of public space when these often backgrounded forms of connectivity are brought into focus, revealing what Adriana de Souza (2006) calls "hybrid spaces." In chapter 7, Katherine Bundy examines Keiichi Matsuda's short film "Hyper-Reality" (2016), in which viewers assume the perspective of Juliana Restrepo, a cyborg subject enmeshed within a hegemonic augmented reality (AR) in the city of Medellín, Colombia. "Hyper-Reality" offers a telling visual rendering of Foth, Mitchell, and Estrada-Grajales's caution that "the mediated geographies served to us via locative devices and urban media might, for instance, show us only the city an algorithm assumes we want to see" (2020, 725), a particularly compelling comment in light of Medellín's full-throttle push to reinvent itself as a Smart City through a series of technological and social interventions.[8] Matsuda's rendering of the city leans toward the dystopian flip-side of grand narratives of urban

progress: rather than a liberated being reminiscent of Donna Haraway's "A Cyborg Manifesto," the cyborg subject of "Hyper-Reality" is a product of a neoliberal system that intuits the consumer decisions of its populace by algorithmically predicting their socio-spatial trajectories and imposing incentives for consumption. Moreover, Bundy examines the transnational creative process behind "Hyper-Reality," highlighting the dangerous interventions of hegemonic technology upon the bodies of marginalized subjects, while localizing them within a speculative version of the technologized Latin American city.

In chapter 8, Norberto Gomez examines the subversive engagement with social media as a tool of authoritarian surveillance in the works of Brazilian artist Eva Rocha. Gomez situates his analysis within the "postinternet": not the end of the internet, but rather its complete and total immersion into everyday life, politics, business, and culture, to the point of becoming invisible and banal. By focusing on Rocha's use of digital technology to both reveal and challenge the objectification and institutional oppression of the digital subject, Gomez identifies a liminal space in which the networked conditions of contemporary life are both embraced and confronted. Rocha's work recalls Taylor and Pitman's exploration of the "ambivalent" appropriation of digital technologies, in which Latin American cultural producers are "at times playing along with the accepted use of such tools, and at others, reformulating them in tactical and partially resistant ways in the interstices of the (global, capitalist) system" (2013, 200). Beyond the individual impact of this entanglement within a digital network, Rocha's concern extends to a new form of colonialism brought on by the ideology of digital globalization, one that requires new tactics for electronic decolonization.

These resistant or subversive uses of digital technology illustrate how Latin Americans carve out territories of language and practice on the internet that defy the hegemonic norms of digital connectivity imposed by the Global North. In chapter 9, Eduard Arriaga examines PretaLab, a Brazilian initiative that centres the experiences and expertise of Afrolatinx and Indigenous women as a means of transforming the exclusive and hegemonic "language of power" of virtual technologies. PretaLab takes a critical stance with respect to the premise of digital connectivity as a unilaterally empowering means of sharing world views and experiences. The potential for digital oppression, exploitation, and appropriation of the knowledge and experiences of marginalized subjects is a central concern of Afrolatinx communities, which understand the potential benefits of digital connection yet also recognize the risks posed by surveillance and algorithmic determinism. Rather than adhere to narratives of digital connectivity as a liberative end in itself, PretaLab

espouses a more critical and strategic use of digital tools and platforms to make greater authoritative claims. Continuing this focus on Latinx cultural producers' subversive appropriations of the capacities of the digital, Thea Pitman in chapter 10 studies the positioning of Latinx identity as an active agent capable of challenging preconceived ideas held in the West about the role or place of Latin America. Expanding on Jon Beasley-Murray's notion of a "viral latinidad" that surpassed the discrete and bounded region south of the Río Grande, Pitman identifies a new form of subversive "Latin-American-ness" that has entered into popular circulation around the globe.

These connective encounters raise pressing questions about community formation. In chapter 11, Rhian Lewis examines the affective connections fostered by the Twitter hashtag #MiPrimerAcoso, which was launched by Mexico City–based activists Catalina Ruíz Navarro and Estefanía Vela-Barba during the 2016 Primavera Violeta protests against gender-based violence. By exploring the connective impulse of testimony and mediatized feelings of community, Lewis approaches #MiPrimerAcoso as a resonant narrative structure that enables expressions of catharsis and solidarity between Twitter users. In turn, Lewis makes a case for moving beyond quantitative network analyses of Twitter and toward more nuanced contextual explorations of the affective life of hashtag discourses.

Our contributors grapple with different configurations of power, agency, and intention as they explore the connectivity that generates ever-more intimate interactions with code, new forms of communication between authors and readers, and activist movements that depend on the narrative capacities of social media. By investigating the conflicts and convergences of a networked state of existence, the authors raise pressing questions about Latin America's engagement with the mediated connectivity of contemporary life.

NOTES

1 Internet World Stats, 2019, https://www.internetworldstats.com/
2 For examples, see Chasquinet et al. (2002) and Lizarazo (2002).
3 Among these studies, de Souza e Silva et al. (2011) offer a nuanced study of mobile phone appropriations in favelas for a discussion of relationships between materiality, intention, and accessibility in shaping the social life of mobile phones. They reveal how creative and illicit methods of acquisition and appropriation defy manufacturers' ideals of device ownership as well as hegemonic narratives of ICT for development.

4 There is a growing body of scholarship on the social lives of digital technolo-
gies in Latin America. Some look toward the way digital connectivity reflects
the experience of public space and social life, in order to understand how
searching for a hotspot (Dye et al. 2017) or carrying an internet-enabled mobile
device (de Souza e Silva 2006) leads users to renegotiate their experiences of
time and place. Others examine perceptive experiences of the algorithmic com-
municative architectures of the web, such as the influence of bots on opinion
formation and political affiliation during elections (Cevallos and Gordón 2019)
and Pariser's concept of "filter bubbles" (*filtros burbujas* or *burbujas de filtro*) spe-
cifically in the context of Latin America (Rossi 2018; Rodríguez Cano 2017)
5 For examples of this field of study, see Hilbert (2001).
6 Based on rankings data from Alexa Web Analytics, 2020 and SimilarWeb,
2020.
7 See Gordon and de Souza e Silva 2011; Taylor and Pitman 2013; and Taylor
2014. Taylor and Pitman (2013) argue that "it is … at the intersection of
these two developments – on the one hand, a rise in scholarly debates on
Latin American (popular) culture and new media, and, on the other hand,
the deconstruction of the term 'Latin America' in itself – where the study of
Latin American online cultural production lies" (19).
8 See also the explorations of Medellín's Smart City initiatives by Ewelina
Biczyńska (2019) and Félix Talvard (2018).

REFERENCES

Arnaudo, Dan. 2017. "Computational Propaganda in Brazil: Social Bots
during Elections." In *Working Papers,* edited by Samuel Woolley and Philip
N. Howard, 1–39. Computational Propaganda Research Project no. 2017.8.
Avila Pinto, Renata. 2018. "Digital Sovereignty or Digital Colonialsim." *Sur:
International Journal on Human Rights* 27: 15–28.
Biczyńska, Ewelina. 2019. "The Smart City of Medellín, Its Achievements and
Potential Risks." *Urban Development Issues* 62.1: 29–38.
Bruno, Fernanda, Paola Barreto, and Milena Szafir. 2012. "Surveillance Aesthetics
in Latin America: Work in Progress." *Surveillance and Society* 10.1: 83–9.
Bush, Matthew, and Tania Gentic, eds. 2015. *Technology, Literature, and Digital
Culture in Latin America: Mediatized Sensibilities in a Globalized Era.* Routledge.
Caballero, Francisco Sierra, and Tommaso Gravante, eds. 2017. *Networks,
Movements and Technopolitics in Latin America: Critical Analysis and Current
Challenges.* Springer.
Cevallos, Gabriela, and Mario Gordón. 2019. "Análisis de cuentas
automatizadas y su influencia en la opinión de los usuarios de Twitter en
Ecuador." *Revista ibérica de sistemas e tecnologias de informação* E20: 553–65.
Chacón, Hilda, ed. 2018. *Online Activism in Latin America.* Routledge.

Chasquinet, Fundación, et al. 2002. *Community Telecentres for Development: Lessons from Community Telecentres in Latin America and the Caribbean*. PAN Americas.

Corrales, Javier. 2002. "Lessons from Latin America." In *Democracy and the Internet*, edited by Simon, Leslie David, Javier Corrales, and Donald R. Wolfensberger, 30–66. Woodrow Wilson Center Press.

Couldry, Nick, and Ulises A. Mejias. 2019a. *The Costs of Connection: How Data Is Colonizing Human Life and Appropriating It for Capitalism*. Stanford University Press.

– 2019b. "Data Colonialism: Rethinking Big Data's Relation to the Contemporary Subject." *Television and New Media* 20.4: 336–49.

de la Selva, Alma Rosa Alva. 2015. "Los nuevos rostros de la desigualdad en el siglo XXI: la brecha digital." *Revista mexicana de ciencias políticas y sociales* 60.223: 265–85.

de Souza e Silva, Adriana. 2006. "From Cyber to Hybrid: Mobile Technologies as Interfaces of Hybrid Spaces." *Space and Culture* 9.3: 261–78.

de Souza e Silva, Adriana, et al. 2011. "Mobile Phone Appropriation in the Favelas of Rio de Janeiro, Brazil." *New Media and Society* 13.3: 411–26.

Dye, Michaelanne, et al. 2017. "Locating the Internet in the Parks of Havana." *Proceedings of the 2017 CHI Conference on Human Factors in Computing Systems*, 3867–78.

Elizalde, Rosa Miriam. 2019. "Colonialismo 2.0 en América Latina y el Caribe: ¿qué hacer?" In *Más allá de los monstruos: entre lo viejo que no termina de morir y lo nuevo que no termina de nacer*, edited by M. Caciabue and K. Arkonada, 102–17. Editorial Universidad Nacional de Río Cuarto.

Foth, Marcus, Peta Mitchell, and Carlos Estrada-Grajales. 2020. "Today's Internet for Tomorrow's Cities: On Algorithmic Culture and Urban Imaginaries." *Second International Handbook of Internet Research*: 725–46.

Gordon, Eric, and Adriana de Souza e Silva. 2011. *Net Locality: Why Location Matters in a Networked World*. Wiley-Blackwell.

GSM Association (GSMA). 2019. "Latin America's Evolving Digital Landscape." GSMA.

Hayles, N. Katherine. 2007. "Intermediation: The Pursuit of a Vision." *New Literary History* 38.1: 99–125.

Hilbert, Martin R. 2001. *Latin America on Its Path into the Digital Age: Where Are We?* United Nations Publications.

Huizar, Angelica J. 2020. *Cosmos, Values, and Consciousness in Latin American Digital Culture*. Palgrave.

International Telecommunications Union. 2000. *Americas Telecommunication Indicators 2000*. International Telecommunications Union.

Lizarazo, D. 2002. *Un rastro en la nieve. Comunicación comunitaria en el mundo de la globalización comunicativa*. Secretaría de Educación Pública, Gobierno de México.

Mato, Daniel. 2003. "Prácticas intelectuales latinoamericanos en cultura y poder: sobre la entrada en escena de la idea de 'Estudios Culturales Latinoamericanos' en un campo de prácticas más amplio, transdisciplinario, crítico y contextualmente referido." *Revista iberoamericana* 69.203: 389–400.

Monsiváis, Carlos. 1999. *Del rancho al internet*. Instituto de Seguridad y Servicios Sociales de los Trabajadores del Estado (ISSSTE), Gobierno de México.

Moreiras, Alberto. 2001. *The Exhaustion of Difference: The Politics of Latin American Cultural Studies*. Duke University Press.

Ortiz, Rocío Rueda. 2008. "Cibercultura: metáforas, prácticas sociales y colectivos en red." *Nómadas* 28: 8–20.

Ricaurte, Paola. 2019. "Data Epistemologies: The Coloniality of Power, and Resistance." *Television amd New Media* 20.4: 350–65.

Rodríguez Cano, César. 2018 "Los usuarios en su laberinto: burbujas de filtros, cámaras de eco y mediación algorítmica en la opinión pública en línea." *Virtualis* 8.16: 57–76.

Rossi, Aníbal. 2018. "¿Burbujas de filtro? Hacia una fenomenología algorítmica." *Mediaciones de la comunicación* 13.1: 263–81.

Scolari, Carlos A. 2004. *Hacer clic: hacia una sociosemiótica de las integraciones digitales*. Editorial Gedisa.

– 2008. *Hipermediaciones: elementos para una teoría de la comunicación digital interactiva*. Editorial Gedisa.

Talvard, Félix. 2018. "Can Urban 'Miracles' Be Engineered in Laboratories?" In *Creating Smart Cities*, edited by Claudio Coletta et al., 62–75. Routledge.

Taylor, Claire. 2014. *Place and Politics in Latin American Digital Culture: Location and Latin American Net Art*. Routledge.

Taylor, Claire, and Thea Pitman, eds. 2007. *Latin American Cyberculture and Cyberliterature*. Oxford University Press.

– 2013. *Latin American Identity in Online Cultural Production*. Routledge.

Villeda, Karen, and Denise Audirac. 2014. *POETuitéame*. http://www.poetronica.net/poetuiteame.html.

Weintraub, Scott. 2018. *Latin American Technopoetics: Scientific Explorations in New Media*. Routledge.

Winocur, Rosalía. 2013. "Los diversos digitales y mediáticos que nos habitan cotidianamente." In *Hegemonía cultural y políticas de la diferencia*, edited by Alejandro Grimson and Karina Bidaseca, 245–61. Consejo Latinoamericano de Ciencias Sociales (CLASCO).

# 1 Translating (Publishing) Networks from Print to Pixel

NORA C. BENEDICT

The mid-1930s to the mid-1950s is often referred to as the Golden Age of Argentine publishing. This period saw an explosion of new publishers, printers, and booksellers as well as the development of entire networks dedicated to producing and circulating books, magazines, and other types of print materials. These drastic shifts and changes in the burgeoning book industry enabled Buenos Aires, Mexico City, and Havana to emerge as the three epicentres of Latin American book production in the twentieth century. Although an important body of critical research has emerged recently on individual publishing houses in Buenos Aires, the global impact of these firms and their methods of communication and collaboration remain under-explored.[1] For instance, how do we account for the dinner parties, chance encounters, and other social engagements that introduced publishers and editors to new writers and their works? How do we capture word-of-mouth literary recommendations and unwritten endorsements? How do we represent the intangible links that bring a group of people together? In other words, how do we see the *invisible* aspects that make up complex networks? In an effort to address these issues, I will look to Victoria Ocampo's *Sur* enterprise as a case study for analysing the implications and opportunities provided by moving a print network into the digital realm. Here I describe not only *how* print materials are translated into digital formats, but also *why* we should consider such a move from print to the digital. In the process, I detail a series of practical – as well as ethical – concerns surrounding data creation, data curation, and data preservation (for both print and born-digital materials).

Victoria Ocampo (1890–1979), her world-renowned literary journal *Sur*, and her publishing house of the same name all loom large over Latin American cultural production in the twentieth century. As a member of an elite Argentine family, Ocampo was able to travel

to Europe throughout her life. It was here where she formed close relationships with a large number of writers and artists. Although she quickly made new friends and contacts throughout the continent, who all expressed deep admiration and appreciation for her creativity, intelligence, and aesthetic sensibilities, Ocampo still felt that she was an outsider, which was only confirmed when many of these same acquaintances displayed their ignorance about South America: "Was Buenos Aires in Brazil? she was asked. Were the natives civilized? How did she stand the tropical heat all the time?" (Meyer 1990, 104). Fuelled by her discontent with Latin America's alienation and isolation from Europe, Ocampo launched *Sur*, which "would be a cultural bridge between the Americas, a forum for the best thinkers of both continents" (Meyer 1990, 107). Broadly speaking, she conceptualized her journal, and the publishing house of the same name, as a way to connect not only North and South America, but also Europe and the Americas. While much has been written about her impressive literary enterprises, a great deal of work still remains to be done with regard to the extent of her global reach. To that end, I will consider how Victoria Ocampo's publishing networks evolve and, more specifically, what it means to translate these circuits of conversation and collaboration into the digital realm.

Ocampo's literary journal *Sur* – teeming with original essays, translations, prologues, and poetry – and Editorial Sur, her publishing house, are primary examples of a flourishing *print* network. More specifically, in the pages of the journal and in works published by Editorial Sur, we find the names of authors, translators, editors, and general contributors as well as those of printers, artists, and graphic designers, all of whom collaborated, communicated, and ultimately formed a part of Ocampo's network. Systematically adding layers of biographical and professional information about each person who aided in the creation of these literary materials provides us with a more nuanced understanding of how these groups emerged and is also a necessary first step in translating these print networks into the digital. In tandem with these personographies, private correspondence from, to, or about Victoria Ocampo provides a second major data source for translating her print network into the digital. These personal documents enhance our understanding of the infrastructure of any given network, especially the less visible personal details about how and why people met, interacted, and ultimately worked together. More specifically, crucial channels of direct and indirect communication emerge from these letters, which provide insight into the level of intimacy and the types of relationships that certain individuals fostered. In addition to foregrounding the intricate

circuits of conversation, collaboration, and creation that blossomed in Argentina during this time, it is also important to generate an archive of metadata about the physical aspects of these letters, magazines, journals, and books that link all of the involved intellectuals in the move from print to pixel.[2]

In light of the fact that my current analysis centres around networks, or groups of connected and interrelated individuals, it is helpful to define the relationships between "entities" (people, places, things) and their "attributes" (characteristic properties of an entity).[3] An example of an entity would be "person," and the attributes of this entity might be "name," "birthplace," and "occupation." Every person that I identified in Ocampo's publishing network was entered into a database with his or her corresponding attributes.[4] This type of (digital) data retrieval and entry requires an extreme level of standardization. All dates, names, locations, and any other unique attributes had to be formatted consistently in the database. Aside from developing a uniform and impressively large dataset, this process of standardization, data formatting, and data cleaning points to one of the unique opportunities that digital data provides researchers: seeing information in a new way. In other words, by refining inconsistent and error-ridden biographical information into standardized datasets, we are able to identify previously invisible overlaps or shared aspects among individuals or materials. In addition to storing, organizing, and standardizing information, the use of a database also allows for the creation of new information. More specifically, after all of the identified individuals and their attributes have been added to the database, we can export selected datasets, such as specific genres of journal articles or shared occupations among collaborators.

Figure 1.1 is a dynamic representation of various genres of contributions to Ocampo's literary journal *Sur*. More specifically, the nodes point to the specific genre of each work in the issue: essay, art, letter, poetry, review, fiction, and announcement. Since genre is an *invisible* aspect of most journal contributions – or at least not an attribute that is physical printed alongside each work – this visualization exemplifies the opportunities that digital data offer for making print materials more visible and legible. Here we see that essays are the most frequent type of contribution in the first three issues of the journal (50 per cent of the entire work), while fiction and poetry are a much smaller percentage of the overall contributions (around 10 per cent for each). In essence, these more veiled elements in Ocampo's print production foreground how her editorial decisions accentuated specific literary forms and cross-cultural resonances.

● essay    o art    ⊕ letter    o poetry    ⊘ review    ⦶ fiction    ◑ announcement

Sur 1, no. 1 (enero 1931)        Sur 1, no. 2 (mayo 1931)        Sur 1, no. 3 (agosto 1931)

Figure 1.1.  Genre Distribution in *Sur* (Issues 1–3). Network Graphs created by author using Cytoscape.

## From Print to Pixel

How do print materials – including contracts and physically published books and magazines – encounter the digital? More specifically, how do we *translate* print materials into a digital format? What gets lost along the way, and how do we ethically account for these gaps and changes? These questions lie at the heart of my current analysis, as I aim to show what it means to transform – and *translate* – an entirely print corpus into a sustainable digital format. Even though we might be able to arrive at some of the same conclusions by analysing a collection of print materials, there are several advantages and new conclusions that can be drawn from these digital methods. Above all is the ways in which these approaches make the invisible visible. That is to say, by systematically identifying individuals in Ocampo's network and then entering them into a relational database, we are able to shed light on unknown figures, especially female translators, who contributed extensively to this vibrant community and hardly ever receive credit or recognition for their work. In a similar vein, we can add additional layers of meaning through metadata, which fill in gaps, make aspects of these networks more legible, and reveal the large amount of invisible, uncredited labour on which these networks are built. To best explain

this process and its affordances, I will describe how actual print materials – correspondence and books – translate into digital data. Then, I will discuss some of the ethical concerns involved in moving from a print to a digital format.

Many of the primary sources for my current project come from the archives of Latin American authors that are housed at Princeton University.[5] Here we find a treasure trove of print ephemera pertaining to some of the most influential Latin American writers in world literature, ranging from correspondence and manuscripts to photographs, diary entries, and detailed travel itineraries. These collections embody the interconnectedness of authors' global networks: we are able to glean the most holistic image of a single author or intellectual by not only parsing their *own* papers, but also examining traces of their involvement with other important figures around the world. In the case of Victoria Ocampo, we must look not only to her personal correspondence in the Fraga and Peña Collection of the Ocampo Family, but also to letters – and other ephemera – from her in other writers' archives.[6] This comprehensive approach allows us to consider the links between oft underrepresented – or understudied – individuals and Victoria Ocampo. More specifically, we can learn how she came into contact with certain writers, intellectuals, and artists. We can pinpoint where – in which cities or countries – she first met these individuals, and under what circumstances. We also can use these documents to identify the various chains of contact and associations that developed and blossomed in world literature.

Broadly speaking, there are two basic types of data that can be collected from print material: information relating to the object's *content* and information relating to the object's *physical form*. With regard to the specific category of correspondence, we can break each letter's content into three subcategories: people, place, and time.[7] "People" refers to not only the recipient and the sender of each letter, but also any direct or indirect references to other individuals in the body of the letter. "Place" pertains to the geographical location the letter was written in and/or sent from, the location the letter was sent to, and also any indirect references to other locations that might appear in the body of the letter. "Time" reflects the date of the letter's composition, the date when it was sent, and any other references to temporal markers (past, present, or future) in the body of the letter. All of these subcategories of a letter's content provide invaluable data that must be created and catalogued in order to adequately translate a print object into the digital realm. The physical form of a letter – its physical and material components, which are not to be confused with the structure of its textual elements – also

presents us with another layer of information that must be collected: What type of paper is used for the letter? Is there an envelope? What are the dimensions of each of these items? Is the letter handwritten or typed? What colour is the ink? Are there any inserted materials? By collecting data about the letter's physical form, we develop a better sense of the conditions under which each item was written and why specific letters were written at certain times and in certain places. For instance, Victoria Ocampo's letters are written on a variety of stationery from unique locations, including Bergdorf Goodman's hair salon in New York City. Thus, the location and medium of her writing provide another layer of data that can help contextualize the length or detail of her letters, or perhaps explain the catalyst for their composition.

I will now turn to two actual letters – one written by Ocampo and one written about her – to provide the first case study of data collection in action. The first letter is handwritten by Victoria Ocampo and addressed to her sister, Angélica Ocampo (figure 1.2).[8] It is dated 15 December 1948 and is written on stationery from the Waldorf Astoria hotel in New York City. The paper is tissue-thin and white with a prominent logo for the hotel in black at the top of each page. This stationery crops up multiple times in Victoria Ocampo's papers, which indicates that, rather than having her own personalized stationery, Ocampo tended to write her letters on whatever paper was available to her at a given time and in a given place. Moreover, her use of Waldorf stationery signals her frequent stays at one of the most iconic and prestigious hotels in New York City. According to other snippets of her correspondence, it was her preferred lodging in the city. Paying close attention to these material details enhances our understanding of individuals by providing an intimate look into their day-to-day lives and creature comforts, as well as physical evidence of spending habits and lifestyle choices. In essence, these details allow for a more well-rounded image of historical figures. Throughout her letter, Ocampo references several individuals, including Ernest Ansermet (Swiss conductor, 1883–1969), William Walton (English composer, 1902–83), Igor Stravinsky (Russian composer, 1882–1971), María Rosa Oliver (Argentine writer, 1898–1977), Matthew Huxley (English anthropologist, 1920–2005), and Rita Hayworth (American actress, 1918–87). This impressive list of twentieth-century intellectuals, artists, and celebrities immediately showcases Ocampo's connectedness within networks of cultural production at the time of writing her letter. Beyond simply name-dropping, Ocampo introduces these prominent figures in the context of personal encounters: in the body of her letter, she describes her most recent afternoon with Ansermet, an upcoming lunch with Huxley, and a chance meeting with

Figure 1.2. A portion of a letter from Victoria Ocampo to her sister Angélica. Photo taken by author. Fraga and Peña Collection of the Ocampo Family; Manuscripts Division, Department of Special Collections, Princeton University Library.

Hayworth in a record store. She also alludes to her close friendship with Stravinsky and Walton, while pointing to her "on the ground" *Sur* networks with María Rosa Oliver.[9] Thus, from just one letter, we can begin to see the intricacies of Ocampo's global networks and the number of interactions she could potentially have in any given day.

The second letter, handwritten by Victoria's sister Silvina, is to José Bianco, one of the most notable editorial secretaries for *Sur*.[10] It is dated 20 February 1949, and thus serves as a good counterexample to the

previous letter, since they are written within two months of one another. Unlike Victoria's letter, Silvina's is not on the letterhead for a hotel or other type of institution but rather is simply handwritten in black ink on cream-coloured paper (the majority of Silvina's letters are on generic stationery). Silvina speaks frankly about her sister's concerns for the future of *Sur* while Bianco is away from his editorial post, which highlights the fact that Victoria still maintained a tight control over her literary enterprise, even while away on business in New York City. Much like Victoria's earlier letter, Silvina's correspondence with Bianco reveals a list of well-known literary and intellectual figures in Latin America and Spain. She opens with a passing reference to the prologue that she is writing for an anthology of lyric poetry edited by Ricardo Baeza (Cuban writer, editor, literary ambassador, 1890–1956), and then dedicates the remainder of her letter to a discussion of the pros and cons of the potential candidates to fill Bianco's position. She mentions Enrique Pezzoni (Argentine writer, 1926–89), Rosa Chacel (Spanish writer, 1898–1994), and Ernesto Sabato (Argentine writer, 1911–2011) as possibilities, yet none of these contenders appear to appeal to Silvina or to Victoria.

When information in these letters is translated into manageable chunks of data, each letter takes on a new, more dynamic life in the digital realm, one that is almost akin to a recreation of the physical environment of its composition. While any immersive research in a physical print archive might provide us with a similar type of experience, parsing the data and relationships that are represented within each of these letters gives us a more nuanced, bird's-eye view of Ocampo's networks. In other words, by meticulously recording the metadata of any specific document, we can more easily – and more quickly – zoom in on or zoom out from particular figures, places, or dates to get a more global sense of how, where, and *why* certain individuals collaborated and formed alliances. Perhaps the greatest strength of this type of digital translation is that it makes it much easier for scholars to filter and sort through the information and ultimately identify key nodes and connections while also making these data more reachable for broader publics. Aside from the sender, recipient, places, and dates of the document in question, one can easily access a description of the physical medium, the individuals referenced, and the length of letter. By identifying and pulling out these pieces of information from collections of correspondence, we can begin to conceptualize entire networks of interrelated individuals. Beyond simply linking sender and recipient through their letters, a more nuanced data-entry system provides a wider range of information, which, in turn, leads to a more nuanced network, not only

in terms of the people that can be linked, but also the physical spaces in which they (first) crossed paths and developed their relationships. While digitized scans of the letters in question are undoubtedly helpful for scholars, purposing the people, places, and other key elements of this correspondence into a database gives a more dynamic understanding of *how* and *why* these individuals came into contact with one another.[11]

In addition to Ocampo's extant correspondence (and other forms of single-page documents such as contracts), a large portion of my print corpus consists of physical books published by Editorial Sur and full runs of the journal *Sur*. While the data gleaned from physical books share some of the categorical attributes we saw in our examination of Ocampo's correspondence – namely, people, places, and dates – there are many more hands involved in a book's production and, as a result, several more essential pieces of data to account for. Unlike the set form and structure of a letter, the key chunks of data about a book and its physical production can be found in many varying locations throughout the book itself.[12] Consider, for instance, Victoria Ocampo's *Virginia Woolf, Orlando y Cía*, published by Editorial Sur on 8 January 1938. First is the cover of the book and its title page, on which we find basic information including the author of the work (Victoria Ocampo), the title of the work (*Virginia Woolf, Orlando y Cía*), and the name of the publishing house (Editorial Sur). The cover of this specific book is a vibrant green with white sans-serif typography.

The title page adjoins a list of Ocampo's previously published works. The list points to other works produced by not only Editorial Sur, but also by another firm that Ocampo is affiliated with in Spain – namely, the publishing house linked to José Ortega y Gasset's *Revista de Occidente*. The next place to look is the colophon, which typically is printed on the final page of books produced in Latin America. Here we find the name of the printer, the date of printing, and the location of the printer's shop in Buenos Aires: "Se acabó de imprimir este libro, para la editorial SUR, a los ocho días de enero de mil novecientos treinta y ocho, en la Imprenta López, calle Perú 666, Buenos Aires" (This book was printed, for Editorial SUR, on 8 January 1938, at Imprenta López, calle Perú 666, Buenos Aires). On the first page of the work itself, we learn that it originated as a conference "pronunciada en 'Amigos del Arte' de Buenos Aires el 7 de Julio de 1937" (given at the Buenos Aires "Friends of Art" on 7 July 1937). Turning to the back cover of the book, we find a price ($1.50). Similar to the benefits of examining correspondence about Victoria Ocampo, but not written by her, we discover a great deal more information about specific works published by Editorial Sur through extratextual material,

such as marketing advertisements in *Sur*.[13] In the case of *Virginia Woolf, Orlando y Cía*, we learn that it is "El primer estudio completo en nuestro idioma sobre la famosa autora de 'Orlando'" (the first complete study in our language about the famous author of *Orlando*).

Prior to the book's publication by Editorial Sur, the entire text appeared in *Sur*, which suggests a heightened level of marketing and promotion on the part of Ocampo.[14] Betraying its origins as a conference speech, *Virginia Woolf, Orlando y Cía* occupies only a slim volume of seventy-two pages. The diminutive physical composition of the book stands out in comparison to other works published by Editorial Sur, which tended to be novels or collections of essays and short stories. When analysed as a unified whole, the form and content of this book showcase Ocampo's deep-seated interest in the life and works of Virginia Woolf. The fact that Ocampo originally delivered this work as a speech, then printed it within the pages of her literary journal, and finally published it with Editorial Sur (with extensive advertisement!), reveals a desire to spread knowledge and information to as large an audience as possible. We miss all of these crucial details about the production and circulation of *Virginia Woolf, Orlando y Cía* by ignoring its physical features.

As these two case studies demonstrate, translating key data from print materials to a digital format can enable new means of understanding and interacting with the material outputs of cultural production. While it is possible to get a sense of these networks without digital tools, these interventions allow for more accuracy, more speed, and more data processing. By translating the material forms of letters, contracts, books, and/or journals for various types of information into a digital format, we encounter them anew, and begin to conceive of them not as the production of one individual at one specific moment in time, but rather as the products of an entire network of connected individuals working together in unique spaces and times.

The translation from print to pixel, however, naturally involves certain types of loss. First, and quite possibly the most apparent, is that of *physicality*. This type of loss refers to many different things, but often pertains to the nature, quality, and feel of the materials themselves. Although I strive to record as much information as possible about any given object's physical features – including the paper and ink used to compose a letter or the binding and typefaces selected for a book – there is no way to translate the experience of physically engaging with these materials. As it stands now, when we read her digitized works, there is no technology available that will allow us to smell the pages of Victoria Ocampo's books or touch the raised indents left by her pen. All of these sensory experiences are reserved for in-person interactions with

the physical documents themselves. That said, by describing and recording all of these features to the best of our abilities, we certainly gain a deeper understanding and knowledge of these essential textures. Another related type of loss is that of an intended experience. This type of loss is unique to the move from print to pixel of items that were produced prior to the existence of computers, the internet, and the digital itself. We lose the sense of scale and weight of these print materials in this translation from print to pixel, and, as a result, a large part of their intended use. When digitized, the pages of a pocket-sized pamphlet or manifesto appear virtually identical to those of a hundred-page book, yet their original physical forms are drastically different. Similarly, in recording data about physical books or literary journals, there is a tendency to rely on one physical copy as a stand-in for all other copies (or even all other editions). In doing so, we lose a sense of variants – both accidental and substantive – that might have occurred at any stage in the production process.

All of these potential losses point to the crucial fact that these digital translations are not meant to be replacements for the original materials. On the contrary, these types of moves from print to pixel actually result in greater levels of access to and maintenance of the original print materials. First, by generating digital data, we allow more individuals to have access to potentially rare, fragile, and never-before-seen materials, often from the convenience of their own homes. While the creation of digital data does not necessarily mean the digitization of the original materials, it does entail the production of more information about these items that was previously not available (or not known), such as biographical details for individuals that are not available in any other digital format. Second, these translations preserve key information about fragile or difficult-to-access materials for future generations, who might eventually rely on such digital data if the originals are ever damaged or destroyed. That said, we must remember the fact that "every reproduction is a new document, with characteristics of its own, and no artifact can be a substitute for another artifact" (Tanselle 1989, 33–4). In short, these transitions from print to pixel should not be seen as a *replacement* for the original materials, but rather as further support for the print documents themselves.

## Visibility, Space, and Movement

Having discussed how print materials can move to the digital realm – as well as several of the ethical and practical implications of this type of "translation" – I now turn to the larger question of why we should

consider such a move to the digital, which I approach from three distinct angles: visibility, space, and movement. First, no other medium affords the same density of information, while also making this density intelligible, legible, and visible. Efforts to digitize the literary journal *Sur* – or any of the books published by Editorial Sur – certainly provide greater access and visibility to Ocampo's cultural production, and these scans serve as invaluable tools for data collection.[15] From the scans alone, we are able to glean information about prices of issues, prices of books, advertisements from linked firms, and a whole host of involved individuals. With that said, it often can be daunting to sort through hundreds if not thousands of digital scans of books, letters, journals, and other print materials in search of information relating to one single individual (or one single place or date in time). This issue is exacerbated by the reality of human error in digitization: we must also always account for such error in the production of these scans, which may result in incomplete page scans, or images that are blurry, damaged, or hard to read. In order to make the entire process of finding information more intelligible, more legible, and more visible, we have an obligation to identify and link essential (digital) metadata about these physical items, and to store this information in such a way that allows users to sort (and filter) through it with ease. In other words, the use of digital tools, methods, and technologies allows us to work with much larger sets of information, while still maintaining a sense of intelligibility (as well as legibility). At the same time, there also must be an awareness about ensuring the accessibility and legibility of digital items.

On the level of space, by shifting from the analogue to the digital, we can isolate individual locations and people on a micro level or compare people and spatial data on a macro level in order to understand the geographies of human interaction that impact cultural production and collaboration. In the case of Ocampo's literary networks, we might consider a macro-level analysis of location data pertaining to individuals in her circles. More specifically, with the help of geospatial data, we can approach her global reach in new and exciting ways.

Figure 1.3 maps where individuals in Ocampo's network were born (grey) and where they died (black).[16] The size of each point, or node, reflects the number of people who share this birth or death place. One of the largest nodes is naturally that of Buenos Aires, which was not only home to Ocampo, but also the heart of her entire publishing enterprise (see figure 1.4 for a detail of networks in Argentina).

The map also reveals a large concentration of points throughout Europe as well as clusters in the United States and Central America, all of which emphasize Ocampo's ultimate goal of linking North and South

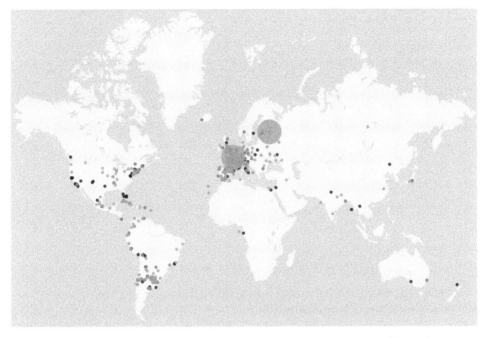

Figure 1.3. "Global Networks of Cultural Production". Map created by author using Palladio.

America while also building transatlantic bridges and ties (see figure 1.5 for a detail of networks in Europe). Moreover, a handful of understudied outliers in Asia and Australia contribute to our overall understanding of her reach and present us with future avenues of investigation. For instance, these geographical outliers raise the question of not only Ocampo's engagement with global writers and intellectuals, but also her own presence and reception throughout parts of Asia and Australia.

Along with a consideration of the spaces and regions that helped shape Ocampo's networks, digital data provide a means of analysing certain biographical and biological trends among the people involved in her literary enterprises. Consider, for instance, the network graph shown in figure 1.6.[17] In contrast with figure 1.3, which focuses on the *geographical* dimensions of Ocampo's networks, this network graph shows the *interpersonal* dimensions of her networks. In other words, this visualization draws on personal information from the individuals in Ocampo's network – both biological data (sex) and biographical data (occupation) – in an effort to showcase the relationships among these

Figure 1.4.  Detail of "Global Networks of Cultural Production": Argentina. Map created by author using Palladio.

Figure 1.5.  Detail of "Global Networks of Cultural Production": Europe. Map created by author using Palladio.

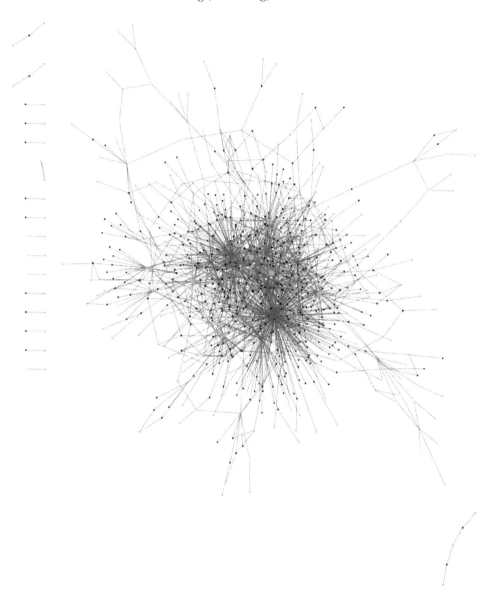

Figure 1.6.  Biological Distribution of People in Ocampo's Network. Network graph created by author using Cytoscape.

people on a larger scale. The complex network of nodes in figure 1.6 pertains to an individual's sex – male (filled circle) or female (hollow circle) – while the grey nodes show their shared occupations.[18] We immediately can see a larger concentration of men in Ocampo's networks, and also a fair number of shared occupations between the sexes, if we home in on particular occupations, such as writer (figure 1.7) and artist (figure 1.8).

What all of these visualizations highlight is the power and versatility of digital data (and tools). More specifically, they show the possibilities of social-network analysis for visualizing large, complex data sets that would not be as easy to visualize in the print realm and, more importantly, they accentuate previously *invisible* aspects of a network.[19] Although Ocampo's literary journal *Sur* is traditionally associated with the successes and fame of its many *male* collaborators and contributors – most notably that of Jorge Luis Borges – these network graphs reveal a strong female presence in her publishing enterprise that tends to be overlooked.[20]

Moving to the third and final angle of approach, we can utilize digital technologies to track fluid movement among people, continents, and languages. In other words, we can pinpoint the location of specific people across the globe and determine each individual's relation to a central hub, such as Buenos Aires in the case of Ocampo's networks. Recalling the spatial element of this digital translation, a movement-focused approach considers not only where a specific person was at a given moment in time, but also why they were there. In the case of Ocampo's *Sur* enterprise, this crucial question can be explored further to situate her movements from place to place in the context of her business ambitions and contact with influential figures. For instance, by drawing on information from her correspondence (and that of other writers), we can trace her travels around the globe and pinpoint the specific place and time when two networks collided. These mapped data points can then be expanded to create an interactive digital itinerary that allows users to click through and navigate her movement throughout the world.

### Building (Global) Bridges in the Digital Realm

In the case of Victoria Ocampo, spatial, biographical, and biological dimensions work together to digitally reconstruct and model the creation of networks, literary circles, and literary canons. Moreover, the digital realm affords opportunities to create more accessible documents – both in a digital sense and in a material sense; in turn, this accessibility leads to more dynamic cross-cultural and cross-continental collaboration.[21]

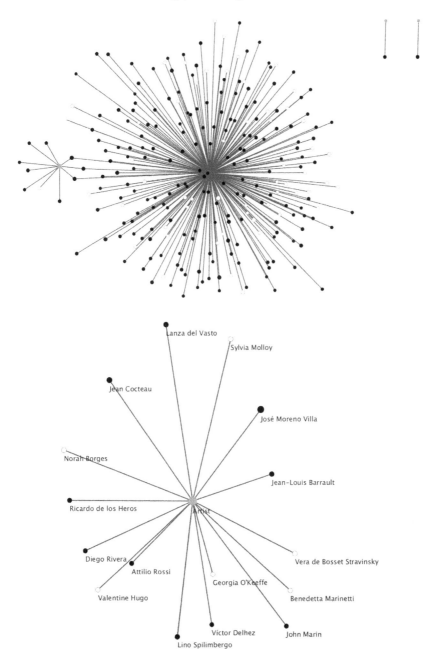

Figures 1.7 and 1.8.  Top, writers in Ocampo's network. Bottom, artists in Ocampo's network. Network graphs created by author using Cytoscape.

However, while the digital makes it possible to see the invisible aspects of many networks, this does not mean that print networks are any less nuanced or complex than their digital counterparts. As a way of concluding, I will end here with a brief reflection on how print networks might differ from digital networks, and some of the affordances that each medium brings. I consider what it means to be connected and the ways in which our modern-day understanding of connectedness might differ from that of Ocampo's.

The first stereotype that comes to mind is that print networks – or pre-digital networks – are smaller and less developed than our contemporary Twitterspheres or Facebook groups. Ocampo's extant correspondence reveals that she communicated with other writers, intellectuals, artists, editors, printers, and publishers, as well as close friends and family, on a daily basis, and even multiple times a day in some instances. Every issue of *Sur* functions as a virtual community brimming with intellectual exchange, intimate conversations, and unique networks of people and places.[22] If we envision these print networks as very small, close-knit groups of people, we are sorely mistaken. In Ocampo's network alone, we find a cluster of around 2,000 unique contacts and individuals affiliated with either her literary journal or her publishing house from just the first decade of their existence (1931–41). Thus, we should understand that print networks are in many ways just as connected, active, and integrated as our contemporary digital networks. Even though Ocampo's methods of communication were not as fast as instantaneous text messages or emails, her print archive, from letters and receipts to journal issues and books, reveals a massive network of interrelated individuals who were continually meeting, conversing, and collaborating.

Another revealing aspect of the print network is the importance placed on specific locations and moments in time. In contrast with our contemporary digital networks, which allow us to be in multiple places at once, the emergence and development of most print networks depended heavily on being in the right place at the right time. Ocampo's autobiographies and correspondence are rife with anecdotes about chance encounters with prominent intellectuals in Paris, including the likes of Jacques Lacan and Simone de Beauvoir. While contemporary digital networks can lead to lasting collaborations and conversations, these interactions can happen virtually anywhere and, in a sense, are not as reliant on the chance encounter as print networks are.

On the whole, these digital approaches to Ocampo's *Sur* enterprise are a way to carry on her work of building bridges across continents and across cultures by building bridges across bandwidths and servers.

More specifically, the digital realm allows for both distant and close readings of print networks. On the one hand, a series of previously invisible aspects, such as gender distribution among contributors, come into sharp focus when we examine large sets of data from a distance. At the same time, we also can home in on specific collaborators and their contributions to the larger (publishing) network. In addition, translating not only print materials but also correspondence into manageable chunks of digital data bridges the gap between published books and magazines and the labour that goes into producing them. Aside from developing a better understanding of the various social and economic forces at play in publishing, these print-to-pixel transfers enable the many hands involved in producing these print materials, whose efforts are often unknown, to surface and gain the recognition they deserve. In short, translating print materials into the digital realm provides greater access to information. It bridges the visible and the invisible, the known and the unknown, and keeps Ocampo's networks alive and relevant to more people in more places throughout the world. By digitally reconstructing Ocampo's networks, we enhance our understanding of her global impact and, in the process, foreground her monumental efforts in creating international communities linked by their cultural production.

NOTES

1  See Raúl H. Bottaro (1964), Eustasio A. García (1965), Rodolfo A. Borello (1977), Jorge B. Rivera (1980), Rafael Olarra Jiménez (2003), Gloria López Llovet (2004), Eduardo Gudiño Kieffer (2005), José Luis de Diego (2014, 2015).
2  I will return to the importance of recording the material aspects of these physical objects in the second section of the chapter.
3  Here I draw the language of "entities" and "attributes" from entity-relationship modelling.
4  The abstract visualization of my dataset as an entity-relationship diagram led to the development of a relational database using the open-source management system MySQL, where I created tables, or entities. Within each table, there is a series of defining attributes, such as name, birthdate, birthplace, death date, death place, occupation, sex, and VIAF id. Figures 1.9 and 1.10 provide visualizations of my design schema (created with Davila.js) to give readers a better sense of how I break up and parse information into the database. The first of these two figures presents the header for each table while the second includes all of the unique attributes within each table.

Figure 1.9

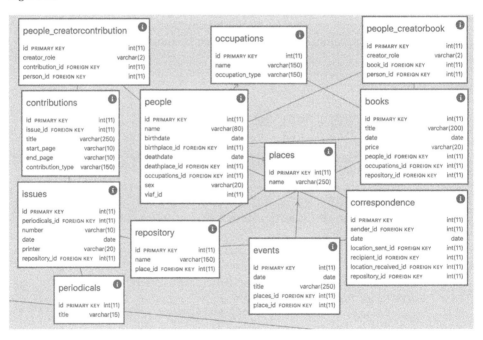

Figure 1.10

5  The Ocampo papers housed at Princeton University are not
   Victoria Ocampo's only extant archives. The largest portion of her
   correspondence – and several original manuscripts by not only Victoria
   Ocampo but also other global authors – is housed at the Houghton
   Library, Harvard University. Her personal library, along with a series of
   rare contracts and financial documents pertaining to the literary jour-
   nal *Sur*, and the publishing house of the same name, is housed at Villa
   Ocampo in Argentina. While the dispersion of her documents across the
   Americas might initially raise several red flags with regard to cultural
   patrimony reappropriation, it is important to highlight the fact that the
   current location of Ocampo's papers reflects her own wishes and desires
   for them: "pienso hacer algo en alguna universidad de U.S.A. con las car-
   tas" (I'm thinking of doing something with my letters at some university
   in the United States) (letter from Victoria Ocampo to Angélica Ocampo,
   1973, sent from Paris, France, Fraga and Peña Collection of the Oca-
   mpo Family, Manuscripts Division, Department of Special Collections,
   Princeton University Library).
6  Along with the Ocampo family papers, I have flagged the following archi-
   val collections that all contain items that – directly or indirectly – relate to
   Victoria Ocampo: María Rosa Oliver, José Bianco, Manuel Mujica Láinez,
   the Goodwin Weinberg Collection of Aldous Huxley, Elena Garro, Igor
   Stravinsky, José Donoso, Carlos Fuentes, Saint-John Perse Pléiade Editions
   Collection, Sylvia Beach Papers, Emir Rodríguez Monegal, Alberto Girri,
   Guillermo Cabrera Infante, Mario Vargas Llosa, and Bernardo Ortiz de
   Montellano. These two types of archives – personal papers and the papers
   of others – point to a *direct involvement* on the part of Ocampo and a series
   of *indirect references* to Ocampo that crop up in other individuals' archives.
   This latter situation is certainly the case with the papers of José Bianco,
   who served as the editorial secretary for *Sur*, and those of María Rosa Oli-
   ver, who was part of the original editorial board for *Sur*.
7  I draw these specific categories of data from Jean Bauer's "Anatomy of
   a Letter," accessed via web at http://jeanbauer.com/documents/letter
   _anatomy.pdf.
8  A portion of a letter from Victoria Ocampo to Angélica Ocampo, 15 De-
   cember 1948, Fraga and Peña Collection of the Ocampo Family, Manu-
   scripts Division, Department of Special Collections, Princeton University
   Library.
9  As noted, María Rosa Oliver was on the original editorial board for *Sur*;
   she also was a very close friend of Ocampo's.

10  Letter from Silvina Ocampo to José Bianco, 20 February 1949, manuscript, Fraga and Peña Collection.
11  Along with digital scans, the finders' guides that are created for most archival collections, such as those for Princeton's materials, are invaluable resources for data collection.
12  In his foundational book, *Paratexts*, Gérard Genette (1997) describes all of the textual elements that frame the main text, and also that influence our understanding of the work as a whole, as paratexts. These include items directly appended to the main text, such as cover art or colophons ("peritexts"), as well as extratextual items including authors' correspondence or interviews ("epitexts").
13  In addition to the advertisement, similar promotional ads appeared in the following issues of *Sur*: nos. 44, 46, 47, 48, and 49, all published in 1938.
14  *Sur* 35 (1937): 10–67.
15  The National Library in Buenos Aires (Biblioteca Nacional Mariano Moreno), for instance, is currently working to digitize the entire run of *Sur* (1931–1992) and to make the digital archive freely available and accessible. While digital scans of the periodical exist in other repositories and archives around the globe, many (if not all) of these digital resources are behind pay walls or are accessible only with certain institutional credentials or logins.
16  All of these visualizations were created with biographical and biological data from around 750 unique individuals. The spatial visualizations in Figures 1.3, 1.4, and 1.5 were produced with Stanford's open-source tool Palladio (http://hdlab.stanford.edu/palladio/).
17  Figures 1.6, 1.7, and 1.8 were created using Cytoscape. For an interactive version of this network, see bit.ly/ocampo-networks.
18  My data structure occupation around the following five general categories: artist, activist, (literary) producer, writer, and academic. Within each of these five categories, there are more specific occupation type descriptions, including poet, dramatist, film director, screenwriter, professor, and archivist, among (many) others.
19  While it would be possible – in a technical sense – to mark each of these points on a map or take a detailed inventory of the sexes and occupations of all of the members of Ocampo's global networks, they would take a great deal more time to produce, and would not be as legible or transferable across time and space.
20  In his foundational study of *Sur*, John King (1986) highlights this slanted perception of Ocampo's literary journal: "Indeed *Sur* would be remembered not so much for its publication of scholars as for its promotion of the writer who made scholarship, and in particular philosophical enquiry, a teasing intellectual game: Jorge Luis Borges" (90).

21 When data creation includes the provenance of a book or a document, as well as noting the repository site where the original materials are housed, users might realize that many of the materials they are interested in are much closer to home than originally thought. As a result, there might be a spike in visits to not only the digital databases, but also the cultural institutions where the original documents are stored.

22 Broadly speaking, most twentieth-century literary journals from around the globe present readers with similar communities. See, for instance, Philip Gleissner's GitHub repository, "soviet_journal," for another take on these (digital) networks: https://github.com/philipgleissner/soviet_journals.

REFERENCES

Bauer, Jean. 2009. "Anatomy of a Letter." http://jeanbauer.com/documents/letter_anatomy.pdf. Accessed 21 February 2018.

Borello, Rodolfo A. 1977. "Autores, situación del libro y entorno material de la literatura en la Argentina del siglo XX." *Cuadernos hispanoamericanos* 322–3: 35–52.

Bottaro, Raúl H. 1964. *La edición de libros en Argentina*. Troquel.

de Diego, José Luis, ed. 2014. *Editores y políticas editoriales en Argentina (1880–2010)*. Fondo de Cultura Económica.

– 2015. *La otra cara de Jano: una mirada crítica sobre el libro y la edición*. Ampersand.

García, Eustasio Antonio. 1965. *Desarrollo de la industria editorial argentina*. Fundación Interamericana de Bibliotecología Franklin.

Genette, Gérard. 1997. *Paratexts*. Cambridge University Press.

Gleissner, Philip. 2020. "soviet_journals." *GitHub repository*, https://github.com/philipgleissner/soviet_journals.

Gudiño Kieffer, Eduardo. 2005. *Losada: Gonzalo Losada, el editor que difundió el libro argentino en el mundo*. Dunken.

King, John. 1986. *Sur: A Study of the Argentine Literary Journal and Its Role in the Development of a Culture, 1931–1970*. Cambridge University Press.

López Llovet, Gloria. 2004. *Sudamericana: Antonio López Llausás, un editor con los pies en la tierra*. Dunken.

Meyer, Doris. 1990. *Victoria Ocampo: Against the Wind and the Tide*. University of Texas Press.

Ocampo, Victoria. 1938. *Virginia Woolf, Orlando y Cía*. Editorial Sur.

Olarra Jiménez, Rafael. 2003. *Espasa-Calpe: Manuel Olarra, un editor con vocación hispanoamericana*. Dunken.

Rivera, Jorge B. 1980. *El escritor y la industria cultural*. Centro editor de América Latina.

Tanselle, G. Thomas. 1989. "Reproductions and Scholarship." *Studies in Bibliography* 42: 25–54.

# 2 The Networked Search: Nation, Identity, and Digital Literary Content in Chile and Argentina

CECILY RAYNOR

Newspapers in Latin America have historically served as sites for the dissemination of literary content. One of the central and often over-looked arguments in Benedict Anderson's study on the imagining of communities in print capitalism is the weight he gives to the time of the nation, codified in the development of daily newspapers with national distribution. He develops the idea of "homogeneous, empty time," in which members of the nation move "calendrically through ... a precise analogue of the idea of nation, which also is conceived as a solid community moving steadily through history" (1983, 26). The idea of homogeneous, linear time evokes a sense of chronological simultaneity, in which members feel as if they coexist in a shared and singular temporality, irrespective of their location. The circulation of newspapers furthered this sense of temporal simultaneity, as the nation received daily news on locally bound contexts. Thus, Anderson argues that the dissemination of print capitalism, via newspapers and other lettered materials, gave a sense of temporal unity to consolidating nation states. Similarly, Ángel Rama, the late Uruguayan literary and cultural critic, argues, in his exploration *The Lettered City* (first published in 1984), that newspapers have played a fundamental role in the creation of Latin America's literary culture. Newspapers and other circulating texts were fundamental in capturing a sense of national unity as publics engaged with this content in systematic ways. Indeed, national newspapers have long shaped the public imaginary. Papers, including the Argentine newspaper *La Nación* and the *revistas gauchescas*, reached newly literate populations in powerful and unique ways for the printed medium as early as the late nineteenth century. Latin American newspapers in both print and digital forms have also reinforced canonical and hegemonic conceptions of literature, often fortifying the idea of the cultivated reader of a particular socioeconomic class. As I explore later

in this chapter, digitized versions of national newspapers might provide discursive space for alternative voices, but power dynamics are often replicated on the web via traffic patterns, search rankings, and decisions about what kind of content to prioritize. Thus, I observe how the digital editions of these papers reconfigure and challenge, but also reinforce, analogue relationships between literary content and national newspapers.

Digital newspapers face challenges that arise in the tension between the need to sustain an active online readership, given broadly decreased print circulations and advertising revenues (see Paterson and Domingo 2008), and the contested territory of the web as a transnational or multinational space that stands in contrast to the historically national circulation of print newspapers. With that said, the newspapers I examine in this study are large outlets with significant print and digital readerships that extend beyond the parameters of nation. Furthermore (and as one would expect of any large newspaper, especially one in a cultural context that favours far-reaching literary consumption), the newspapers' coverage of literature far exceeds national or regional parameters. At the same time, the arts and letters section has long been an institution in Latin American newspapers, with many different forms of literary content in one place: this is a place for authors' work to be shared, for contributors to share opinions, and for readers to get recommendations, analysis, commentary, and insights. But how does such a section work online? What brings people to read literary content in online newspapers, given that finding and reading digital content is a process inflected by geographical location, search engines, keyword relevance, site rankings, paid advertising, and the seemingly infinite number of places a site visitor could read about literature? Arts and culture sections – where literary content would typically be found in a print newspaper – represent a particularly promising site of investigation. As newspapers adapt their formats and journalistic modes to an increasingly online readership, this chapter asks how, from where, and with what intentions do people connect with literary content on the websites of Spanish-language newspapers?

In my previous work (Raynor 2018), I examined *El Boomeran(g)* (el-boomeran.com) an extensive platform for Spanish-language literary content, with an over fourteen-year web presence. Undertaking close and distant readings of ten years of literary and cultural content, I found that the Spanish news conglomerate–owned (PRISA) website had diversified its texts to include an array of Latin American authors and intellectuals, while engaging an ever-diverse set of readers from across the globe, as seen in its traffic patterns. Observing the entire

site as a textual aggregate, I noted that many of the frequent spatial words, including but not restricted to *mundo* (world), reflected content that concerned itself less with the intricacies of a particular country or locale, but rather engaged global themes. This was something that I also affirmed through close readings of the blog posts from a set of sample authors. Turning from sites like *El Boomeran(g)* that deliberately position themselves as transnational readership spaces to newspapers that are firmly grounded in national identities and geographies, what happens to the notion of language territories based on shared interests? What does the observation of cultural content from online news sources in Argentina and Chile tell us about the transnational and/or trans-Hispanic web?

In this chapter, I wish to extend questions of post-national reading to spaces of the web that are engrained in nation. Approaching the question of space from a national angle, I consider how literature and culture are presented, consumed, and broadcast in the online editions of the Argentine newspaper *La Nación* and on *Culto* (culto.latercera.com), the digital home to cultural content for Chilean newspaper *La Tercera*. Departing from my earlier work on transnational blogs, I use mixed methods with respect to content created under national contexts, including web analytics and close readings of selections from each site. However, rather than text-mining the sites through distant analysis of spatial words, what drives this chapter is the role of search. By what means and from where are readers engaging these sites? What might keyword analysis reveal about their intentions and interests? If these sites form part of the trans-Hispanic web, how might their cultural content illuminate the act of reading in the digital space as a networked undertaking? Dialoguing with Ed Finn's work on search as a means of untangling complex cultural territories, I argue that literary content in national newspapers provides important spatial lessons for readers on the transnational web. Not only do we continue to see trends toward post-national reader engagement from the standpoint of site traffic, but close observation tells us that writers and readers are connecting on planes that destabilize the space of the newspaper as connected to or defined by national geographies. In order to structure this chapter, I employ a three-tiered "reading" of the data: distant readings through traffic trends and key word analysis; medium readings in examining audience engagement across and within both sites; close readings through individual observations of the content itself.

I draw on web traffic analytics data from Alexa (now owned by Amazon) and SimilarWeb, as well as close readings of the literary and cultural content available on the websites of *La Nación* and *La Tercera*.

Returning to the goals of this chapter – namely, to examine the complex cultural territories of search and reader intentionality – a distant survey of these sites' traffic and audience data provides a contextual backdrop for closer examination of their literary and cultural content. In general terms, the sites have relatively comparable levels of traffic, although it is significant that *La Nación*'s traffic exceeds that of *La Tercera*. I use the term "comparable," because, when compared to their competitors, the sites seem to occupy relatively similar positions, particularly when examining the types of downstream and upstream sites that visitors traverse before and after they spend time on these sites.[1] As literary and cultural content are responsible for a relatively small portion of the traffic to online newspapers – compared to, for example, current events – there are limitations inherent to assessing the place of cultural content, and especially literary content, from data that study site traffic and audience engagement. Web analytics tools like Alexa and SimilarWeb offer information about the site's traffic and audience engagement broadly and offer very limited (or no) information about visitors to subdomains or subdirectories on a given webpage. Accordingly, one of the principal limitations when working with these tools is that the broad-level quantitative web traffic data apply to the sites overall, and not specifically the sections devoted to arts and culture.[2] However, there are certain areas within this distant data that allow for inspection of the role of arts and culture (relative to other sections) in attracting readers; in particular, Alexa's keyword analysis tool allows users to download the search terms that draw traffic to a site. Thus, in an attempt to achieve a broad-ranging analysis, I look at traffic data, as well as traffic source, keyword analysis, and close readings of the text in order to assess the role of search and desire in these sites.

## Putting Search into Context

Previous studies of Latin American digital newspapers have taken very diverse approaches to assessing the position of online periodicals and their audiences) with respect to a wide variety of contemporary cultural and political issues. These include several studies of newspapers' use of participatory or interactive media (Bachmann and Harlow 2012a and 2012b); mixed-methods studies of the homogenization of discourse in print and digital formats (Boczkowski and de Santos 2007); the alternative (or non-mainstream) positioning of born-digital media outlets (Harlow and Salaverría 2016); as well as the discursive tactics of newspapers' social media accounts (Anselmino, Sambrana, and Cardoso 2017). Before turning to the digital versions of these papers, it

is important to lay some historical groundwork. Founded in 1870, *La Nación* is Argentina's oldest newspaper, and the second-most-read paper in Argentina (following its closest competitor, *Clarín*). Counter to *Clarín*'s broad target audience and relatively centrist outlook, *La Nación* tends to target readers of a higher socioeconomic status and adopts a more conservative approach (for more of this context, see Boczkowski and de Santos 2007). With a historically significant circulation, some of the Hispanic world's most important writers, intellectuals, and thinkers have published in the paper, including José Martí, Miguel de Unamuno, Eduardo Mallea, José Ortega y Gasset, Rubén Darío, Alfonso Reyes, Jorge Luis Borges, Mario Vargas Llosa, and Manuel Mujica Láinez. As noted by Tania Gentic in her important study, *The Everyday Atlantic: Time, Knowledge and Subjectivity in the Twentieth-Century Iberian and Latin American Newspaper Chronicle* (2013), Rubén Darío featured several of his travel chronicles in the paper, through which "the Andalusian, Castilian, and Catalan politics and culture at odds with each other in Spain travel to middle and upper-class Spanish-language readers on both sides of the Atlantic – literarily uniting disparate communities through the distribution of the Argentine periodical" (5). Indeed, the newspaper has long been a hub of cultural content, uniting readers across the transatlantic space and certainly extending beyond its Argentine base. The digital version of *La Nación* was launched in 1995, making it the first Argentine national newspaper with an online presence. As of 2016, *La Nacion*'s digital iteration was the fourth-most-read Spanish language newspaper in on the web, with 7,382,000 unique users recorded that year (*El País* 2016).

*La Tercera* is a younger newspaper, founded in 1950 by the Picó Cañas family. Although the paper originally leaned left, it became more conservative in the period leading up to the 1973 Chilean coup, at which point it, along with conservative papers *El Mercurio* and *La Nación* (CL), backed the military regime of General Augusto Pinochet. *La Tercera* targets middle-class readers through both language and content.[3] The group that owns *La Tercera*, Copesa, launched the Diario Electrónico de Copesa in November 1994, under the direction of Juan Carlos Larraín. This was one of the first news-focused websites worldwide, and in Chile in particular. Before the entire newspaper was put online, the supplement sections of *La Tercera* were made available in a digital format; in 1997, *La Tercera Internet* was launched, with the full content of the print paper. As mentioned previously, the *Culto* section (culto.latercera.com) serves as a digital home to all of *La Tercera*'s literary and cultural content and has a link directly on the newspaper's home page, redirecting readers.

In terms of choice of case studies, it is important to emphasize that the national contexts chosen for this study are deliberate: Chile and Argentina share a language and a lengthy border and have rich literary and journalistic cultures. Both sites feature long-established national newspapers that have a well-developed digital presence. In the vocabulary of Web Analytics, it is clear that both are authority sites, or webpages who have gained a substantial enough recognition within their ecospheres to be called upon simply by their URLs. Their status as authority sites is based not only on their historical presence, but also their connection to the print-based versions, and these factors quickly led to broad online readership. Readers trust these sites, and their content has been online for over two decades. This longevity is significant, not only because search engines have been crawling these newspapers for a significant amount of time, but also because their content has been catalogued historically by web-archiving tools, including archive.org. Researchers have access to numerous earlier caches and can draw upon this information to study the evolution of the papers with respect to content, layout, links, and analytics. One of the primary ways in which sites gain prominence with regard to metrics, including PageRank, is through the production of sustained, refreshed, and abundant content. Given the presence of these papers online and off, their broad readership, and refreshed content from a dynamic set of writers, *La Nación* and *La Tercera* certainly fit the bill with regard to having an established authority on the transnational web. In the case of *Culto*, which was first cached in 2016, we observe the emergence of a new trend of literary and cultural writing on the web, one that attracts a younger readership whose members are savvy users of social media and the web. While its digital footprint is far smaller, it is clear that *Culto* represents an evolution in the ways in which newspapers propagate and disseminate this type of material, which is aesthetically and thematically in line with a new type of reading and writing about literature and culture. Thus, *Culto* is also a fertile territory for the exploration of contemporary web culture.

Notably, both sites devote significant space to arts and cultural content and feature that content more prominently on their sites than their competitors (more so than Emol.com, for example, or Clarin.com, where the arts and culture tabs are hidden from the main pages). Thus, not only in their print form, but also in their digital presence, both provide fertile ground for exploration for some of the questions that are central to this chapter. To return to how readers arrive at literary content online, we can take an initial look at some distant traffic data for both newspapers. As shown in figure 2.1, the sites draw similar percentages

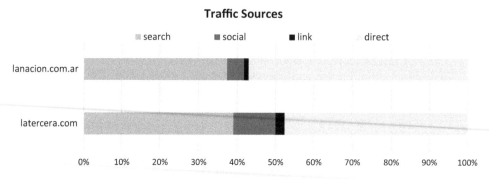

Figure 2.1. Traffic source breakdown for La Tercera (latercera.com) and La Nación (lanacion.com.ar). Visual created by author using Alexa traffic source breakdown from 15 July 2019.
Source data © Alexa Web Analytics 2019.

of their traffic through search (nearly 40 per cent) and direct traffic (48 per cent for *La Tercera* and about 57 per cent for *La Nación*), although *La Tercera* gets more traffic from social media (about 11 per cent). The fact that both sites garnish such a significant amount of direct traffic is in line with our understanding of them as authority sites. Readers know and reach these sites by name.

However, *La Nación* and *La Tercera* differ somewhat in the national concentration of their respective readerships. From the web traffic data, we can see that *La Nación*'s audience is more closely concentrated in Argentina than *La Tercera*'s audience is in Chile. Across six months of monitoring the data presented on Alexa's audience geographies tool (January–June 2019), the estimated percentage of *La Nación* site's users who were located in Argentina varied between 77 and 80 per cent, with most of the remaining traffic coming from Spain, Mexico, and the United States.[4] For *La Tercera*, the proportion of domestic users is slightly lower, although the estimates are more volatile, ranging between 61 and 68 per cent during the same period, with the next most frequent contributing countries Mexico and Argentina (6–10 per cent) followed by several other Latin American countries.[5] In this way, it is clear that, while these sites both target and draw in national readerships, *La Tercera* extends into a less nationally concentrated and perhaps more trans-Hispanic web that consistently extends beyond Chile, despite the national focus of the newspaper's circulation. It is also noteworthy that both sites have relatively different audiences (as defined through the websites their readers visit) as seen in the audience overlap tool on Alexa.[6] Although

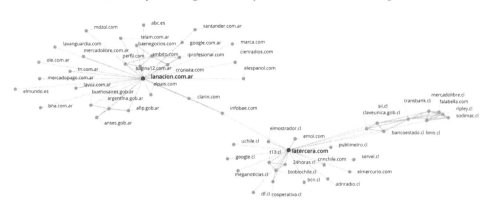

Figure 2.2.  Audience overlap graph generated by author using Alexa. © Alexa Web Analytics 2020.

the two digital newspapers have very little direct audience overlap, they are closely related to a very similar set of websites: other newspapers (including *Clarín* in the *La Nación* cluster and *El Mercurio* for *La Tercera*), ecommerce sites, search engines, and social media sites. This indicates that, although their national audience profiles may differ, *La Nación* and *La Tercera* occupy very similar roles in their users' habitual web use.

With these considerations in mind, I pursue my study of readership pathways with the understanding that distant data – even vividly illustrative data like the keyword corpuses available through Alexa's web analytics tool – have limitations for assessing the readerly intentions of users who access literary content on either site. Search implicates intention at every turn, yet it is very difficult to retroactively ascribe intention to users based on web traffic data. The question of what and how readers are reading online links to quantitative and qualitative queries about the intersection between national readership spaces and users' practices of seeking and finding digital content. As the traffic data refer only to the site as a whole, it is unclear how many users arrive directly at arts and literature content on the sites, how many find said content by searching within the site, and how many search for literary content and, based on those search results, arrive at a digital newspaper. In the section that follows, I outline a qualitative conceptual framework of internal searches within the two webpages for literary content by way of assessing the readership architecture that readers navigate in finding literary content on *La Nación* and *La Tercera*. Later, I look at external searches by using keyword data to explore readership pathways that begin at a search engine and employ literary keywords.

## Assessing Readership Pathways

In his study of the cultural ramifications of search, *What Algorithms Want: Imagination in the Age of Computing*, Ed Finn (2017) discusses the limitations of computational and machine-based search for deducing human desire, calling for an investigation into the limitations of search as a mode of grasping complex cultural territories. He reminds us that "the cathedral of abstractions and embedded systems that allow the pragmatic algorithms of the world to flourish can be followed down to its foundations in symbolic logic, computational theory, and cybernetics, where we find a curious thing among that collection of rational ideas: desire" (21). Finn interrogates the claim that algorithms will one day have the possibility of mimicking human behaviour with a high level of accuracy, citing the often-imagined task that they will be able to closely imitate election results (22). The desire to understand the world through calculatable means lies at the heart of the algorithm, as Finn explores, and is something that deserves to be challenged and nuanced, as we approach the web analytic results of this chapter. Indeed, beyond the algorithmic reverse-engineering of desire that pulls together a set of unique search results for a user based on their personal data, every search emerges from the desire for a specific result, as readers weed through a complex set of pages and content when they arrive at national newspapers. The implications of the fact that the development of algorithmic search is highly propriety bear further exploration. In some ways, search results have an air of anonymity and mechanization, yet they are also highly personal and customizable. What better way to target an individual than to follow their pathways across the web? Indeed, results depend on users' IP address, language, previous search patterns, and an entire ecosystem of paid ads and links, which muddy waters as they become increasingly indistinguishable from organic results. An individual need only do a simple search of newspapers in the Google search bar to find themselves in the complex jungle of inorganic and organic search results. Thus, I argue that, in addition to how readers arrive at these sites, it is fundamental to look at what happens when they get there. How are these sites designed to hold readers attention when it comes to literary and cultural content? How is this content presented and propagated? An analysis of users' intentions and readership pathways must include a careful examination of the architecture of digital periodicals in order to understand the presentation of literary and cultural content relative to other content and the type of readerly experience sustained on the site. This is based on the understanding that the kinds of content that a newspaper has online in its arts/culture/

literature section, and the way it displays that content, say a lot about the kind of readership it hopes to attract.

Although *La Nación* reserves a dedicated space for an arts and culture section in its print edition, the paper takes a markedly different approach to organizing its online content. Rather than nesting materials within clickable sections linked to corresponding subdomains, all of the articles on *La Nación* are searchable by tags. Literary content can be found by clicking on the main menu and through to the culture section, and then clicking on other tags that appear below each piece of content, such as *Literatura* (literature) or *Libros* (books). However, even in this part of the site, there is little impression of a space specifically devoted to cultural content, as the only feature that distinguishes the culture section from the other online sections is the heading at the top of the page and the shared themes of the content. The articles that can be aggregated by clicking the theme buttons for *Cultura* (culture) or *Arte y Cultura* (arts and culture – it is unclear what the difference is between these two tags) – or more granular tags like *Libros* and *Literatura* – do not offer an easy pathway between thematically linked pieces of content (for example, book reviews). This is in part because the tagging system used to organize literary and cultural content on *La Nación* is inconsistent. The tags *Libros* and *Literatura* are both easily searchable, and they are used relatively interchangeably, but it is not uncommon to find literary content, such as book reviews, that are not tagged with either heading. Clicking on the *Libros* tag aggregates content ostensibly tagged as #Libros that also appears under the headings #Ideas and #Literatura. Literary content may be tagged as *libros*, *literatura*, and/or *ideas* (note that "Ideas" is also a cultural supplement of the newspaper)[7] – although it may have none of these tags. When the reader reaches the bottom of an article, the suggested links are not necessarily thematically consistent with the subject of the article at hand (that is, literature, or arts and culture more broadly). This lack of relevance makes for a discontinuous experience of reading. Readers are faced with a variety of often poorly structured reading pathways that don't appear to have a great deal of semantic cohesion. When we consider the foundations of the searchable web are based on semantic relationships, *La Nación* does not provide a great deal of rational structure in its placement of the connections it forges between literary and cultural content. This does not mean that this content isn't there. On the contrary, there are abundant resources at hand across the site. However, abundance and discoverability are not one and the same.

In comparison, *La Tercera*'s *Culto* sustains a very different readership experience. When entering the *Culto* subdomain, one arrives at digital

space that is markedly divergent from *La Tercera*. The site maintains a great deal of digital autonomy, and its aesthetics and content are targeted and clear, showing no signs of visual continuity with its parent site. Indeed, there is virtually no mention of *La Tercera*, except in a subtle banner at the bottom of the page, and there are nearly no other clickable links back to the newspaper. The *Culto* subdomain features a youthful design with bold colours and with content that is intensely focused on culture. What "culture" means for *Culto* is wide-ranging – topics are often popular and frequently contemporary in nature. The site is not a home for stale or traditional cultural content but rather a lively and fresh space for wide-ranging, global cultural materials. A dynamic variety of literary and cultural texts and visuals can be found by scrolling through the #Libros section of *Culto*. A piece discussing the prevalence of book piracy in Chile rubs shoulders with a seventieth-anniversary retrospective on Simone de Beauvoir's *The Second Sex*. Well-known canonical names appear frequently, along with popular new authors. An interview with Isabel Allende touches on topics as diverse as #MeToo, the state of affairs in Venezuela, Allende's recent marriage, a ballet adaptation of *La casa de los espíritus* (*The House of Spirits*), and the eightieth anniversary of the arrival of 2,200 Spanish Republican exiles in Chile. This approach – literature broadly understood – functions well given the connective mandate of contemporary digital media. Overall, compared to *La Nación*'s cultural materials, *Culto* is much more expansive and inclusive, with content about countries that extend beyond the typical literary and cultural powerhouses. The site strives to appeal to a curious reader who is familiar with Latin American and foreign canonical works, or at least a reader who is knowledgeable about a few names and curious to find out more. In a context where tagging creates pathways of readership to other pieces of content, it advantages a newspaper to have materials that touch upon many popular topics. From the perspective of web analytics, search-based semantic relationships are clearly centred around popular culture as its own complex landscape, rather than on a specific geographic or literary focus. This approach has the ability to draw in a wider, transnational audience through varied and popularized keywords, as I will explore next.

### Keywords: Distant Readings of Search Pathways

When we turn to keyword analysis, we are able to tailor our results much further, arriving at topics more closely related to intentionality and desire. For the purposes of the present chapter, I used a word bank of literary keywords to identify search terms related to literature for

both *La Nación* and *La Tercera*.[8] The initial results from this method of filtering the keyword data revealed that *La Nación* had more literary search terms in its keyword bank than *La Tercera* (about 650 and 346, respectively). *La Nación* also had a significantly greater diversity of terms (710 unique words versus *La Tercera*'s 423). *La Tercera* had substantially fewer search terms collected overall (about 50,000 compared to *La Nación*'s roughly 80,000) and fewer terms related to literature overall and as a percentage of total search terms. It is also noteworthy that thematic, conceptual, or form-based words that were effective search operators for capturing the keywords related to literature in *La Nación* retrieved a more limited range of results in *La Tercera*.[9] Although assessing each literary search term with respect to its ability to reveal a pathway of readership provides a promising lens into this otherwise unwieldy dataset, reviewing each of the more than 60,000 keywords would have been impossible. However, as the keyword data in fact represent search terms (usually two or more words each), the high specificity of the search term data allowed me to combine qualitative readings of the search data with the quantitative metrics that Alexa provides for each keyword. Alexa calculates two metrics for each keyword: share of voice (the share of the "voice" for that keyword that is accounted for by traffic to a site) and percent traffic (the percentage of a site's search traffic that is attributable to that keyword).[10] As newspapers are sites that cover a broad range of searchable topics, it is understandable that relatively few of the search terms for each site would relate to literature, or even to arts and culture more generally. Furthermore, it is unsurprising that few of the literary search terms generate substantial traffic to either site. However, the sites did capture a surprisingly large share of the voice for several literary keywords, as I will discuss further on.

As an alternative approach, I assessed the kind of search context that forms around a set of generic literary keywords from the initial search bank – words such as *libro, escritura* (writing), *autor* (author), and *narrativa* (narrative). In each of these search contexts, the matching terms – and the contextual data about their share of voice and percent traffic – allow me to illustrate some significant search pathways for each newspaper. Overall, the *La Tercera* results for *libro/s* reveal a preoccupation with authors and genres, whereas the *La Nación* results for *libro* reveal a focus on format and modes of reading. In fact, *La Nación* holds a whopping 37 per cent of the voice for the search term *comprar libros por internet argentina* (buy books on the Internet Argentina), and smaller but significant (5–10 per cent) shares for other prominent search terms around this theme, including *plataforma descentralizada para la venta de libros de autor* (decentralized platform for the sale of books author) (11

per cent), *tienda de libros online* (online bookstore), *comprar libros online argentina* (buy books online Argentina), *como bajar libros gratis* (how to download books for free), *como descargar libros en pdf gratis* (how to download books in PDF for free), *libros gratis on line* (free books online), and *libros digitales gratis* (free digital books), among many others. In fact, nearly 15 per cent of all the literary search terms retrieved for *La Nación* relate to shareable electronic reading formats, particularly ebooks and pdfs. In contrast, terms related to genre – horror, mystery, and biographies in particular – dominate the (less-numerous) search contexts for *libro* in the *La Tercera* data. What is fascinating about these terms is that they point to a more general culture around literature, and a cultural life that extends beyond simple buying or downloading books, to one of public spaces and specific literary categories.

When we consider the type of content that readers seek in their literary searches, both sites' keywords reveal a readership experience that extends far beyond national contents. It is fitting, given the exuberantly multinational, youthful, web-savvy cultural space that *Culto* sustains, that *La Tercera*'s search terms would prominently feature authors from many backgrounds. The implications of the keyword data are particularly significant when comparing the results for identical search terms between the two sites. For example, *La Tercera* holds about 15 per cent of the share of voice for the search term *último libro isabel allende* (the last book by Isabel Allende), whereas *La Nación* pulls in less than 4 per cent for the same term. Whether this is a product of the sites' divergent geographic groundings – Isabel Allende is, after all, one of the most notable Chilean authors – is beyond the scope of this chapter. However, I wish to note that this discrepancy also raises questions about the quantity and quality of published content relating to a given search term. *La Tercera*'s coverage of Allende's life and works is broad-ranging, both canonical and hyper-contemporary. In comparison, *La Nación*'s coverage of Allende sticks to more traditional formats – author retrospectives and feature articles that do not have the same media- and culture-crossing relevance. It is important to reiterate, however, the limitations of deducing a singular desire from a keyword. What I would argue for, instead, is to consider these words as a collective whole, one that might inform a cosmos of thinking rather than a specific vein of thought. When looking at both sets of prominent keywords as a collective, observers are confronted with national and transnational authors, different forms of reading and writing, as well as different spaces and places to engage in the consumption of literary and cultural content. These are beautiful webs to be observed as a whole ecosystem, rather than untangled and analysed in their minutiae.

## Medium and Close Readings

Throughout my work in the digital humanities, I argue for multimodal forms of reading and interpreting data. Distant, close, and what I term "medium" readings can speak to one another in dialogue, illuminating and informing each other. Nowhere is this more the case than if we consider literary content online, whose nuances and strengths often get lost in the shuffle of large-scale data visualizations and other quantifiable approaches. When I speak about medium readings, I mean looking at a subset of texts from a close-up *and* zoomed-out angle in order to ascertain thematic tendencies. Smaller subsets of texts allow us to rise above the datafication of cultural materials and extend beyond computational measures while still benefiting from the perspective of scale. In this way, we are better able to determine what drives cultural content online and perhaps gain perspective on the notion of readership desire. In this section, I examine a month's worth of literary content from *La Nación* and *La Tercera*. I am particularly interested in approaching themes, authors, content types, and geographic focus in order to draw out nodes of connection across space and time. These factors have been isolated in two aggregate spreadsheets in order to allow for a more panoramic perspective.

Based on the data collection of articles in the literature section on the *Culto* subdomain of *La Tercera* in June 2019, one observes that most articles are connected to Chile directly either by author or theme of the article or they are in some way Pan-American (in other words, they are focused on the Americas – North, South, Central – and the Caribbean). When non–Latin American authors/works are addressed, the content tends toward coverage of European authors featured in a sort of "homage" format – for example, the above-mentioned article noting the anniversary of *The Second Sex*, an article on George Orwell's *1984*, and coverage of the winners of major literary prizes, like the Nobel Prize and the Manuel Rojas Prize in Latin America, with accompanying literary articles. The collection of *La Tercera* data from June 2019 is also a subset that is dedicated to global forms of thinking through literature. Indeed, a significant number of articles (seven of fifty-three articles in the literature section of *Culto* during the month of June) are devoted to a series of world literary authors, often of popular significance, especially of folk or counterculture fame. One article recounts the historical connections between Bob Dylan and famous Beat Generation authors such as Allen Ginsberg and Jack Kerouac. While Kerouac and Ginsberg travelled to Latin America and wrote about it, the Beat movement was known as a North American avant-garde phenomenon. Hunter S. Thompson

(author of *Fear and Loathing in Las Vegas*) makes an appearance among the articles as well, along with Nick Cave (Australian post-punk musician, actor, and author), the postcolonial theorist Michel Foucault, and the iconic Japanese author Haruki Murakami. In other words, there is a focus on the reader who would recognize these names in the global counterculture canon, but there is also an implication that these figures are often grouped together for the same reader, and thus share space on the same platform alongside Latin American literary content. In general terms, *Culto* presents a mix of global and Latin American literary content, displaying everything from the highly canonical, such as an abundance of content on Gabriela Mistral, to the highly specialized, including works by minor or peripheral authors with cult followings. Compared to *La Nación's literatura* section, *Culto* is much more expansive and includes countries other than the typical literary and cultural "powerhouses." The site strives to appeal to a curious reader who is familiar with Latin American and foreign canonical works, or at least a reader with some knowledge and an openness for discovery. Bringing up literary polemics and controversies between Mario Vargas Llosa and Alejo Carpentier, for example, is a way for *Culto* to address important canonical debates in Latin American literature, serving a didactic function for readers.

Looking at *La Nación* over the same timeframe, we can certainly see convergences, but also some significant deviations in content.[11] Similar to *Culto*, *La Nación* celebrated Svetlana Alexievich's Nobel Prize as well as the polemics of Mario Vargas Llosa and his new book release. *La Nacion* also stresses world literary works and figures, while looking into some of the intricacies of canonical works. For example, an article on "Twitterature" informs the reader about the social mediatization of classic texts – the works of Miguel de Cervantes and Margaret Atwood are mentioned – while also highlighting their salient themes: the article itself thus serves as an extension of the objectives of Twitterature. Another article plays a more critical role by connecting Homer and Jorge Luis Borges as literary figures, tying together classics and national history through literature. In another piece, the author lauds J.G. Ballard, a British author, describing him as a "visionary machine."

Comparing this small sample from *La Nación* to *Culto's* section on the non–Latin American canon, it would appear that *La Nación* is promoting a more traditional notion of the canon rather than a countercultural one. Indeed, *La Nacion's* literary section tends to be more insular or closely connected to Argentine traditions and migration patterns.[12] However, when the themes of literature and culture are explored from the perspective of the non-Argentine, they tend to be European, with a particular

focus on Italy. It is also worth noting the hinging from the cinematic to the literary sphere, indicative of cross-media conversations that seem to happen in *La Nación*. One example of this is an article published in late June 2019, with the headline, "¿Qué lee Antonio Banderas en *Dolor y Gloria*, la última película de Almodóvar?" (What is Antonio Banderas reading in *Dolor y Gloria*, the last film by Almodóvar?). In it, author Daniel Gigena details the list of books on the shelf of the main character, played by Banderas. The list of books includes *Cuentos* by Anton Chekhov; *Desgracia* by J.M. Coetzee; *Hijo de Jesús* by Denis Johnson; *Libro del desasosiego* by Fernando Pessoa; *En la orilla* by Rafael Chirbes; *Miguel Hernández, Destino y Poesía* by Elvio Romero; *Manual para mujeres de la limpieza* by Lucia Berlin; *Laetitia o el fin de los hombres* by Ivan Jablonka; and *Nada crece a la luz de la luna* by Norwegian author Torborg Nedreaas. Many of these authors are linked via book reviews or related articles in an effort to create a sustained readership and inform them about the hypertextual world literary dialogues in the filmic canon of Almodóvar. There is perhaps no better example that this article to highlight the broader trend of intertextual dialogues between popular culture and high art, Argentine and transnational works, present in *La Nación*.

If we take our approach a step closer and examine the content from the perspective of individual articles, we are further struck by the many differences between *Culto* and *La Nación*. The sidebar on *Culto* highlights a special feature on the books and films that inspired the Duffer brothers, the American creators of the television series *Stranger Things*, including a suggested Spotify playlist, a list of recommendations for what to watch, a set of book recommendations. Although the recommendations at the bottom of the page are not exclusively literary content from the #Libros tag, they are content found elsewhere on *Culto*. While *La Nación*'s site contains a link to the digitized version of the paper, *Culto* contains no similar link to *La Tercera*. Moreover, in the digitized print version of the latter paper, cultural content appears to be sectioned off as "Cultura & Espectáculos" (Culture and Spectacles), with the heading "Culto" reserved for a special annual supplement of the paper (see figure 2.3).

In contrast, the close reading impression of the *Culto* website is more of a "one-stop shop" for cultural knowledge, albeit with a focus on pop culture, with some high culture references. The colourful layout, recommended playlists, and curious, conversational headlines (which occasionally feel like clickbait) imply an inquisitive and cosmopolitan readership (see figure 2.4).

As discussed earlier, *La Nación* does not create a bounded or continuous readership experience focused on arts and culture in the same way

Figure 2.3.  Details from the digitized print version of the arts and culture section of LaTercera, compiled by author from editions published in July 2019. Source material © Grupo Copesa, 2019.

Figure 2.4.  Screenshot showing variety of content on the homepage of Culto, 11 July 2019. © Grupo Copesa 2019.

that *La Tercera* does with *Culto*. Rather than a self-contained arts and culture section, articles relating to these themes that can be aggregated by clicking the section buttons for *Cultura* or *Arte y Cultura* – or more granular tags like *Libros* and *Literatura*, or the *Ideas* tag (denoting that a piece of content is included in *La Nacion*'s "Ideas" supplement) – do not lead a reader from one to the other. They have a scattered, sporadic feel. Literary content can be found by clicking on the main menu to get to the culture section, and then clicking on other tags (e.g., *Literatura*) that appear below each piece of content. The site gives little impression of a space specifically devoted to cultural content, as the only feature that distinguishes the culture section from the other online sections is the heading at the top of the page and some shared themes. Given this set-up, the section makes it difficult to have a sustained cultural reading experience. This is in part because the tagging system used to organize literary and cultural content on *La Nación* is less consistent than it is with *La Tercera*'s *Culto*. On *La Nación* site, the tags *Libros* and *Literatura* are both easily searchable; however, they often seem to be used interchangeably and inconsistently. Clicking on the *Libros* tag aggregates content ostensibly tagged as #Libros that also appears under the headings #Ideas and #Literatura. The article "Literatura: del boom a las nuevas voces de la libertad" (Boom literature and the new voices of freedom) by Fabiana Scherer is a good example of distinctly literary content found on a search for the *Libros* tag, but that is also cross-tagged with *Ideas* and *Literatura*. It is not uncommon to find literary content, such as book reviews, that are not tagged with any of these three headings. Book reviews in particular are likely to be found with the #Ideas tag, and not with the #Libros and #Literatura tags that one might assume would be appropriate for organizing such content for a more fluid readerly search. It is worth noting here, especially when we return to the idea of "medium reading," that the Argentine focus of *La Nación*'s literary content may take arise from the nationality of an author, the setting of an event, a canonical or thematic discussion, or the publication history of a work – the latter evident in an article about the Belgian author Amélie Nothomb, "Los libros de Amélie Nothomb editados en Argentina" (Books by Amélie Nothomb edited in Argentina). The links suggested at the close of the articles are not always thematically consistent with the subject of the article at hand. For example, the links at the bottom of an article about literature are not generally confined to literature or arts and culture more broadly. There are also ads at the bottom of the page – which *Culto* doesn't have – a further "opening" of the cultural readership space to external content.[13] This inevitably changes the readership experience, as readers muddle their

way through proprietary content as they attempt to consume content of a cultural and literary nature.

**Conclusion**

In this three-tiered approach, I have illustrated a more granular reading of how and from where readers are engaging with literary and cultural content on *La Nación* and *La Tercera/ Culto*. It is clear from each of these methods that readers are arriving at these sites from varied locations across the web and that they are searching for and consuming content with local, national, trans-Hispanic, and transnational themes. While both sites serve as authorities on the web and receive a large percentage of their traffic from direct search and links, *La Tercera* seems to garner traffic that is slightly more geographically varied than *La Nación*, and additionally, offers materials on a more diverse range of literary topics. Despite the challenges inherent in assessing a site's readership in terms of thematic interest, I argue that these observations speak to a base of readers that extends into more varied terrains.

   In our examination of keyword data, there are notable differences in the kinds of search associations that form around generic literary terms such as *libro* and *escritura*, revealing diverse user intentions in the areas of genre preferences, desired reading format, and popular authors. From this data, it is clear that readers of both sites are interested in accessing and consuming content on literature and culture, but how we define "culture" must be extended into the popular sphere. Perhaps in contrast with analogue readership and the history of *La Nación* in particular, the online papers are less home to high art or canonical reflections from trans-Hispanic intellectuals on the place of literature, culture, or film, and more arenas for the consumption of global popular culture in an increasingly prominent way. It would also appear that literary and cultural parameters have taken a further multimedia, cross-cultural turn in the digital sphere – the keyword patterns illuminate this for us in ways that print circulation does not. Yet, there are many questions that remain unanswered, as we face the limitations of the web analytic tools we use, as well as the very notion of algorithmic search itself. Ed Finn (2017) speaks to the "seductive claims about the status of human knowledge and complex systems," which he sees in tension with "the relationship between culture and cultural machines" (27). Nowhere is the tension better explored than in trying to untangle web analytic results from the pathways of readership desire and content presentation in these two papers, which have become institutions in Argentina and Chile.

At the same time, what I have argued here is that taking a closer look at what is being written, by whom, and for whom, through medium and close readings is essential to our understanding of the experience of readership on these sites. In assessing their structure, layout, and the nature of their content from a thematic perspective, we find connections back to some of the keyword data. These sites combine high and low culture; forays into Boom literature, along with content that has a more global footprint; popular culture from across the world along with countercultural materials on literature, culture, and film. It is perhaps unsurprising that *La Nación*, a traditional, conservative paper, would lean toward content that is more traditional, and that *Culto*, the youthful culture-focused offshoot of *La Tercera*, would feature more varied content. *La Tercera*'s *Culto* subdomain reflects aesthetic trends on the web that speak to a social-media-savvy, young, and perhaps increasingly digitally born readership that wishes to engage with culture on their own terms, in the current language(s) of the web. As newspapers adapt to meet a shifting landscape of readers, this trend is likely to remain pertinent. In the coming decades, it would be unsurprising if more traditional newspapers increased the amount of featured cultural content or offshoot sites of a similar aesthetic, speaking directly to readers of a contemporary profile. On the other hand, the tendency of papers such as *La Nación* and *La Tercera* – along with their close competitors *El Mercurio* and *Clarín* – to include both a web-native format and a downloadable digital edition of the print paper tell us that the the analogue-form newspaper remains prominent in the imaginary of many Latin American countries. Time will tell with regard to the evolution of cultural content online, but these two case studies offer some compelling predictions.

NOTES

1  SimilarWeb (via Google Analytics) estimates the average number of visitors per month to *La Tercera* to be between 30 and 40 million as of June 2019. This is noticeably lower than the traffic to *La Nación*, which SimilarWeb estimates at approximately 60 million for June 2019, never dipping below 50 million since the beginning of 2019. Users also spent more time on *La Nación* (11 minutes via Similarweb and about 8 minutes via Alexa) compared to *La Tercera*, where users spent on average 4–5 minutes (4 minutes via SimilarWeb; 4:47 via Alexa, as of June 2019). It is also notable that *La Tercera* has a significantly higher bounce rate.
2  For example, although, in January 2019, Alexa offered a subdomain analysis feature that estimated that approximately 10 per cent of visitors to *La*

*Tercera* visit the *Culto* subdomain, this tool is no longer available. We do not have a corresponding figure for the number of visitors to *La Nación* who seek out pages with cultural content. This is because while *La Tercera* posts such content on a dedicated and highly developed subdomain, *La Nación* does not.

3   This changed in 2003, when the format of *La Tercera* went from tabloid to Berliner format, featuring long-form content. At the same time, the paper lengthened its articles in order to reach a higher social class. In more recent years, the aesthetics of the paper have been minimized, and the logo has been restyled to meet contemporary design standards, both on- and offline.

4   Spain, 3–5 per cent; Mexico, 2–4 per cent; the United States, approximately 2 per cent.

5   SimilarWeb notes clearly that its location estimates are drawn only from desktop visits, which is particularly problematic, given that many users in Latin America connect to the internet primarily through their mobile devices. Alexa does not specify a connection modality for its data.

6   Interestingly, in figure 2.2, the sites are clustered closely with prominent news outlets in each country, although it is significant that *La Nación*'s cluster also includes news sites with domains in Peru, Spain, and Mexico. It is an interesting finding that the audiences for these sites differ so significantly geographically, given that the sites' content – particularly that on literature, culture, and similar topics – often overlaps. It is also curious that neither audience-overlap visualization is confined by national contexts, as both delve into other language and cultural zones of the web, as seen in the figure. This fact might speak to the notion of the web as an arena for more global encounters; however, it is important to note that readers of both sites seem to primarily be coming from and engaging with sites stemming from national, and certainly Spanish-language, contexts.

7   Book reviews in particular are likely to be found in the #Ideas tag.

8   The initial search terms were *libro* (book), *literatura* (literatura), *cuento* (story), *autor* (autor), *historia* (story; history), *ficción* (fiction), *poesía* (poetry), *poema* (poem), *novela* (novel), *crónica* (chronicle), *literario/a* (literary), *leer* (read), *narrativa* (narrative), *narración* (narration), *escrito* (writing; written), *escribir* (to write), *escritura* (writing), *biblioteca* (library), and *librería* (bookstore). Author names were added to the list as they were retrieved during the searches, with both datasets being searched for each author name that appeared.

9   For example, while a search for *libro* in *La Nacion*'s keyword data returned 646 results, in the *La Tercera* dataset the same search returned about half that number (n=317).

10  Using this data, Alexa also calculates proxy metrics for the keyword's popularity, a "traffic score," and estimates of its popularity among competing sites. However, these items are beyond the scope of this chapter.

11  It is notable that a large portion of the content aggregated under the #Literatura or #Libros tags is #LiteraturaInfantil (children's literature), or a recurring feature titled and tagged "Qué vas a leer con tu hijo esta noche?" (What are you going to read with your child tonight?). This finding appears to indicate a focus on the parenting relationship with regard to the consumption of literary content. These articles also included some didactic pieces on the benefits of reading to children sponsored by OHLALA (a women's lifestyle subdomain of *La Nación*).

12  Curiously, in *La Nación*, there are a number of obituaries and homages as a reminder of famous literary figures from Argentina and Italy, reinforcing Argentina and Italy's close diasporic relationship. For example, five of the twenty-five articles from June were dedicated to obituary-style homages to recently deceased authors from Italy or Argentina.

13  Alexa finds that *La Nación* has many more links in its site than does *La Tercera* – close to 12,000, which is also more than the average of *La Nación*'s competitors (again, according to Alexa). While the prevalence of links certainly speaks to the site as an authority, given that many sites link to the digital universe of both *La Nación* and *La Tercera*, what is also clear is that *La Nación* propagates itself as a site that buys and sells links and ads for commercial purposes.

REFERENCES

Anderson, Benedict. 1983. *Imagined Communities: Reflections on the Origin and Spread of Nationalism.* Verso.

Bachmann, Ingrid, and Summer Harlow. 2012a. "Interactividad y multimedialidad en periódicos latinoamericanos: avances en una transición incompleta." *Cuadernos de información* 30: 41–52.

– 2012b. "Opening the Gates: Interactive and Multimedia Elements of Newspaper Websites in Latin America." *Journalism Practice* 6.2: 217–32.

Boczkowski, P., and M. de Santos. 2007. "When More Media Equals Less News: Patterns of Content Homogenization in Argentina's Leading Print and Online Newspapers." *Political Communication* 24.2: 167–80. https://doi.org/10.1080/10584600701313025.

*El País*. 2016. "El País, el periódico digital en español más leído del mundo." 23 November. https://elpais.com/elpais/2016/11/22/actualidad/1479853627_478107.html.

Finn, Ed. 2017. *What Algorithms Want: Imagination in the Age of Computing*. MIT Press.

Fundación Nuevo Periodismo Iberoamericano. 2011. "Sondeo de tendencias de los emprendimientos periodísticos digitales en América Latina." 10 March. http://www.fnpi.org/noticias/noticia/articulo/-7556b0a6d3/.

Gentic, Tania. 2013. *The Everyday Atlantic: Time, Knowledge, and Subjectivity in the Twentieth-Century Iberian and Latin American Newspaper Chronicle*. State University of New York Press.

Harlow, Summer, and Ramón Salaverría. 2016. "Regenerating Journalism: Exploring the 'Alternativeness' and 'Digital-ness' of Online-Native Media in Latin America." *Digital Journalism* 4.8: 1001–19.

Paterson, Chris, and Domingo, David. 2008. *Making Online News: The Ethnography of New Media Production*. Peter Lang.

Raimondo Anselmino, Natalia, Alejandro Matías Sambrana, and Ana Laura Cardoso. 2017. "Medios tradicionales y redes sociales en Internet: un análisis de los posteos compartidos por los diarios argentinos *Clarín* y *La Nación* en Facebook (2010–2015)." *Astrolabio* 19: 32–68. https://revistas.unc.edu.ar/index.php/astrolabio/article/view/17787.

Rama, Angel. 1996. *The Lettered City*. Duke University Press.

Raynor, Cecily. 2018. "Geografías digitales: iluminando las relaciones espaciales en una colección de blogs literarios." *Digital Humanities Quarterly* 12.1.

Rodríguez, José Miguel Rodríguez, and José María Albalad Aiguabella. 2012. "Nuevas ventanas del periodismo narrativo en español: del big bang del boom a los modelos editoriales emergentes." *Textual and Visual Media* 5: 287–310.

Zuckerman, Ethan. 2013. *Digital Cosmopolitans: Why We Think the Internet Connects Us, Why It Doesn't, and How to Rewire It*. W.W. Norton.

# 3 Print *Then* Digital: Material Reimaginations in *Anacrón* and *Tesauro*

ÉLIKA ORTEGA

Despite perennial forewarnings of the death of the book due to the newest digital device or service, it is increasingly evident that a book-less future is not looming on the horizon. On the contrary, we continue to witness a series of intersections where print and digital book innovations occur. In the literary realm of the twenty-first century, as N. Katherine Hayles (2007) and, later, Matthew Kirschenbaum (2017) have explained, most works published in print experience a series of digital mediations encompassing their creation, production, distribution, and reception. For example, the *dwarsligger* or flipback book – recently launched in the United States – is "a new kind of book, which opens top to bottom and has sideways-printed text, so you get a full length novel in little more than the size of a *smartphone*. The book concept is incredible handy due to its convenient size (it fits even in your pocket) and the ability to *read it in one hand*."[1] Described and marketed in language that appeals largely to those with digital device sensibilities, the flipback book is indebted to both the pocket book tradition and the reading conditions that emerged after the worldwide popularization of handheld supercomputers.

While the world of intersections between print and digital is vast and plentiful, I am interested in a specific phenomenon of their blurring boundaries recurrent since the mid-1980s: the creation – and publication – of hybrid literary works made up of a print book or booklet and a digital application. Even a general chronology can reveal how these hybrid works have traversed a gamut of computational media innovations, from diskettes and CD-ROMs to web and mobile applications, in contrast to the palpable stability of the print codex. Relationships between digital literature and non-bound paper in the form of punch cards and dot-matrix-printed rolls of paper go even farther back in time, as Nick Montfort (2004) has shown in his study of *Eliza/Doctor*

and *Adventure*. This trajectory positions print-digital works as an ideal locus to examine media encounters in literature and literary publishing over the past three decades.

That said, aside from their artefactual print and digital composition, hybrid works have little in common. Consequently, an umbrella characterization of the phenomenon is no easy task. Two considerations underlie this challenge: individual authors' literary and aesthetic intentions, and the specific ways of "binding" digital media and the print book. For example, we can observe the radically specific writing and reading practices in works utilizing augmented reality, like Luis Correa-Diaz's QR code collection of poems, *Clickable Poem@s* (2016), which relies on the juxtaposition of a digital device and a print book. In contrast, a very different experience is offered by works that alternate the reader's attention from a print page to a digital application, like *El libro del fin del mundo* (1996/2002) by Belén Gache, and Luis Bravo's *Árbol veloZ* (1990/1998). Quite another dynamic exists in works like Rafael Pérez y Pérez's computer-generated short-story collection, *Mexica: 20 años – 20 historias* (2017), where the book constitutes the output of the computer application.

Within the spectrum of possible print-digital configurations, there are also works whose components have been published one after the other. Giselle Beiguelman's *O livro depois do livro*, for example, first came out as a hypertextual bilingual (Portuguese and English) web essay in 1999, and was later published in print in São Paulo by Peirópolis in 2003. The temporal distance between parts of the same work prompts a constellation of questions regarding their relationship to one another (print then digital, digital then print, or simultaneously print and digital) as "versions," "adaptations," "translations," "remediation," and others. Characterizing a work in a specific way will likely arise from the tenets of the theoretical framework at hand, and from whether the emphasis is put on the transcoding of content, forms of engagement, media specificity, or publication history. In this chapter, I discuss two Mexican works whose media hybridity ruptures the overlapping complexity of these theoretical frameworks: Augusto Marquet's *Anacrón: Hipótesis de un producto todo* (2009/2012), and Karen Villeda's *Tesauro* (2010). Villeda first published *Tesauro* as a print anthology before quickly remaking the work as a collection of digital poems. *Anacrón* presents a slightly more complex case, as the work is Marquet's reinvention of Gabriel Wolfson's "Hipótesis IV" from his collection *Caja* (2007). An examination of *Anacrón* and *Tesauro* helps us explore the complex processes of adaptation, translation, remediation, transcoding, and so on, at the heart of asynchronously published print-digital hybrid works.

Translation approaches to electronic literature have strived to bring together these considerations into an all-encompassing framework. In "Electronic Literature Translation: Translation as Process, Experience and Mediation," Søren Pold, María Mencía, and Manuel Portela (2018) arrive at the extremely expansive conclusion that, "if translation is redefined as remediation between languages, then e-lit translation can be described as a multidimensional process of remediation that involves natural languages, computer codes, and media materialities" (n.p.). Such a broad theorization about translation seems to be able to replace the theoretical frameworks that nurture it but, by doing so, eschews and muddles the details of each one. Under the notion of Pold et al., any media transformation would fit under the umbrella of e-lit translation.

In parallel, translation theories of electronic literature have, up until now, paid little attention to media shifts as dramatic as that from print to digital publication – a shift that seems to fall more conventionally under the paradigm of adaptation, remediation, and even digital edition. However, due to their artefactual uniqueness, print-digital works resist this overarching framework. As a matter of fact, works like *Anacrón* and *Tesauro* seem to ask scholars to produce critical frameworks that reflect and engage their multiple media landscapes. Approaches from electronic literature translation, media studies, and scholarship on adaptation are only partially useful, and establishing a conversation between them over their basis is crucial to describe and understand *Anacrón's* and *Tesauro's* transformation from printed prose and verse to highly interactive visual digital applications.

## Genealogies of Print then Digital

The remediating practice of taking literary works from the print codex to the small screen has a long history within the fields of digital humanities and electronic literature: among them, we can mention Father Busa's *Index Tomisticus*, Vannevar Bush's *Memex*, and Michael Heart's e-book. At its most capacious, the notion of remediation – that is, the representation of a medium in another medium – encompasses a "genealogy of affiliations" where "all current media function as remediators" (Bolter and Grusin 1999, 55), including textual media transformations like those of print-digital works. More specifically related to the hybrid media of print-digital works is Voyager's Expanded Books Project (EBP). The emphasis on the interactive possibilities afforded by digital media that characterized EBP, I believe, provides a useful backdrop and a point of departure for my analysis, as that project walked a similarly

fine line between born-digital and print objects as *Anacrón* and *Tesauro*, among many others.

The history of Voyager leading up to the EBP takes us from the success of Bob Stein's Criterion Collection, which sought to make movies "more like books" (Moor 2012), through the production of Robert Winter's CD companion to Beethoven's Ninth Symphony (1989) as the inspiration for the model of the expanded book. The CD companion, which "offered all sorts of interactive historical, musicological, and biographical information about the work and its composer, and even included a running text commentary synced to the CD recording" (Cohen 2013), provided the precedent of adding content and forms of interaction to well-known works of art whether musical or literary. Over the short span of two years, the Expanded Books Project went from being an idea hashed out in a now almost mythical meeting of multimedia and hypertext experts on Bloomsday 1990 (Krall 2013), to the production of its first three titles: *The Complete Hitchhiker's Guide to the Galaxy*, *The Complete Annotated Alice*, and *Jurassic Park*. The demoing of these initial titles at the 1992 San Francisco Macworld Expo gathered enough enthusiasm that it led to the development of the Expanded Books Toolkit and, further, to the establishment of agreements with publishers like Random House, Macmillan, HarperCollins, and NTC to use the toolkit for their multimedia productions (*IDP Report* 1992, 4; Virshup 1996). While, admittedly and as the name itself indicates, Expanded Books offered little in terms of reimagining the original print "content," it added additional features like annotation, searching, and some multimedia-like sound and animation to the publications. Although EBP was certainly one of those instants of innovation that blurred the boundaries between print and digital book publishing, as Bolter and Grusin (1999) assert, the Voyager interface "indicated the priority of the older medium" (46). Even if that is the case, Bob Stein's efforts were key to coupling multimedia production and book publishing in a way that, ensconced in the realm of electronic literature, the software company Eastgate couldn't do.[2]

Though Voyager is now seen as the multimedia publishing branch of digital text, parallel and not totally dissimilar processes were taking place in the scholarly realm in the United States at the same time. Following the genealogy of Busa and Bush, the field of humanities computing, later renamed digital humanities, was heavily invested in creating digital editions of canonical works in the English language since around the 1990s. Some of the best-known were the Blake Archive (1996), the Whitman Archive (mid-1990s), and the Rossetti Archive (first instalment, 2000). The Women Writers Project had started work in 1988 as well. Matters of accessibility, collection, recovery, and – crucially – scholarly

enquiry were, and still are, at the heart of these projects' ongoing development. Unlike Voyager's ultimate demise, these projects continue alive and at the centre of important research projects.

In Mexico, the adaptation of canonical literary works to digital platforms has not been rare in the past decade. Interestingly, however, this practice has not been widespread in experimental literary and publishing circles, or innovative scholarly ones, but, most notably, through the patronage of government institutions. In 2012, and led by Consuelo Sáizar, CONACULTA (the National Council for Culture and Arts) made a big splash in the digital world by releasing its *Proyecto Cultural Siglo XXI Mexicano* (Amador Tello 2012). In addition to conferences and symposia, CONACULTA's project included the establishment of the Centro de Cultura Digital México (CCDMx), which has since become an indisputable hub of digital literary creation in Mexico. More to the point, the project included the development and publication of seven iPad applications, the most celebrated of which were renditions of Octavio Paz's 1967 poem "Blanco" (CONACULTA, 2012b) and of José Gorostiza's "Muerte sin fin" from 1939 (CONACULTA, 2012a). The project also included "Nezahualcóyotl" (CONACULTA, 2013b) and "Seducciones de Sor Juana" (CONACULTA, 2012c), which celebrate the life and works of these respective Mexican literary pillars, and Alfonso Reyes's "Visión de Anáhuac" (1519), the app for which was never released.

Not unlike the titles published by Voyager – though with the impressive levels of resolution, capacity, interactivity, and breadth of content enabled by twenty years of technological developments – the CONACULTA apps sought to incorporate multimedia elements capable of enriching the poems in the app format while leaving the content of the works untouched. The council's endeavours included readings of the poems in the voices of the authors themselves or by well-known actors, as well as commentary, translations, interviews, and galleries of visual materials related to the works. Only in the exceptional case of "Blanco," where meaning depended heavily on the physical medium, was there a more thorough process of adaptation and remediation. The app's description indicates how its design follows Paz's original idea as "una sucesión de signos sobre una página única; a medida que avanza la lectura, la página se desdobla: un espacio que en su movimiento deja aparecer el texto y que en cierto modo, lo produce" (CONACULTA 2012b; a succession of signs over a single page; as reading progresses, the page unfolds: a space that, as it moves, reveals the text and, in a way, produces it). The effect, achieved in print with the accordion-book format and multicolour printing, is remediated as the continuous scrolling of the touch screen. The reading modes suggested

typographically in print in the app are specified as "la versión completa" (the full version), "el poema erótico" (the erotic poem), "el contrapunto" (the counterpoint), and "el tránsito de la palabra" (the passage of the word) (CONACULTA 2012b). In all of these cases, it is apparent that CONACULTA sought to "improve" upon print editions of the works so as to popularize them.

   Outside of the institutionally sponsored apps, the work of the Mexican writer Benjamín Moreno and the Argentinian artist Belén Gache also provides insights into the processes underlying the "screening" of print works that go well beyond the "expansion" or "enrichment" of the original texts. In their study of Gache's *Gongora Wordtoys* and Moreno's *Concretoons*, Ortega and Saum-Pascual (2021) maintain that both pieces enact, or put into practice, principles and literary concerns proper to previous literary traditions – Golden Age baroque, and twentieth-century experimentalism, respectively. Furthermore, Moreno (2010) lays out some of his poetic intentions as giving the print poems "un tratamiento formal atractivo para una audiencia más amplia y basado en uno de los usos específicos de los medios digitales: el uso de los videojuegos como medio de creación poética" (an attractive formal treatment for a wider audience, which is also based in a specific use of digital media: the videogame as a medium of poetic creation). This "formal treatment" is a rather opaque way of characterizing the remediation and adaptation processes underlying the poetic exploration of videogames. Likewise, in the preface to *Gongora Wordtoys*, Gache (2011) establishes the equivalence of her pieces to baroque poetry through "despliegue visual y artificios" (visual display and artifices). Both authors acknowledge that revisiting these past literary traditions responds to the parallelisms between current poetic and philosophical concerns about language and those expressed by Góngora and twentieth-century poets. This self-conscious revisiting, almost an evocation along with the temporal and authorial distance that it establishes, I argue, are the key distinctions between these works and Marquet's and Villeda's hybrid works.

   I raise these various examples of ways in which literary works have been taken from the pages of a codex into various digital formats (the extended contexts of which are much too broad to cover in this chapter) in order to help us focalize on the phenomenon I am interested in exploring here. By contrast, we can establish that, unlike digital humanities projects, *Anacrón* and *Tesauro* are not digital editions of print texts and do not include critical and scholarly apparatuses. Similarly, these works' digital facets do not constitute digitizations, understood as creating digital surrogates of print objects, nor facsimiles. The impetus behind their transformation from print to digital was not to include

commentary, video, or galleries of related materials. Ultimately, they are not revisiting texts from the past to explore their relevance to the present. While adjacent and similar, in that they underscore their passage from one medium to another, all of those possible paths *not taken* suggest the uniqueness of Marquet's and Villeda's projects.

Jessica Pressman (2014) argues that all electronic literature can be seen as comparative literature and that it fastens literary analysis to media analysis. Given their media hybridity, *Anacrón* and *Tesauro* intensify this potential as they expose the scaffolding of various media contexts, languages, and the transitions and translations occurring between distributed interfaces and reading conditions, all of which are a precondition of their existence. The display of these components often has an overtness that resembles the works' mechanisms having been turned inside out. In itself, the simultaneous existence of a print and a digital text forces the reader to engage with these dimensions and their associated literary, reading, and media protocols. Under a literary framework, like that of adaptation scholarship, the transformations of *Anacrón* and *Tesauro* might pose questions about how the textual elements or the "content" are made digital, an impetus that is hard to resist. But this impulse seems misguided in that it suggests that there is a somewhat liquid "content" that is poured from one version into another as though into a mould. Adaptation theorists such as Linda Hutcheon argue that themes and stories, rather than a "spirit," are the common denominators among adaptations (Hutcheon 2006, 10–11). Others, such as Kamilla Elliot more esoterically proposes that adaptation shows that form can be separated from content (2003, 133). Following the argument of both Elliot and Hutcheon, the distinctions between adaptations come in the various forms of engagement: narrating, performing, or interacting (Hutcheon 2006, 36–52). Yet in *Anacrón* and *Tesauro*, the "content" is left untouched.

Indeed, rather than interrogating the success of the transformations achieved in *Anacrón* and *Tesauro,* or how faithful the digital "parts" are to the earlier print ones, I base my examination on Katherine Hayles's now classic tenet that "to change the physical form of the artefact is not merely to change the act of reading … but profoundly to transform the metaphoric network structuring the relation of word to world" (2002, 23). Therefore, the more intriguing question is how *Anacrón* and *Tesauro* undergo an ontological shift affecting the meanings they foster specific to each of their media. Further, these works' hybridity also forces a reckoning with how the change of medium entails the creation of distinct publics – for example, via the small print runs of one thousand copies through institutional presses (Universidad de las Américas and

Tierra Adentro), or, in contrast, by inhabiting the space of abundance and hyperconnectedness of the web. In the following pages, I seek to query the works' media specificity in order to interrogate the junctures of theories of adaptation, remediation, translation in electronic literature, and media hybridity.

**Print then Digital**

*Anacrón*

Augusto Marquet first created *Anacrón* in 2009 as an experimental publishing project using Acrobat and Flash to create an interactive PDF (figure 3.1). A subsequent web version launched in 2012 forms part of the *Electronic Literature Collection*, volume 3 (Boluk at al. 2016). The work's text can be traced to Gabriel Wolfson's *Caja*, published by the Universidad de las Américas in 2007. The origin story of this fortuitous collaboration, as told by Marquet, is that he found a copy of Wolfson's book in a coffee shop while visiting the city of Puebla. The design of the print book – which included alternating typographies, photographs, and bright red section dividers – caught Marquet's attention. At the time, Marquet was a recent graduate of the program of editorial design at Universidad Nacional Autónoma de México and was searching for "a short text, with short sentences that could be turned into focalized blocks" to create an artefact (interview with the author, 29 January 2019). Wolfson's short and almost obsessively circular musings about death in "Prosas IV" (from the section of *Caja* titled "Dos Reales") fit this description. Marquet established an email collaboration with Wolfson that saw the transformation of "Prosas IV" into *Anacrón*.

"Dos Reales" takes as a point of departure a comically redundant phrase from Lope de Rueda's *El Convidado*: "y por tanto querría suplicar a vuesa merced que vuesa merced me hiciese merced de me hacer merced, pues estas mercedes se juntan con esotras mercedes que vuesa merced suele hacer, me hiciese merced de prestarme dos reales" (60; and therefore I would like to beg from your grace that your grace do me the favour of doing me a favour, [and] since these favours add to those other favours that your grace usually does, to do me the favour of lending me two *reales*). This circular and repetitive structure is mimicked in "Prosas IV," as the text spreads the hypothesis – or paranoia – about dying to all possible family relations, and even to cats. As a language experiment in repetition, "Prosas IV" suggests an intimate, stream-of-consciousness moment of fright. The key to reading "Prosas IV" is in the title section and epigraph: the last point in the circular

Figure 3.1.  The two pages in Anacrón showing the full text. © Gabriel Wolfson and Augusto Vinicius Marquet 2009.

logic resolves the redundancy as "producto de una hipótesis todo" (79; everything the product of a hypothesis), which brings to a halt the crescendoing anxiety evoked by Wolfson's text. This closing segment serves as a negation of everything that came before, as a subject not to be thought of, mentioned, or, even less so, realized.

With Wolfson's text as a point of departure, Marquet creates segmented blocks of text out of each short sentence and turns the text into a "hypertextual minefield … [that] responds to the pointer's position over the text, delivering alternate texts, frenzied movement, sound and video clips, and animated sequences" (Boluk et al. 2016). This strategy allows him to situate the various blocks along a series of thematic paths and contexts – Mexico's *Día de Muertos*, the death toll of the war on drugs launched by then-president Felipe Calderón, corruption scandals, global politics, and capitalism. While Wolfson's text does not acknowledge any overt connections to the *Día de Muertos*, the war on drugs, or other such subjects, Marquet uses the extremely broad theme of death to zoom into a constellation of possible evocations. This experimental and intuitive approach, as Marquet described it in our interview, creates conceptual couplings between "hypothetical" forms of death and the concrete political and social crises plaguing Mexico at the time (29 January 2019).

The contrast between the inward-facing "Prosas IV" and *Anacrón's* references to popular culture and contemporary issues is not just a matter of individual interpretations of death and its associations for either Wolfson or Marquet, but also a question of medium. The "Dos Reales" section in *Caja* plays with repetition and redundancy as effects afforded by language about words themselves, colours, notebooks, and death. The references in "Dos Reales" are to other works of literature and textual practices. Death is taken as a hypothesis, made abstract, and

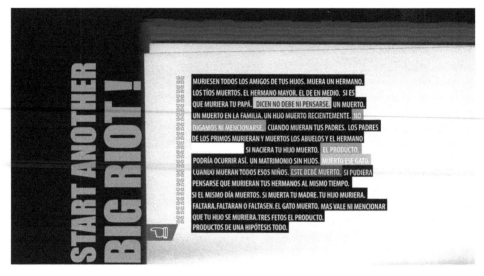

Figure 3.2.  Upon hovering the pointer over Wolfson's "mejor no hablar," the text is alternated emphatically with the lyrics of Hutton's song. © Gabriel Wolfson and Augusto Vinicius Marquet 2009.

negated repeatedly through the use of subjunctive tenses and phrases aimed at repressing the unthinkable at the very moment when it's being hypothesized: "no digamos ni mencionarse" (let us not say or mention) and "mejor no hablar" (better not to speak) (Wolfson 2007, 78). Conversely, *Anacrón* relies on references that take us outside of the text itself to denounce those unthinkable deaths that already were happening or had happened. This contrast can be clearly seen in the alternating texts from "Prosas IV" mentioned above. Hovering over the "mine field" of *Anacrón*, "no digamos ni mencionarse" turns into the emphatic "entonces mencionémosla" (then let's mention her) and "mejor no hablar" becomes "start another big riot" – lyrics and a sound clip from Betty Hutton's song "It's Oh So Quiet" (figure 3.2).

Not only does Marquet's call to speak out puts the spotlight on the human repercussions of the violence affecting Mexico; but also, as a piece of art that lives on the internet, *Anacrón* simultaneously engages with the public space of the web, where much of the information and disinformation about this violence circulates. The repetition of words related to death sheds the cloak of hypothetical language and becomes the numerous victims of the war on drugs, the 2009 Guardería ABC

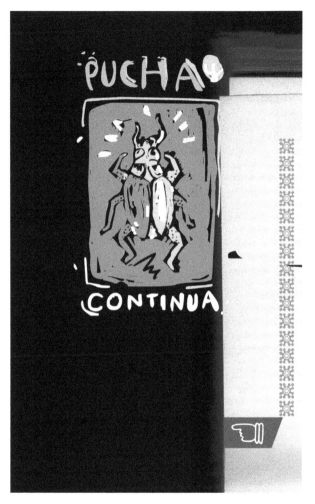

Figure 3.3.  The resolution of death in the text continues outside of Anacrón. ©
Gabriel Wolfson and Augusto Vinicius Marquet 2009.

fire in Sonora, and police brutality. The "mine field" in the work takes
on the shape of the *masacres, balaceras,* and *desapariciones* taking place
daily and flooding the news and social media. The hypothetical and in-
ert death in Wolfson's "Prosas IV" comes alive with an overt acknowl-
edgment that the end of this state of affairs is nowhere in sight. The
last block of text in *Anacrón* features a subtle change from the singular

*producto* of "Prosas IV" to the plural *"productos* de una hipótesis todo" (Marquet 2021; my emphasis), lending the closing segment a bitterly ironic tone. The animation activated by the last text block resolves into an invitation to click and continue (figure 3.3), and the hovering alternative text declares "Yo no estoy muerto … Ja … Continua la hipótesis" (I'm not dead yet … Ha … continue the hypothesis).

It's important to point out that, in parallel with the sobering denunciation of the deaths taking place in Mexico, Marquet adds a few jokes, references to video games and pop culture, and *albures*.[3] This lighter attitude toward the topic of death ties the work tightly to the social attitudes during celebrations of Mexican Day of the Dead: both an homage to the departed and a mockery of Death from those who have managed to stay alive. The reference to the Catrina in particular links *Anacrón* to the work of José Guadalupe Posada, who, in addition to creating the ultimate Day of the Dead icon, dedicated much of his work to political and social commentary.

The interplay between humorous elements and social commentary in *Anacrón* suggests that Marquet holds an adversarial position toward Wolfson's text; moreover, it establishes a tension between print and digital media. Rather than positioning "Prosas IV" as a foundational text whose meaning and content must be unearthed and presented, Marquet appears to be disputing the text's inward-facing, "closed" print manifestation through multimedia annotations that subvert the confines of words on paper. Wolfson's text is not presented as a source text or its palimpsestic remains, but rather is rendered verbatim and unconcealed on the screen in the style of a statement presented for debate: one that is not about ideas exclusively, but about medium of expression. The interplay of Wolfson's and Marquet's texts on the same screen underscores not only the passage of words from print to digital, but also how their overlap enables the elaboration and discussion of ideas and, ultimately, the personal and the social dimensions of death. In this way, the treatment of "Prosas IV" balances the relationship between the two authors, and *Anacrón* emerges as a discussion between them as well as between the media they each use.

*Tesauro*

Karen Villeda's highly polyphonic poetry collection *Tesauro* was published in 2010 by Tierra Adentro, the publishing branch of CONACULTA. Villeda, who has also worked as a visual poet, constructs her collection through a series of strategies including varied typefaces, layout, and punctuation, mixing italics, underlining, spaces, footnotes, quotation marks, ellipses, parenthesis, and other elements. Intertextual

markers and expressions in languages other than Spanish complement these typographic and formatting strategies, together creating the voices of multiple characters. Villeda's characters (among them, Femenino, Masculinidad, Tiempo, Espacio, Lobreguez, and others) populate a world of words inhabiting the *tesauro* – a dictionary of terminology (section 1) and lexicons of each vowel (sections 2–6).

In the first section of the collection, "Términos preferidos" (Preferred Terms), Villeda establishes the terms or characters that will traverse the collection by using a dictionary motif and the genre of definitions. However, these are not straightforward or fixed definitions; indeed, right from the start, Villeda plays with the very principles of the genre and deconstructs every characterization through internal and external associations. For example:

Espacio$^2$ m ...
   $^2$ Espacio (sin Femenino) Habilidad que se concreta en la fisura: "Estaba" *Passim* "A lo ancho de" *Orbis unum* "Era" *Qua patet orbis* (18)

(Space$^2$ m ...
   $^2$ Space (without Feminine) Skill concretized in a fissure: "It was" *Passim* "Along the" *Orbis unum* "It was" *Qua patet orbis*)

Definitions like these allow us to see how various words (and sometimes the same word) start with a closely related meaning and, increasingly, pass from one context or register to the next. Through these exercises in morphing meanings, Villeda exploits the characterization of her collection as *Tesauro* – treasury, index, dictionary, catalogue – a collection of related meanings. The association of the title with "thesaurus" (the dictionary of synonyms), which has gone unnoticed by reviewers of *Tesauro*, is indicative of Villeda's strategy of morphing meanings as well. The development of meanings is further emphasized throughout the collection via the characters of Tiempo and Espacio (Time and Space), as they highlight the variations in meaning from one page or section to another. Instances of this focus, such as "ustedes no tienen nombre propio SIN TIEMPO" (20; you don't have a proper name WITHOUT TIME) and "*Tiempo* y *Espacio* traducen" (31; *Time* and *Space* translate), among others, underscore how, throughout the collection, very specific contexts affect the meaning of the same words. A similar process takes place in each of the sections, the *lexicografías* A, E, I, O, U, where the expressions associated phonologically with each vowel (Ah, Eh, Y, Oh, Uh) mutate from page to page.

The immediate result of the morphing meanings is that *Tesauro* presents a challenging collection, where readers follow textual

clues to try and tie together the loose parts of the collection. Ignacio Ballester (2018) has linked Villeda's experimentalism to the contemporary Mexican neo-barroque "difficultism" first proposed by Alejandro Palma Castro ("Poesía mexicana contemporánea"). But, aside from the undeniable obscured meanings and the often-inscrutable connections between motifs in the poems, Villeda reveals an acute attention to context specificity – words, expressions, definitions mutate along with the two characters Tiempo and Espacio. This instability of meaning, I argue, opens a path to understand not only the development of the collection's lexicon but, more importantly, its remediation from print to digital media.

The web version of *Tesauro* comprises twenty-four digital poems – a subset of the same texts in the book – that follow the same six-section structure and the pagination of the print book. There are two types of web poems here: flash animations of the texts on the screen and web visual poems. Other elements, including hyperlinks to Wikipedia entries and YouTube videos, are meant to foster what Villeda (n.d.) calls "an aesthetic nomadism." Just as in the print book, Villeda resorts to typographic and punctuation strategies to convey the multiplicity of voices in her work. However, these are amplified by a broader range of typographical effects, typefaces, colours, and animation. Examples like "P. 30–31" evoke a dictionary-entry page design with a definition and an illustration (figure 3.4). Other examples, like "P. 49" (figure 3.5), take advantage of simple animations to further the changeability of the words' meanings due to context. As Villeda makes our eye follow words or text blocks that move across the screen and intersect others, she seems to be asking us to make a series of – in her own words – "playful" and "wild" associations and dissociations that would be difficult in static text (Villeda n.d.).

In the introduction to the web poems, Villeda states that she sought to "evad[e] the restrictiveness of the printed page" when taking her poetry collection to the web (Villeda n.d.). As mentioned before, it is true that we are able to see some amplification of her print strategies through flash animations, but it is undeniable that her fundamental referents remain tightly fastened to affordances found in the print medium. For example, the decision to follow the paging and sections from the print book reproduces the organizing logic of a bound codex and is likely to hinder the "wild" associations Villeda aims to foster. Similarly, she also seems somewhat overly optimistic about the role the reader – whom she calls a "receiving user" – can play in actualizing her digital poems: *"The receiving user is the backbone of the semiosis of the poems of Tesauro (Thesaurus) because he/she creates a sign that is alike to the one issued*

P . 3 0 - 3 1

zorzal. m.
*Nombre común de diversas aves paseriformes de 20 a 25 cm de longitud, pico del dorsal de color pardo y al pecho alado del pequeñas motas. Son aves migratorias que invernan en la península Ibérica.*

F&m&nino y Masculinidad
observan detenidamente la
ilustración del TURDUS PILARIS en
*Maravillas del reino animal*, p. 155 La
inscripción les dice: "Ocúltate en el
Zorzal"

*AMBOS* (m, f) Aprenden la
canción, imitan el trino Zorzal
entona la balada, tentativa que
deslumbra Su multitudinaria estirpe
irrumpe en Dúplex *La ventana
trasiega altitudes* El jardín de
cristal o la **HABITACION** reproduce
sonidos de la opacidad y cantaletas:
el blabla de la reyerta, el snif de
las invocaciones, el ¡plúm! de los
cuerpos y esa palabra que en
ningun Tiempo y Espacio traducen...

Figure 3.4.  Through the use of images, pagination, and various typeface,
Villeda builds the notion of dictionary that pervades the entire work.
© Karen Villeda 2010.

¿ eh?

p. 49

F&m&nino y Masculinid

interj. Dubitación de

F&m&nino y Masculinidad

Teoría del color

Figure 3.5.  The text blocks and recurring motives/characters are more clearly
articulated in the digital instantiation of the work than in print as they come
together typographically, visually, and well defined as blocks of texts. © Karen
Villeda 2010.

*and, despite being a similar interpretation to mine, is another sign as being a result of an updated sign. Therefore, a more developed and active reading is achieved and it completes the poem"* (Villeda n.d.).

Undeniably, some facets, like the external links of the digital poems, can be actualized only by the reader; however, this is not unlike recognizing intertextual references: some readers will be able (or willing) to actualize them and others won't. These links, similarly, are not variable. The connections, and even the need for them, have been established by the author. The same dynamic takes place in the flash animations: given that the animations are predetermined and not interactive, the "wild" and "playful" associations are also pre-programmed by Villeda herself. I point out the rift between the author's declared intention and what seems to be operating in the digital poems not to imply that there is a failure in the process of remediation, but to argue that its successes are not necessarily found where Villeda explicitly indicates.

Read side by side, the two facets of *Tesauro* highlight Villeda's strongest suit: visual poetics. The typographic strategies exhausted in the print book, while adequate to weave the intricate networks of characters and motifs, reveal an excess of meaning, at times to the point of impenetrability. In contrast, on the web, the same strategies, some even amplified, do reveal this complexity. For example, on the web, the typographic strategies are considerably more effective at creating the networks of meaning. Villeda achieves this through the moderate use of colours (pink for Femenino, and blue for Masculinidad) and handwriting – for example, for Lobreguez – that recur throughout the six sections, making them readily recognizable and tying them together. In addition, animated blocks of text (figure 3.5) provide directions to organize the multiple voices within whole poems. Here, Villeda's intent to go beyond the affordances of print is much more clearly and effectively realized. The visuality that *Tesauro* vehemently strives to convey in print is a built-in feature in the web version.

These characteristics might make us wonder if *Tesauro* is not, in principle, a collection of poetry conceived through (or at least heavily inspired by) a web frame and that just happened to have been published first in print. Alex Saum-Pascual (2018) has proposed the term "postweb" to characterize the recurrent phenomenon of print works that reveal a "gestación digital y … poética electrónica" (29; a digital gestation and … electronic poetics). Saum-Pascual refers, for example, to interfaces (or print surfaces) where the mark of the digital is made evident – the clearest case being Jorge Carrión's *Crónica de viaje* (2009/2014). More relevant to this discussion is Saum-Pascual's

examination of the typographic experiments in Robert Juan Cantavel-la's *Otro* (2001), where the digital mark is manifested as printed, inexecutable line breaks, commands, and binary code (110–13).

Certainly, Villeda's print *Tesauro* does not go as far as *Otro*. However, the fact that her associations and networks of meaning seem to bear the mark of the digital space rather than print conventions suggests that *Tesauro* might have had a similar "digital gestation." We can speculate about the limitations that an institutional publisher like Tierra Adentro would have had imposed – even from a budgetary perspective – such as the inability to include images or to print in colour. Villeda's experimental poetic intentions are by no means thwarted by these limitations, especially in the face of all the strategies she employs. But examined next to its web counterpart, print *Tesauro* is rendered unnecessarily complex: the digital serves as a reading guide to the print – both a sequel and a prequel. In a very similar fashion as that seen in *Anacrón*'s full citation of "Prosas IV," the overt remediation of print conventions like pagination highlight not just the back and forth between media in *Tesauro*, but also the discontinuities between them.

**Print Made Digital**

In their digital embodiments, both *Anacrón* and *Tesauro* draw attention to their earlier print instantiations. In addition to Villeda's perpetuation of print pagination and sections on the web version of *Tesauro*, and Marquet's integral display of Wolfson's text, we encounter several representations of print and types of stationery. In *Tesauro*, as can be seen in figures 3.6 and 3.7, we find notebooks ("P. 95–96"), Polaroids and Post-its ("P. 99"), and type from a label maker ("P. 19").

Similarly, *Anacrón* includes photographs, books, product labels, passports, and stamps. More importantly, the entire work is laid out over the background of a yellowish book, the edges of which can be seen at the top and bottom of each page (see figure 3.1). Although the version of *Anacrón* anthologized in the *Electronic Literature Collection* and the one available on Marquet's website do not include any front matter, the earlier 2009 PDF version features a glitched facsimile of the front page of René Descartes's *Meditations* as a background (figure 3.8). Further, the earlier version displays, in Jessica Pressman's terminology, an "aesthetic of bookishness" (2020), with book covers and marbled endpapers used as background (figure 3.9). These characteristics, which have been progressively shed in the over ten years since Marquet first created *Anacrón*, would allow us to read this work not just as a remediation of

AYER

FEMENINO

presiente el retro.

Incapacidad de acción.

Plano de extravíos. Observa a

*Masculinidad*

empacar.

Finge tristeza

pero el hilillo de saliva evidencia la boca sin

expresión. Se pinta los labios y le escribe

con lápiz 2H antes de salir del

Dúplex

un **POST-IT**

que pega en el refrigerador,

al lado de los imanes

fosforescentes de abecedario.

TÉRMINOS
PREFERIDOS

p. 11     p. 13     p.19     p.20     p.p.

Figure 3.6. Villeda's use of pagination, post-its, Polaroids, and black tape labels. © Karen Villeda 2010.

Femenino,

Hice nidos en mi corazón por y para (ref.) esperarte
esgrime mi espinazo y suspire al ritmo de tu seso ahí en
nuestra lamentación (he regresado a la soledad) encontré
a los pájaros - def.? - resucitando haciéndonos estables y
no Persona hasta mis rodillas se doblegaron ante mí
Hierofanía de tus piernas el blanco de mí ojo fue negritud
cuando mis dedos escribieron el rito entrelíneas

,,,

el reverso de la memoria en el Tesauro de tu cuerpo

// Memorice el silencio memorice la manera en que no
dices mi nombre memorice nuestras miradas cosas
antes de nominalizarlas en el presente,,, antes de una
esperanza memorice el después  en un pasado

**// NO HAY NADA NADIE AHÍ**

// Hice nidos ... Ya no soy Persona a menos que
" Nosotros seamos para delinear despedidas a más que
te signifique volver a volar volvernos a tus alas,

// "el universo de la mirada" "el sentido que con el
lugar adjudicado y su por la permanencia no se pudo
truncar el mismo universo de los trocos... de los tejidos para su magia
un acto de magia

// Me hundí en el fluir de tus consuetas y así nacimos
conocí el camino de la sangre durante la ascensión de los
pájaros pero el Zorzal siempre durmió en tu vientre (ese
huesudo cuerpo truncando tu ombligo) mientras espero
en Lóbreguez sin saber si vuelves creyendo en tu reaparición
sin irme del abrazo la parte baja de la espalda es
invierno

Figure 3.7. Villeda's use of notebooks. © Karen Villeda 2010.

Figure 3.8.  The front-matter of Anacrón not included in the anthologized version in the ELC3. © Gabriel Wolfson and Augusto Vinicius Marquet 2009 However, the entry for the work in ELC3 does show this screenshot. © Gabriel Wolfson and Augusto Vinicius Marquet 2009.

Figure 3.9.  The 2009 PDF version of Anacrón uses the motif of the book much more overtly than newer versions. © Gabriel Wolfson and Augusto Vinicius Marquet 2009.

Wolfson's text, but even as an altered book – both Wolfson's book in particular, but also the physical book as a medium.

These visual and material characteristics suggest that both Marquet and Villeda seek to highlight the links between their digital works and the previous print ones. Furthermore, these creative decisions suggest that the authors may not be especially interested in finding language equivalences, similar software functions, or readerly forms of engagement as they would if their works were translations, portings, or adaptations. Although it is true that the content of the print works undergoes a process of transcoding, it is often copied or quoted, rather than remediated. Moreover, far from supplanting one work and medium with the other, *Anacrón* and *Tesauro* not only keep the textual content fundamentally intact, but also, by stacking affordances and cues to print textual media, they underscore the ruptures and continuities between these media. This palpable emphasis on media leads me to believe that it is *medium* – rather than text, theme, or story – that is reimagined in these works. In this way, *Anacrón* and *Tesauro* embody the hybrid media moment of the twenty-first century, where print and digital intersections create meanings, and the passage from one to another is simultaneous rather than sequential.

This chapter's examination of the change of medium in *Anacrón* and *Tesauro* has aimed to shed light on the complex juncture of processes that have been the bases to study transformations of electronic literary works in digital media (Marecki and Montfort 2017; Pressman 2014; Pold et al. 2018): adaptation as the change of medium taking place from print literature taken to the (big) screen or the stage (Hutcheon 2006); remediation as the representation of one medium in another (Bolter and Grusin 1999); and theorizations about translation and porting. *Anacrón* and *Tesauro* rehearse these issues around the relationship of the more recent digital text to the older print one on multiple levels that can be pinpointed one by one. As all four texts are in Spanish, translation does not occur from one human language to another. However, some transcoding of the text into images, sounds, moving images, and so on, does take place in both works. For Hutcheon (2006), adaptation itself constitutes "a transcoding into a different set of conventions" (33), although the realms of those conventions (linguistic, technocultural, computational) are not specified. There is also a change of medium, a remediation, from the print page to interactive web applications that significantly alters the modes of engagement. In this remediation, *Anacrón* and *Tesauro* also undergo a transcoding or translation from printed human language to machine-readable language – a principle of new media first identified by Lev Manovic (2001, 46). In works like *Anacrón*

and *Tesauro*, the change of medium from print book to digital application entails the weaving of their poetics, the transcoding of their words, the remediation of their pages into "web pages," and even the porting of their specific reading conditions.

As mentioned earlier, electronic literature scholarship that focuses on translation has taken great steps toward the conceptualization of these simultaneous processes. Much emphasis has been put on the "layered" process of translating computer language and human language, with attention to various human languages, software, hardware, and so on (Marecki and Montfort 2017; Pressman 2014; Pold et al. 2018). Similarly, the notion of porting, most commonly articulated as a change from one programming language to another, has also yielded a useful emphasis on transferring code from one system to another so as to achieve a similar functioning (Flores 2012). In this way, porting offers a way to explore the interactivity and visuality of platforms, beyond the translations of human or machine languages. The mode of engagement gains relevance for Marecki and Montfort (2017) as well, as they declare that "respecting platform specificity and platform consciousness is … a crucial element of the project" (i86). And ultimately, unearthing the minutia of these practices within digital media, Kathi Berens (2015) argues insightfully that a change from desktop to iPad is "at least as profound as the jump from book to desktop" (170). Reading the adaptation of Steve Tomasula's TOC from the desktop (2009) to the iPad (2015), Berens indicates that, while the story remains identical, "the habits of readerly engagement are device specific" (171) – a parallel phenomenon to that of *Anacrón* and *Tesauro*.

Although a capacious redefinition of translation like that proposed by Pold, Mencía, and Portela (2018) brings together a broad catalogue of processes taking place at the junctures afforded by change of medium from print to digital, treating all those aspects as *translation* seems to flatten the conceptual depths that media hybridity brings to works like those of Villeda and Marquet and Wolfson. *Anacrón* and *Tesauro* demand to be examined with special attention to the meaning-making mechanisms (writerly and readerly) afforded by the media specificity of each instantiation as well as the overlap between them. The distinctions I made at the beginning of this section are tentative and quickly begin to coalesce. However, I believe it is important to tease apart the smaller or incomplete processes that are often encompassed in concepts like adaptation, remediation, and translation. The media hybridity of these works renders each of these frameworks insufficient, and simultaneously demonstrated that an all-encompassing framework offers unsatisfactory results. Indeed, this is the mark of their importance as

experimental literary artefacts and, I believe, the critical space proposed and engaged by these works.

Lastly, although this critical space has been studied here apropos of two Mexican works, the issue is not indigenous to the country or the region of Latin America more broadly. Print-digital works abound in other geographies: Stephanie Strickland's *Vniverse*, for example, has been published in print twice and in digital two more times, once as a web application with Cynthia Jaramillo Lawson, and once as an iPad app with Ian Hatcher. The reverse process, a change of medium from digital to print, deserves its own investigation. Works following this trajectory include J.R. Carpenter's *Etheric Ocean*, *Notes on the Voyage of Owl and Girl*, *Once Upon a Tide*, and other digital works that were gathered in print as *An Ocean of Static*; the Electronic Disturbance Theater 2.0 / b.a.n.g. lab's *Transborder Immigrant Tool*; and the already mentioned *O livro depois do livro* by Giselle Beiguelman. Although largely experimental, the wealth of print-digital works is emblematic, and indeed archaeological, of an ongoing transitional media moment in literary creation and publishing of the past four decades.

NOTES

1  Flipbackbook, at https://www.dwarsligger.com/ (my emphasis).
2  Eastgate was founded in 1982 by Mark Bernstein. It was the software company that produced and distributed Storyspace, the hypertext authoring program first developed by Michael Joyce, Jay David Bolter, and John B. Smith. Storyspace, as Katherine Hayles (2008) explains, was the basis for the first generation of electronic literature in the late 1980s and early 1990s (6–7). Notable titles created in Storyspace include Michael Joyce's *afternoon, a story*, Shelley Jackson's *Patchwork Girl*, and Stuart Moulthrop's *Victory Garden*. More important, however, is the fact that Eastgate became the publisher of those hypertext fictions as well. Following a small-press model, as Scott Rettberg (2019) suggests, Eastgate was behind the publication of a good part of the early canon of electronic literature (68–9). The distribution of these titles initially followed a book-like approach, where "cover" folios held a work's disks (floppy and CD-ROM) and small booklets with running and reading instructions, software licences, tables of contents, and other paratextual items. Focused specifically on this kind of fiction and fiction writer, and having created a small but consistent audience of electronic literature enthusiasts, Eastgate has operated in parallel but well aside from the larger publishing landscape that ventures like Voyager, Brøderbund, and others sought to influence.

3 *Albures* are double entendres common in everyday Mexican speech.

REFERENCES

Amador Tello, Judith. 2012. "Consuelo Sáizar rinde informe de Llbores del Conaculta." *Proceso*, 10 September. https://www.proceso.com.mx /cultura/2012/9/10/consuelo-saizar-rinde-informe-de-labores-del -conaculta-108177.html.
Ballester, Ignacio. 2018. "Karen Villeda." *Poesía mexicana contemporánea*, 4 February. http://poesiamexicanacontemporanea.blogspot.com/2018/02 /karen-villeda.html.
Beiguelman, Giselle. 2003. *O livro depois do livro*. Peirópois. http://desvirtual .com/thebook/.
Berens, Kathi. 2015. "Touch and Decay: Tomasula's TOC on iPad." In *Steve Tomasula: The Art and Science of New Media Fiction*, edited by David Banash, 167–82. Bloomsbury.
Bolter, J. David, and Richard Grusin. 1999. *Remediation: Understanding New Media*. MIT Press.
Boluk, Stephanie, et al., eds. 2016. *The Electronic Literature Collection*. Vol. 3. Electronic Literature Organization.
Bravo, Luis. 1998. *Arbol VeloZ: Poemas 1990–1998*. Ediciones Trilce.
Cantavella, Robert Juan. 2001. *Otro*. Laia Libros.
Carrión, Jorge. 2014. *Crónica de viaje*. Aristas Martínez.
Castro, Alejandro Palma. 2016, "De la extrañeza al dificultismo: los monstruos de Gerardo Deniz." In *"This Spanish Thing": Essays in Honor of Edward F. Stanton*, edited by Michael McGrath, 221–36. https://www.academia .edu/34143726/De_la_extra%C3%B1eza_al_dificultismo_los_monstruos _de_Gerardo_Deniz.
Cerda, Irma Idalia. 2011. "Anuncia Sáizar proyecto cultural del siglo XXI." *Horacero*, 10 December. https://www.horacero.com.mx/vida-y-cultura /anuncia-saizar-proyecto-cultural-del-siglo-xxi/.
Cohen, Micheal E. 2013. "Scotched: Fair Thoughts and Happy Hours Did Not Attend upon an Early Enhanced-Book Adaptation of Macbeth." *The Magazine* 32, December. http://the-magazine.org/32/scotched.
CONACULTA. 2012a. "'Muerte sin fin' de José Gorostiza." App Store, https:// itunes.apple.com/mx/app/muerte-sin-fin-de-jos%C3%A9-gorostiza /id520651849?mt=8.
– 2012b. "'Octavio Paz – Blanco." App Store. https://itunes.apple.com/mx /app/octavio-paz-blanco/id484285852?mt=8.
– 2013a. "IPad App: Visión de Anáhuac (1519)." Behance. htts://www .behance.net/gallery/8112355/iPad-App-Vision-de-Anahuac.
– 2013b. "'Nezahualcóyotl." App Store. https://itunes.apple.com/mx/app /nezahualc%C3%B3yotl/id583518997?mt=8.

– 2013c. "'Seducciones de Sor Juana." *App Store*. https://itunes.apple.com /mx/app/seducciones-de-sor-juana/id630253735?mt=8.

Correa-Díaz, Luis. 2016. *Clickable Poem@s*. RiL Editores.

Elliott, Kamilla. 2003. *Rethinking the Novel/Film Debate*. Cambridge University Press.

Flores, Leonardo. 2012. *Porting E-Poetry: The Case of First Screening*. https:// www.slideshare.net/leonardoflores3/porting-epoetry-the-case-of-first -screening.

Gache, Belén. 2002. *El libro del fin del mundo*. Fin del Mundo Ediciones.

– 2011. *Gongora Wordtoys*. Sociedad Lunar Ediciones. http://belengache.net /gongorawordtoys/.

Hayles, N. Katherine. 2002. *Writing Machines*. MIT Press.

– 2007. "Intermediation: The Pursuit of a Vision." *New Literary History* 38. 1: 99–125.

– 2008. *Electronic Literature: New Horizons for the Literary*. University of Notre Dame Press.

Hutcheon, Linda. 2006. *A Theory of Adaptation*. Routledge.

*IDP Report*. 1992. "Apple Outlines New Multimedia Initiatives (Apple Computer Inc.; Random House Inc., National Textbook Co., and Macmillan Computer Publishing Inc. Agree to Create Electronic Book Standard for Macintosh Using Voyager Software Format)." *IDP Report* 13.36: 4.

Kirschenbaum, Matthew. 2017. "Books.Files: New Project to Help Scholars Assess Digital Components of Today's Bookmaking." *Maryland Institute for Technology in the Humanities*, 1 November. http://mith.umd.edu/books-files -new-project-help-scholars-assess-digital-components-todays-bookmaking/.

Kral, Christina. 2013. "Expanded Books // Initial Thoughts on Translating a Book for the Screen." *Hybrid Publishing Lab Notepad*, 23 July. https://web .archive.org/web/20161013090557/http://hybridpublishing.org/2013/07 /expanded-books/.

Manovich, Lev. 2001. *The Language of New Media*. MIT Press.

Marecki, Piotr, and Nick Montfort. 2017. "Renderings: Translating Literary Works in the Digital Age." *Digital Scholarship in the Humanities* 32.184–91.

Marquet, Augusto. 2012. *Anacrón: hipótesis de un producto todo*. http://hey .viniciusmarquet.com/anacron/Vinicius_index2.html.

Montfort, Nick. 2004. "Continuous Paper: The Early Materiality and Workings of Electronic Literature." Text of a paper delivered at the MLA convention, Philadelphia, 28 December. http://nickm.com/writing/essays /continuous_paper_mla.html.

– 2018. "Minding the Electronic Literature Translation Gap." *Electronic Book Review*, 5 August. http://electronicbookreview.com/essay/minding -the-electronic-literature-translation-gap/.

Moor, Robert. 2012. "Bones of the Book." *N+1*, 27 February. https:// nplusonemag.com/online-only/book-review/bones-of-the-book/.

Moreno Ortíz, Benjamín. 2010. *Concretoons: poesía digital.* Centro de Cultura Digital México. http://concretoons.centroculturadigital.mx/.

Ortega, Élika, and Alex Saum-Pascual. 2021. "Toys and Toons: From Hispanic Literary Traditions to a Global E-Lit Landscape." In *Electronic Literature as Digital Humanities: Contexts, Forms, and Practices,* edited by Dene Grigar and James O'Sullivan, 43–53. Bloomsbury.

Pérez y Pérez, Rafael. 2017. *Mexica: 20 Years – 20 Stories = 20 Años – 20 Historias.* Counterpath.

Pold, Søren Bro, María Mencía, and Manuel Portela. 2018. "Electronic Literature Translation: Translation as Process, Experience and Mediation." *Electronic Book Review,* 30 May. https://electronicbookreview.com/essay/electronic-literature-translation-translation-as-process-experience-and-mediation/.

Pressman, Jessica. 2020. *Bookishness: Loving Books in a Digital Age.* Columbia University Press.

– 2014. "Electronic Literature as Comparative Literature." In *The 2014–2015 Report on the State of the Discipline of Comparative Literature.* https://stateofthediscipline.acla.org/entry/electronic-literature-comparative-literature-0.

Rettberg, Scott. 2019. *Electronic Literature.* Polity Press.

Saum-Pascual, Alex. 2018. *#Postweb! Crear con la máquina y en la red.* Iberoamericana; Vervuert.

Villeda, Karen. n.d. *POETronicA | Poesía Digital de Karen Villeda.* http://www.poetronica.net/digitalpoetry.html. Accessed 4 March 2019.

– 2010. *Tesauro.* Tierra Adentro, CONACULTA.

Virshup, Amy. 1996. "The Teachings of Bob Stein." *Wired,* July. https://www.wired.com/1996/07/stein/.

Winter, Robert. 1989. *Ludwig van Beethoven Symphony No. 9: CD Companion.* Voyager.

Wolfson, Gabriel. 2007. *Caja.* Universidad de las Américas.

# 4 (404) Page Not Found: Technology, Failure, and Disconnection in Alejandro Zambra's *Mis documentos*

MARÍA JOSÉ NAVIA

It has probably happened to all of us.

We click on a link only to encounter a white screen that tells us that the page we are looking for cannot be found. Bad luck, yes, but also a paradox of sorts: the message that informs us of our failure to connect comes precisely from a proof of connection (another webpage that we were able to access) or an attempt at achieving it. A similar phenomenon occurs in the stories that make up the collection *Mis documentos* (2013) by Chilean writer Alejandro Zambra, in which technology becomes one of the protagonists, only to highlight its possibilities for failure and disconnection – a phenomenon that I explore in this chapter through three primary angles. First, even though the title of the book seems to suggest that this collection will be dedicated to digital technology in one way or another, and though there is some truth in that implication, the reality is that that link is somewhat broken and defies our expectations or assumptions as readers. Zambra, in his stories, *brings technology back to its materiality*, reminding us that, before virtuality or the possibility of connection granted by computers' access to the internet, the machines are themselves material entities, and very particular and expensive ones, especially in the Chilean/Latin American context. Or, as Héctor Hoyos (2015) observes, "while contemporary capitalism thrives in producing an ever-shorter lifespan of products, leaving behind literally mountains of waste, Zambra dwells on the object" (114).

Second, if technology or the discussion on technology is brought back to materiality, particularly the material reality of computers, some other questions arise. What type of object is a computer in these characters' lives? What place does it occupy? In these stories, computers are *home computers*, or laptops that stay at home most of the time. Despite the association between digital devices and mobile access, technology rarely grants mobility or speed in Zambra's work. This is important if

we consider how Zambra's work has been studied as an example of "literatura de los hijos," a term coined by Chilean scholar Lorena Amaro to describe literature told by the sons and daughters of parents who lived during the dictatorship, which has become a prominent lens for studying Chilean literature in recent years. If computers are protagonists here, as objects within a familial landscape, we might also ask how they rearticulate the idea of a family, family memories, or the familiar. This discussion recalls other fundamental topics in Zambra's oeuvre (and Chilean fiction generally): memory and forgetting, especially in middle-class families. In Zambra's work, the use or place of technology can be seen as a political gesture about the impossibility of actually inheriting a past, as I will discuss later on.

Finally, Zambra's stories depict computers as a source of disconnection, discord, and even violence. Throughout *Mis documentos*, the machines disrupt the sense of the familiar, transforming it into something unfamiliar: families and couples argue over computers, characters learn new kinds of solitudes in the company of their machines and endure new forms of scarcity and precarity because of the high cost of these objects. These stories confront us with the plausibility of the technological "uncanny," in Freud's terminology, not because the virtual world confounds the characters, but because the sheer materiality of computers transforms everything they considered stable or homely. As Jesús Montoya Juárez (2016) states in "Hacia una arqueología del presente: cultura material, tecnología y obsolescencia":

> Ante los procesos de virtualización de la cultura contemporánea, muchas de estas obras subrayan no tanto la ganancia expresiva de la tecnología como lenguaje – aunque sin duda muchas la expliciten – sino que se centran en la pérdida, en el residuo que producen los nuevos usos del tiempo en la globalización. (267–8)

> (Faced with the virtualization processes of contemporary culture, many of these works emphasize not so much the expressive gains of technology and language – although they certainly illustrate them – but instead focus on the loss, the detritus produced by these new uses of time within globalization.)

In these stories, computers become an integral though uncomfortable part of each character's personal identity. This connection extends to characters' reflections on their sense of self over time, as they reminisce about their lives while always considering the presence of computers – a sort of technobiography. This chapter will explore Zambra's depiction

of technology as both a familiar and material entity in *Mis documentos*, particularly the stories "Mis documentos" and "Recuerdos de un computador personal."

## Technology ... at All Costs

In *The System of Objects* (2005), his study of material culture, Jean Baudrillard mentions that objects are the most domestic of animals. Bruno Latour, in *We Have Never Been Modern* (2002), posits that we need to consider every action as a network in which different *actants* participate (be they objects, people, animals, etc.). Jane Bennett (2010) coined the term "vibrant matter" to speak of things and their power to affect us. She calls this phenomenon "thing power," and uses the term "assemblages" to refer to the interaction between different material entities.

In *Mis documentos*, computers are always new objects that come to invade and radically alter characters' lives (usually in rather unexpected ways); with that, they seem to alter the characters' abilities to register the past, to protect their memories and intimate lives. The computers become *actants*, alongside human characters, forming networks or assemblages that make action happen and that give a certain sense of the familiar. In Baudrillard's words, "the arrangement of furniture offers a faithful image of the familial and social structures of a period" (2005, 13).

In *Mis documentos*, computers do not offer that solace but, instead, provide countless opportunities for experiencing discomfort. This material discomfort can be seen in different ways: the computers described here are bulky – most of the time they do not fit into the characters' rooms and thus have to be placed on top of unstable furniture. They invade the characters' lives, create a new network of interactions (to use Latour's terminology), challenge the characters' actions and decisions with their "thing power," which is, most of the time, associated also with their cost. In Héctor Hoyos' words in "The Telltale Computer: Obsolescence and Nostalgia in Chile after Alejandro Zambra," "provocatively, the computer comes to occupy its place in the ensemble of objects that is the household by affecting its composition and circadian rhythms" (2015, 115).

In Zambra's stories, computers are always difficult to pay for, representing a financial sacrifice that burdens the human protagonists. Even though a computer's price is the same for every customer, the form of payment signals the financial situation in which each costumer is immersed. In the first (and titular) story of the volume, the narrator writes:

> En 1999 el notebook que me había regalado mi padre, un IBM negro, con
> una pequeña pelota roja en medio del teclado que funcionaba como mouse

(a la que los informáticos llamaban "el clítoris") se descompuso definitiva-
mente. Saqué en muchas cuotas un olidata inmenso. (*Mis documentos*, 27)

(In 1999 the laptop my father had given me – a black IBM, with a little
red ball in the middle of the keyboard that served as a mouse (which the
techies called the clitoris) – broke down definitely. I bought, with many
monthly payments, an immense Olidata. [*My Documents*, 31])[1]

Rather than functioning reliably, the computer breaks down and obliges
the narrator to purchase another machine. As Hoyos (2015) indicates,
"Zambra offers a glimpse into what the situation is like for the rest of
the world, namely, for those who cannot afford the latest or the sec-
ond latest model, but the one that is already several steps closer to the
dumpster" (116).

The fact that the protagonist does not pay for the computer upfront
not only indicates his precarious financial situation but also extends
the financial commitment of the computer to run alongside his own
continued existence. Thus, the protagonist's biography is intertwined
with that of his computer, whose physical and financial presence the
narrator describes as "immense." By turning their attention to the *ma-
terial conditions of technology*, Zambra's stories highlight technology's
literal price, as well as the *cost* (economic, spatial, personal) it has in the
lives of the characters. Also, the computer that breaks down is the one
given to the protagonist by his father, as a sort of defective inheritance,
a gesture that is replicated in other stories in the volume and that may
be read as a family inheritance that doesn't work anymore, a system
always at the verge of malfunction.

Alejandro Zambra's text, although it is certainly part of a realist tradi-
tion, can also be described as technophobic, a characteristic posited by
Macarena Areco in her discussion of the technophobia that sets contem-
porary Chilean science fiction apart from other works within the genre.
Although science fiction usually embraces technology for its possibility
of creating new worlds or expanding life's possibilities, Areco examines
Chilean works in which technology is deemed suspicious, and even
evil, because of its connection to capitalism. Of the work of Jorge Bara-
dit, Areco (2017) writes that the author "tras una aparente delectación
en las tecnologías de conexión, vela una crítica al capitalismo mundial
informatizado, el cual, al fragmentar y conectar a los seres humanos a
redes de información, *facilita su esclavitud*, convirtiéndoles en piezas
de maquinarias poshumanas" (129, my emphasis; through an appar-
ent delight with communication technologies, veils a critique of global
information capitalism, which, upon fragmenting and connecting

humans through information networks, *enslaves them*, converting them into pieces of post-human machinery). In other words, in Baradit's work, the fact that we are surrounded by machines is because the capitalist system needs us that way: in order to be more productive, more distracted, or even under vigilance.

In Zambra's stories, the notion of a costly, obligatory, and perhaps surveilling computer is explored in "Recuerdos de un computador personal" ("Memories of a Personal Computer"), rewritten from Zambra's earlier "Historia de una computadora." In this story, the computer takes on its own material life as a disruptive (and expensive) protagonist. The title of this story is interesting, as it highlights the fact that the memories *belong to the computer* and not to a human being – after all, it is a *personal* computer.[2] The story begins, "Fue comprado el 15 de marzo del año 2000, en cuatrocientos ochenta mil pesos, pagaderos en 36 cuotas mensuales" (*Mis documentos*, 51) ("It was bought on March 15, 2000, for four hundred thousand eighty pesos, payable in thirty-six monthly installments" [*My Documents*, 95]). Here, we are informed, from the very first lines, and with much detail, about the computer's price and the form of payment, which gives us a sense of the material or financial burden of the computer. In this case – as in the first story, "Mis documentos" – the main protagonist's financial situation is very vulnerable: he pays for the computer over three years.[3] Following Areco's ideas, perhaps the payment plan could be considered as another way in which the capitalist system can keep us captive: by encouraging us to plunge into debt.[4] The story goes on to describe the sense of obligation that drove Max to buy the computer: "Era el primer computador de su vida, a los veintitrés años, y *no sabía con certeza para qué lo quería*, si apenas lograba encenderlo y abrir el procesador de texto. Pero era *necesario* tener un computador, *todo el mundo opinaba eso*" (*Mis documentos*, 51; my emphasis) ("He was twenty-three years old, it was the first computer he'd owned, and *he didn't know exactly what he wanted it for*, considering he barely knew how to turn it on and open the word processor. But it was *necessary* to have a computer, *everyone said so*" [*My Documents*, 96; my emphasis]). Here, the computer is cast as a luxury item, an aspirational product that the narrator buys without really understanding, although everybody tells him that it is "necessary" to have one. This necessity could be studied, following Jean Baudrillard, in his *System of Objects*, where he states:

> The myth of a happy convergence of technology, production and consumption masks all political and economic counterpurposes. How indeed could a system of techniques and objects conceivably progress

harmoniously while the system of relations between the people who produced it continued to stagnate or regress? *The fact is that humans and their techniques, needs and objects are structurally interlocked come what may.* (2005, 134; my emphasis)

Max, the protagonist of "Recuerdos de un computador personal," espouses a combination of fear and marvel with respect to his new computer, emotions that bear a significant resemblance to the technophobia Areco describes. Although Max admires the new machine, this feeling is based not on the computer's intangible connective ability but on its outward appearance and materially perceivable "outputs" – for example, music and heat. In fact, the connective capacity of the computer instils a persistent fear of infection and viruses in the protagonist:

No le interesaba internet, *desconfiaba* de internet, y aunque en casa de su madre un amigo le había creado una cuenta de correo, él se negaba a *conectar* el computador y también a insertar esos diskettes tan *peligrosos*, eventuales *portadores de virus* que, según decían, *podían arruinarlo todo*. (*Mis documentos*, 53; my emphasis)

(He wasn't interested in the internet, he *distrusted* it, and though he had set up an email account at his friend's mothers house, he refused to *connect* to the web, or to insert those diskettes that were so *dangerous*: potential *virus-carriers*, he'd been told, with *the power to ruin everything*. [*My Documents*, 97; my emphasis])

Max distrusts technology and the internet; he doesn't even want to connect to a network or use email. The computer becomes a source of paranoia and is more closely associated with infection and contagion than innovation or efficiency. It is also an example of the disruptive character of media in general and how it may render the safety of the home porous. James Donald, in his article "Flannery," argues that, "with the arrival of telephone and television, the home became less of a container and more of a membrane, a rather broad-meshed filter of sounds, words and visions continually entering and traversing by means of communication technologies" (2005, 161). Beyond merely distrusting the computer, the protagonist feels anxiety because of what this object may do to his living space, or his life in general – that is, the possibility of making the familiar uncanny (or even enslaving him, if we use Baradit's terminology). Max's aversion to the internet implies that the connective capacity of the computer is conceived as a threat, a source of vulnerability, rather than an opportunity. As a result, the

possibility of establishing a virtual community and fighting loneliness is also thwarted.

The materiality of the computer is not subject to the same suspicions. Indeed, the protagonist seems to trust the material machine and wants to be physically close to it. Thus, Max is drawn to the machine's warmth: "A veces, a falta de una estufa, Max evadía el frío acariciando, de rodillas, la CPU, cuyo leve rugido se juntaba con la ronquera del refrigerador, y con las voces y bocinas que llegaban desde afuera" (*Mis documentos*, 53) ("Sometimes, lacking a heater, Max fought off the cold by kneeling and embracing the CPU, whose low hum merged with the refrigerator's snore and the voices and horns that filtered in from outside" [*My Documents*, 97]). Yet, although the computer in its material form is treated as a member of the family or a good friend – after all, Max embraces the computer to keep the cold away – the machine's intangible, "immaterial" functions render it a threat to the familiar space. Across the stories in *Mis documentos*, objects often end up working in ways that diverge from their intended use, thus showing the precarity that surrounds the different characters and the deep entanglement of their home lives and those of their digital devices. Like Max in "Recuerdos de un computador personal," the narrator of "Mis documentos" describes embracing the machine for warmth: "Ese invierno, como no tenía estufa ni guateros, dormí varias noches abrazado a la CPU del computador" (*Mis documentos*, 27) ("That winter, because I didn't have a heater or a hot-water bottle, I spent several nights sleeping with my arms around the computer" [*My Documents*, 31]). Instead of functioning as a computer, the object here is used as a source of electrical warmth, reduced to the physical output of its material functions – heat – rather than the costly connectivity it was purchased to achieve, because the narrator doesn't have proper heating at home. Furthermore, this fragment shows the importance of the computer as a sentimental placeholder: instead of holding a partner, the narrator holds part of the computer. This is consistent with the mouse of the previous computer being nicknamed "the clitoris," both highlighting a sexual or intimate connotation. Or, following once again Baudrillard's ideas, "we encounter the ambition of objects to act as replacements for human relationships. In its concrete function the object solves a practical problem, but *in its inessential aspects it resolves a social or psychological conflict*" (2005, 135; italics in the original).

In "Recuerdos de un computador personal," the purchase of the computer brings myriad transformations to Max's intimate life. As the narrator of this story indicates, "Gracias al computador, o por su culpa, sobrevino una s*oledad nueva*. Ya no veía las noticias, ya no perdía

el tiempo tocando la guitarra" (*Mis documentos*, 52) ("The computer brought about a *new kind of solitude.* Max didn't watch the news anymore, or waste any time playing the guitar" [*My Documents*, 97; my emphasis]). As the narrator mentions, the computer brings about a new form of loneliness. Nonetheless, soon after buying the computer, he starts a romantic relationship with a woman named Claudia, and his computer becomes a third party involved in the relationship, a witness of sorts: "Una mañana, al salir de la ducha, Claudia se detuvo frente a la pantalla apagada, como buscando arrugas incipientes u otras marcas o manchas esquivas" (*Mis documentos*, 53) ("One morning, emerging from the shower, Claudia stopped in front of the darkened screen, as if looking at her reflection, searching for incipient wrinkles or some other stray mark or blemish" [*My Documents*, 98]). Thus, the computer affects both its owner and the people in his life. Claudia, at least at this point of the story, doesn't interact with the computer as technology, or form of connection, but uses it as a different object, as a (black) mirror that shows her own fears – in other words, an "object which looks back" (Ngai 2005).[5] The monitor becomes a mirror in which she can see the passing of time and the physical evidence that signals that she is getting old. One way or another, the computer in these stories always ends up becoming a catalyst for the characters' fears and secrets, somehow altering the familiar landscape of their domestic lives and their own relationships to time. Or, in Baudrillard's words, the object becomes "a humble and receptive supportive actor" (2005, 26).

**Home Edition**

The first story we encounter in this collection – and the one that gives the book its title – "Mis documentos," begins as follows: "La primera vez que vi uncomputador fue en 1980, a los cuatro o cinco años" (*Mis documentos*, 9) ("The first time I saw a computer was in 1980, when I was four or five years old" [*My Documents*, 11]). The narrator's biography is connected (pun intended), from the very beginning, to technology. However, as we have already mentioned, technology seems to be there only to disconnect, or make distinctions and establish a distance between the different family members. As the narrator states: "Quizás puedo decirlo de esta manera: mi padre era un computador y mi madre una máquina de escribir" (*Mis documentos*, 10) ("Maybe I can say it like this: my father was a computer and my mother was a typewriter" [*My Documents*, 12]). The narrator, for his part, describes himself initially as "un cuaderno vacio y ahora un libro" (*Mis documentos*, 10) ("an empty notebook and now a book" [*My Documents*, 12]). By describing his

parents as different types of machines, he poses questions about their relationship; yet, by describing himself as an entirely different communication technology – a notebook that is empty, perhaps with nothing to say, then later, a book – he highlights the impossibility of truly or effectively communicating with them, thereby foregrounding the disconnection between different generations in terms of memory making.

Technology is what makes possible these distinctions, while, at the same time, the narrator seems to consider these pieces of technology as part of the family. This characteristic is also present in other stories in the volume, and it becomes an interesting gesture if we return Lorena Amaro's conceptualization of recent Chilean literature as a "literatura de los hijos"– that is, texts that deal with the Chilean past from the perspective of sons and daughters of parents who endured the dictatorship. The question that ensues though is, if Chilean literature is so focused on family dynamics, what happens when we start considering objects and technology as a part of it? Amaro gives the following analysis, which considers the importance of the middle class and its representation:

> Zambra escribe sobre cierta clase media que, promovida intelectualmente y con más cultura y herramientas que sus padres, se enfrenta a su pasado con una mirada distanciada, buscando pistas que ayuden a precisar el presente pero incluso en los casos más duros, enjuiciándolos como en sordina y sin llegar, a diferencia de lo que ocurre con varias narraciones argentinas contemporáneas, a escenas de filicidio o parricidio. (2014, 1)

> (Zambra writes about a certain middle class that, intellectually promoted, more cultured, and better equipped than their parents, confront their past with a distant gaze, looking for clues to ascertain the present but, even in the toughest cases, prosecuting them mutely and without arriving, unlike what happens in several contemporary Argentine narratives, to scenes of filicide or parricide.)

Amaro considers Zambra's protagonists as children who let their parents take them along, without much resistance. However, as they investigate their memories (especially when it comes to moments of embarrassment), usually some technological artefact comes into the picture. Thus, in his novel *Formas de volver a casa* (Ways of going home), a child, a member of the younger generation, accidently erases something that belongs to the (musical) memory of his parents (a song recorded in a cassette) and, in doing so, feels a great shame. In Zambra's texts, there is always a difference in the attitude of parents and their

sons toward technology, something that also highlights a disconnection. Therefore, in this story, it is the father who wants his son to have a computer that the son doesn't really want; then later, in "Recuerdos de un computador personal," the protagonist, Max, who didn't want to have a computer but ends up buying one anyway, later decides to give the computer to his son, who, in turn, stows the machine in the basement as he already has a newer computer.

Technology, as every other theme in Zambra's work, is profoundly related to both affections and affects. Technology transforms his characters' intimate lives, as it probably does in our lives, too. As Rubí Carreño states in one of her works on Alejandro Zambra's oeuvre, "Así como logra que un símbolo de prestigio y poder como es un computador se convierta en símbolo de lo obsoleto ... o en un elemento o sujeto querido de la cotidianidad que da calor en invierno, como una estufa, pareja o gato ... *Zambra logra hablar de la historia traumática chilena desde los afectos*" (Just as he manages to convert a symbol of prestige and power such as a computer into a symbol of the obsolete ... or a treasured feature of daily life that gives warmth in winter – like a stove, a partner or a cat ... Zambra manages to speak about Chile's traumatic history from the perspective of affections) (forthcoming, n.p). Just as happened with the story "Mis documentos," in "Recuerdos de un computador personal," attention is also placed *on the biography of the computer as an object.* As the narrator mentions:

> El 30 de diciembre de 2001, a casi dos años de su adquisición, el computador fue trasladado a un departamento un poco más grande en la comuna de Ñuñoa. El entorno era ahora bastante más favorable: le asignaron un cuarto propio, y armaron, con una puerta vieja y dos caballetes, un escritorio. (*Mis documentos*, 54–5)

> (On the thirtieth of December 2001, almost two years after its purchase, the computer moved neighborhoods to a slightly larger apartment in Ñuñoa. Its surroundings were significantly more favorable now: it had its own room and its own desk, which had been assembled from an old door and two saw horses. [*My Documents*, 99])

Notice here the reference to Virginia Woolf's fundamental text and notion of "a room of one's own." Even though the characters themselves live in very precarious conditions, the computer is granted its own room. The money that should go along with such a space, at least in Woolf's ideal, is always lacking, as can be seen by the making of a desk out of an old door.[6] But no matter how much space the computer

finally enjoys, the machine's crucial characteristic – as is also the case with every other story in the volume – is that it fails:

> Desde hacía meses, sin embargo, había señales de *un desastre mayor*, decenas de *demoras inexplicables,* algunas breves y reversibles, otras tan prolongadas que había que resignarse a reiniciar el sistema. Ocurrió un lluvioso sábado que deberían haber pasado tranquilos, viendo tele y comiendo sopaipillas, en el peor de los casos moviendo las palanganas y las ollas de gotera en gotera, pero tuvieron que dedicar el día entero a reparar o intentar reparar, con más voluntad que método, el computador. (*Mis documentos*, 55; my emphasis)

> (For some months, however, there had been portents *of a greater disaster*: dozens of *inexplicable delays*, some of them short and reversible, others so long they had to give in and restart the computer. It finally happened one rainy Saturday, which they should have spent calmly watching TV and eating sopaipillas or, in the worst of cases, moving the cooking pots and basins from one leaky spot to another; instead they had to devote the whole day to repairing the computer – or trying to repair it, more with willpower than any real, coordinated strategy. [*My Documents*, 102; my emphasis])

Here, the initial words – "greater disaster … inexplicable delays" – leave the reader uncertain as to whether the breakdown and foretold disaster is mechanical or interpersonal. As the scene unfolds, we learn that it is perhaps both: the failure of the computer is narrated in the midst of a vignette that highlights a certain state of vulnerability, as the couple struggle to fix different leakages in their apartment. Also, the computer loses two of its keys: A and T (102).[7] In a way, the damage to the keyboard foreshadows the couple's difficulty in communicating with one another. Baudrillard (2005) comments that, "at all events, whatever the functioning of the object may be like, we invariably experience it as OUR functioning: whatever the object's efficient mode – even should it be absurd, as in the case of the 'gizmo' – *we project ourselves into that efficiency*" (128; my italics).

In contrast to the computer's role in "Mis documentos," in "Recuerdos de un computador personal," the computer brings not only discomfort but also the possibility of chaos and violence: "Se le hizo necesario investigar por internet, y ese fue el gran cambio de aquel tiempo, que provocó la primera gran discusión de la pareja, porque Max seguía negándose a dar ese paso, definitivamente no quería saber nada de internet ni de antivirus" (*Mis documentos*, 56) ("It became necessary for her to do research on the internet, and this was a big change; it led to the couple's first fight,

because Max still refused the Internet – he wanted nothing to do with web pages or antiviruses" [*My Documents*, 102]). Claudia starts to surrender to technology, thereby creating distance and conflict in her relationship with the narrator. At another point in the story, Claudia, during an night of insomnia, gets onto the computer and, after trying a couple of times, she discovers her partner's email password and is able to read some of the emails written to his ex. She decides to leave him, they fight, and technology becomes an important part of the violent scene:

> Claudia arrancó el teclado e intentó defenderse sin éxito. Después, dos minutos después, Max eyaculó un semen escaso, y ella pudo volverse y mirarlo fijamente, como insinuando una tregua, pero en vez de abrazarlo le pegó un rodillazo en los cocos. Mientras Max se retorcía de dolor ella desconectó la multifuncional, y pidió el taxi que la llevaría lejos de esa casa para siempre. (*Mis documentos*, 64)

> (She grabbed the keyboard and tried to defend herself, unsuccessfully. Then, two minutes later, Max ejaculated a meager amount of semen, and she turned around and stared at him, as if suggesting a truce, but instead of embracing him, she kneed him in the balls. While Max writhed in pain, she unhooked the all-in-one device and called a taxi that would take her far away from that house forever. [*My Documents*, 109–10])

Once again, Claudia uses the computer (at least a part of it) *as something else*: as a weapon in order to defend herself, to *disconnect* herself from this toxic relationship. Before she leaves the scene, the only thing she takes with her is the all-in-one printer. Another thing worth mentioning is that Claudia gets angry and decides to leave Max not because she finds flirty emails to his ex but because, in those interactions, he doesn't even mention her – despite her position as the new girlfriend – at all. In other words, technology makes possible a communication or interaction in which she is rendered invisible: those emails make her disappear.

Once the relationship is over, Max decides to give his computer to his son, who lives with his mother in the south of Chile. He barely visits him, but nevertheless he decides to offer him this gesture, this gift. Interestingly, the first time that we hear about the son is when Claudia, after the computer breaks down and a lot of files get deleted, decides to create different users with passwords so that they can access the internet, and she creates one for Max's son as well. At the end of the story, Max has to carry the computer with him, on his lap during a long bus ride, as he would do with a baby, something that also makes him physically uncomfortable. The scene is described as follows: ""Ese viernes por la noche, Max partió

rumbo a Temuco. No tuvo tiempo para embalar el computador, así que se echó el mouse y el micrófono en los bolsillos, puso la CPU y el teclado bajo el asiento, y viajó las nueve horas con la pesada pantalla sobre las piernas" (*Mis documentos*, 64) ("That Friday, Max took an overnight bus to Temuco. He had no time to box up the computer, so he put the mouse and the microphone in his pockets, the CPU and keyboard under the seat, and the heavy screen on his lap" [*My Documents*, 110]).

The story doesn't have a happy ending, and the gift is not received very joyfully. Despite the long journey, Max leaves almost immediately after handing over the computer, perhaps out of discomfort when his son asks where Claudia is. Thus, the computer is not able to connect what has been disconnected from the start: Max's uneasy relationship with this son. In line with the focus on the computer as a protagonist of this mini-technobiography, the reader learns after Max's departure that the unwanted machine is relegated to the basement, as the son already has a newer, more advanced computer. The son and his stepfather store the machine among other now-obsolete objects, where it remains "a la espera, como se dice, de tiempos mejores" (*Mis documentos*, 47) ("waiting, as they say, for better times to come" [*My Documents*, 111]).

## Break-up, Break-down

To close this discussion, I will briefly mention two other stories in this collection in which technology and (dis)connection are related to travel and physical distance. One, entitled "El hombre más chileno del mundo" ("The Most Chilean Man in the World"), tells the story of Rodrigo, whose girlfriend, Elisa, has left for Europe to study for a doctorate. At first, they try to keep the relationship long distance:

> Durante los primeros meses era difícil saber si Elisa de verdad lo extrañaba, aunque le enviaba toda clase de señales y él creía interpretarlas bien – estaba seguro de que esos largos mails y esos mensajes caprichosos y coquetos en el muro de Facebook, y sobre todo esas inolvidables noches (tardes de él, noches de ella) de sexo virtual vía Skype *solo podía interpretarse de una manera*. (*Mis documentos*, 150; my emphasis)

> (During the first months, it was hard to tell if Elisa really missed him, even though she sent him all kinds of signals that he thought he interpreted correctly: he was sure that those long e-mails and the erratic and flirtatious messages on his Facebook wall and, above all, those unforgettable afternoon-nights (afternoons for him, nights for her) of virtual sex via Skype *could be interpreted only one way*. [*My Documents*, 178; my emphasis])

Technology – here, the internet – does help the characters to keep their relationship alive for some time, but, it turns out, only as a fiction. All the messages are mixed and misleading, and are also misread by Rodrigo. As with everything in Zambra's stories, technology brings about another debt, another vulnerability. Rodrigo maxes out his credit card to buy a plane ticket to visit Elisa. Unfortunately, once he gets there and calls her on the phone, she doesn't even consent to seeing him. He ends up wandering around the city, trying somewhat desperately to find a wifi connection (once again as a placeholder for human connection), since he doesn't speak the language and cannot tell people what he wants. He even wonders how he could mime wifi and finally decides not to. In this story, technology is connected to the internet and not to the cost or place of a specific computer. The narrator mentions Skype, Facebook, and wifi, as if the relationship itself had been rendered virtual, intangible, and, with that, doomed to failure: a ghost.[8]

The second story is "Vida de familia" ("Family Life"), which was recently adapted to the big screen by Chilean filmmaker Alicia Scherson. It tells the story of Martín, a forty-year-old man, who has to housesit for a distant cousin, Bruno, during a family vacation. He also has to take care of the family's cat, Mississippi. As one might expect, the cat gets lost only a few pages into the story. Technology comes to the rescue, so Martín can make signs for the missing cat, but, then again, technology brings about disaster and the loss of memories: "Busca sin método, atropelladamente, en el computador, alguna foto de Misisipi, pero no hay nada, pues antes de partir *Bruno limpió el disco duro de archivos personales*" (*Mis documentos*, 173; my emphasis) ("He searches on the computer erratically, incoherently, for a photo of Mississippi, but he finds nothing; before leaving, *Bruno cleared all personal files from the hard drive*" [*My Documents*, 204; my emphasis]). Bruno's decision to delete all his personal files so Martín cannot access them highlights his distrust of his cousin. It is an interesting gesture, for it implies a certain sense of privacy, or a protection of it; at the same time, the fact that Martín is in Bruno's house would imply a lack of privacy. Ultimately, Martín is allowed to invade Bruno's familiar/material space but is not allowed to access his digital memories.

While searching for the cat, Martín meets Paz, a single mother who is also looking for the missing pet. They start dating and, when she visits Martín for the first time, she sees a picture of Bruno's wife. Martín makes up a dubious family story to explain the situation: the story involves him being divorced, and the house being his property. This vulnerability makes him seem even more attractive to Paz, and, for some time, things seem to be going well between them. But Martín starts to get anxious as his lies become bigger and bigger by the minute: "Que

me bajen el volumen, piensa Martín. Que me adelanten, que me ret-
rocedan. Que graben encima de mí. Que me borren" (*Mis documen-
tos*, 185) ("May they turn my volume down, thinks Martín. May they
fast-forward me, rewind me. May they record over me. May they erase
me" [*My Documents*, 218]). Once again, technology is seen or described
as something capable of making things disappear instead of making
them exist or flourish. Martín imagines himself to be an old VHS or
DVD, one where you can record new information on top of the old. This
idea can be linked to José Van Dijck's concept of mediated memories.
Van Dijck, in her book *Mediated Memories in the Digital Age*, coins the
term "mediated memories," which encompasses "the activities and ob-
jects we produce and appropriate by means of media technologies, for
creating and re-creating a sense of past, present, and future of ourselves
in relation to others" (2007, 21). She further argues that "memory is
not mediated by media, but media and memory transform each other"
(21). Her concept is closely related to Marita Sturken's (2017) defini-
tion of "tangled memories," a category that refers to the memories of
a group as rooted in material objects.[9] Van Dijck's concept differs from
Sturken's, for rather than placing emphasis on the *collective* memory as
rooted in objects or as mediated, Van Dijck is interested in the way *in-
dividuals* construct their memories in a constant interplay with different
media. In Zambra's story, Martín imagines his recording or registering
process as a form of technology as well as his memory as tangled with
everything that surrounds him.

In *Mis documentos*, rather than enabling new forms of connection and
exploration, technology returns to being *a material thing among other ma-
terial things*. It doesn't hold any particularly "innovative" status, and
most of the time it brings about unfortunate events. It represents slow-
ness and not speed, friction and not fluidity, disconnection and never
connection. In the stories, technology is seen as a ruin and as something
that has the power to ruin, or dramatically affect, the characters' lives,
allowing them to lose themselves without being found, to erase them-
selves. Computers and other technological devices seem as vulnerable
and fallible as human beings: they seem to live and die, altering peo-
ple's lives.

At the end of the story "Mis documentos," the narrator obsesses over
his machine:

> Es de noche, siempre es de noche al final de los textos. Releo, cambio
> frases, preciso nombres. Intento recordar mejor: más y mejor. Corto y
> pego, agrando la letra, cambio la tipografía, el interlineado. Pienso en cer-
> rar este archivo y dejarlo para siempre en la carpeta Mis documentos. Pero

voy a publicarlo, quiero hacerlo, aunque no esté terminado, *aunque sea imposible terminarlo.* (*Mis documentos,* 28)

(It's nighttime, it's always nighttime when the text comes to an end. I re-read, rephrase sentences, specify names. I try to remember better: more, and better. I cut and paste, change and enlarge the font, play with line spacing. I think about closing this file and leaving it forever in the My Documents folder. But I'm going to publish it, I want to, even though it's not finished, even though it's impossible to finish. [*My Documents,* 33])

This fragment is one of the few times in which technology is indeed connected to the act of writing, to Zambra's key theme of *creation.* However, even though the computer gives the character the chance to create a text, it still serves to highlight its very impossibility: "But I'm going to publish it, I want to, even though it's not finished, *even though it's impossible to finish.*"

**Connection Failed**

To conclude this discussion of Zambra's material/familiar machines, I offer a final reflection on technology and speed. One of the most lucid recent studies on Latin American fiction is Daniel Noemi's work *Tiempo fugitivo,* in which he studies the idea of velocity in Latin American litera-ture and what it says and reflects about the world it depicts. Particularly in the most recent novels he includes in his study, technology is concep-tualized as a "producer of speeds" and linked to the transformations of capitalism. Noemi considers speeds "como relaciones entre tiempo y espacio; velocidades como relaciones de saber-poder; velocidades que hablan del modo en que el capital y la información circulan; veloci-dades que impactan a los sujetos y los cuerpos" (26; as relationships between time and space, speeds as relationships of knowledge-power, speeds that speak of the way in which capital and information circulate, speeds that impact subjects and bodies). Thus, he posits that neoliberal economic processes now penetrate every aspect of daily life: "la vida diaria se incorpora a una temporalidad propia de la acumulación del capital financiero" (17; daily life has been assimilated into a temporality of capital gains). However, in this context, he identifies the sluggishness we would associate with failure with the possibility of a new world and new stories. Noemi states that "esta literatura del fracaso, funciona como productor de significados alternativos a las construcciones ofi-ciales de la historia, ofrece otra velocidad" (36; this literature of failure produces alternative meanings that collide with official constructions of

history, proceeding at a different pace). Svetlana Boym also highlights the importance of slowness and imperfection as a somewhat healthy antidote to capitalism's hectic rhythm and expectations in her recent (posthumously published) book *The Off-Modern*. There she claims that "a byproduct of the high speed of everything is *a renewed need for continuity and slowness,* for other *more human temporalities that no software of the anticipatory nostalgia industry can possibly simulate ...* There is *a new longing for the imperfect human memory*, for a possibility to reclaim the individual right to self-reinvention not determined solely by computer algorithms" (18, my emphasis).

In this sense, the case of Alejandro Zambra's stories in *Mis documentos* is a very particular one. Although the book focuses heavily on technology's impact on everyday life, this impact is not a revved-up pace of life fuelled by instantaneous digital connection: rather, computers are clumsy, unreliable machines, invasions of space that bring discomfort and invite disaster. This may sound pessimistic, but, if we reconsider the stuttering, slow connections of Zambra's stories in terms of their possibilities for renewal and self-reinvention, maybe there is a spark of hope in that lack of speed and in the ever-present failure: the possibility of doing things at our own pace, of going out in the open,[10] of challenging our dependence or expected dependence on technology (and, with that, disrupting our dependence or expected dependence to capitalism). Of getting rid of unwanted memories. In Hoyos's words, "Some readers will miss a more forceful recourse to indignation or straightforward position-taking on the pressing contemporary question of the effects of new technologies on literature. Zambra merely sets the stage for such a reflection … Zambra's writing affects with subtle estrangements – of objects and love … but not only these. Its proposal of interrupting nostalgia with obsolescence allows us to regard time as time and not as a monument or consumer good" (120–1). In other words, and going back to the beginning of this chapter, if the page we are looking for cannot be found, perhaps we can go and find something else, something better. And in our own time.

NOTES

1  All English translations of *Mis documentos* provided here are by Megan McDowell, for McSweeney's English edition of the book.
2  Alejandro Zambra's novels, essays, and short stories all deal with the theme of memory in connection to Chile's political past as well as an individual exploration of the characters. In *Mis documentos*, the reflection on

memory is impregnated by the presence of technology. In a way, technology has also granted us ways of remembering.

3  Rubí Carreño has also highlighted the precariousness present in Zambra's novels and stories in her book *Av. Independencia* (2013).

4  We may also establish a connection between Zambra's depiction of debt and consumerism under a very ominous sign as a way to point in the direction of Chile's economical system and its dictatorship. Even though that past is not mentioned in these stories, the ghost of capitalism or of the neoliberal system may haunt these stories as an echo of that period.

5  In Zambra's stories, technology serves also to bring about what theorist Sianne Ngai (2005) calls "ugly feelings."

6  This desk can also be read as very dark humor. Instead of, as the saying goes, "open some doors," computers and technology serve to dismantle the characters' lives. This connection between technology and vulnerability also bring us back to Macarena Areco's work, especially her book *Acuarios* (2017). There, Areco studies different representations of space, trajectories, and even characters that populate contemporary Latin American fiction. Among them, we can find the fish tank, which, for her, represents the transparency and vulnerability of the globalized world (a notion that she also takes from Sloterdijk's work on bubbles and other spheres). She finds a fish tank in one of Zambra's novels, *La vida privada de los árboles*, as well as in other novels and stories by contemporary Latin American writers, and she relates this space with a feeling of being under surveillance, of being protected while exposed, as well as being separated from the rest of the world while being able to become a witness or a voyeur": "La idea subyacente de estar dentro de una pecera cerrada, pero transparente, expuesta pero protegida, estrecha pero con visión panorámica – o más bien con la imagen que se tiene en un espejo convexo o de 'ojo de pescado,' la cual es, según he leído en internet, virtual, justo con la sensación de estar encerrados entre paredes y relaciones familiares estrechas, pero conectados y visualizando todo lo que ocurre en el mundo, sin olvidar la paranoia de que nos vigilan – parece ser tan productiva que prolifera en las formas más diversas en los relatos que se cuentan en el presente" (12; "The underlying idea of inhabiting a closed yet transparent fish tank, exposed but protected, narrow but with a panoramic view – or rather with the image that one has in a convex or 'fisheye' mirror, which is, as I have read online, virtual, just with the feeling of being enclosed by walls and close family relationships yet still connected and visualizing everything that happens in the world, without forgetting the paranoia that we are being watched – [this idea] appears so productive that it proliferates in diverse forms in the stories being told right now.")I mention this, not because we may find fish tanks in Zambra's stories (we don't) but because computers do work as a

challenge to the fish tank, to the intimacy it grants. As the narrator of "Mis documentos" states, the computer is seen through a paranoid lens, as s source of viruses, infection, and contagion – a threat to the familiar space (even though, as I previously discussed, the computer is often treated as a part of the family).

7  "Fue por entonces cuando perdieron la vocal a y la consonante t" (*Mis documentos* 102) ("It was around then that they lost the vowel a and the consonant t") (*My Documents* 102).

8  This link between technology and movement or travelling can also be connected to Macarena Areco's work. She makes the distinction between intimacy novels and out-in-the open novels (*novelas de la intimidad* versus *novelas de la intemperie*). She states that Zambra's novels sometime start as intimacy novels only to be challenged to go outside (and thus becoming a *novela de la intemperie*). In this story, it is technology and debt that make the protagonist move: to move to Europe, to move around the city, and, we hope, eventually to move on.

9  Sturken's traditional example of a tangled memory is the interaction between the Vietnam Veterans Memorial and its visitors: how visitors often leave personal objects or messages next to the wall, thereby transforming the space of the memorial as a space of communication.

10  This insistence on failure can be connected to Alejandra Bottinelli's ideas in her article "Narrar (en) la 'Post'" (2016), where she states: "Alejandro Zambra otorga la posibilidad de volverse verosímiles a personajes que arriesgan y les sale pésimo, a seres desacostumbrados a la amabilidad ... a hijos de familias donde no había muertos ni había libros ... al escritor de perpetuos borradores ... y a Yasna, cuya historia es la de la violación de la más elemental integridad, a ellos y a ellas, el autor escoge regalarles una oportunidad en la intemperie: una voz y dos paraguas, uno azul y uno negro, 'el azul para el equilibrio y el negro para la lluvia' ... para seguir camino" (28; "Alejandro Zambra offers a chance at verosimilitude to characters who take risks and flounder, to beings unaccustomed to kindness ... to children of families where there were neither dead nor books ... to the writer of perpetual drafts … and to Yasna, whose story is that of the violation of the most elementary integrity: to all of them, the author offers exposure to the elements: a voice and two umbrellas, one blue and one black, 'the blue for balance and black for rain' … to follow the path").

REFERENCES

Amaro, Lorena. 2014. "Formas de salir de casa, o cómo escapar del Ogro: relatos de filiación en la literatura chilena reciente." *Literatura y lingüística* 29: 109–29.

Areco, Macarena. 2015. *Cartografía de la novela chilena reciente: realismos, experimentalismos, hibridaciones y subgéneros*. Ceibo Ediciones.

– 2017. *Acuarios y fantasmas: imaginarios de espacio y de sujeto en la narrativa argentina, chilena y mexicana reciente*. Ceibo Ediciones.

Baudrillard, Jean. 2005. *The System of Objects*. Translated by James Benedict. Verso.

Bennett, Jane. 2010. *Vibrant Matter: A Political Ecology of Things*. Duke University Press.

Bottinelli, Alejandra. 2016. "Narrar (en) la 'Post': la escritura de Álvaro Bisama, Alejandra Costamagna, Alejandro Zambra." *Revista chilena de literatura* 92 (April): 7–31.

Boym, Svetlana. 2017. *The Off-Modern*. Bloomsbury.

Carreño, Rubí. 2013. *Av. Independencia: literatura, música e ideas de Chile disidente*. Cuarto Propio.

– Forthcoming. *Historia crítica de la literatura chilena*, volume 4. LOM Ediciones.

Connerton, Paul. 1989. *How Societies Remember*. Cambridge University Press.

Donald, James. 2005. "Flannery." In *Geographies of Modernism*, edited by Peter Brooker and Andrew Thacker, 165–76. Routledge.

Hoyos, Héctor. 2015. "The Telltale Computer: Obsolescence and Nostalgia in Chile after Alejandro Zambra." In *Technology, Literature, and Digital Culture in Latin America*, edited by Matthew Bush and Tania Gentic, 109–24. Routledge.

Latour, Bruno. 2002. *We Have Never Been Modern*. Translated by Catherine Porter. Harvard University Press.

Montoya Juárez, Jesús. 2016. "Hacia una arqueología del presente: cultura material, tecnología y obsolescencia." *Cuadernos de literatura* 20.40: 264–81.

Ngai, Sianne. 2005. *Ugly Feelings*. Harvard University Press.

Noemi, Daniel. 2004. *Leer la pobreza en América Latina: literatura y velocidad*. Editorial Cuarto Propio.

– 2016. *Tiempo fugitivo: narrativas latinoamericanas contemporáneas*. Ediciones Universidad Alberto Hurtado.

Sturken, Marita. 1997. *Tangled Memories: The Vietnam War, the AIDS Epidemic, and the Politics of Remembering*. University of California Press.

Van Dijck, José. 2007. *Mediated Memories in the Digital Age*. Stanford University Press.

Virilio, Paul. 2007. *Speed and Politics*. Trans. Mark Polizzotti. Semiotext(e).

Zambra, Alejandro. 2013. *Mis documentos*. Anagrama.

– 2015. *My Documents*. Translated by Megan McDowell. McSweeney's.

# 5 C$U%B#A#+53: Glitches, Viruses, and Failures in Cuban and Cuban-American Digital Culture

EDUARDO LEDESMA

Noise. Contagion. Communication breakdown. Spam. Systems failure. Digital pollution. Errors. Glitch. These are some of the less desirable and anarchic characteristics of our digital and online environments, the product of software and hardware malfunctions, of faulty code, of viral attacks. Occasionally they are the product of a deliberate manipulation of the digital for artistic purposes. Whether deliberate or accidental, the phenomenon of glitch and failure undermines all sorts of propriety: the proper functioning of digital media, the proper use of online sites, the proper output from computer code and algorithms. In this chapter, I will argue that failure can also encode a revolutionary potential with its capacity to disarticulate or, at least, briefly interrupt both authoritarian sources of power and neoliberal networks of global capital, in cyberspace and/or "real" space. More specifically, I will examine how Cuban-American artist Antonio Mendoza uses glitch to undermine capitalism, while a Cuban artist, Yonlay Cabrera, deploys it against state socialism. By juxtaposing these two artists, whose official national identification is separated by (only) ninety miles of water across the Florida straits, I seek to provide a glimpse into Cuban glitch art production in the context of the flows, migrations, and diasporas that have always characterized the island's experience – an experience that, replete with paradoxes and contradictions, has had its share of glitches and failures, but has also been a source of utopian inspiration globally. This comparison serves to provide a more expansive and multigenerational perspective since, as Andrea O'Reilly (2016) proposes, "when speaking of present-day Cubans, one is referring simultaneously to those that live on the island as well as to a multilocal population that has spread across the globe and now includes three generations born outside Cuba following the 1959 revolution ... [in] a series of interlinked communities (both on and off the island) that are related to one another, yet

whose positions are not identical" (2–3). Artists such as the ones I will foreground here engage in critical media practices that seek to intervene against states of hegemonic media control, whether by authoritarian governments or more diffuse systems of economic coercion, so that, as Rita Raley (2009) argues, their tactical (net) art practice "signifies the intervention and disruption of a dominant semiotic regime, the temporary creation of a situation in which signs, messages, and narratives are set into play and critical thinking becomes possible" (6).

In Latin America, notwithstanding notable advances in new media technologies over the past decade, such glitches and failures are systemically hardwired into local material and physical realities (as seen, for instance, in the digital divide through the pricing of broadband, which becomes a luxury good rather than a necessary utility for many Latin American countries; or in Cuba's specific case, where the individual sale and purchase of personal computers was illegal until 2008). This is not to posit an "original" backwardness when it comes to technology, since, as Hilda Chacón (2019) astutely observes, "considering Latin America as a region that had been left behind in media-related technology and electronic media developments would be inaccurate" (13). However, although this simultaneous technological development with the United States and Europe was the case with print and electronic media (radio, television), things have been a bit spottier with new media, and access and connectivity often vary drastically from country to country in Latin America. For instance, 2018 internet usage statistics show that Argentina (with 93% of its population connected), Chile (77%), and Brazil (70%) lead in terms of access statistics, whereas Cuba (38%), Nicaragua (30%), and Honduras (29%) lag far behind in these and other new media technology indicators (Latin American Internet Usage Statistics 2019). Despite the supposed deterritorialized nature of the virtual, throughout Latin America digital malfunction often exposes unequal access, slower networks, and the capacity of technological innovation to exacerbate social inequalities. Nevertheless, failure and glitch, when redirected tactically by artists and hacktivists, can be refreshingly deployed for political dissent against neoliberal systems and/or authoritarian regimes that seek to control media networks. As artists introduce glitches and viruses into code, or simulate doing so, they question code's rules and challenge its supposed universalism, hack and repurpose proprietary software, and seek to make visible – and freely available – black-box programming. Error and glitch provide emancipatory potential, so that, as Mark Nunes (2010) observes, "in its 'failure to communicate,' error signals a path of escape from the predictable confines of informatics control: an opening, a virtuality, a *poiesis*" (3).[1]

In this chapter, by way of introducing Cuban and Cuban-American glitch practices, I will present a reading of works by two artists that employ glitch as political disruption: Antonio Mendoza (USA-Cuba) and Yonlay "Yoni" Cabrera Quindemil (Cuba). Their objectives in their political glitch practice, however, differ and respond to very different circumstances. In Mendoza's case, he mobilizes glitch and critical code strategies in order to undermine transnational capitalist practices, including copyright laws and proprietary software, as well as to challenge the growing interconnections between US militarization and media surveillance. For Cabrera, glitch becomes a sardonic form of critique against the grand narratives of Cuban socialism, an undermining of state-sponsored media channels, as well as an effort to expose the (im)possibility of being a new media artist on the island (on account of technological and political barriers).[2]

### Code, Glitch, and Virus in the (Cuban) Diaspora: Antonio Mendoza's "Criminal" Net Art

Along with his complex cultural hybridity, one can detect in Antonio Mendoza's projects a similarly hybrid approach to art forms, methods, and media.[3] As a polymath artist, Mendoza has painted, created video and performance pieces; jammed with his electronic music band, Mr. Tamale; and programmed new media art, producing an extensive body of work for online platforms. A self-described critical glitch artist, Antonio Mendoza was born in Miami in 1960 to Cuban exile parents who formed part of the first post-revolutionary immigrant wave.[4] Despite his current leftist-progressive leaning, Mendoza was likely born to privilege and in a conservative pro-Batista Cuban household. This is a reasonable conjecture considering his parents' 1959 departure from the island and their subsequent move to Franco's Spain in 1964, a move that would have been unlikely had they been sympathizers of the Cuban Revolution. After spending most of his childhood and adolescence in Spain, Mendoza returned to the United States for college, received his degree in semiotics from Brown University, and settled in Los Angeles in 1983. It was in LA that Mendoza began practising as a visual artist and soon demonstrated a preference for various forms of internet art, including browser art and glitch art.[5]

Although the content of Mendoza's glitch art does not necessarily spring directly from his multiply hyphenated identity – and in some respect transcends the national to touch on themes of global concern – the sheer baroque exuberance of his digital collages and his subversive attitude toward institutions and proprietary boundaries undoubtedly

link him to other artists with Cuban roots working on and off the island. That is to say, much like these other artists, Mendoza's work bears the stamp of a profoundly anti-establishment position. Moreover, it can be argued that this anti-establishment attitude is compounded by the glitch sub-genre itself, as most browser and glitch art tends to be substantially rebellious and foundationally opposed to rules and institutions.[6] The use of irony and (often sardonically dark) humour has become almost expected in contemporary Cuban art broadly speaking, by way of commenting on social and political realities (in Cuba or elsewhere); one such form of irreverent humour, *choteo*, will be discussed in relation to Yonlay Cabrera's work in the next section. In the case of Antonio Mendoza, I will focus my attention strictly on his internet art, most of it created from 1994 through 2012, and therefore a bit "retro" by now, given the fast pace of change in internet and media technologies in the past decade. More recent works are not available, as Mendoza's online art trail grows faint after 2012. For unknown reasons, from that year until now, his presence on the web, which used to be considerable – he was involved in various digital projects, including glitch art, electronic music, video art, performance, and so on – has gradually disappeared.[7]

Some of the salient elements that characterize Mendoza's art are its combativeness, its profoundly anti-copyright stance, and its blatant desire to subvert institutional norms and structures – the last point is a trait that Mendoza's work shares with that of Yonlay Cabrera. One defining aspect of Mendoza's digital work that I have written about elsewhere is his use of what Alan Liu, in *The Laws of Cool* (2004), calls "viral aesthetics," referring to a digital aesthetic that blurs the distinction between creation and destruction, proper function and error, legality and criminality, resulting in an "aesthetics of mutation and remixing" (324). For Liu, digital works that mobilize viral aesthetics entail a destructive mode of productivity or creativity, as they attack channels of communication and knowledge through technological means and "introject destructivity within informationalism" (331). Works deploying viral aesthetics typically favour noise and disruption over information, as hacks, viruses, glitches, and communication delays and interruptions become significant subversive events undermining the smooth operations of a fully networked society. As we will see later with Yonlay Cabrera, however, the question becomes more complex when a society is not fully networked (as in Cuba itself), in which case disruption, virus, and glitch may not be deployed against the internet itself, but will more likely be directed against older forms of media communication – state-sponsored television, newspapers, and physical spaces of official

discourse. The presence of glitch art in Cuba also raises the question of whether creating such art makes sense when "glitch" is just part of everyday experience with faulty technologies. At the same time, it is worth considering that much of the software used for glitch art is not proprietary; programs such as HexFiend are free and open source, and can be used to manipulate the "lower" levels of data (a practice called "databending"), allowing the manipulation of the binary code itself, and thus providing access – at least to those in the know – to the raw data of files, rather than just to the higher-order programming code. Corrupt data can then be fixed, or, alternatively, data can be corrupted to create deliberate glitches. The same can be said for programs such as Avidemux or PixelDrifter, which allow the processing, manipulation, and corruption of video and image files (through "data moshing" or data compression and other techniques). Glitches are also created with software that was not specifically designed for the purpose of creating "glitch," so that, at times, proprietary programs are being used in "improper" ways, even against the express wishes of their manufacturers. In the case of hardware, physical damage to the circuitry or other components can also result in interesting effects (these practices are sometimes referred to as "circuitbending").

Mendoza, in contrast with Cabrera's distortion of media broadcasts, focuses his glitch-based art strictly on the internet. The deployment of viral aesthetics is a strategy Mendoza has used in several of his web creations, including his website subculture.com, an example of so-called browser art in which the user is suddenly assailed by what appears to be a hacking viral attack but is in reality only a simulation, albeit a dizzyingly frightening one (Ledesma 2015, 106–12). The piece I will analyse here, mayhem.net, shares many characteristics with Mendoza's subculture.com website; in fact, one can access subculture.com through the mayhem.net portal, since the latter functions as an entry point to much of Mendoza's web-based art. In keeping with the viral nature of Mendoza's net-based creations, it is often difficult to disentangle how his different websites are linked, intermingled, and rehashed, a situation that is made even more confusing by the considerable amount of remixing, repurposing, and borrowing present in Mendoza's net art. The chaos and confusion are also in keeping with the artist's deliberate intent to spread mayhem and scramble browsing practices, to disseminate "viral" code, so as to "challenge the corporatist power structures already ensconced within the Web" (Ledesma 2015, 106).

The snippet description of mayhem.net reveals much about Mendoza's flirtation with criminality – or at least, his (pseudo) criminal hacktivist ethos.[8] The caustic snippet echoes surrealism's most iconic

phrase – the chance encounter between an umbrella and a sewing machine on a dissecting table – yet provides the image with a new twist: "The chance meeting of art and crime on the dissecting table. Home of the online serial killer. Home of the digital pirate" (Mendoza n.d.). Thus Mendoza, adopting a hacker-pirate-artist persona, aligns himself – somewhat tongue-in-cheek – with a history of the avant-garde, on the one hand, and with a history of piracy, criminality (even heinous variants such as serial killing and mass murder), and chaos, on the other. This rather ambiguous "play" at criminality is consistent with the emergence of digital spaces of resistance against the market-driven web and its cybernetic imperative of maximum efficiency and maximum profits. Through the creation of hacker net art, Mendoza's websites fashion self-replicating and unwanted objects that have no real market value and simulate digital viral outbreaks in the host machine. These practices, hostile to proper online decorum, refer constantly to the dark web (those restricted parts of the web not indexed by search engines, which are often pro-privacy and anti-establishment and may at times involve criminal or illicit practices), without ever fully becoming part of it. They seek to create

> an informatics structure that plays off of the creative potential of equivocation, a form of sabotage in which the cybernetic imperative is turned against itself. From within the network of programmatic control, these are the tactics of "bad actors" who game the system in order to divert the rules toward their own ends. The recuperation of the "hack" … as a term associated with a liberatory potential does not take away from the fact that for a majority of daily users of new media technologies, the hacker is a figure of malevolent potential. (Nunes 2010, 16)

In his artwork, Mendoza fully asserts that "malevolent" hacker stance. He plays up the hacker persona in order to accentuate his work as a counternarrative to global capitalism and US hegemony. Accessing the mayhem.net site, we are faced with a screen composed of ten square boxes, each of them an entry portal to different sections of the website or linked to other websites designed by Mendoza, each a veritable universe of hack+artivism (figure 5.1). Everything in this first page is dizzying for the viewer/user: both text and images are moving, flashing, and shaking, the colours are quickly shifting, and the overall effect is one of extreme disorientation, triggering a veritable optical assault.

The offensive content of the rapidly changing heterogeneous imagery is also meant to disturb mainstream sensibilities, as these boxes include alien beings, criminal mug shots and photographs of serial killers,

Figure 5.1. Home page for Antonio Mendoza's "mayhem.net" website (screen capture). Antonio Mendoza.

pornography, and profanity-laden text. The electronic synthesized sound (or music) is equally aggressive and recalls futurist and Dadaist experiments: distorted voices, loud percussion, cacophonous noises, bangs, clanks, assorted rings and tones, and a deliberately degraded industrial-like quality that meshes electronic music with the sounds of war, of mechanical failure, and of technology. As Nunes (2010) observes, the mechanisms of glitch and mayhem foregrounded by Mendoza and other glitch artists serve to highlight "moments in which error makes visible both the dominant logic of all-actualizing-systems as well as those of interstitial spaces that escape control" (18). According to Nunes, error and noise provide an opportunity for unintended readings (and misreadings) as well as a chance to make unforeseen but perhaps illuminating aesthetic and critical interventions. Mendoza's homepage begins to cultivate a sense of fragmentation, glitch, and illegality through sound, image, and text ("art dam age," "imagepirate," "internet crime archives," and so on).

It is necessary to delve a bit deeper into mayhem.net to fully grasp its deployment of glitch and its affinity with the darker underbelly of the web. If we click on the box displaying the text "ART DAM AGE," we are immediately directed to another screen that features rapidly

Figure 5.2. "ART DAM AGE" page for Antonio Mendoza's "mayhem.net" website (screen capture). Antonio Mendoza.

shifting image and text (in the centre), surrounded by a background of degraded illegible script, and another series of menu choices beneath it (figure 5.2). If we patiently decode the quickly moving and flashing text – which resists and defies easy legibility – we can read "Art on the edge of damage. Putrid Afterthought is what is seen at the end of the double-barreled, shotgunned cesspool of hyperreality. View at your own risk." Mendoza's statement/warning/threat, suffused with the imagery of surrealism (its references to violence, scatology, putrescence, sex), also hints at one of glitch art's primary goals, to expose the false hyperreality of contemporary media images, to disarticulate (and "damage") mainstream and institutionalized art practices. Mendoza has stated as much, insisting that both a disregard for copyright and the ability to manipulate and falsify images, perhaps paradoxically, enhance the possibility for critique: "Photography could never be trusted. It always could be doctored. Now with computers, everyone can do the doctoring. Computers have democratized the ability to manipulate images" (Mendoza 1994). In Mendoza's opinion, the proliferation of "fake" and photoshopped images is a sign of democratized access, and it has arguably inoculated us with a healthy dose of scepticism about media manipulation – although, in the era of "Fake News" and Russian

election meddling via internet and social media manipulation, this latter point may be a bit difficult to sustain.

The webpage, through its remix of sounds and images, is a palimpsest of referentiality and self-referentiality. In fact, the phrase "Putrid Afterthought" is also the name of Mendoza's first website (dating from 1994), which featured his digital paintings made from material "borrowed" from various online and analogue sources, reinforcing his defiant anti-copyright stance. The baroquely busy image collage at the centre of the screen is assembled, in part, from one of those paintings. The image is replete with art historical referents – for example, Botticelli's *The Birth of Venus* (1486) is referenced by the nude male figure stepping out of a giant seashell – as well as references to pornography and sadomasochism (the nude and heavily tattooed male figure who flaunts his erect phallus also evokes S&M imagery) and to Eastern religion (the repeating image of the crown-wearing Krishna, the main Hindu deity), and replete with floating animal heads that are superimposed onto the human figures. This video image is created by rapidly flashing a digital collage painting titled *Krishna Venus* (1994). The image blinks and moves around the screen, offering fragmented and otherwise distorted views. The painting is one of many collages by Mendoza that repurpose pre-existing images taken from various online and print sources, which are then crudely photoshopped unto an unidentifiable urban backdrop. Speaking about Mendoza's digital paintings, art critic Josef Woodard has remarked that their "repetitive motifs, visual echoes and reconstituted anatomy – often genitalia cloned – add up to an effect at once psychedelic and kaleidoscopic. But this work also conjures up a clear cultural reference to the tapestry effects of Indian art, as referred to in such playful titles as 'Venus Penis' and 'Krishna Venus'" (1996). The repetitiveness of pattern, reminiscent of the ad infinitum repetition of fractal-like images, and the deliberate emphasis on the breakdown of such patterns form the basis for glitch art. To underscore this point, the background of this page consists of a series of rows of letters placed against alternating colour stripes (pink and white). The letters themselves are mostly illegible, appearing partly degraded as if affected by a resolution problem, all of this adding to the overall aesthetic of decaying digitality of the piece.

Moreover, as evidenced by his repurposing of materials and images, Mendoza's disregard for copyright is also constitutive of his glitch art practice. So is the desacralizing act of appropriation, which the artist resolutely defends, stating that,

appropriation is subversive when it deals with manipulating cultural iconography. But it doesn't have to be specifically socio-political, it can just be

funny. But then, most art involves a certain degree of appropriation. Some are more blatant than others. Furthermore, I don't think appropriation needs to be justified. I think people should lighten up about the sanctity of their images. (Mendoza 1994)

Irreverence, subversion, and an embrace of decay and error are nevertheless still held in check by a partial desire to not openly, not really, break the law, as Mendoza recognizes in his somewhat colourful language. His anticorporatist attitude (expressed as hostility toward corporations like Disney) is tempered by a fear of legal repercussions, which act as a form of censorship:

I've never gotten permission for any of the images I use. I mean, do you think anyone would give me permission to stick a bunch of penises on their picture? I have to pull some collages off-line every once in a while, when the guy running the underground.net gets nervous and feels a lawsuit coming. Technically, he has nothing to worry about. The worst that could happen is that we would get a cease and desist court order to which we would comply. I have some collages using Disney characters that I haven't put on-line because the Disney people will look for me, find me and break my balls. (Mendoza 1994)

Aligned with his dislike and distrust of both corporations and government institutions, Mendoza is also suspicious of the way the internet itself is entangled with (and controlled by) the global capitalist system; this distrust extends to the very technical mechanisms of computing, to hardware and software itself. For example, in his net art, Mendoza often attempts to expose the functioning of computer code, data, files, and algorithms. If we return to the main page of mayhem. net and click on the box labelled "FETCH" (in the upper left of the screen), when the next page loads we see an image that mimics an open computer window and displays the architecture of a file storage system (figure 5.3). This kind of filing system provides order to data, facilitating storage and retrieval, separating data into discrete units each assigned to a particular file, each file in turn forming part of a folder or directory. A file system is the basic structure used by computers to manage space, content, and metadata, and serves as a mechanism of control, to police access (files can be secured or not, visible or invisible, encrypted or legible, for example).

Needless to say, this kind of orderly archiving structure becomes an ideal target for hackers and hack-artists such as Mendoza. The very filenames he uses on this page begin to suggest the work of "undoing"

Figure 5.3.  "FETCH" page for Antonio Mendoza's "mayhem.net" website (screen capture). Antonio Mendoza.

structure, regulation, order: "crash," "sex," "blink," "idiot.robot," "bugger," "terror," "broken," "loop," and so on, all part and parcel of a semantic field that alludes to piracy, hacking, and digital anarchy. It is likely that these are the same image and video files that are activated once one enters the subculture.com page previously mentioned (that is, the root directory's name displayed in the image), so that Mendoza is allowing a glimpse into his very own file structure, revealing otherwise hidden mechanisms. This suspicion is reaffirmed once we click on any of these filenames and are instantly redirected to one of Mendoza's webpages, with their chaotic browser action (windows open and close uncontrollably, the user is redirected to sites they have not chosen, etc.) and their proliferating images of pornography, politics, the War on Terror, and so forth. Most of the activated webpages display similar image and sound breakdown and glitch characteristics.

As Sabato Visconti – a Brazilian artist who also creates glitch art – explains this twenty-first-century art phenomenon, "glitch art has a way of exposing the coded logic behind things, and this tendency lends itself to conveying a wide variety of messages, whether it is aesthetic, political, or even emotional. Every glitch bears traces of failure and death" ("Interview" 2014). On Mendoza's "FETCH" webpage, the (negative)

exposure of the file system as a kind of mechanism prone to failure, to misdirected paths, 404 errors, and corrupt(ed), deleted, or unreadable files – in sum, to impossible or inaccurate retrieval – is visually evoked by the background image, which is a negative and mirror-image reversal of the central display, one that is fractalized into a mosaic. Both code and filing structures are presented as fraught with apocalyptic danger by way of the threatening filenames, inverted colours, and active links to menacing pages that simulate the dark web.

No less important is Mendoza's desire to make the functioning of his code visible, legible – as seen in his exposure of his file structure. Elsewhere, I have written about his recourse to making code visible, a strategy he has used in several web projects:

> Mendoza's deployment of a self-reflexive code-aesthetic that incorporates dark humor and disorder to parody the established Internet global capitalist order through digital disruption, enacts an ethos of hacktivism whose aim is to distort, fragment and expose the ideological underpinnings of media images through a process which defamiliarizes and disorients the viewer. Without actually showing its source code, Mendoza hints at the computer code that underlies his work, by offering glimpses of its functioning, and suggesting how computers might be hacked into, interrupted and compromised through cyber-warfare tactics. Additionally, text is overlaid on abstract patterns to give the appearance of a software or system break-down or glitches. (Ledesma 2015, 109)

This is to say that Mendoza's work, like most glitch art, privileges noise and failure over communication and signal, and, by reorganizing patterns and breaking down the "proper" sequences, seeks to undermine the existing hierarchies and power structure present in contemporary digital culture: the control of the web by capitalist and military interests, the penetration/hacking of undemocratic forces into supposedly democratic systems, and the established (but reified) institutions of art itself. While his aesthetic and political concerns are not strictly Latin American or Latinx, his recourse to an aesthetic of the dark web situates him as someone who reflects on current events from the perspective of marginalized minority culture. For all his claims to anarchic web practices and mayhem, Mendoza must be seen as a digital activist, even a hacktivist, rather than (as some may see it) a cyberterrorist. According to new media theorist Peter Krapp (2011), artists of Mendoza's ilk who skirt illegality and adopt hacking practices must be seen in the light of an increasingly surveilled and controlled net environment, since, "once the protection of privacy and free speech is hollowed out

by surreptitious data mining and invasions of data privacy, activism becomes all too easily equated with cyberterrorism, turning into enemies of the state anyone who dares question some of the more insidious consequences of the pervasive commodification of the network infrastructure" (28). For Mendoza, the deployment of images of the War on Terror, narcotrafficking, digital piracy, hacking, and pornography, represents a de facto stance of resistance against rigid order and the power of elites, whether in the United States or in Latin America, and, indirectly (and perhaps unintentionally), against the political elites within the Cuban Revolution. While his art may not directly reference Cuba or even display obvious markers of Cuban-American identity (or Spanish identity either), the experience of exile and diaspora with its "residue of anxiety, fear, and loss" permeates his work, which demonstrates, at the very least, a patent defiance regarding assimilation into mainstream US culture, but also a distrust and disdain for all authoritarian power structures (Alvarez and Bosch 2009, 8). Mendoza's parents were "exiles," a politically inflected term that hints at a possibility of return, and that often aligns with a degree of cultural identification with the island by Mendoza's generation, despite their never having lived there. Thus, the children of exiles are inextricably linked to the 1959 revolution: they are, in effect, the product of historical forces that shaped their lives and, sometimes in subterranean fashion, inflect their artistic production. This art will perforce reflect a hybrid cultural identity, but also will retain linkages to the "homeland," and to the originary moment that changed everything (the 1959 revolution), even if indirectly.

### Disconnected in the Island: Yonlay Cabrera's Low-Tech *Choteo* Glitch

To continue this discussion of glitch art, I shift my focus from Mendoza, an American artist of Cuban descent, to Yonlay Cabrera (1988–) a Cuban still living on the island, whose oppositional art potentially carries greater risk. Cabrera was born in Havana, is a graduate of the University of Havana's art history program, and has worked mostly on video art, interactive installations, and computer-created art. His interest is to explore "los cambios sociales incorporados por las nuevas tecnologías, con énfasis en la dimensión ontológica del sujeto desconectado; el libre ejercicio de la voluntad ciudadana y la importancia de la ética como sustento de la expresión individual" (Cabrera 2017b; social changes brought about by new technologies, with special emphasis on the ontological dimension of the alienated subject; the free exercise of the will of the citizenry and the importance of ethics as the foundation

of individual expression).[9] For Cabrera, those new technologies, which are available only to a limited segment of Cuba's citizenry, are exposing the double nature of the Cuban subject as *desconectado*, in that word's double sense of alienated and also disconnected from the very latest technology and the "outside" world. Alienation or estrangement (in a Marxian sense) and isolation are recurring themes in Cuban net art, and in the island's contemporary art more broadly. The feeling of being alienated or disconnected from the outside art world, and estranged from one's own work product, is coupled with a sensation of backwardness that is aggravated by the loss of utopian expectations. There is a kind of irony in this alienation, which Marx had linked to the worker's own separation from the means of production in capitalism, but which here is re-experienced in a socialist society by disaffected artists unable to access the materials they need or the liberty to create unrestricted art. This point is echoed by Rachel Weiss in *To and from Utopia in the New Cuban Art* (2011), which tracks a major (but gradual) shift in Cuban contemporary art from a utopian optimism in the early 1980s to a despondent cynicism today.

Disconnectedness, real and imagined, stems also from the scarcity of resources and limited access to the internet and to new media technologies, problems exacerbated by Cuba's profound isolation – economic, technological, geographic, political – since the 1990s, all of which favours an emphasis on an aesthetic of breakdown, corruption, and glitch as a form of critique. Rewell Altunaga (1977–), another net artist close to Cabrera's generation, paints a stark outlook for those working on new media art in Cuba:

> After two decades we find ourselves in a context of disconnection and new-media vigilance, which makes our work have an anti-establishment character in the face of the local power and control mechanisms, but also in the face of the world macro power. In Cuba, Internet is perceived as an illusion, a black world accessible illegally, and strictly linked to piracy – through *proxi* – the black market or hour quotas that represent more than half the average monthly salary of a common worker. Thus, it can be said that we participate in a process of double alienation, since every illusion is, in turn, alienating. (Altunaga 2013)

Despite these adverse conditions, there is a growing cadre of young artists (born mostly in the late 1980s and 1990s) developing Cuban net art, including Cabrera and Altunaga, but also several others, among them Mauricio Abad, Alexander Arrechea, the duo Celia and Yunior (Celia Gónzalez Álvarez and Yunior Aguiar Perdomo), Fidel García,

Luis Gómez, Núria Güell, Jairo Gutiérrez, Ernesto Leal, Glenda León, Levi Orta, Rodolfo Peraza, Naivy Pérez, Susana Pilar Delahante Matienzo, José Rolando Rivera, and Lázaro Saavedra.

These net artists face staggering technical challenges. Access to the internet is very difficult on the island, where only 5–10 per cent of the population has reliable connectivity (even though roughly half of all Cubans have email and Facebook accounts). Some of these access problems stem from the difficulty in obtaining fiberoptic cable and other nearly insurmountable challenges to building the proper infrastructure, in part on account of the long-lasting US embargo. But, embargo aside, internet access has not been a matter of high priority for the Cuban government until very recently.[10] While the government has, since 2015, increased the number of internet access points and expanded access to wifi, connectivity is painfully slow (1 Mbps at public wifi hotspots), prices remain prohibitive (approximately $2 per hour, well beyond the means of most Cubans), and the flow of information is restricted and closely monitored. Moreover, in Omar Granados' view, "Cuba remains the most restricted country in Latin America regarding Internet freedom for its citizens. In addition to limited bandwidth and technological resources, a rigorous institutional model for access has reinforced the monopoly that the government has kept over all media, press, and cultural organizations since the 1959 revolution" (2019, 175). Given this dismal state of affairs, it is not strange that many digital artworks deal with issues of disruption, disconnection, and misinformation, and tap into an aesthetic that, like reality, can be described as decidedly "glitchy." To think about internet and new media in Cuba is, in a sense, to think about failure. To think about any media is to think about surveillance and control.

As part of Cabrera's interest in glitch art, we find a desire to expose the mechanisms of new media in particular, and all communication media more broadly, especially the way they may be (mis)used to either bolster or undermine state discourses. Cabrera believes that artists must adopt an ethical stance that requires making art that challenges state-controlled media mechanisms, positing that "el artista es un sujeto activo que no acepta los modos en que los medios construyen la realidad y trata de mover el foco de atención hacia las zonas de conflicto, lo obliterado por los discursos oficiales" (Cabrera 2017a; the artist is an active subject that does not accept the way in which media constructs reality and so he seeks to shift the focus towards conflict zones, towards that which is obliterated by official discourses). His posture, openly stated, is to practise art aggressively (bypassing official expectations, transgressing aesthetic canons, and injecting, insofar as it is possible,

a degree of political critique), regardless of acceptance by the official channels in Cuba. He understands the risks (and benefits) such postures may carry, arguing that

> no ser invitado a participar en una exposición, es un freno para aquellos que consideran las decisiones institucionales un impedimento. Pero existe otra postura que al menos en el arte cubano joven aparece bastante poco: entrar a la fuerza. Está claro que no todos los artistas pueden enfrentarse de esta forma a la institucionalidad y salir ilesos en el acto. (Cabrera 2015)

> (Not being invited to participate in a gallery show is a detriment for those who consider institutional decisions as a barrier. But there is another posture that is not present enough in young Cuban art: to enter by force. Clearly not all artists can oppose institutions in this way and remain unscathed.)

Writing about the work of another young Cuban artist (Levi Orta, 1984–), Cabrera lays out some of his basic beliefs regarding oppositional artistic practice, which he situates within the use of *choteo*, a kind of subversive ridicule, mockery, or jest with regards to official and institutional positions, an approach dating at least to the early twentieth century (and identified critically since Jorge Mañach's 1940 *Indagación al choteo* [Investigation into *choteo*]) and currently deployed by some of the younger Cuban artists (including Orta and Cabrera himself). According to Ted Henken (2008), "Cuba's unique brand of irreverent mockery or satire, intended to undercut and question authority, *choteo* is deeply ingrained in Cuban culture and has only been nurtured by what many see as illegitimate revolutionary authority" (455). It is not difficult to see how one may align *choteo* with glitch art, in a sense bringing this time-honoured Cuban irreverence up to date with new media tools, engaging in what I call "glitch *choteo*." A broader category could be called "technological *choteo*," and a well-documented precursor artwork that captures this practice is Lázaro Saavedra's (1964–) piece *Detector de ideologías* (1989) (Ideology detector). Saavedra created a device to look like a medical apparatus, like a blood pressure gauge or an EKG monitor. When the user activates the device, a needle moves and points to a scale that supposedly determines that individual's ideological status, ranging from "unproblematic" to "problematic," "counterrevolutionary" to "ideologically diversionist." Given the widespread use of surveillance by the Cuban state, Saavedra's device is obviously tapping into subversive *choteo* to obliquely criticize serious concerns related to state vigilance, ideological control, political indoctrination, and so on. In another provocative

piece of techno or glitch *choteo* titled *Software cubano* (2012), Saavedra painted a large canvas depicting a decision tree algorithm (a flow chart), appropriating both the language and syntax of code to present a series of binary decisions and paths that guide the "user" away from or toward accepted political doctrine, and demonstrate the limited paths of political thought and dissent on the island. As part of the same display, there are also several items that activate *choteo*, including an out-dated first-generation Nokia cellphone taped to the official government newspaper and voice of the Communist Party of Cuba, *Granma*, and labelled with the ironic text "cell phone with Internet access." The irony here is not only a commentary on technological lack (internet-enabled phones are not available, and neither is web accessibility), but also a critique of the content available if such access were possible (i.e., the official propaganda of the state). Saavedra, like Cabrera and others, uses humour as a way to disarm charges of "counterrevolutionary art" and also to connect with the widespread attitude of *choteo* among the Cuban citizenry. Musing about the effectiveness of *choteo*, Cabrera writes, "de ahí que se trate de una forma de resistencia ciudadana y a la vez una falta de confianza en los beneficios de las jerarquías sociales. Es precisamente en este punto, donde el choteo se vuelve sumamente efectivo como detonante de significados" (Cabrera 2017a; it is a form of citizen resistance and also a lack of confidence in the benefits of social hierarchies. This is precisely the point where *choteo* becomes extremely effective as a detonating mechanism for meaning(s)).

In Cabrera's video installation *Cuba_20170127*, we can see the artist's approach to glitch *choteo* in action. The installation piece was exhibited in March 2017 at two separate venues (the Norwegian Embassy and the gallery Estudio Figueroa-Vives) as part of the *GlitchMix, not an error* show in Havana. Miami-born net artist Mark Amerika, who also participated with several digital works, curated the exhibition. The show included works by three visual artists (Mark Amerika, Fidel García, and Cabrera) as well as a glitch music performance. The publicity poster for the exhibition is itself a piece of glitch art, with a decidedly retro appearance (figure 5.4). The all-caps blocky bitmap black letters indicating the title are an echo of old-school technology from the early 1980s – 8-bit computers like the Commodore 64 or the Apple II, and video game consoles like the Atari 2600 – when displays had few pixels, ROM memory was scant, and processors were painfully slow and could not keep up with the actual speed of code, resulting in frequent image and sound glitches. While part of the aesthetic has to do with everything old having become new again, in the case of Cuban glitch art, it is also a direct reference to a "natural" retro state, a degree

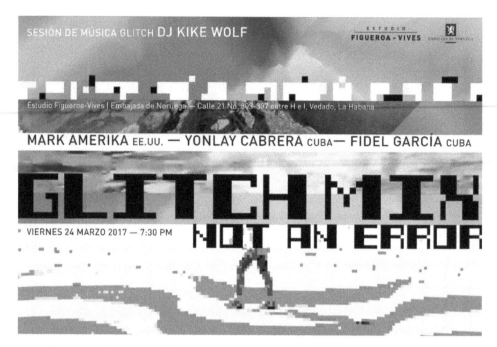

Figure 5.4. Poster for Glitch Art exhibition in Havana: GlitchMix, not an error (screen capture). Image courtesy of Estudio Figueroa-Vives, La Habana. Design © Lily Díaz.

of technological backwardness that is both embraced aesthetically and deployed as critique.

The visual appearance of the poster also aligns with the fundamental aesthetic of glitch as "fragmentation, replication/repetition, and linearity," as well as "repetitive abstract patterns [that] contain recognizable elements becoming increasingly abstract" (Betancourt 2017, 32). This move from the figurative-recognizable toward the abstract-ambiguous, which in an oversimplified sense parallels a similar shift in Cuban art since the revolution, is also evident in Cabrera's video installation, as it takes a recorded broadcast featuring a well-known neoclassical building and deconstructs it through glitch.

The title of Cabrera's installation piece, *Cuba_20170127*, evokes computer code through both the use of the underscore and the repetitive number (20170127). The underscore was a convention in DOS, a system that could not read blank spaces in file names, so its use also connotes a retro flavour. This glitch project itself is somewhat retro in that it does

not actually rely on the internet, but rather performs its glitching operations on a recorded television signal, returning to an old medium. The installation comprised several large TV screens simultaneously playing a recorded segment of the Cuban National Television News broadcast from 27 January 2017. The broadcast was scrambled by Cabrera on the receiving end and simultaneously recorded. At the installation, each of the screens played a loop of the recorded scrambled broadcast. The audio and video signals from the original broadcast appeared corrupted, pixilated, and otherwise distorted. While this glitch-creating process can now be easily achieved on a computer with freely available apps such as PixelDrifter,[11] here the scrambling was attained through relatively low-tech means, by manipulating the home decoding device that received the high-definition digital television signal – in a sense, destroying or defacing the "product" (the broadcast) put out by the official news service. Perhaps more to the point, by defacing the signal from the official newscast as it happened (and recording the act), rather than distorting a recorded version of the broadcast, Cabrera is actually tampering with the government's emission, making it an act bordering on sabotage (granted, the only signal he defaced was the one in his own television set). As the state-run propaganda is dismantled and made less recognizable, the broadcast begins to resemble (become) a work of abstract art, the drab background transforming into an explosion of bright and rapidly shifting colours.

This kind of low-tech solution for creating glitch echoes both the famed Cuban inventiveness in the face of scarcity, and the black-market approach to technology. Yudith Vargas (2017) points this out in her review of the exhibition, not without some *choteo* of her own: "una vez más resurge la inventiva humana – léase cubana – y en vez de pan, casabe: en vez de iphone7, Alcatel; en vez de monitor de pantalla plana de última tecnología, ATEC-Haier" (Once again human (read Cuban) inventiveness resurges and instead of bread, cassava: instead of iPhone7, Alcatel; instead of the latest model flat-screen monitor, ATEC-Haier). *Casabe* (cassava), made from yucca, was a key substitute for bread made from wheat flour for the Spaniards who arrived in the Caribbean region, giving rise to the saying "A falta de pan, casabe" (In the absence of bread, cassava). But if that saying seems to imply that one should accept with resignation the reality one is living in, Cabrera and other artists prefer to expose and protest that reality through acts of subversive glitch. Cabrera may be forced by economic conditions to use the lower-quality Chinese Haier flat screens – a company accused of installing malware in its cell-phones prior to selling them in Europe and elsewhere – but the broadcast from the Cuban official news will

Figure 5.5. A still from Yonlay Cabrera's Cuba_20170127 (Video installation, 2017). Scrambling Cuban National TV (screen capture). © *Yonlay Cabrera 2017, source: yonlaycabrera.com/en/selection.*

not remain unchallenged or unscathed, as the force of avant-garde abstraction (in the form of uncontrolled glitch) gradually consumes the official HD television broadcast. So much for the form and format of the aggression against official channels of communication, but what about questioning the content of such a broadcast, and how is that opposition, if it exists, carried out in *Cuba_20170127*?

A closer reading of one of the frames (figure 5.5) taken from the broadcast sheds additional light on Cabrera's subversive glitching. The image is a pixelated frame from Cabrera's (appropriated) footage, depicting the main entrance and steps of the University of Havana's Aula Magna at the top of the Colina Universitaria (University Hill), in the Vedado district. The source newscast covered an official event to commemorate Julio Antonio Mella, a student hero associated with the (virile) patriotic values of the revolution. In the upper right section of the image capture, we can see the banner that reproduces an emblematic photograph and noble profile of this heroic figure, presented with an epic aesthetic that would later encapsulate the concept of the Socialist New Man as

a model to be followed by all good socialist youth. Renowned photographer and fellow Marxist Tina Modotti took Mella's photo while both lived in Mexico in the 1920s. Mella was one of the founders of the Cuban Communist Party and of the Federación Estudiantil Universitaria (FEU, University Student Federation), as well as a University of Havana law student who was expelled during the Machado regime for his leftist and anti-machadist political views. He was assassinated in 1929 while exiled in Mexico, most likely by order of Machado, although the crime remains unsolved. The January 2017 newscast defaced by Cabrera covered an officially sanctioned and student-organized political rally to render homage to Mella on the eighty-ninth anniversary of his death. By pixelating the video signal of this broadcast, Cabrera is desacralizing a hero and icon of the Cuban Revolution, as well as questioning the institutional authority of his own alma mater, the University of Havana, and the subservient ties of the FEU student union to the regime. But if the glitch is, on the one hand, a realist depiction of digital failure (triggered deliberately), it is, on the other hand, a visual rejection of a broadcast that purports to present a certain transparent and unmediated "reality" (the reality of patriotic values, and a cult to the heroic revolutionary figure). Glitch, as abstraction, challenges realism, and glitch also foregrounds the materiality of the medium, the HDTV signal that is emitted and controlled by government programmers and technicians and carries within its apparent transparency the official discourse of the nation, mediating any possible understanding of reality.

Undoubtedly, Cabrera has quite deliberately selected the subject-artefact to be glitched. The setting of the video is fundamental to the message. The monumental front steps of the University of Havana are laden with symbolism in the revolutionary imaginary. The entrance to the university is a site where past generations of students protested against the successive dictatorships of Machado and Batista, in contrast with the current FEU's unquestioning alignment with the ruling Communist Party. The location and its televised image fulfil similar functions to the *lieux de mémoire*, which, as Pierre Nora (1996) theorized, are spaces "at once natural and artificial, simple and ambiguous, concrete and abstract, they are *lieux* – places, sites, causes – in three senses: material, symbolic and functional" (14; emphasis in original). The steps and surrounding neoclassical buildings are places for official acts celebrating national heroes such as José Martí, Mella, and other figures adopted by socialism as models for successive generations – exemplified, in 2017, by a tribute to Fidel Castro held on the first anniversary of his death. Cabrera manipulates the broadcast and, as seen in this frame, triggers a glitch effect that scrambles the area of the steps where

participants are congregated and eventually spreads to cover most of the screen. Multicoloured rectangular shapes, jagged edges, and other visual distortion effects resulting from macroblocking, signal interruption, and decay gradually obscure the broadcast. The audio is similarly plagued by sound lag and random noise disturbances. In effect, by destroying the signal, Cabrera seeks to rewrite, or at least reframe, the political and cultural narratives associated with the grand steps and, more generally, the (failed) grand narratives they represent.

Although the repurposing of the national TV broadcast may recall Mendoza's anti-copyright attitude and his embrace of appropriation and remix, *Cuba_20170127* arguably takes critique in a different direction than a rejection of copyright issues (a complex question in Cuba, where copyright was abolished after the triumph of the revolution, with dismal consequences for artists, and was ultimately reintroduced). Ridiculing the symbolic language and the political content of the official broadcast, Cabrera's glitch *choteo* disarticulates the glorious and epic history of the revolution and replaces it with a narrative of muted dissent, one that relies on and exposes a certain technical "backwardness," the precariousness of signals, and ultimately, the complete disconnect (*desconexión*) between much of the younger generation and the official posture represented by National Television broadcasts. It also exposes a certain aesthetic anachronism that is enacted by Cabrera's referencing of early computing technologies (HTML, early web aesthetics, outdated hardware) used, in a sense, to overwrite pre-internet media (television, radio, newspapers). Cabrera, no doubt, seeks to undermine and disturb the official discourse exemplified by these newscasts and other news sources. While he may not be questioning the revolution as a whole, he foregrounds the patent contradictions between the heroic models proposed by the revolution – often symptomatic of cult of personality, inflexible orthodoxy, unimaginative discourse, tired and patently false rhetoric, blind obedience to the system, glorification of death – and the painful reality of daily life in Cuba. Political events commemorating socialist heroes are frequently present both on television and in print media, and they often employ a grandiose and inflated rhetoric, as can be seen in an unctuously laudatory text about Mella disseminated by the official Cuban News Agency for the same event:

> Mucho habrá siempre que aprender de tan formidable joven, muerto con solo 25 años, y de quien Fidel dijo que nadie más hizo tanto en tan poco tiempo, y esas últimas palabras suyas: "¡Muero por la Revolución!", han de guiarnos, generación tras generación, en el empeño de preservar y continuar la obra de millones. (Álvarez Pomce 2018)

(Much remains to be learned from such a formidable young man, dead at the young age of 25, of whom Fidel said that no one did so much in so little time, and those last words he uttered, "I die for the Revolution!", should guide us, generation after generation, in the effort to preserve and continue the work of millions.)

Patently, Cabrera associates these reified political narratives with a similarly stultified idea of art that bears little relevance for his generation and makes manifest again the level of *desconexión*, asserting that, "los políticos no han logrado evolucionar al ritmo de la práctica artística. El arte contemporáneo presenta sus problemáticas de una forma poco accesible para una disciplina, la política, que añora las grandes narrativas épicas producto de la pintura de caballete y la habilidad manual del artista-genio" (Cabrera 2017a; politicians have not been able to evolve at the same speed as artistic practice. Contemporary art presents issues in a way that is not accessible for a discipline (politics) that is nostalgic for the grand epic narratives once produced by easel painting and by the manual skills of the artist-genius). But while epic revolutionary art is no longer possible, it is also difficult to achieve an avant-garde art free from commercialism and corporate influence. Thus, if we consider both Mendoza and Cabrera's art (despite significant contextual differences), one can uncover a critical attitude toward the mechanisms and institutions of the art world and the political arena, but also a willingness to turn those mechanisms against the very same institutions (whether the US government, the World Wide Web, Cuban universities, museums, and broadcast television, even the Cuban Communist Party). At the same time, there is a willingness to place their artworks in an in-between and somewhat contradictory position – in between genuine independent critique and commercialism, kitsch and avant-garde, retro and cutting edge, centre and periphery, Cuban and other.

Despite its "contamination" by commercialism, Cuban art has opened up avenues for social discussion and even dissent within Cuba, in part by engaging with new media and other digital and technological tools, although these are often low-tech and retro in nature. Taking both the technological precariousness and lack of broadband access, as well as the prevalence of state surveillance as inspiration, artists such as Cabrera work to undermine the smooth functioning of signals. With *Cuba_20170127*, Cabrera "scrambles" the signal put out by the Cuban Communist Party's political apparatus – National TV, the Cuban news agency, official and public ceremonies at the University of Havana – as the very title of his work indicates, since the second half (0127) of the number sequence "20170127," in addition to

indicating the date of the broadcast as 27 January, is also a scrambled version of the first four numbers (2017), representing the year. In 2017, Cuban official signals are being scrambled, glitched, and undermined, as *choteo* becomes one possible answer to the status quo by a frustrated generation of young artists.

I am not claiming that net artists pioneered or invented this sort of attack on Cuban institutions. The anti-system message transmitted (or scrambled) in this example has many antecedents in Cuban art since at least the 1970s. Opposition has often been a feature of Cuban artwork and has been tolerated by the system as a sign of openness, to a point. As with Cabrera's installation, such artistic resistance is often double-edged, against the political system itself and against the grandiose artistic forms it traditionally endorsed (epic totalitarian art, socialist realism, monumental art, even some forms of depoliticized non-figurative art). In his analysis of Cuban contemporary art since the 1970s, Pablo Alonso González describes this tendency toward articulating resistance through art that rejects the monumental. For him, this anti-monumentality was a struggle that was played out in the public sphere, precisely in places like the grand steps of the University of Havana:

> The hidden transcript of artistic resistance in Cuba was made manifest in the public sphere and recognized by the public, albeit in a veiled form that submerged political resistance under an artistic claim for abstract expression, as opposed to socialist realism. Artists attempted to put forward a different monumental aesthetic, and also another politics. It has been commonly argued that Cuban art was largely free in terms of form but limited in different ways concerning content. In the area of public monuments, I will argue this was not possible because these were considered key representational devices for the exercise of power, and their control was deemed fundamental to building legitimacy. As monuments are not private but public artworks, and because of their intrinsic relationship with history, politics, memory and identity, they are often subject to contestation and political negotiation. (Alonso 2016, 272)

Disarticulating the monumental through his glitch *choteo*, Cabrera embarks on a contemporary art practice that is representative of much Cuban art in the new millennium. It is also the case that the new contemporary art (net and otherwise) is not strictly concerned with pure motives, and a dose of self-interest is almost always at work. According to art critic Felix Suazo, this new anti-establishment aesthetics plays a dual game, simultaneously offering a posture of resistance while seeking increased marketability in foreign circuits:

Between its questioning of ethics and the pragmatism of the market, Cuban art of the new millennium has been characterized by its confrontation of the limits of political control on the island. It has in part assumed this circumstance as a stamp, a brand or "designation of origin" that is quite appetizing to foreign demand, and in part it has taken advantage of controversial themes relative to the informative restrictions and the ideological contradictions of the revolutionary government in order to position a critical perspective of the national reality. (Suazo 2018)

As Suazo explains, although the government may tolerate some expressions of critique as a way to demonstrate the magnanimity of the revolution and its capacity to accommodate dissent, there have been plenty of cases of censorship for "irreverent use of revolutionary iconography," including the closing of exhibitions and, in some cases, even the imprisonment (if brief) of artists, as was the case with Ángel Delgado, jailed after conducting a performance that involved defecating on the state-sponsored newspaper *Granma*. Admittedly, other artists reject the notion that all Cuban art must carry a strong political subtext, striking for a greater degree of aesthetic autonomy. That said, Cabrera's glitch artwork, at the very least seeks to explore some of the controversial aspects of socialism today, as well as questions of materiality and medium, even as the artist also takes into consideration the ebbs and flows of the art market and the possibilities for international projection of a seemingly "oppositional" art.

To conclude our look at *Cuba_20170127* by returning to glitch art from a more material standpoint, it could be argued that, just as glitch interrupts "the aura of the digital's illusion of perfection" (Betancourt 2017, 103), the use of broken and non-functional technology becomes political in Cabrera's work as it interrupts the illusionary and totalizing discourse that posits the revolution as a path toward attainable socialist perfection. In terms of materiality, glitch, for Michael Betancourt, is opposed to a (seamless) digital singularity, "one that is both normative and standard, where any deviation from that norm necessarily carries a political charge" (2017, 103).[12] But for this political charge to be activated, he argues, one needs an active and discerning audience, otherwise the glitch becomes a mere technological failure (devoid of political content), so that "critical interpretations depend on the precise context of a glitch's generation/use. The stoppage results from a violation of established (anticipated) structures within the work – an unanticipated variance from the audience's expectations: the necessary factor in this process is an actively engaged audience that is challenging the work as it proceeds and whose violated

expectations produce the glitch" (103). In the Cuban context, that glitch can be read as either/or/and technical failure and deliberate intervention, depending on the circumstances surrounding the glitch itself, and, at times, the intentionality of the glitch will remain ambiguous, providing a certain "cover" for the artists as they push the political envelope. Whether exploiting or causing errors in source code, circuit bending the machines themselves, or, in Cabrera's case, intentionally disrupting television signals, these efforts seek to challenge technological standardization and determinism, as well as the kind of homogenizing ideological standardization carried by the broadcast's officialist message.

## A Final Look at Glitch

The deliberate pursuit by these two Cuban/Cuban-American artists of the glitch reflects a contemporary condition in which we are increasingly controlled by rigid codes and computer scripts, but into which indeterminacy, errors, viruses, and hacks are seen as injecting a potential for resistance, introducing an element of the human into software. As our societies become more automated and data-centric, and technology begins to colonize every aspect of our daily lives, glitch becomes a kind of response, as an attempt to escape the determinacy and dependency of hardware and software. Glitch, in that sense, provides a kind of hope. Refreshingly ambiguous, the glitch might, on the one hand, leverage coding against the encroachment of increasingly dehumanizing web capitalism, while, on the other, it may spur paranoia about systemic failures and digital Armageddon.

Unfortunately, glitch can also become co-opted, commoditized, repetitive, and even predictable, as media theorist and glitch practitioner Rosa Menkman explains in relation to the technique of datamoshing, a specific glitching process for video files that became ubiquitous in music videos in the mid- to late 2000s. According to Menkman (2011), in the first instance of an artist using the technique in a show that "was intended to critique popular culture by way of datamosh interventions, this culture caught up with [the artist] overnight, when the effect penetrated the mainstream just prior to the opening of his show" (54). In that particular case, the language of this type of glitch art, which was meant to undermine the repetitive and sometimes superficial nature of mass culture itself, was rendered toothless, as it became just one more instance of that same mainstream referent. Glitch can be rendered ineffective as a form of critique, not only by virtue of becoming mainstream and losing its avant-garde political

edge, but also through the danger of relying strictly on surface effects and aesthetic design, or of producing glitches uncritically and with proprietary software.

[Such] conservative glitch art puts an emphasis on design and end products, rather than on the post-procedural and political breaking of flows. There is an obvious critique here: to design a glitch means to domesticate it. When the glitch becomes domesticated into a desired process, controlled by a tool, or technology – essentially cultivated – it has lost the radical basis of its enchantment and becomes predictable. It is no longer a break from a flow within a technology, but instead a form of craft. For many critical artists, it is considered no longer a glitch, but a filter that consists of a preset and/or a default: what was once a glitch is now a new commodity. (Menkman 2011, 55)

While Menkman considers glitch as a kind of genre that has the capacity to evolve over time, adapt to different situations, and range anywhere from commercial to subversive, depending on specific circumstances, it is difficult to envision how such an evolution may take place in Cuba. There is an uncanny parallel between the oscillating movement in glitch – as a cutting-edge form of art that is *also* a sign of faulty technology and obsolescence – when compared with the political situation on the island, with a regime that also oscillates between the (remains) of progressive and utopian ideals, and the decay and detritus of daily life, attempting to move forward while staring at the ruins of the past. It is a parallel that reinforces the disconnect felt by the current generation of artists (trapped between a future that does not arrive, or arrives late, and a past that never quite recedes), although this painful sense of disconnection may also prove to be a key or "breach" used to foster real political dialogue in Cuba. If a critical message can be rescued from glitch art going forward, perhaps something can also be rescued from Cuba's own failed social project.

The work of Mendoza and Cabrera also shows that, despite certain commonalities and a shared cultural background, the specific contexts of life in the United States and Cuba spur very different uses and interpretations of glitch. Some of the commonalities seem anchored in the capacity of glitch to disrupt a kind of illusion of "perfection," whether we are speaking of the seamlessness of capitalist commodities and the rule of corporations in the United States, or the attempt to maintain the illusion of socialist utopia in contemporary Cuba. In that sense, both artists seek to expose the false transparency and hyperreality of contemporary media – in one case, to shatter the slavish complacency

driven by the market logic; in the other, to expose the manipulated fictions undergirded by totalitarian state narratives. There is a shared tendency toward (dark) humour and cynicism, as well as a suspicion of authority, on the part of both artists, and, perhaps, slightly different versions of *choteo* at work. Based on these commonalities and shared cultural background, we might even hope for a greater degree of cooperation between artists who, like Mendoza, work in the United States, and those who, like Cabrera, remain on the island, perhaps to effect what Thea Pitman (2019) has optimistically described as an incipient community of activist bloggers who are working toward "the creation of an online/offline network of civil society actors – Cubans living on the Caribbean island, those in the diaspora, and other sympathizers across the world – to protect those most outspoken in their demands for substantive change in Cuban politics" (146).

There are, naturally, significant differences at the level of technique and technology between these artists. For example, although both artists manipulate cultural and political iconography, Mendoza has unrestricted access to the web and relative freedom of action. Cabrera has to settle for limited access and low-tech solutions, which he nevertheless turns to a strategic advantage in a time-honoured Cuban (but more broadly, Latin American) tradition of making do. Irrespective of access, both artists believe that computers and technology may lead to greater freedom, as the tools of image creation and manipulation reach everyone's hands, arguably democratizing them. This latter point seems a bit naïve in the age when referentiality to external truth has become endangered, but nonetheless, glitch can perhaps be redeemed. Glitch artists like Mendoza and Cabrera, according to Ted Gournelos (2010), alter the public sphere through noise, "not to destroy it but to accentuate existing (internal) counternarratives. In other words, they productively disrupt the system in order to accentuate its fallibility," ultimately shifting the balance of power in favour of a fairer system (152).

There is one marked difference between these artists that, beyond any theoretical considerations, has serious repercussions at the level of *lived* consequences. Whereas Mendoza can afford to "play" at criminality and stop just shy of breaking the law and committing acts of actual internet piracy, Cabrera is risking much more by deliberately tampering with official Cuban TV newscasts, even while he stands to gain the recognition of Western art markets, which so fetishize the art of Cuban political subversion. This contrast depressingly demonstrates what was already evident: that capitalist circuits can usually appropriate oppositional political-aesthetic practices (such as glitch art) for market interests. We have yet to find an appropriate glitch for that insidiously

vicious outcome. Perhaps that commodification of glitch, or even its impending obsolescence as it goes mainstream, is responsible for Mendoza's own disappearance from net art, having either gone deeper into the more obscure corners of the web or disconnected himself altogether from net art circuits.

NOTES

1 Programming can be messy – even "leaky." For instance, a leaky abstraction in software programming is one in which a system that usually abstracts away complexity allows for those inner layers to be seen. Intentional leakiness means that a program is designed to provide an external, higher level of functionality, but still allows access to traditionally hidden levels of code (either to the higher-order programming language, to the underlying binary code, or to other hidden layers). No doubt, all networks, algorithms, and code(s) are, on some level, at least partly unreliable. On a more sinister point, "leaks" can also be captured by control mechanisms, and agencies such as the National Security Agency in the United States or their counterparts in other countries have long been known to "collect" the data that "leaks" from our computers, cellphones, and other devices, as we partake, willingly or not, in a kind of collaborative self-surveillance (van der Velden 2015, 182–4).

2 Although one of these artists, Mendoza, whose family migrated from their country of origin, Cuba, lives a hyphenated identity, he retains cultural and social links to a marginal positionality as an artist, coder, and programmer whose work pushes against the material and political limits of "proper" coding. It is instructive, however, to study both the similarities in the work of the Cuban-American glitch artist (Mendoza) and his Cuban counterpart (Cabrera), but also the significant differences in context, subject matter, and technical approach to glitch art.

3 Mendoza's itinerant life and his heterogeneous ethnic and national identity – as a mix of Miami Cuban, Spaniard, and American – push against standard definitions of what constitutes Latin American or US Latino, highlighting the complexity of outdated concepts of the national in our transnational reality. That is not to say that Mendoza has not retained traces of *cubanidad* and ties to the island. But his work does not (overtly) court signs or markers of his family's Cuban origins, reaffirming Isabel Álvarez Borland and Lynette Bosch's assertion that "there is no one true marker of *lo cubano* or *lo cubano-americano* … In transforming themselves, Cuban-Americans effect change in mainstream American culture as they become part of its life and its institutions" (2009, 4). Mendoza's understanding of mainstream US culture is complete, as evidenced by the facility with which he manipulates

American imagery and US cultural and political iconography in his internet art, doing so in highly irreverent ways.

4  Not to be confused with the Cuban-American photographer Tony Mendoza, who was born in Havana and moved to Miami in 1960, escaping the revolution.

5  Browser art is a subgenre of net art that dismantles links between webpages, opens pages indiscriminately, and generally takes over the user's browser in real or simulated ways. Glitch art, while not exclusive to the internet, elevates digital errors and glitches to an art form for aesthetic and/or political purposes.

6  There are too many Cuban-American artists to mention here, but, among them, one could consider the work of painters such as Alberto Rey, Luis Cruz Azaceta, or Rafael López Ramos, and, still in Cuba, visual artist Esterio Segura, performance artist Tania Bruguera (recently released from jail by the Cuban authorities, where she was serving a sentence because of her oppositional artwork), visual artist and sculptor Luis Manuel Otero Alcántara, and others.

7  It is unclear as to why Mendoza no longer has an active Web presence, and all efforts on the part of this author to contact him have been unsuccessful. We can only assume he continues creating art offline, although I could not find any record of recent gallery exhibitions either.

8  "Snippet description" is the text displayed beneath the website name and URL in a Google search listing.

9  All translations in this chapter are my own.

10 Current president Miguel Díaz-Canel has stated that access will be improved, and clear steps have been taken to provide access to mobile phones through ETECSA, the state-owned telecommunications company, as of December 2018.

11 For more information about PixelDrifter, read Margaret Rhodes' article "This Glitch Art Is Made of Pixels Powered by Their Own AI" (2014). Although PixelDrifter is no longer supported software, it can still be downloaded at https://pixeldrifter.tumblr.com/.

12 Betancourt is both a practitioner and theorist of glitch art, and his *Glitch Art in Theory and Practice: Critical Failures and Post-Digital Aesthetics* (2017) is one of the few monographs on the subject. Betancourt's text offers a solid critique of digital capitalism and explores the critical uses of glitch art.

REFERENCES

Alonso González, Pablo. 2016. "Monumental Art and Hidden Transcripts of Resistance in Revolutionary Cuba, 1970–1990." *Journal of Latin American Cultural Studies* 25.2: 271–96.

Altunaga, Rewell. 2013. "Interview: Rewell Altunaga and the Cuban Game Art Scene." By Mathias Jansson. *Gamescenes: Art in the Age of Videogames*, 11 July. www.gamescenes.org/2013/07/rewellaltunagacubangameart.html.

Álvarez Borland, Isabel, and Lynette M.F. Bosch. 2009. "Introduction." In *Cuban-American Literature and Art: Negotiating Identities*, edited by Álvarez Borland and Bosch, 1–14. SUNY Press.

Álvarez Ponce, Maria Elena. 2018. "Homenaje del estudiantado y los jóvenes cubanos a Julio Antonio Mella." Tiempo21.cu, 9 January. www.tiempo21.cu/2018/01/09/homenaje-del-estudiantado-los-jovenes-cubanos-julio-antonio-mella/.

Betancourt, Michael. 2017. *Glitch Art in Theory and Practice: Critical Failures and Post-Digital Aesthetics*. Routledge.

Cabrera, Yonlay. 2015. "Cómo tomar a la institución por la fuerza." Art on Cuba, 1 July. artoncuba.com/blog-es/como-tomar-a-la-institucion-por-la-fuerza/.

– 2017a. "Los resquicios entre creación y política en la obra de Levi Orta." *C de Cuba Art Magazine*, no. 23. cdecuba.org/levi-orta/.

– 2017b. "Semblanza personal." *C de Cuba Art Magazine*, no. 22. cdecuba.org/yonlay-cabrera/.

Chacón, Hilda. 2019. "Introduction." In *Online Activism in Latin America*, edited by Hilda Chacón, 1–30. Routledge.

Gournelos, Ted. 2011. "Disrupting the Public Sphere: Mediated Noise and Oppositional Politics." In *Error, Glitch, Noise and Jam in New Media Cultures*, edited by Mark Nunes, 151–67. Continuum.

Granados, Omar. 2019. "*Voces Cubanas*: Cyberactivism, Civic Engagement, and the Making of *Cubanía* in Contemporary Cuba." In *Online Activism in Latin America*, edited by Hilda Chacón, 175–88. Routledge.

Henken, Ted. 2008. *Cuba: A Global Studies Handbook*. ABC CLIO.

"Interview with Sabato Visconti." 2014. *Periphery Magazine*, December. www.theperipherymag.com/interview-sabato-visconti/.

Krapp, Peter. 2011. *Noise Channels: Glitch and Error in Digital Culture*. University of Minnesota Press.

Latin American Internet Usage Statistics. 2019. Internet World Stats. www.internetworldstats.com/stats10.htm.

Ledesma, Eduardo. 2015. "The Poetics and Politics of Computer Code in Latin America: Codework, Code Art, and Live Coding." *Revista de estudios hispánicos* 39.1: 91–120.

Liu, Alan. 2004. *The Laws of Cool: Knowledge Work and the Culture of Information*. University of Chicago Press.

Mañach y Robato, Jorge. 2009. *Indagación del choteo (Pensamiento)*. Lingkua.

Mendoza, Antonio. n.d. *Mayhem.net*. http://www.mayhem.net/.

– 1994. "Image Pirate: An Interview with Antonio Mendoza." By Steev Hise. *Synergy* 4 (Fall). www.detritus.net/archive/texts/synergy/mendoza.html.

Menkman, Rosa. 2011. *Network Notebook #04: The Glitch Moment(um)*. Institute of Network Cultures.

Nora, Pierre. 1996. "General Introduction: Between Memory and History." In *Realms of Memory: The Construction of the French Past*, vol. 1, edited by Pierre Nora and Lawrence D. Kritzman, 1–21. Translated by Arthur Goldhammer. Columbia University Press.

Nunes, Mark. 2010. "Error, Noise and Potential: The Outside of Purpose." In *Error, Glitch, Noise and Jam in New Media Cultures*, edited by Mark Nunes, 3–26. Continuum.

O'Reilly Herrera, Andrea. 2016. *Cuban Artists Across the Diaspora: Setting the Tent Against the House*. University of Texas Press.

Pitman, Thea. 2019. "Revolución.com? Resemanticizing the Discourse of Revolution in Yoani Sánchez's *Generación Y* Blog." In *Online Activism in Latin America*, edited by Hilda Chacón, 139–50. Routledge.

Raley, Rita. 2009. *Tactical Media*. University of Minnesota Press.

Rhodes, Margaret. 2014. "This Glitch Art Is Made of Pixels Powered by Their Own AI." *Wired Magazine*, 7 August. www.wired.com/2014/08/this -glitch-art-is-made-of-pixels-powered-by-their-own-ai/.

Suazo, Felix. 2018. "Art and Politics in Cuba in the New Millennium: A Brief Review." *Colección Cisneros: Art and Ideas from Latin America*, 16 February. www.coleccioncisneros.org/editorial/cite-site-sights/art-and-politics -cuba-new-millennium#_ftn1.

Van der Velden, Lonneke. 2015. "Leaky Apps and Data Shots: Technologies of Leakage and Insertion in NSA-Surveillance." *Surveillance and Scoiety* 13.2: 182–96.

Vargas Riverón, Yudith. 2017. "El arte del error: vivir para ver." Cachivache Media: Tecnología, Cultura, Sociedad, 14 April. cachivachemedia.com /el-arte-del-error-para-vivir-glitch-art-cuba-8a198b6030f.

Weiss, Rachel. 2011. *To and from Utopia in the New Cuban Art*. University of Minnesota Press.

Woodard, Josef. 1996. "Paintings and Photos Emphasize the Erotic at Studio City Gallery." *Los Angeles Times*, 29 August. articles.latimes.com/1996 -08-29/entertainment/ca-38562_1_nude-figures.

# 6 The Poetics and Politics of Code: An Analysis Based on Chilean Digital Literature

CAROLINA GAINZA CORTÉS

In *La novela luminosa* (2014), Uruguayan writer Mario Levrero reflects on his use of computers: "El lenguaje de programación parece ser, según me di cuenta hace ya cierto tiempo, una transición necesaria entre un estado digamos de dependencia, hacia otro de mayor libertad mental. En la programación hay un buen margen de creatividad" (47; A programming language seems to be, as I realized some time ago, a necessary transition between a state of what we could call dependence to another of greater mental liberty. In programming there is a generous margin of creativity). There is no doubt that computing obeys a language: *code*, the written scripts that represent numerical operations activated upon their execution. However, within literature, the arts, and the humanities more generally, there has been little reflection on the characteristics of programming languages and how they affect us as readers. In his comment, Levrero refers to a "margin of creativity" present in programming languages, a premise that relies on us, the users, to liberate ourselves from a state of dependence on the code itself. I propose that such liberation has to do with becoming conscious of the status and characteristics of digital language, as only then can users work with and manipulate said language. In this chapter, I examine digital literature as a source of this consciousness, with its potential for intervention that derives from literature's appropriation of the properties of a programming language. Furthermore, this chapter argues that digital literature makes us, the readers, newly conscious of our role in the development and execution of digital works, and thus of the particularities of code: this constitutes an aesthetic experience which I have termed the "digital aesthetic."

"Digital literature" can be defined as that which is created to be read in an electronic format, and whose existence is sustained, at least in part, through the use of a programming language.[1] Such works possess

certain features – hypertextuality, movement, multimediality – that make it practically impossible to translate digital literature "back" into print. This definition follows that of Katherine Hayles (2008), who writes: "Electronic literature, typically considered to exclude print literature that has been digitalized, is by contrast 'digitally born,' a first-generation digital object created on a computer and (usually) meant to be read on a computer" (3). However, I find it necessary to clarify the difference between digital literature and electronic literature. To that effect, Claudia Kozak (2012) has argued that "se habla hasta hoy de ciberliteratura, literatura digital o de manera más amplia de literatura electrónica casi como sinónimos aunque no lo sean en sentido estricto" (31; up to this point, we have discussed cyberliterature, digital literature, or electronic literature more broadly almost as if they are synonyms, even though they do not necessarily mean the same thing). Throughout this chapter, I use the term "digital literature" to refer to works that experiment with digital language – that is, with the code of computer programming. "Electronic literature," on the other hand, encompasses digital literature and also includes experimentation with non-digital technologies. I consider "digital literature" to be a more appropriate term for what Hayles called "digitally born" literatures, a syntactic choice that also aligns with the conceptual discussion of these subjects in Latin America.

In light of the aforementioned characteristics, I propose that digital literature produces an aesthetic experience characterized by forms of perception that in turn reflect the role of programming languages. This digital aesthetic, as I have proposed in earlier work (Gainza 2016), must be understood in relation to two primary characteristics of digital literature: hypertextuality and cultural hacking. "Hypertextuality" refers to a web of connections between distinct textualities, both within and between works. The hypertextual experience, then, consists of a digitally mediated network of textualities in which text elements can be arranged in diverse configurations in the process of meaning-making. In earlier works, I have described the political potential of digital literature, given the possibility of manipulating digital language: a process that I call "cultural hacking" (Gainza 2016; 2017). I use that term to describe the possibility of manipulating a work through its code, which opens the door for remixing, rewriting, appropriation, and sampling, among other creative practices. These two characteristics generate an aesthetic experience principally anchored in the user's ability to intervene in the works. Such a potential for user intervention ranges from partaking in an interactive experience to the ability to intervene directly in the work's development. In this way, the aesthetic joy (following

Barthes)[2] moves from the act of contemplation and interpretation of a work toward the areas of participation and intervention. Regarding the latter, digital literature instils the user with a desire to intervene in the work, as they become conscious of the inherent potential of code. This consciousness may constitute a step toward the "greater mental liberty" that Levrero (2014, 47) referred to in his work – a liberty that I interpret as a greater awareness of the potential of digital language.

I will begin by examining the nature of digital language itself. This question first emerged in my study of a compilation of Chilean digital texts and extends to the present investigation of Latin American digital literature. In this chapter, I analyse two works of digital poetry by Chilean authors: *A veces cubierto por las aguas* (Sometimes covered by the waters) by Carlos Cociña and "Poema del Terremoto" (Earthquake poem) by Gregorio Fontén. Both works use digital language in different forms – hypertextual poetry programmed in PHP in the former and interactive poetry programmed in HTML in the latter. Both works utilize this language to experiment with writing that surpasses the limits imposed by alphabetic text and the print medium, both traditional elements of modern literature.

## Code, Aesthetics, and Poetics in Chilean Digital Literature

The area of critical code studies has emerged as a field of scholarly investigation, led by Rita Raley, Mark Marino, and Lev Manovich in North America. Mark Marino argues that this area of study emerged in 2006, "as a set of methodologies that sought to apply humanities-style hermeneutics to the interpretation of the extra-functional significance of computer source code" (2013, 283). Critical code studies is most often situated within the theoretical context of cultural studies, a favourable environment for a transdisciplinary approach to the phenomena of digital culture, and one that offers an analysis of code that "engages the code as an artifact contextualized in a material and social history" (Marino, 2013, 283). In Latin America, however, this topic has received relatively little attention. This may be attributed, at least in part, to the alternative pathways that literary experimentation with the digital has taken in the region, as Kozak (2012) discusses:

La novela hipertextual y más tarde la hipermedial por ejemplo, muy transitada en los Estados Unidos, ha tenido aquí poco desarrollo. Quizás porque no hubo acceso por este lado del planeta a ciertos programas informáticos que desde finales de los ochenta fueron las plataformas específicas que se usaron en las primeras novelas hipertextuales ... La tradición

Latinoamericana más fuerte – Con mayor presencia de la poesía elec-
trónica brasileña- sería la que se deriva de la poesía concreta en su paso
hacia una imaginación digital. (34)

(The hypertextual – and later hypermedia – novel, widely read in the
United States, has been less developed here. This might be due to a rela-
tive lack of access on this side of the planet to certain informatic programs
that have, since the end of the 1980s, been the specific platforms that were
used in the first hypertextual novels ... The stronger Latin American tra-
dition – with a larger presence of Brazilian e-poetry – would be one that
derives from analog poetry in its step toward a digital envisioning.)

As Kozak describes, the development of digital literature in Latin
American countries has been shaped by other traditions and geopoliti-
cal contexts. Furthermore, although digital literary production in the re-
gion has expanded rapidly in recent years, the genre has not received the
same level of attention as Western works and theoretical production. Gen-
erally, the field of critical code studies has focused on works that make
code highly visible, such as code poetry or code -forward artistic expres-
sions like those that Rita Raley analyses in her book *Tactical Media* (2009).
In the context of Latin America, Eduardo Ledesma (2015) has analysed
code-based poetry and art, paying attention to both the aesthetic features
of code and the political implications of its use. In this context, the study
of code is presented as a possible critique of the post-capitalist society, a
context in which code is "hidden" and reserved for those who possess
the knowledge necessary to manipulate it. In this context, experimental
uses of programming languages aim to "liberate" code from such a re-
strictive environment while spreading awareness among authors and us-
ers of code's capacity for aesthetic and political manipulation. Ledesma
finds that code-based poetry and art constitute a comparatively small area
within Latin American digital cultural production, given that their crea-
tors belong to a privileged group within Latin America that has access to
the world of programming (96). With that said, I pose a further question:
can we encounter this aesthetic and political potential within digital works
that include artistic appropriations of code but do not explicitly display a
programming language? What happens to artists or writers who traverse
the world of digital literature without prior knowledge of programming?
Are they less conscious of the "meaning" of code language? In this chap-
ter, I explore these questions through a variety of critical lenses, examining
code's status as a language in the work of Cociña and Fontén.

In a prior investigation (Gainza, 2016), we compiled seventeen works
of digital literature by Chilean authors. These are available online on

the *Cultura digital en Chile* website (www.culturadigitalchile.cl), which includes works of music and cinema in addition to literature. This site is a "map in-progress," which includes a variety of works that experiment with language and digital media, from auto-generated poetry to transmedia projects.[3] Various iterations of hypertext provide the scaffolding for these projects, offering a tool for poiesis. As digital poetics scholar Loss Pequeño Glazier (2002) notes, his goal "is to argue electronic space *as a space of poiesis*; to employ the tropes, hypertextualities, linkages, and static of the medium; to speak from the perspective of one up-to-the-elbows in the ink of this writing machine" (5). The radical nature of hypertext originates from the programming language that permits the extension of a potentially infinite network of links.

The common attribute of the works compiled for the *Cultura digital en Chile* project is their existence in a digital medium, which we might also understand as their reliance on a specific shared language. Before a digitally rendered cultural object – whether it be image, text, or video – enters the plane of human perception, a script must first be programmed and executed to generate a series of actions within the machine, only some of which are visible to our eyes. The difference between a written text and one based in code is that the former is made to be interpreted by humans, while the latter is composed of signs designed to be interpreted and executed by machines. Accordingly, the language of code unleashes an action, unremarkable save that this action encompasses a portion visible to the user and another that is often invisible, legible only to the machine. For this reason, when we access a digital literary object, we do not usually interpret the meaning of the code itself, but rather the actions triggered when the code is executed. This context gives rise to a linguistic-mechanical phenomenon of which we are generally unaware. In his analysis of videogames – themselves confluences of human and machine actions – Galloway (2006) offers an interpretation that can be extrapolated to the analysis of digital cultural objects:

> I suggest that the game critic should be concerned not only with the interpretation of linguistic signs, as in literary studies or film theory, but also with the interpretation of *polyvalent doing*. This has always been an exciting terrain for hermeneutics, albeit less well travelled, and in it one must interpret material action instead of keeping to the relatively safe haven of textual analysis. (105)

In order to connect programming languages with an aesthetic experience of digital literary phenomena, we must first evaluate the form in which code unfolds across written texts, images, animations, and

sounds. In most cases, these objects are displayed in non-linear formats. Here, the emphasis falls on the change in the materiality of writing: writing becomes performative, because digital literature is the expression of a code's execution. This execution is activated by a subject, in front of whom a series of user-interactive textualities are displayed. To understand this change in the materiality of the text, it is useful to refer to Boris Groys's analysis of the digital image:

> Una imagen digital, para ser vista, no ha de ser meramente exhibida sino escenificada, performada. Aquí es cuando la imagen comienza a funcionar de forma análoga a una pieza musical – La partitura en sí siendo la parte silenciosa. Para que la música pueda resonar, ha de ser interpretada. En consecuencia, se puede decir que la digitalización convierte a las artes visuales en un arte escénico. (2012, 16)

> (A digital image, to be seen, should not be merely exhibited but staged, performed. Here the image begins to function analogously to a piece of music, whose score, as is generally known, is not identical to the musical piece – the score itself being silent. For music to resound, it has to be performed. Thus, one can say that digitalization turns the visual arts into a performing art.)

Among the compiled works, there is a difference between texts that experiment with the medium and those that experiment with digital language itself. We can say that transmedia, intermedia, and multimedia works experiment with the medium. An example is Jorge Baradit's *Synco*, where the printed text is accompanied by online resources, which transform the novel into a multimedia work. Each of the elements of *Synco* – audio, video, and print – are in dialogue with one another, while also existing as stand-alone works. This distinguishes *Synco* from transmedia works, where a piece is constructed through each of a number of distinct media. In the projects that directly experiment with language, like those of Schopf and Fonten, or the hypertextual works mentioned in the table in the endnotes, we refer to works whose code interacts with written, oral, and visual textualities, allowing the creation of new narrative structures and poetics, as seen in digital hypertexts and hypermedia, auto-generated literature, and animated poetry. In essence, code is the language that gives life to these productions, which become ever more sophisticated and complex. With the relatively recent advent of machine learning, we encounter algorithms capable of writing poems, or even novels,[4] without human intervention.

In my interviews with authors of Chilean digital literature, some respondents noted that they perceive the existence of something *like* a language in their digital works, but that they did not know if it could be effectively *defined* as a language. However, they were nonetheless aware of a change at the level of experience. For example, Carlos Cociña (2017) noted that "No sé exactamente cuáles son los nuevos lenguajes, pero que están ahí, están, percibo que son distintos" (n.p.; I'm unsure exactly what the new languages are, but [I know] that they are there, they are, I see that they are distinct). He also perceives that this language affects the experience of readers, beyond the computers as material artefacts. Language affects the subjectivity of the reader, which recalls Roland Barthes' *jouissance*. Furthermore, as Cociña (2017) argues, these languages have an effect on perception that persists beyond readers' interactions with digital works:

La forma de percepción había cambiado por la computación, y es aplicable mucho más allá que sólo a ese medio. La posibilidad de tener varias imágenes, varias ventanas abiertas al mismo tiempo, no tiene que ver solamente con algo operativo, sino que cambia un paradigma de formas de relacionar datos, información, incluso como percibes. Era mucho más clave la computación, iba mucho más allá de ser un medio que te facilitaba la comunicación. La computación entendida como el Internet y los medios digitales, cambian la forma de percepción.

(The form of perception has been changed by computing, and this is true beyond just that medium. The possibility of having multiple images, multiple windows open at the same time, is not just a matter of operation of computers, rather it changes the form in which we relate pieces of information, even how we perceive it. Computing is much more impactful; it goes beyond being a means of communication. Computing, understood just as the internet and digital media, has changed the form of perception itself.)

Cociña's work, *A veces cubierto por las aguas* (2003, available on the website *poesía cero*), is a hypertextual poetic work in which the element of randomness is harnessed through a programmed search engine to configure the construction of meaning and the aesthetic experience of the reader. As if it were a video game or an artefact to assemble, the poem is prefaced by a set of instructions for the quest that the reader will perform: "Motor de búsqueda aleatorio en el cual el usuario accede a uno de los 39 poemas cada vez. Al desear ver otro poema, se despliega nuevamente al azar uno de los 39, pudiendo repetirse un poema

visto anteriormente. Existe la opción de regresar, pero la elección de otro poema, será siempre aleatorio" (A random search engine in which the user accesses one of the 39 poems each time. If the reader wishes to see another poem, one of the 39 is displayed again at random, and a previously viewed poem can be repeated. There is the option to go back, but the choice of another poem will always be at random). In this sense, readers are invited to immerse themselves in the search. In this search, there is a strong component of randomness and spontaneity. One of the poems found at random in *A veces cubierto por las aguas* reads (see figure 6.1):

Todo proceso espontáneo, natural e irreversible, aumenta la entropía del universo. Sin embargo, las feromonas se acercan al vómeronasal, en desorden, desde la piel y como el almizcle se van a los sueños desde el hipotálamo. Es éste un acto desde el azar. (Cociña 2003)

(Every spontaneous, natural and irreversible process increases the entropy of the universe. However, the pheromones approach the vomeronasal organ, in disorder, from the skin and like the musk they go to the dreams from the hypothalamus. This is an act of happenstance.)

The notion of randomness is one of the (de)constructive elements of Carlos Cociña's poetry. Here, I use the term "(de)constructive" because the digital medium of his poetry serves as a structural scaffolding for the works in question, while simultaneously deconstructing elements of conventional writing, and disrupting the reader's understanding of the text. Cociña is a pioneer in the use of digital technologies in Chilean poetry. Contrary to what usually happens in digital writing, where print texts are later published digitally, Cociña's latest print publications contain material originally published on the *poesía cero* web page (www.poesiacero.cl).

Manipulation is an intrinsic characteristic of digital language and dominates Cociña's works. Lev Manovich (2005) has argued that all images in movement, sounds, forms, spaces, and texts are computable, as they are composed of informatic data. Given their numerical nature, the new media objects may feasibly be manipulated algorithmically. In this sense, "media becomes programmable" (73). In Cociña's poems, readers are asked to manipulate the work through their clicks, journeying through the poetic fragments. The length of the work and the order of the poems are decided in part by the reader, through their clicks, but in part through the random selection of the fragments, a function of the poems' programmed search engine. Here, I refer to an aesthetic

Inicio

Otro

Todo proceso espontáneo, natural e irreversible, aumenta la entropía del universo. Sin embargo, las feromonas se acercan al bómero nasal, en desorden, desde la piel y como el almizcle se van a los sueños desde el hipotálamo. Es éste un acto desde el azar.

Figure 6.1. A screenshot from a search within "A veces cubiertos por las aguas." The poem quoted above is displayed between two buttons: at left, to return to the home screen ("Inicio"), at right, "Otro," to proceed to another of 39 poems, selected at random. © Carlos Cociña 2003.

characterized by search, a quest not only to affect the meaning of the texts, but also to impact the materiality of the work. In one of my many searches through the fragments of *A veces cubierto por las aguas*, I found the following poem:

Del orden de los afectos es el proyecto del lugar en que estamos. La ceremonia de las construcciones adquiere sentido cuando la elevación, en cotidiano, elimina la perspectiva de la isla. Entre ambas situaciones, se traspasan energías como si la laxitud de los árboles desconociera lo que parece constancia en lo que llamamos bóveda. Aquélla es vista como inmovilidad, pues la evidencia de la misma la asignamos a las actitudes con que nos acercamos a la orilla. Es un espejismo salir a navegar cuando efectivamente no nos hemos alejado más allá de dos pasos o brazadas.

(The order of affections is the project of the place we inhabit. The ceremony of construction becomes meaningful when elevation eliminates the perspective from sea level. Energies run between both situations, as if the laxity of the trees were unaware of what seems to be proof, in what we call the vault. It is seen as immobility, because the evidence is ascribed to the attitudes with which we approach the shore. It is a mirage to go sailing when we have not really gone further than two steps or strokes.)

Here, Cociña implores his readers to leave this mirage, to devote themselves wholly to the quest, to "affect"– in the double meaning that we identify in his poems – the texts as much as our surroundings. For me, the work is a call to go beyond a superficial "sail" through the features

of language and explore the depths of linguistic possibility. In the case of computing languages, the aesthetic and active features of the code affect us as users as much as we affect it through our active intervention by programming and executing scripts. Thus, Cociña asks readers to be conscious not only of the power of written and coded language, but also our own power as transformers and manipulators of said language.

The existence of a manipulable language is integral to Gregorio Fontén's "Poema del terremoto" (2010). Although Fonten's work differs substantially from that of Cociña, the authors share a preoccupation with the potential of the digital medium and its languages. "Poema del terremoto" is an interactive digital poem constructed from statements collected from people who experienced the 2010 earthquake in Chile. The homepage advises the viewer that the site hosts a ten-page poem,[5] and warns visitors that navigating the site (and poem) can be difficult. The reader attempts to access different parts of the poem by clicking on the letters of the word *terremoto*, but, when clicked, the letters move. The poem simulates the terrestrial quaking, as the letters dance from one side of the page to the other, alternately spinning, rising, and falling. While the reader clicks to read the statements of survivors of the earthquake, the on-screen chaos jars and displaces the testimonies, often rendering them difficult to read. Through this dynamic textual display, Fontén seeks to disrupt the reader's expectations of the format and invites the reader to explore a terrain – the digital – that is constantly in movement (see figure 6.2).

In my interview with Fontén, the author emphasized that written text appears in the medium that interacts with the programming language. The text exists materially in this interaction, or as a projection of code, but the object does not exist in the same physical sense as a print book. In this sense, digital language can allow the materiality of the poem to exist at a distance from the materiality of the object. To this effect, the author noted:

> por un lado, está el objeto propiamente tal, que es la forma que adquiere el poema, por el otro lado, está el código, aunque no sea necesariamente el código escrito, pero sí la intención de utilizar el código de cierta manera, de utilizar imágenes en movimiento, generadas por GIF. En el fondo, ese trabajo, el plan, eso creo que es el verdadero derecho de autor, aunque ese quizás no es defendible, pero ahí está la poética del "Poema del terremoto," por más que haya una "T" corriendo de aquí para allá o una "E," eso es un poco un accidente del poema. La gracia en lo digital es que hay una mayor posibilidad de jugar con esa distinción, mientras que, quizá en un poema escrito, va a terminar en un papel impreso, no hay una manera

Figure 6.2. A screenshot from "Poema del terremoto" displaying a few of the testimonies that appear as the reader clicks. © Gregorio Fontén 2010.

eficaz de dividir lo que podría ser el código de ese poema, la materialidad del poema. El digital abre la posibilidad de tener esa distinción. Yo lo veo no necesariamente como algo que se inventó con lo digital, sino que lo digital permite explorar un aspecto literario que venía quizás persiguiéndose desde mucho antes de "La Nueva Novela" de Juan Luis Martínez, en la intención de la hipertextualidad, en la pregunta sobre *dónde* está la obra. (Fontén, 2017)

(On the one hand, there is the object in itself, which is the form that the poem takes, and on the other, there is the code – although it might not necessarily be written code, but yes, the intention of using the code in some way, of using animated graphics in GIF format. In the background, the work, the plan, that I think that is the true "right" of the author, although this may not be defensible, but there is the *poetic* aspect of "Poema del terremoto," even if there is a "T" running back and forth or an "E," that's kind of an "accident" of the poem. The benefit of the digital is that

there is a greater capacity to play with that distinction, while a written poem might end with a printed page, there is not a straightforward way of figuring out what the code of that poem might be, the materiality of the poem. The digital format makes it possible to make such a distinction. I don't necessarily see it as something that was invented with the digital, but rather that the digital allows us to explore an aspect of literature that has been pursued since long before Juan Luis Martinez's *La nueva novela*, in the intention of hypertextuality, the question of *where* the work exists.)

Although neither Fontén nor Cociña engage directly with programming language in the way that creators of code poetry often do, they nevertheless make evident the digital language that is hidden behind their works. Furthermore, the authors are conscious of the effect that this language has on both author and reader – as Fonten (2017) explains:

En ese poema en particular, yo creo que eso era algo que me interesaba trabajar bajo el mismo criterio, de cómo el terremoto rompe con lo que uno esperaría, todo se ve pasado a llevar por esta fuerza. Entonces, el "Poema del terremoto" intenta mantener ese mismo ritmo del terremoto, en el cual, quizás, una persona salga corriendo o ve el primer pantallazo y lo cierra. También puede haber unos que conozcan más de internet y lo puedan hackear fácilmente, porque es cosa de cambiar el URL y puedes ver todos los poemas. Entonces, tampoco es un poema sofisticado en su tecnología, es un HTML muy sencillo. En ese sentido, es muy abierto a lo que pueda suceder. Alguien podría cargar sólo un pedazo, hay partes que se podrían tomar autónomamente, entonces está abierto a que sea "terremoteado."

(Regarding this poem in particular, I believe that it was something I was interested in creating under the same criteria as the way in which an earthquake shatters one's expectations, everything is brought down by force. So, "Poema del terremoto" tries to maintain the rhythm of the earthquake, in which, perhaps, a person flees or sees the first tremor on the screen and immediately closes the window. There might also be users who are more familiar with the internet, and could easily hack the poem, because it's only a matter of changing the URL and you can see all the poems. So, it's not a technologically sophisticated poem, it is a very simple use of HTML. In this sense, [the poem] is very open to whatever will happen. Someone could load only a piece of the poem, [and] there are some parts that could be autonomously operated, so it's open to being "earthquaked.")

The openness that Fontén describes here is what I refer to as the potential for manipulation, which readers recognize as they perceive

the opportunity to intervene in, and perhaps expand, a digital literary work. This muddling of traditional understandings of creatorship surpasses the closer relationship between author and reader that we can see in different writing experiences on the web, such as blogs or social networks. Digital literature is not only expandable by virtue of its hypertextuality – enabled, of course, by the underlying code – but can be further expanded by readers who decide to "hack" the work, perhaps by changing the URL as Fontén suggests. This is the context in which subjects engage the materiality of digital language and are thus able to create connections through the appropriation of the work's intrinsic characteristics.

This capacity for manipulation, returning to Manovich (2005), is closely linked to the algorithmic nature of programming languages. As Galloway (2004) observes, "media critic Friedrich Kittler has noted that in order for one to understand contemporary culture, one must understand at least one natural language and at least one computer language. It is my position that the largest oversight in contemporary literary studies is the inability to place computer languages on par with natural languages" (xxiv). The algorithms certainly configure a language, yet code differs substantially from a written language. To that effect, Galloway asks, "how can code be so different than mere writing? The answer to this lies in the unique nature of computer code … Code is a language, but a very special kind of language. Code is the only language that is executable" (165). Pondering the linguistic nature of code, Mark Marino (2014) writes that "computer code is written in a particular language, which consists of syntax and semantics" (64), adding that "code is a layer of digital textuality whose pointers lead in many directions. Nonetheless, as the semiotic trace of a process or even as the artistic fodder of codework, code offers an entryway into analysis and interpretation of the particular instantiation of a work, its history and its possible futures" (67). In this sense, in the analysis of these poems I am interested in outlining the procedure that is triggered upon execution of a script, a program written in code that produces an aesthetic experience linked to the manipulation of, and intervention within, the text itself.

It is quite plausible that the author or user may not be completely conscious of the programming language that scaffolds the textualities that play out before their eyes, but that their experience of the work may nevertheless lead them to perceive the manipulability of the text. Thus, I describe a game of language that has the potential to be hacked, and the way that this sense of possibility is transmitted to readers and authors alike through their interactions with the works. To that effect,

Eduardo Ledesma (2015) explains, "Code is the invisible and virtual mechanism underlying software, the instructions that make it run" (91); consequently, the reader must act to affect the materiality of the work, the moment in which a performative act of the code is displayed such that the contents of the work are projected before the eyes of the reader. Even if the reader does not have access to the code or it is not evident to them – which is the case with the works discussed above – the fact of being exposed to the option of choosing paths and interacting with the poems provokes an experience of hacking and intervention. In this sense, cultural hacking becomes, in these poems, a potential and an experience of a performative language that has a sensible effect over us.

The human-algorithm interaction affects the aesthetic experience based on new forms of perception that results from the performance of the underlying code. This experience, as I discussed at the beginning of this chapter, is linked to two primary features of code-based literary works: a hypertextual quality that allows diverse pathways to be created through segments of meaning, which in turn sets the stage for the association of digital literature with cultural hacking – a capacity for intervention, for hacking, and for materially affecting the works. These qualities have an impact on the author as much as the readers – or perhaps it would be better to call them "operators" – of a digital literary work. In perhaps the majority of cases, the digital offers the possibility of inciting a desire in the user to extend and intervene in the textual networks and language of a work, upon realizing digital language's capacity for manipulation.[6]

## Toward a Poetics of Hacking

Now, I wish to revisit Levrero's proposal regarding the liberty of intervening in programming, which supposes a pre-existing awareness of programming languages. This theme is fundamental in Latin America, given that the rise of digital technologies in this region has been closely linked with the possibility of user intervention, as much in software development as in "cracking" digital languages. This association recalls the historical status of Latin Americans as "pirates" – as people who appropriate and transform cultural production – to subvert both intellectual property rights and the dominant conditions of creativity. In his work, Levrero wonders if he is a thief for cracking a program: "Creo que no soy estrictamente un ladrón; no tengo la mentalidad necesaria para serlo. Entonces, ¿Por qué robo programas? Me respondo que no robo programas, sino el derecho a usarlos" (I think that I am not exactly a thief, I don't have the right mentality. So, why do I steal programs?

I would say that I do not steal programs, merely the right to use them) (281). Later, he added,

> Cuando yo "robo" un programa estoy haciendo uso del derecho a la cultura, que no es propiedad privada de nadie. Los programas que «robo» no me producen dinero; al contrario, me hacen perder el tiempo. No obtengo ningún beneficio material de ellos. La cultura, los productos de la inteligencia y la sensibilidad, es algo que debe circular libremente, gratuitamente, porque no puede ser propiedad privada de nadie, ya que la mente no es propiedad privada de nadie … Un texto escrito por mí no es "mío" porque yo sea el propietario; es "mío" como puede ser "mío" un hijo. (282)

> (When I "steal" a program, I am making use of a right to culture, which isn't anybody's private property. The programs that I "steal" don't make any money for me; in fact, they make me spend time. I don't receive any material benefit from them. The culture, the products of intelligence and sensibility, is something that should circulate freely, at no cost, because it cannot be anybody's private property ... A text written by me is not "mine" because I am the owner, it is "mine" in the way that a child might be "mine.")

Here, Levrero questions the system of intellectual property that penalizes sharing, thus limiting the creative process without necessarily benefiting authors. At the same time, he is aware that the greatest conflicts of contemporary cultural production are related to intellectual property rights. The authors of the poems reviewed in this chapter are conscious to a degree of a loss of control over their works, which can be attributed to the characteristics of programming languages. As I have discussed, code language has its own aesthetic, one that is characterized by hypertextuality and is subject to the manipulation of cultural hacking (Gainza 2016). The resulting capacity for extension and intervention disrupts the dichotomy between author and reader, as well as troubling conventional understandings of intellectual property and what constitutes a literary work. As a result, and as Levrero argues, the norms of copyright established to regulate the production and circulation of offline works simply do not translate to the digital realm. This is generating new forms of creativity – among them, digital literature – and it might lead us, in the future, to new ways of living.

In this sense, digital literature falls within the "hacker" label, given the manipulation of language as much as the conditions of existence characteristics of digital works, which are usually linked to inherent circulation and open access. This is particularly important with respect to digital literature in Latin America, because the majority of such works are available for free on the internet, and authors are aware

of the potential for intervention in their works. This context offers a political dimension, related to the concept of cultural hacking, that merits exploration in the present discussion. As Hayles (2008) writes, "we cannot afford to ignore code or allow it to remain the exclusive concern of computer programmers and engineers ... Implicit in the juxtaposition is the intermediation of human thought and machine intelligence, with all the dangers, possibilities, liberations, and complexities this implies" (61). The aesthetic experience of digital literature instils the user with a desire to intervene in the work, and thus makes the user aware of the potential to liberate language from the protocols that surround it.

To close, I would like to highlight the increasing foothold of algorithms in everyday life, from sophisticated vigilance systems to interventions in the decisions of citizens and consumers. Algorithms are not only mathematical operations; they are a language manipulated by protocols determined by institutions that exert power (Galloway 2004). The author of a work of digital literature becomes a hacker of sorts upon changing the meanings associated with programmed and written languages, thus equipping the language with an aesthetic quality that affects the reader and creates a desire to intervene in the textual fabric of the work. This digital aesthetic addresses the possibility of liberating the language of computing "to reintroduce new noisy alphabets into the rigid semantic zone of informatics networks" (Galloway 2006, 159). At the same time, such a discussion questions the status of authorship, readership, and even literature itself, as well as the system of intellectual property that determines the circulation of literature and the position of creative production within new apparatuses of capitalism. Digital literature has taken up an inherent function of literary practice: to serve as a reflection of a society while also questioning its structures and allowing us to imagine other possible worlds.

NOTES

1 The programming languages that are used most frequently in the works collected in the research are HTML, Action Script, and Java.
2 Here I refer to the Barthesian concept of "jouissance," as different from pleasure. Barthes understood joy (*jouissance*) as the possibility of the reader to change literary codes. See Barthes (2003).
3 The following table shows the works compiled during this project, organized by the category that matches their use of digital technologies (and, accordingly, their use of code).

| Transmedia | Social media | Autogenerated works | Hypertext / hypermedia | Digital sound poetry | Animated – interactive poetry |
|---|---|---|---|---|---|
| *Policía del Karma* Jorge Baradit | *Cuentwits* Fabián Sáez | *Máquina de coser* Demian Schopf | *Poesía cero* Carlos Cociña | *Feedback* Martín Gubbins | *Poema del terremoto* Gregorio Fontén |
| *Lluscuma* Jorge Baradit | | *Máquina Condor* Demian Schopf | *Pentagonal. Incluídos tu y yo* Carlos Labbé | *Pneutrin@s* Martín Bakero | |
| *Synco* Jorge Baradit | | | *Mi pololo volvió de Antuco* Ignacio Nieto | *Orquesta de poetas* Fernando Pérez, Federico Eisner, Pablo Fante and Marcela Parra | |
| *Hembros* Eugenia Prado | | | *Video Narratives* René Orellana | *Quick Faith* Felipe Cussen | |
| *Clickable Poem@s* Luiz Correa Díaz | | | | | |

4  For example, a novel written by an artificial intelligence system reached the final round of a literary competition in Japan in 2016.
5  That the pages are superimposed, so that readersclick on letters and phrases to reveal the text of the poem.
6  This is visible primarily in practices of fanfiction, memes, gifs, and other such cultural objects. Remixing, sampling, and other exercises of appropriation form part of the aforementioned potential.

REFERENCES

Baradit, Jorge. 2008. *Synco*. Ediciones B.
Barthes, Roland. 2003. *El placer del texto.* Siglo XXI Editores.

Cociña, Carlos. 2003. *A veces cubierto por las aguas.* http://poesiacero.cl/aveces.html.
– 2017. "En lo digital, me interesa aquello que me lleva a lugares que no están dentro de mis expectativas." Interview by Carolina Gainza. Proyecto Fondecyt *Cultura digital en Chile: literatura, música y cine.* http://culturadigitalchile.cl/wp-content/uploads/2017/08/Carlos-Coci%C3%B1a.pdf.
Fontén, Gregorio. 2010. "Poema del Terremoto." https://chupilcon.github.io/poematerremoto/.
– 2017. "Es la búsqueda poética la que guía a lo digital y no al revés." Interview by Carolina Gainza. Proyecto Fondecyt *Cultura digital en Chile: literatura, música y cine.* http://culturadigitalchile.cl/wp-content/uploads/2017/11/Gregorio-Font%C3%A9n.pdf.
Gainza, Carolina. 2016. "Literatura chilena en digital: mapas, estéticas y conceptualizaciones." *Revista chilena de literatura* 94: 233–56.
– 2017. "Networks of Collaboration and Creation in Latin American Digital Literature." *CLCWeb: Comparative Literature and Culture* 19.1. http://docs.lib.purdue.edu/clcweb/vol19/iss1/1/.
Galloway, Alexander. 2004. *Protocol: How Control Exists after Decentralization.* MIT Press.
– 2006. *Gaming: Essays on Algorithmic Culure.* University of Minnesota Press.
– 2007. *The Exploit: A Theory of Networks.* University of Minnesota Press.
Glazier, Loss Pequeño. 2002. *Digital Poetics: The Making of E-Poetries.* University of Alabama Press.
Groys, Boris. 2012. "De la imagen al archivo de imagen – y de vuelta: el arte en la era de la digitalización." In *Arte, archivo y tecnología,* edited by Alejandra Castillo and Cristian Gómez-Moya, 13–25. Ediciones Universidad Finis Terrae.
Hayles, Katherine. 2008. *Electronic Literature: New Horizons for the Literary.* University of Notre Dame Press.
Kozak, Claudia, ed. 2012. *Tecnopoéticas argentinas: archivo blando de arte y tecnología.* Editorial Caja Negra.
Ledesma, Eduardo. 2015. "The Poetics and Politics of Computer Code in Latin America: Codework, Code Art, and Live Coding." *Revista de estudios hispánicos* 49.1: 91–120.
Levrero, Mario. 2014. *La novela luminosa.* Literatura Random House.
Manovich, Lev. 2005. *El lenguaje de los nuevos medios de comunicación.* Paidós.
Marino, Mark. 2013. "Reading Exquisite-Code: Critical Studies of Literature." In *Comparative Textual Media: Transforming Humanities in the Postprint Era,* edited by K. Hayles and J. Pressman, 283–309. University of Minnesota Press.
– 2014. "Code." In *The Johns Hopkins Guide to Digital Media,* edited by Marie-Laure Ryan et al., 64–9. Johns Hopkins University Press.
Raley, Rita. 2009. *Tactical Media.* University of Minnesota Press.

# 7 Cyborg Citizenship in Keiichi Matsuda's "Hyper-Reality" (2016)

KATHERINE BUNDY

In a precarious digital age, the increasingly narrow divide between technology and the body is converting what once was science fiction into a plausible prediction. The reimagining of science fiction as a precursor to scientific discoveries reiterates the concept that fictional narrative can prefigure material realities. Jules Verne's conceptualization of the submarine in *Twenty Thousand Leagues Under the Sea*, and live video chats that Verne referred to as "phonotelephote" in his article "The Year 2889," are among famous examples of how science fiction informs scientific inventions (Kristoff and Chandler 2011). A new wave of cultural products has shifted away from the futuristic aesthetic of films like *Bladerunner* (dir. Ridley Scott, 1982) or *The Fifth Element* (dir. Luc Besson, 1997) in favour of a more intimate connection between technology and humans in settings that reflect on futures that are rapidly approaching. This cultural movement from the science fictional to the speculative in popular streaming shows such as *FutureStates* (2010–14) and *Black Mirror* (2011–19), Spike Jonze's film *Her* (2013), and the series of animated shorts *Love, Death & Robots* (2019) is timely, as these cultural products reflect on an underlying anxiety about the constant communion between humans and digital technology. The depiction of ubiquitous connectivity and of the human/cyborg stories that operate within these worlds now functions as a narrative blueprint for future product designs and architectures. Among the new wave of techno-futuristic speculations is a 2016 six-minute short film titled "Hyper-Reality" by London-based designer and filmmaker Keiichi Matsuda, who weighs in on this cultural trend by including a J.G. Ballard quotation on the main page of his website (www.km.cx): "Everything is becoming science fiction. From the margins of an almost invisible literature has sprung the intact reality of the 20th century."

Keiichi Matsuda's online-produced film is a speculative exploration of how the technologized human (cyborg) perceives and interacts with the city of Medellín, Colombia. In my analysis of the six-minute film, I take a two-pronged approach, analysing the interventions of cyborg citizenship in the plot and paying attention to the transnational and digital processes from concept to production of "Hyper-Reality" as an example of web-facilitated filmmaking. In the spirit of connecting this essentially transnational film to the Latin American scope of this book, I interrogate traditional connections to nationhood and belonging of web-based cultural products that rely on digital modes of production and distribution that transcend regional institutions of short-film production in Latin America. Since Matsuda is neither Colombian nor Latin American but rather of Japanese descent and living in the United Kingdom, the choice of the film's location and language and the decision to film in Medellín complicate the response to the question "Is this film Latin American?" Within the traditional channels of regional short films, from production to international distribution, nationhood is frequently assigned to the country of origin of the filmmaker, even if the filmmaker has been living abroad for an extended period. Matsuda's decisions to collaborate with a storytelling and production company in Medellín called Fractal Media could effectively position this film as a Colombian product, since Matsuda and his team filmed for several weeks on location in the city with local actors and resources. The technological capabilities of filmmaking in the digital age are crucial in expanding notions of nationhood and regionalism that move beyond of the director's country of origin, especially when global technologies and local oppressive governance is at the centre of the plot.

In fewer than six minutes, Keiichi Matsuda's hyperreal world explores the materiality of a Colombian urban landscape full of unsettling virtual gags from the point of view of a marginalized cyborg subject. The perspective of the cyborg protagonist, Juliana Restrepo, projects an augmented reality experience of Medellín. Juliana's physical surroundings are constantly vivified by interactive apps, incentive systems, notifications, videogames, advertising, and consumer rankings. Throughout the film, Juliana struggles to decide whether to reset her identity outside the system, which means losing her loyalty points as a citizen/consumer and the connectivity she relies on to navigate daily life in Medellín. When a technical error in her augmented reality setup mistakes her for a male-bodied person named Emilio, Juliana follows the navigation's instructions to provide a biometric sample to confirm her identity. In the street, a glitched bio-hacker approaches Juliana and stabs her hand to extract a blood sample before fleeing. In a panic,

Juliana resets her identity, thus losing her loyalty points in all her applications. In the final moments of the short film, Juliana is attracted to a statue of the Virgin Mary, where she proceeds to trace a virtual cross to begin her journey anew, now banking loyalty points in the name of the Catholic Church.

## Matsuda's Urban Speculations in Immersive Augmented Reality (AR) Filmography

"Hyper-Reality" situates the globally speculative within the city of Medellín, the second largest urban metropolis in Colombia, known for its year-round warm temperatures and nicknamed "the City of the Eternal Spring." Matsuda's biography and the production of "Hyper-Reality" also come into play when setting up an encounter with the global viewer to experience the technologized Colombian city. Matsuda's Japanese heritage and London residence may seem far removed from a short film in Colombia, yet his decision to make a film in Medellín seems deliberate: in his Kickstarter promotional video, he explains:[1]

> The film is going to be set in Medellín, Colombia. Medellín is a beautiful city with a troubled past dominated by gangs, drugs, and violence. In the last twenty years though, the city has transformed itself completely, and was last year awarded the title of most innovative city. I'm interested in how rapid, technological transformation could have impact on a culture which makes Medellín an ideal location. The city is going to be lovingly designed for the near future complete with its own laws, customs and politics. (Matsuda 2013b 1:54–2:28)

In this vision of Medellín articulated by Matsuda, the formerly troubled urban space is on the upswing, thanks to technological innovation and improvement for all citizens. The technological ambience of "Hyper-Reality" goes merely one step further to imagine the future of the Latin American city, liberated by technology and ubiquitous connectivity. Matsuda's decision to set the film in Medellín rather that in his hometown of London was a mixture of convenience and curiosity to explore the relationship between technology and society outside the liberal West (interview with the author, 12 April 2019, 15:10). During our interview in April 2019, Matsuda explained that his interest in technology and society often leads him back to the realization that most technological production comes from a very small section of society that can be geographically narrowed down to some parts of California (Silicon Valley) and, increasingly, parts of China. Matsuda wanted

to show, in his words, something "outside of that, and I don't really consider London to be outside of that. I could have chosen somewhere else, but I happened to visit the city at this time and was really taken by both the spirit of people wanting to be involved and thinking about the vision for their city, as well as the physicality of the city" (interview with the author, 12 April 2019, 15:20).

"Hyper-Reality" serves as both a cultural object and filmic exercise that links the imagination of architectural design with filmmaking as another form of modelling and real-time representation. Matsuda first began working with a Medellín-based creative production team called Fractal (universofractal.com) in 2013 in order to garner additional funding and storytelling resources to film on-site and to collaborate with local actors, composers, and technicians. During that time, Matsuda scouted filming locations around Medellín. In particular, he was drawn to the city's plentiful plazas and restaurant patios, as these open-air spaces lend themselves well to virtual redefinitions in post-production animation.

During our interview, I asked Matsuda about the Medellín-specific aesthetics of the film. I was curious about his inclusion of virtual layers and animation that specifically referenced the space and Latin American interpretations of technology. Although Matsuda had visited Medellín five times since 2013 and was planning a trip to Buenos Aires at the time of our conversation, he had not visited other parts of Latin America. His experience with and access to the city were curated by his teammates at Fractal Media and local collaborators in the film industry, who provided the linguistic and social know-how of filming locations and resources. With that said, Matsuda's comments indicated a special attention to Colombian aesthetics and traditions ingrained in the physicality of the city, features that he enhanced through the film's virtual layers. For example, Matsuda especially noticed the presence of Catholicism, Santeria, and other spiritual traditions co-existing in the city space and was taken aback by visual representations of a blood-covered Christ figure or a depiction of the Virgin Mary juxtaposed with popular culture advertisements, including soccer players, superheroes, and soft drinks. As he elaborated, "that kind of synthesis between these things that in the Global North and the Global West (whatever we want to call it) is not as … it somehow feels contradictory. You could either be into Science or be into Religion, but that was never the case before, and it does not seem to be the case in Colombia at all" (interview with the author, 18:30). This contradictory mash-up of modernity and modernization is what the classic text by García Canclini, Rosaldo, and Chiappari (2005) on hybridity articulates with reference to the Latin American

city. Furthering this aesthetic of remixed cultural signage and virtuality, the continual restructuring of the Latin American city, according to Canclini and his colleagues, is the increasing "audiovisual democracy" mediated through images transmitted into the public space by electronic technologies (211). In this context, Matsuda's project intervenes as a real-time simulation of constant connectivity, whose sounds and sights are transposed onto the Latin American city, although Matsuda himself is an outsider with convenient access to cultural insights and resources in Medellín.

The perspective that Medellín's speculative city design functions essentially "outside" the liberal West becomes groundless when we consider the transnational and hierarchical power structures of the internet in Latin America. Certainly, the overlay of web-based virtual images and animations on the physical architecture of Medellín is both territorial and localized, yet it is also indicative of globalized techno-capitalism, which aims to wash out and homogenize the local. Even the material details of Matsuda's film address the transnational situatedness of filmmaking thanks to web connectivity. By crowdfunding internationally online, collaborating locally on-site in Medellín, and post-producing the animation and design back in London, Matsuda and his team create a global digital film product that is made possible through the transnational capabilities of web-based interconnectivity. The transnational production of Matsuda's project dislocates and redistributes the cultural ownership of the film itself and points back to one of the initial inquiries in this chapter: "Is this film Latin American?" Although short films are often closely tied to nationhood in metadata and in festival circuits, transnationalism and colonialism are implicated as web-collaboration and moneyed technological innovation converge to design the augmented Latin American city. Matsuda's project speaks to this contradictory reality of transnationalism and hegemony for the Latin American web-surfer who is immersed and implicated as a cyborg subject like the protagonist in the film. Another figure that is implicated in the global aesthetics of "Hyper-Reality" is the viewer, who must dive deep into a customized augmented experience of the protagonist as a Colombian working-class woman living in a system designed to proliferate consumerism as a global habit. Matsuda has commented that Colombian viewers tended to respond nostalgically to the film's settings and soundtrack, which sample old advertisements, soundbites, and visual cues. However, to an audience outside of Colombia or Latin America more broadly, the ethical questions of consumer capitalism and ubiquitous connectivity dominate the aesthetic experience. The following questions linger when considering the globalized

audience of the film and its implications for the future of augmented cities and spaces: Who designs connectivity, and can it be universally implemented? How does augmented architecture coming from global designers contribute to nationhood?

In the film, Juliana navigates Medellín as a working-class citizen: she travels by bus, walks on a busy street with heavy traffic, and strolls through the supermarket, running errands for a paying client. While these activities could be accomplished in any number of urban metropolises, the animation superimposed on the live-action footage contains cultural references that evoke a general Latin American – and, at times, specifically Colombian – aesthetic imaginary. These references include Catholic iconography, Latin American brands and advertisements, touristic suggestions for Medellín, and an electronic Latin soundtrack in several scenes; moreover, most of the dialogue is in Colombian Spanish. These features situate the viewer in interchangeable urban spaces, while the virtual layers in the film communicate a technological atmosphere specific to Medellín. As Juliana's narrative unfolds, the intensity of a mere slice of life in an augmented Medellín reveals a seamless continuation between the domestic screen and public space. By mixing the familiarity and comfort of the personal device or "home screen" and the real-time interaction with a technologized public space, the urban citizen in "Hyper-Reality" is constantly connected, networked, and supervised without clear boundaries of privacy.

The connected urban dweller in Medellín embodies a cyborg, or an "electronomad" – a term used by Matsuda himself to describe this networked pedestrian. As a point of departure, my cyborg terminology leans on Donna Haraway's third-wave feminist definition of the cyborg from her canonical text "A Cyborg Manifesto: Science, Technology, and Socialist-Feminism in the Late Twentieth Century" (2013). The feminist cyborg is a hybrid subject that combines the organic body with technological enhancements, bypassing the rigid binaries of nature/culture and human/non-human. While Haraway proposes cyborg subjectivity as a mode of feminist resistance to patriarchal binaries that were co-opted by second-wave feminists, the "Hyper-Reality" viewer must recognize that Juliana's cyborg body is working class, female, and racialized as non-white, and therefore a marginalized cyborg in a world where technological advancements are mere continuations of western white patriarchies. The Latin American subject and the cyborg maintain a historically precarious relation that may be read in the context of labour automation and oppressed subjects of technologies of violence during military dictatorships, as Andrew Brown details in his book, *Cyborgs in Latin America* (2010). Brown distinguishes the Latin American

cyborg from European studies of the posthuman: "Latin America serves as an especially important case study as it adds the prism of techno-logical transfer, of the post dictatorships, and the neoliberal policies of the 1990s that have served as the backdrop to the rapid introduction of Internet technologies" (4). Other visions of the Latin American cyborg by Mexican performance artist Guillermo Gomez-Peña seek to reclaim ownership of technologies that are slippery, dangerous, home-made, and performative in the face of the colonizer. In his lo-fi web clip from 2011 titled "Border Interrogation," Gomez-Peña sports futuristic glasses in the foreground and asks, "Have any of you ever fantasized about being from another race or culture? Which one?" In the back-ground, another actor wears a piece of hardware strapped around his head that obstructs his entire face, a single antler protruding from the top of it as a digital percussive soundtrack plays in the background. This performance of the immigrant cyborg as an illegal "alien" who is racialized and hopes to traverse boundaries and borders is another ex-ample of the difference in Latin American appropriations of the cyborg as posthuman subject. The hybridity of the Gomez-Peña's cyborg actor as simultaneous animal, human, machine, and extraterrestrial suggests a political subject that is difficult to define and capture – a stronger po-sition for undermining oppression. In "Hyper-Reality," Juliana is akin to Brown's description of the Latin American cyborg who is controlled and trapped within a neoliberal surveillance state, yet the slippery sub-jectivity of Gomez-Peña's cyborg performance manifests in the hacker cyborg near the end of Matsuda's film.[2] The hacker's obfuscation of its identity and metadata exemplifies how cyborg subjectivity can assert agency through rewriting and modifying the codes that are meant to oppress them.

Keiichi Matsuda's master's thesis, entitled "Domesti/City: The Dis-located Home in Augmented Space" (2010a) details the ins and outs of augmented space and the empowerment of its electronomads that can "define their own use of space and subjective reading of the aug-mented city" (6). Only a few years before large-scale efforts to cre-ate smart cities and introduce hyper-connectivity into metropolises around the globe,[3] Matsuda's thesis promoted the dislocation of do-mesticity away from the private home space through ubiquity, thereby pushing the private space into the augmented city and into a new do-mestic space that is open, shared, collaborative, and malleable through user connectivity. In Matsuda's view, at the centre of the convergence of domestic and public space is the human-city interface (HCI), which projects and interprets augmented reality in real time. Matsuda distin-guishes virtual reality (VR) from augmented realities in his project: the

former is dismissed as a niche tool for gaming and 3D chat platforms, whereas AR is "a technology that uses a graphic overlay to augment the physical environment with data from an information source, usually the Internet" (Manovich 2005). Matsuda applies AR to the scope of architecture by advocating for designers and architects to design virtual infrastructure on the physical landscape, adding accessible and potentially empowering features for the cyborg or electronomad to use according to their needs:

> She [the cyborg] controls and defines the space she inhabits, bringing together channels and feeds, including tools and spatial definitions, to create a customized and subjective occupation. She constructs and maintains her domestic augmented interface as the environment adapts to her pattern of use. This activity is supported by cloud architecture; buildings as infrastructure, providing warmth and shelter to cyborgs, and orientation, metadata, wireless connectivity and surveillance to computers. The built environment becomes a landscape to be read by machines, *Architecture Parlante* reinterpreted for the augmented age. (2010a, 48)

The optimism in Matsuda's thesis is illustrated in the companion short films he made in conjunction with his thesis project: "Augmented (hyper)Reality: Domestic Robocop" (2010) and "Augmented City 3D" (2011). These shorts offer speculative visions of the technologization of urban spaces, both personal (home, office) and public (cafes, sidewalks, city transport). His techniques in these films and in "Hyper-Reality" are consistent with the augmented city that he envisions in his thesis: live-action filming with animated layers that interact and shift according to the movement of the camera that is positioned over the eyes, thus immersing the viewer and protagonist into the same augmented world. During a 2010 lecture at the International Film School (IFS) in Cologne, Germany, Matsuda explained his approach to AR in his film projects:

> The type of AR that I'm interested in is Immersive AR. Rather than a smartphone and a webcam, it's AR in which you wear some sort of goggles or a head-up display that allows you to exist in a virtual world. AR is interesting because it combines VR with location awareness. AR can give us the ability to liberate data from screens and for it to exist in everyday life. The world we live in contains many virtual layers. With my background in architecture, this has interesting implications because it allows us to apply lessons that we learn from the Internet and to incorporate it into the city. We should think about that now and the complexities and problems that it's going to cause. (Matsuda 2010b, 4:20–5:10)

The AR in "Domestic Robocop" and "Augmented City 3D" shows how humans interact in real time with immersive AR while navigating spaces and "grabbing" and "scrolling" through holographic virtual objects and menus. Taking immersion one step closer to the viewer, "Hyper-Reality" replicates a first-person perspective of the hyperreal city saturated with immersive AR without a limited physical interface such as a Smart phone. In other words, the material world and all its objects are the new points of reference through which to channel AR machine learning, data collection, assisted navigation, commerce, relationships, and so on. As a departure from the optimistic language surrounding the electronomad in Matsuda's thesis, the lessons in "Hyper-Reality" are bleaker, especially when the protagonist is hacked and left without resources and agency at the end of the film. Referring to the algorithmic anticipation of behaviours in immersive AR in his lecture, Matsuda adds, "I think that this is frightening and incredibly scary" (2010b, 14:30).

The title "Hyper-Reality" itself evokes Jean Baudrillard's concept of "hyperreality," which is the inability of the consciousness to be able to distinguish between reality and simulation of reality. In his famous postmodern text *Simulacra and Simulation* (first published in 1981), Baudrillard describes the semiotic phase of the simulacrum, which is simulation, or the state of signs with no signifiers or references of origin. Hyperreality is not only functional within language and semiotics but is also engaged with late capitalism because of commodity fetishism,[4] or the alienation of the consumed product from the material and social processes that produce the item. In the hyperreality of Matsuda's film, the co-mingling of material and digital technology is not distinct or easily deciphered, since the bodies of humans and non-human objects are coded through signals between the gaze of the cyborg subject and networked Cloud technology (figure 7.1). With invisible signals and data streaming back and forth between the cyborg and the network, the cyborg who inhabits an augmented city must occupy multiple existences through a hybrid subjectivity. In other words, the simulacrum is one step removed through the medium of signals, codes, and animation on top of the commodity fetish.

From the very first moments of "Hyper-Reality," the graphics and animation represent an overload of hyperreality in the form of a holographic video game mid-play: the neon colours, the moving image and text, several layers of noise, sound effects, and background music that occur within the worldview of Juliana are meant to immerse the viewer to the point of over-stimulation. The protagonist's hands manipulate the movements of the virtual videogame graphics while she simultaneously receives multiple notifications from various applications

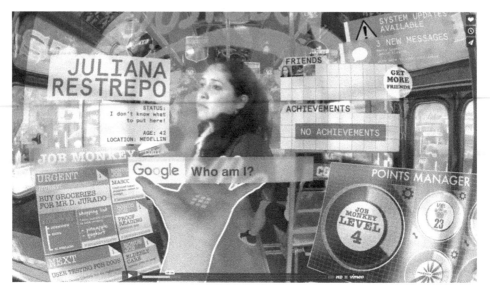

Figure 7.1.  Juliana's first-person perspective and AR interface ("Hyper-Reality" 00:56). © Keichii Matsuda 2016. Source: vimeo.com/166807261.

organized into holographic windows in her "screened" view. The entirety of the film is from this point of view, in which the human eye perceives from the disappeared screen of augmented reality. From this perspective, the viewer can experience the *umwelt* of the cyborg, whose consciousness is connected to a system, while navigating according to Juliana's individual preferences. Juliana's oppression becomes obvious when she receives a call from her application guru, Job Monkey, who assures her that if she accumulates more loyalty points, she will find a job more suitable for her career preparation. In her frustration, she voice dictates the queries "¿Quién soy?" and "¿Adónde voy?" (Who am I? / Where am I going?) into a Google search engine (figure 7.1), only to receive very literal answers that show her a hologram of her official identity card as well as a grid map of her route on public transportation. This mistranslation of her existential search is also a misunderstanding of her desires as a cyborg-citizen-consumer; and the failure of the augmented system to accurately address Juliana's questions suggests that the systematic coding has a limited capacity to answer her human needs. Her frustration is clear as she clicks her tongue and declares, "No es lo que quiero decir" (1:00; That's not that I meant). Juliana's internal debate over whether to "reset her identity" is interrupted when

the bus arrives at her destination. She decides not to opt out of the system just yet, because doing so would mean that all her earned points in her applications would be erased.

Shot from Juliana's point of view, "Hyper-Reality" displays the entrapment of a technologized human experience of urban space. A cyborg vision makes this possible, as the perspective of the camera leads the viewer to assume that Juliana is either wearing a device over her eyes or projecting the images through an embedded technology in her physical eyes. Other subjects in the film seem to be participating in the same AR system, although they do not appear to be wearing any visible devices. This modified connection between the eye and the camera, the merge between the machine and the body, makes Juliana a cyborg subject, since her humanness is altered by technological processes. The immersion of Juliana's cyborg body into her experience and urban space is tethered to the experience of the viewer, who becomes a kind of cyborg-by-proxy as they take on Juliana's perspective. This blurring of boundaries between the human and the technological underscores the ambiguities between the definitions of nature, technology, and humans that help shape the figure of the cyborg. Recalling Haraway's ironic cyborg myth in the name of third-wave feminism, these blurred boundaries in the augmented reality of Juliana's cyborg citizenship only perpetuate the anxiety and oppression of power dynamics that impregnated every decision of the cyborg body in the hyperreal space. To quote Haraway's manifesto, "Our machines are disturbingly lively, and we ourselves frighteningly inert" (2013, 294).

Paul Virilio begins his chapter "The Vision Machine," in his 1994 book of the same title, with a quotation from painter Paul Klee: "Now objects perceive me" (59). This startling reference point begins an in-depth study on optics and technology, as Virilio foretells the future of filmmaking, surveillance, seeing, and automation of perception. Here, I want to focus on Virilio's prediction of an eventual "splitting of viewpoint," or "the sharing of perception of the environment between the animate (living subject) and the inanimate (the object, the seeing machine)" (60). The need for this split is due to the limitations of human retinal retention and memorization in immediate, real time. The computer, or the vision machine, will optimize seeing and foreseeing that human sight cannot achieve alone, mainly through "depth of time" and "real-time presence." Both constructs are symptoms of "paradoxical logic," which Virilio describes as the following:

> *Paradoxical logic* emerges when real-time image dominates the thing represented, real time subsequently prevailing over real space, virtuality

> dominating actuality and the very concept of reality on its head …There
> is a correspondence here between the reality of the image of the object,
> captured by the lens of the pick-up camera, and the virtuality of its pres-
> ence, captured by a real-time "surprise pick-up" (of sound). This not only
> makes it possible to televise given objects, but also allows tele-interaction,
> remote control and computerized shopping. (63–4)

The "paradoxical logic" that Virilio describes is strikingly similar to
the augmented reality in which Juliana dwells in "Hyper-Reality,"
especially considering the video game–like speed of the film, and the
overwhelming density of informational intake from the augmented,
hyper-connected human subject.

Like Virilio's vision machine, Ana Viseu's study of wearable comput-
ers and connectivity focuses on the automation of perception through
augmented intelligence, which "utilizes a distributed model of infor-
mation processing: the cognitive task is split between the various net-
worked actors. The recurrent dream of the perfect memory – assisted
by a computing device that records and helps recall every aspect of
one's daily life" (2003a, 19). In other words, the increasing speed and
bandwidth of virtual image processing demands more than the biolog-
ical human eye can take, and technological augmentation is required to
participate as a fully equipped cyborg citizen.

In his thesis, Matsuda echoes the need for a technological modifi-
cation of human sight to perceive the breach of spatial dimensions in
the augmented city: "It cannot be seen with the naked eye; it must be
viewed through a lens, a human-city interface. Viewed in AR, the aug-
mented city is instantaneously streamed to the HCI" (2010a, 43). The
instantaneous stream of computerized information from all directions
locates Juliana in a mapped public space, yet also dislodges her from a
place of private belonging, as she is constantly surveilled by technolo-
gies that anticipate and direct her actions. In figure 7.1, the background
space of the public bus is altered with decorative and marketing graph-
ics that the viewer assumes are visible to the other passengers through
their own vision machines. In the foreground of Juliana's vision is her
personalized desktop with numerous applications, tasks, and indica-
tors of her social cache as a citizen. Although Juliana's personal tra-
jectory evokes a sense of confusion and disorientation – as suggested
by her existential Google queries – her spatial itinerary is precisely
mapped. These optimization tactics are meant to push Juliana along
the path of virtual achievement, consumerism, and behaviours that are
suggested by algorithms and machine learning in *real time*. Beyond Ju-
liana's immediate vision is the depth of space and foresight of where

she is going, what she will do, and how she will make decisions as a networked cyborg citizen.

Matsuda's optimistic thesis, written six years before "Hyper-Reality" was completed, insists that "the electronomad is not homeless; rather she is empowered to appropriate any space via technology ... it is the soft and subjective occupation of space that defines the electronomad, not the lack of fixed abode" (2010a, 36). The filmmaker's hopeful tone can be situated within a trend of confidence among designers, manufacturers, and academics that augmentation is synonymous with human empowerment, since individual desires can be not only predicted and modelled around them but optimized and customized in real time. While others perceive the inevitable merge of machine and human as a synergistic one that will eventually create more autonomy and optimization through augmentation (Mann and Niedzviecki 2001), Viseau presents critiques of this optimism by questioning the proliferation of programming and by highlighting the diminishing effects that accompany the overreliance and dependence of humans on "smart" objects and spaces (Jeremijenko 2001). Departing from the empowered electronomad of his 2010 thesis, Matsuda's more wary approach to human augmentation in "Hyper-reality" presents an augmented human subject that is existentially homeless and overwhelmed by the proliferation of the connected city. In the film, troubles begin when Juliana's attempts to divert from the predetermined pathways of her wearable HCI device, which creates vulnerabilities and exposes her deficiencies as she wonders if she can function outside of the mainstream of merit-based cyborg citizenship.

**Wearables, Real-Time Code, Algorithms**

In "Hyper-Reality," the virtual system of consumerism interfaced in the augmented Medellín is intimately integrated with the consciousness of the cyborg subject, Juliana. From her point of view throughout the film, the operating system accumulates points within applications for companies such as Juan Valdés, Nivea, Tampax, and Éxito, the supermarket chain. This virtual transposition of capitalism within and onto the body that is nourished by acts of loyalty to the neoliberal system is exemplary of the permeating and invasive reach of wearable computers that are incorporated into the body. In other words, the virtual is "optional" in name alone – opting out means accepting the endangerment of navigating now-illegible public spaces and living outside of an economy whose entry cost is constant access to one's personal data.

In "Hyper-Reality," the interaction between official coding and unofficial coding, or hacking, interrupts the trajectory of Juliana's

apathy within her AR world. These technical errors first occur during a scene in a supermarket, which is a space full of messages and advertisements that shift according to the algorithms flowing as invisible code between the cyborg and fruits and vegetables, both bodies representing an entanglement of human, tech, and nature. As Juliana moves tiredly through the supermarket, pushing her cart, the fruits and vegetables around her quickly become gamified and commodified through a friendly virtual pet dog that yaps at passing fruit and vegetables, indicating +5 points for a pineapple or a coconut. Juliana sighs and mutters, "Ay no … cállate" (Ugh, no … shut up). While Juliana's impatience is apparent, the real-time algorithms are meant to appeal to her system as a consumer and as a personal shopper, since her previous shopping list on the bus included pineapples, coconut, and yogurt. The interaction between non-humans (fruits, shopping items, and virtual pets) and the cyborg is a two-way communication of code, yet the surveillance system always seems to be one step ahead of Juliana's augmented vision.

In the dairy aisle, a glitch in Juliana's augmented vision reveals digitally stratified gendered experiences of daily activities, when the system begins mistaking Juliana for a male-bodied cyborg named Emilio. While shopping for yogurt, Juliana picks up the carton and examines its AR advertising. When the system glitches and begins projecting a male-coded AR experience, the yogurt label reads in English: "MAN YOG: For real men only." Meanwhile, a sexy policewoman dancing with a gun appears in the shopping cart while the reggaeton soundtrack raps the lines "Dámelo, mami" / (Give it to me, baby). The yogurt that had previously projected in Juliana's female-coded view read: "The new super food! Beautiful you: probiotic yogurt. We can help you lose weight!" Meanwhile, a light, frivolous, bossanova soundtrack had played in the background (figure 7.2).

The coded projection of gender binaries onto the cyborg body demonstrates the persistence of purist categories even in the hyperreal space. Another interesting power dynamic facilitated through AR immersion in this scene is the anglicization of the food labels, and the live translation from Spanish audio to English captions throughout a call with a customer service agent. While this live-subtitling tactic broadens the online viewer base and embeds translation into the narrative of the film, the proliferation of English in the networked Latin American city mirrors the historical anglicization of the web in Latin America. There are even larger implications of *who* designed the augmented city and the objects within it, which is another nod to neocolonial and neoliberal relations between Latin America and its colonizers. While this coding

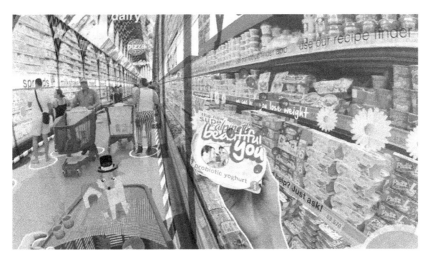

Figure 7.2. Juliana's female-coded AR immersion in the supermarket ("Hyper-Reality" 02:51). © Keichii Matsuda 2016. Source: vimeo. com/166807261.

is the flow of information that facilitates a livelier cooperation between objects and beings in immersive AR, it is also an architecture of power that watches, records, and learns about the most intimate habits and decisions of its subjects.

Still in the supermarket, Juliana's customer-service interface assures her that they are working on the glitch and warns her that they are going to reboot her system. After Juliana repeats her concern about losing her loyalty points, the brightly coloured AR environment of the grocery aisle powers down, creating an eerie moment for the viewer as the once-vibrant scene is stripped of stimulation and adornment, as even the shop banners revert to QR barcodes indecipherable to the un-augmented human eye. When the music cuts, the only remaining sound is the cry of a baby from further down the aisle as Juliana sighs worriedly, a sonic reset that juxtaposes life within the system with life outside of it. As the immersive system boots up again, much like the re-starting process of a computer or device, the animation and applications of her digital world surround her again, and then Juliana is instructed to follow a highlighted path in order to verify her identity within the system at large. Once again, Juliana's subjectivity is dictated by the functionality and utility of her systems as a predictable and legible cyborg citizen whose systems are vulnerable to a hegemonic network.

Figure 7.3. Juliana is hacked in the street by a digitally cloaked cyborg ("Hyper-Reality," 05:01). © Keichii Matsuda 2016. Source: vimeo.com/166807261.

## Docile Cyborgs, Hacker Cyborgs

If Juliana's docile cyborg body does not accomplish the revolutionary projects of Haraway's theoretical cyborg, then perhaps Haraway's cyborg subject is more aptly demonstrated in the indecipherable hacker body that extracts the biometric sample from Juliana's hand in the street (figure 7.3). Haraway explains the activist project of her cyborg figure: "my cyborg myth is about transgressed boundaries, potent fusions and dangerous possibilities which progressive people might explore as one part of needed political work" (2013, 295). In "Hyper-Reality," the obscured movement and transgressive potentialities of the hacker's dynamically fractured form provide a much more effective activist persona, one that can defy the passive consumption encouraged by the architectures of the surveilled city through radical self-coding in a hyperreal context. The physical makeup of the hacker in the film is also vividly Harawayan: "People are nowhere near so fluid, being both material and opaque. Cyborgs are ether, quintessence. The ubiquity and invisibility of cyborgs is precisely why these sunshine-belt machines are so deadly. They are as hard to see politically as materially. They are about consciousness – or its simulation" (294–5).

In its glitched ethereality, Matsuda's hacker figure wears a guise of repeating floral motifs and sampled pieces of the cement pavement,

obscuring any type of solid form that would identify traits such as gender or age, or even an outline of a solid body. The digital noise of this cyborg body complicates the clear channels of information relay by interrupting the hegemonic codes of the augmented city and composing itself as fluid yet effective in resistance. Of course, the alliance of the hacker cyborg is ambiguous, which is another nod to Harawayan tactics. The hacker could be working outside the AR system and disrupting their channels to collect biodata samples from vulnerable citizens, or it could be an agent of the state to punish disloyal and wavering cyborgs like Juliana (possibly triggered by her voice-dictated questions at the beginning of the film). Either way, the hacker enjoys the anonymity of a skilled coder who is cloaked under the confusion of mixed signals.

The contrast of Juliana's experience with that of the hacker cyborg is highlighted in the final scene of the film, when Juliana, desperate after resetting her identity in a panic, approaches a sidewalk altar of the Virgin and child, asking "¿Qué es eso?" (What is that?). Oddly enough, Juliana restarts her virtual participation within the Catholic Church by following the digital instructions to trace a cross before her, simultaneously a ritualistic Catholic gesture and the swipe movements commonly used to calibrate motion-sensing digital devices. In this scene, the hyperreal iconography of Catholicism mingles productivity app tropes and liturgical tradition. The audiovisual portrayal of the Virgin and child features dancing celestial light, choral music, and cursive typography hoisted by angels (figure 7.4). Faced with the anxieties of marginality from the norms of the hyperreal, Juliana's new-found participation in the virtual Catholic Church reboots her passiveness and anxiety as an entrapped cyborg consumer, since she can see no other option. During our interview, however, Matsuda told me that he intended this ending as a alternative to consumer and surveillance capitalism: "I saw Catholicism and that belief system as potentially an effective foil to the dominant neoliberal ideology" (interview with the author, 19:20). Irrespective of the intention and interpretation of this final scene, Juliana cannot convert her passivity into agency while opting into yet another virtual point system, despite the discourse on morality and spirituality. The branding of the Catholic application by "Bully! Entertainment" (figure 7.4) also implies capitalist undertones, and Juliana's rite of passage into society through Catholicism is embedded with colonial meanings that are specific to Latin America and continue into the digital age. The undertones of the film's conclusion also point back to Keiichi's comments about the co-mingling of modernity and modernization in the Latin American urban space, which does not force citizens to choose between worldviews of science or religion,

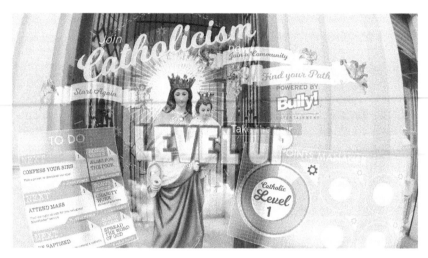

Figure 7.4.　Juliana's new AR immersion interface ("Hyper-Reality," 05:35).
© Keichii Matsuda 2016. Source: vimeo.com/166807261.

but rather the hybridity of these systems as collaborators rather than contradictions.

## Conclusion

Keiichi Matsuda's speculative exercise in architecture and filmmaking in "Hyper-Reality" presents two different modes of electronomadics: the passive cyborg body of Juliana, who views and interacts with a controlled system of consumerism, and the hacker cyborg who disrupts codes and navigates freely within its own resistance script. Based on these two constructs of cyborg citizenship, both Haraway and Matsuda envision the ideal cyborg citizen as an informed user, collaborative virtual architect, and conscious dissident with respect to hegemonic power structures. Despite these idealisms, "Hyper Reality" offers a gloomy simulation of what could come, or perhaps even a direct warning of the entrapment of identity, consumerism, and oppression that could accompany the merging of human consciousness with technological coding. While this is all-too familiar to the conceptualization of the Latin American cyborg that Juliana embodies, Matsuda's initial optimism about the electronomad in his master's thesis reflected the hope for a liberated and empowered augmented citizen. By simulating the split vision of the Colombian cyborg in a networked space, the film's global speculation takes shape in Medellín rather than in another metropolis,

such as San Francisco or Tokyo, that symbolizes technological innovation to the outside world. The digital decor of the augmented Latin American city means that objects and subjects host another virtual layer, which is culturally coded to predict, guide, motivate, and interact with time and space that is both deep and instantaneous. Matsuda's transnational projects appeal to global viewers as well as Latin American ones by speculating about a greater immersion into hyperreality than theorists such as Haraway, Baudrillard, and Virilio could imagine in their historical moments. As a testament to the increasing global concern over the augmentation and/or debilitation of the cyborg, human empathy and technology blend together into a new lexicon, with terms like intuitive advertising, matchmaking algorithms, data optimization, smart homes, AI guardians, and cloud memory storage. The spaces where the human can avoid technology altogether are shrinking due to an increasing technological and virtual presence globally. As users scroll through lengthy terms of use agreements and click "accept," a certain amount of control, privacy, and identity is relinquished to an invisible web of connectivity, not to mention forthcoming technologies that will take connectivity into immersion through wearables and even through the seamless human-computer cognition objectives of Elon Musk's project Neuralink.[5] As the forthcoming data revolution of 5G transforms our spaces into AR immersion and a networked Internet of Things, short film projects like "Hyper-Reality" are essential tools to help current users imagine ways to adapt and/or resist future problems and complexities both locally and globally.

NOTES

1 Kickstarter is a web-based funding platform for creative projects. Contributors learn about projects through promotions and then contribute funding and other resources through online monetary transfers.
2 According to the *Cybersecurity Operations Handbook*, "hacker" is defined as one of the following: "1) A person who enjoys exploring the details of programmable systems and how to stretch their capabilities, as opposed to most users, who prefer to learn only the minimum necessary; 2) A person who programs enthusiastically (even obsessively) or who enjoys programming rather than just theorizing about programming; and 3) A person who enjoys the intellectual challenge of creatively overcoming or circumventing limitations" (Rittinghouse and Hancock 2003, 293).
3 "Smart city" is a term in development that usually implies an urban area that uses different types of information communications technologies (ICT),

such as sensors, to collect data and then uses these data to manage assets and resources efficiently.
4 Karl Marx provides this explanation of "commodity fetishism" in *Capital*: "the commodity-form, and the value-relation of the products of labour within which it appears, have absolutely no connection with the physical nature of the commodity and the material relations arising out of this. It is nothing but the definite social relation between men themselves which assumes here, for them, the fantastic form of a relation between things" (1990, 165).
5 While recruiting and lab testing have been underway since 2019, a C-Net article from April 2017 explains the forthcoming results of Neuralink: "Neuralink's initial goal is to help people deal with brain and spinal cord injuries or congenital defects. The technology could help paraplegics who have lost the ability to move or sense because of spinal cord injury – a medical treatment that's a lot less shocking than radical sci-fi ideas like 'consensual telepathy.' But the long-term goal is to build a 'digital superintelligence layer' to link humans with artificial intelligence, a technology he views as an existential threat to humanity." Musk continues, "Ultimately, we can do a full brain-machine interfaces where we can achieve a sort of symbiosis with AI ... one goal along the way will be letting people type 40 words per minute just by thinking" (cited in Shankland 2019, n.p).

REFERENCES

Baudrillard, Jean. 1994. "The Precession of the Simulacra." In *Simulacra and Simulation*. Translated by Paul Foss, Paul Batton, and Philip Beitchman. University of Michigan Press.
Brown, J. Andrew. 2010. *Cyborgs in Latin America*. Palgrave Macmillan.
García Canclini, Néstor, Renato Rosaldo, and Christopher L. Chiappari. 2005. *Hybrid Cultures: Strategies for Entering and Leaving Modernity*. University of Minnesota Press.
Gomez-Peña, Guillermo. 2011. "Border Interrogation." YouTube, La Pocha Nostra, 8 May. www.youtube.com/watch?v=tG1NBQYTi1Q.
Foucault, Michel, Mauro Bertani, Alessandro Fontana, and David Macey. 2003. *"Society Must Be Defended": Lectures at the College de France, 1975–76*. Picador.
Haraway, Donna. 2013. "A Cyborg Manifesto: Science, Technology and Socialist-Feminism in the Late Twentieth Century." In *Simians, Cyborgs, and Women: The Reinvention of Nature*. Routledge.
Jeremijenko, Natalie. 2001. "A Futureproofed Power Meter." Whole Earth. New Whole Earth LLC. Accessed 13 February 2023. https://margaritabenitez.com/readings/futureproofmeter.pdf.
Kristoff, Emory, and Alvin Chandler. 2011. "8 Jules Verne Inventions That Came True (Pictures)." *National Geographic*, 8 February.

Mann, Steve, and Hal Niedzviecki. 2001. *Cyborg: Digital Destiny and Human Possibility in the Age of the Wearable Computer*. Doubleday Canada.

Manovitch, Lev. 2002/2005. The Poetics of Augmented Space: Learning from Prada. http://manovich.net/index.php/projects/the-poetics-of-augmented-space.

Marx, Karl. 1990. *Capital: A Critique of Political Economy*. Penguin Books in Association with New Left Review.

Matsuda, Keiichi. 2010a. "Domesti/City: The Dislocated Home in Augmented Space." Master of architecture thesis.

– 2010b. "Keiichi Matsuda: Augmented (Hyper) Reality & Cities for Cyborgs @ ifs." Vimeo, 16 October 2012. vimeo.com/51523837.

– dir. 2013a. "Hyper-Reality Kickstarter: Update 3, Day 25 (3D Side-by-Side)." Vimeo, 2 December. vimeo.com/80846079.

– 2013b. "Hyper-Reality: A New Vision of the Future." Kickstarter, 7 November. www.kickstarter.com/projects/723600195/hyper-reality-a-new-vision-of-the-future.

– 2014. "Kickstarter – Hyper-Reality: A New Vision of the Future." Vimeo, 8 April. vimeo.com/78557705.

– 2016a. "Hyper-Reality." hyper-reality.co/.

– dir. 2016b. "Hyper-Reality." Fractal.

Rittinghouse, John W., and William M. Hancock. 2003. *Cybersecurity Operations Handbook: The Definitive Reference on Operational Cybersecurity*. Elsevier Science and Technology.

Shankland, Steven. 2019. "Elon Musk Says Neuralink Plans 2020 Human Test of Brain-Computer Interface." CNet. 17 July.

Taylor, Claire, and Thea Pitman, eds. 2007. *Latin American Cyberculture and Cyberliterature*. Liverpool University Press.

Virilio, Paul. 1994. *The Vision Machine*. Indiana University Press.

Viseu, Ana. 2003a. "Simulation and Augmentation: Issues of Wearable Computers." *Ethics and Information Technology* 5.1: 17–26.

– 2003b. "Social Dimensions of Wearable Computers: An Overview." *Technoetic Arts: An International Journal of Speculative Research* 1.1: 1–82.

Weintraub, Scott. 2018. *Latin American Technopoetics: Scientific Explorations in New Media*. Routledge.

# 8 Eva Rocha: Digital *Desaparecido* in the Postinternet

NORBERTO GOMEZ, JR.

Today, the ubiquity of the digital network results in a homogenization of individual identity and culture. This condition – which I refer to in this chapter as the "postinternet" – does not describe the end of the internet, but rather its complete and total immersion into everyday life, politics, business, and culture. The concept of a "postinternet" was first used by artists and critics in the mid-to-late 2000s to describe artwork informed by the effect of internet communication technologies on aesthetics and culture. In this chapter, however, I apply the term beyond the realm of aesthetics, extending to the "triumph of the network": the end of the on-line/offline binary through perpetual connection in life, death, and the afterlife. This immersion is utterly complete and complex, to the point of digital connectivity becoming invisible and banal. The postinternet is lower case "i" now, because, for most users, the internet is no longer a bounded, definable entity consisting of hardware or even computers that connect or disconnect. The technology of digital connectivity has been backgrounded and thus mystified.[1] The postinternet simply *is*, insofar as "what's your wi-fi?" results in a positive response: the internet surrounds us, invisibly, within a cloud.[2] It defines us, and it expands us, compresses, and extinguishes us throughout its network. Through this constant digital immersion, we are extended until we disappear.

## Eva Rocha and Digital *Desaparecidos*

This disappearance of personhood and the authority of the digital network system feels troublingly familiar to artist Eva Rocha (see figure 8.1). Having grown up in Brazil during the height of the repressive military

I am very grateful to Eva Rocha for her tremendous contributions to my knowledge of her work and its central themes. Thank you, Eva.

regime of the 1970s, Rocha has for years questioned the validity of her own memory, as a result of indoctrination while in a country where the state controlled all facets of the media. The Brazilian state violently suppressed constitutional rights and, beginning with Institutional Act 5 of 1968, engaged in extreme media censorship broadly affecting social and political life (Skidmore 1989, 134).[3] The military tortured, assassinated, and "disappeared" their political enemies, including media figures and journalists.[4] Along with the political fears surrounding her at the time, Rocha, a victim of human trafficking by local criminals at the age of sixteen, is deeply aware of disappearance on both a societal and a personal level. For three days, Rocha was bound and forced to wear a bag over her head before ultimately escaping (Jacobs 2018, 14). This trauma has resulted in Rocha's preoccupation with the objectification of the self and the body, and ultimately of their erasure. As art historian Fredrika Jacobs explains of Rocha, "disassociating herself from her frightening situation and moving to the safety of a psychic space she was doubly absent" (2018, 14).

In recent years, as historical documents and images of repression and torture at the hands of the Brazilian dictatorship became easily accessible through the internet, Rocha, now in the United States, has been triggered by the similarities between a repressive Brazil, her own kidnapping, and a global society immersed in a digital connection in which its infrastructure is empowered by the authority of corporate technocrats and Western powers sustained by systems of surveillance and control. Rocha warns of the "relationship of the language of technology and the language of dictatorship and interrogation" found in social network systems, particularly Facebook, which compels users to provide their personal information (2018).[5] When, for example, a user uploads a photograph, Facebook asks the user to "tag" who they are with and their location, while concurrently harvesting data from the picture, and thus perpetuating multilayering processes of surveillance. In a sense, by gathering this data, Facebook is asking "How much are you worth?" as the platform depends on the advertising revenue gleaned by allowing third-parties access to user data. For Rocha, such digitally mediated acts of objectification harken back to the language of an authoritarian-criminal Brazilian state. However, unique to this postinternet condition is the nebulous nature of a decentralized power and geography – these surveillance mechanisms are stateless. It is through this authoritarian quest for transparency by technology companies, in particular, but also increasingly in tandem with state-sponsored surveillance programs, and individual users' own complicity, that Rocha fears not just the loss of self, but also the "process in which collective memory can be manipulated," where "there is an impossibility of truth created

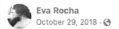

**Eva Rocha**
October 29, 2018 · 🌐

I was born during the Brazilian military dictatorship. Only in 2014 when they opened the archives of the dictatorship I got to know that one of the biggest headquarters of military torture was minutes from the place where I was born. When the archives were opened we got to know things like that the journalist Herzog (middle top image in the still from video) had not hung himself as we had heard in the news but had been killed due to torture in prison. At that time, due to the imageries triggering my memories, I created a video commenting on my personal memories versus the collective memories and manipulated by the power memories implanted on us. At that time I heard that dictatorship, fascism etc were things of the past.

Yesterday my country elected a man whose son wore to vote a t-shirt with the face of the man who was our worse torturer, Colonel Ustra, with the words "Ustra Live!"

The past is not past while we avoid acknowledging its presence and, while careless, we make it present.

Figure 8.1. *"I was born during the Brazilian military dictatorship. Only in 2014 when they opened the archives of the dictatorship I got to know that one of the biggest headquarters of military torture was minutes from the place where I was born. When the archives were opened we got to know things like that the journalist Herzog (middle top image in the still from video) had not hung himself as we had heard in the news but had been killed due to torture in prison. At that time, due to the imageries triggering my memories, I created a video commenting on my personal memories versus the collective memories and manipulated by the power memories implanted on us. At that time I heard that dictatorship, fascism etc were things of the past. Yesterday my country elected a man whose son wore to vote a t-shirt with the face of the man who was our worse torturer, Colonel Ustra, with the words 'Ustra Live!' The past is not past while we avoid acknowledging its presence and, while careless, we make it present."* Eva Rocha, Facebook, October 29, 2018, screen capture by the author, June 9, 2019. © Eva Rocha 2018.

through technology" (2018).[6] Such a process is similar to the censorship and rewriting of history in Brazil and also to the more recent disputes over truth in the post-truth, "fake news" environment after the 2016 US presidential election. Even this struggle over the interpretation of "fake news" is itself a form of sensationalism, as the term is arguably a rebranding of an old problem – disinformation.

In response to this tangled web of digital content and memory, Rocha created the installation *Tag: A Memorial Poem* (2015). She began by collecting archival photographs taken during the Brazilian dictatorship, among others related to social and political oppression and upheaval, including photos of the disappeared. Rocha retrieved the images using basic search engine queries and personal research, and then uploaded them onto a unique, private Facebook account (separate from the artist's own). Together, these images form a bricolage within Facebook's online community, declaring Rocha's awareness of the power and responsibility the individual social media user has in either perpetuating or undermining this new authoritarian system based in technology. Rocha perceives the process of sharing details of one's private life online as a matter of objectification and quantification, as the multifaceted components of users' personal identities "disappear" into their constituent parts and become parsable data. Here, social media users become digital *desaparecidos* – a familiar term in Latin America to describe persons who have "disappeared," often at the hands of authoritarian regimes.

Historically, the *desaparecidos* of Latin America total in the tens of thousands across multiple nations, with extreme numbers in Chile and Argentina, due primarily to military dictatorships like that during Rocha's childhood. In Brazil, among other countries, there is also a new generation of *desaparecidos* as a result of cartel violence and border migration (see Miraglia 2016). Thus, a history of disappearance and loss have, over many decades, become embedded into the national psyche of many in Latin America, leading to the advent of "truth commissions" during the "memory boom" of the 1970s and 1980s. The commissions were initiated by diverse members of civil society – journalists, students, activists, victims and their families – who cooperated with NGOs, religious authorities, and international organizations to demand justice and to find answers for those with missing loved ones. Such commissions, as Azucena Morán and Melisa Ross (2017) explain, operated with the objective of denouncing the crimes of the state and other violent and repressive institutions: "By demanding the acknowledgment and active protection of human rights, these groups promoted the understanding of complicated, often unspeakable realities; gathered the testimonies of survivors – generating and preserving social

memory – ; and years later, became the cornerstone for transitional institutions – allowing for their formation and institutionalization."

Rocha's *Tag* is of the lineage of truth commissions that came before, as she memorializes the kidnapped, tortured, dead, and forgotten of an older, authoritarian system in Brazil. But it contains a twist: she warns of an ongoing disappearance that is growing and spreading throughout the current digital network, and she reclaims the images of the past and positions them within the present. *Tag* is a memory project, a truth commission of one, wherein Rocha reasserts her voice, fragmenting and upsetting the medium – Facebook – so that it becomes a vehicle for its own deconstruction. This is what I mean by bricolage. Rocha's approach even reflects the Situationist tactic of *détournement*, where pre-existing symbols and signs are reconfigured in order to create new, often contrarian, meaning. In a way, Rocha hijacks the Facebook system by uploading images from the Brazilian archives (including ones that aren't typically welcomed into the community due to their content), along with others accessible via the internet (e.g., images of the torture at Abu Ghraib, and the attacks on 9/11), and the artist's own portrait (see figures 8.2 and 8.3). Together, these images collapse the systems of language, image, design technology, and history, opening them up for critique and weakening the "language of interrogation."

Beyond the context of authoritarian repression, *Tag* poses questions about how a person becomes a "user," losing their individuality as their presence – even the fragmented images of their death – is increasingly distributed across the social network in the bits and bytes that code their on/offline activity. On the macro level, the same may be said of a community, culture, or heritage. As much as corporate internet systems facilitate this quantification and surveillance, it is also true that the public participates in the process, often due to social pressures, being more than eager to accept default privacy contracts and statements, and in effect accepting weak privacy standards as the new normal. In this augmented state – where network access is always near one's body, in hand, or tucked into a pocket – the technology of the internet has all but disappeared, as it embeds itself more efficiently into flesh, effectively backgrounding the programming that scaffolds these processes.[7] The border between connection and disconnection is broken; the expectation is a perpetually online world. The boundaries between on- and offline have become blurry and difficult to demarcate. One becomes "tethered," as Sherry Turkle (2011) describes the condition in *Alone Together*. As a result of this perpetually tethered state, we have, Turkle warns, "connectivity and its discontents," the contradiction of technically being more connected and yet feeling disconnected from others,

Figure 8.2.  Images from *Tag: A Memorial Poem* (2015). © Eva Rocha 2015.

or lonely (13). In this transitional state, with its resulting form of augmented reality, chaos reigns as technology evolves faster than humans can adapt – particularly with respect to social relations. By "augmented reality," I refer here to the phenomenon in which we view the *offline* world through an increasingly virtualized lens, the *online* ecosystem from which we develop and administer our identities and social interactions. With the dangers of binarism in mind, the online now informs our physical lives more than ever. In a sense, our online lives have taken precedence, and our offline presence must strive to live up to the digital profile. It may be said that the opposite was true only a decade or two ago: our offline lives mostly tended to inform our escape online: the latter was a place for fantasy and pseudonymity. Now, Turkle describes a shift in our experience of the digital, where "demarcations blur as technology accompanies us everywhere" (162).[8]

I understand this state of being embedded within a global network – or Turkle's state of being tethered to the network – as a condition of the postinternet. Art theorist Gene McHugh, blogging in 2009–10, described the changes in art making in the network age as, "based, not on art objects or individual projects, but rather on 'personal empires,' which are the brands that artists develop over time" (2011, 37). Referring to the work of artist Kevin Bewersdorf, McHugh continued, "he

realized very clearly that the quality of art on the Internet is not measured in individual posts but in the artist's performance through time, through their brand management," where "a user is judged, not by one status update, but rather by their style and pace of updating" (37). This condition extends beyond artists, with many of these same features affecting individuals and their personal use of social media.[9] The network condition of the postinternet, then, is "internet aware," a moment, McHugh claims, "when the Internet is less a novelty and more banality."[10] As Artie Vierkant writes, the postinternet is a "result of the contemporary moment: inherently informed by ubiquitous authorship, the development of attention as currency, the collapse of physical space in networked culture, and the infinite reproducibility and mutability of digital materials" (2010, n.p.).[11]

Rocha's *Tag* demonstrates a profound concern for the negative impact of this immersion: a fear of the system producing an uninformed, servile user (or disappearing person), rather than an empowered actor, as the postinternet person's identity is subjected to the force of an intangible yet ever-present interrogation system. Besides the individual, Rocha's critique can be extended globally to include electronic colonialism, brought on by the ideology of digital globalization. As the largely American-English internet infrastructure extends beyond physical, geographical boundaries, it quietly conquers other cultures. Through homogeny, this "business" produces a less complex consumer – a digital citizen of the world – through social media, apps, and search engines, and so on. With the use of digital communication technologies rising in Latin America, Rocha's creative response is informative and constitutes a warning about the ongoing process of objectification and colonialism.

Recognizing the "globalized localism" of the internet's US origins, Sérgio Amadeu da Silveira (2018) warns that the

> luta pela inclusão digital pode ser uma luta pela globalização contra-hegemônica se dela resultar a apropriação pelas comunidades e pelos grupos sociais socialmente excluídos da tecnologia da informação. Entretanto, pode ser apenas mais um modo de estender o localismo globalizado de origem norte-americana, ou seja, pode acabar se resumindo a mais uma forma a mais de utilizar um esforço público de sociedades pobres para consumir produtos dos países centrais ou ainda para reforçar o domínio oligopolista de grandes grupos transnacionais.
>
> (struggle for digital inclusion may be a struggle for counter-hegemonic globalization if it results in the appropriation of communities and social groups socially excluded from information technology. However, it may

Figure 8.3.  Images from *Tag: A Memorial Poem* (2015). © Eva Rocha 2015.

be just another way of extending the globalized localism of American origin, that is, it can be summed up as yet another way of using a public effort of poor societies to consume products from the central countries or to reinforce the oligopolistic domination of large transnational groups.)

The postinternet, with its rhetoric of digital globalization, continues the project of colonialism in a multimodal electronic format that Thomas L. McPhail (2014) describes as e-colonialism – the dependency of poorer regions on the communication hardware and software of post-industrial nations. In McPhail's reading, e-colonialism is established and perpetuated by the importation of communication hardware, infrastructure, services, and foreign-produced software. However, more than simply a question of technology, McPhail expresses concern that foreign information technology, "frequently favoring the English language, will cause the displacement, rejection, alteration, or forgetting of native or indigenous customs, domestic messages, or cultural traditions and history." He continues: "Whereas mercantile colonialism sought to control cheap labor and utilize the hands of laborers, electronic colonialism seeks to influence and control the mind" and behaviour. Through this rhetoric of language, as the postinternet has moved into maturity, it isn't hard to see other examples of globalization through a standardized sense of aesthetic and social conventions, humour, memes, and so on, emerging and

resulting in a global popular monoculture, or what Edilson Cazeloto (2010) calls an "informatics monoculture." In this monoculture, the "standardization of cultural practices based on the dissemination of digital technologies leads to a concept of universality which is implicit in the wide acceptance of the computer as a fundamental tool of human culture. This universality is seen as part of the hegemony of capitalism, with its presumption of a 'cult of quantitative efficiency'" (187).[12] This cult of data, whose end goal is monotony threatens to annihilate personal and cultural difference. It threatens identity and body with its philosophy of objects: in its wake lie the digital *desaparecidos*.

## Memorialization and Culture Industries

The ability of *Tag* to engage and disorient the audience derives substantially from the work's multimedia and spatial quality – its very own in-betweenness. Rocha's compiled imagery is edited into a looped video and then installed in a small dark physical space, creating a simulated interrogation room, with a large cement block in the centre (figure 8.4). While the video projects onto a wall – featuring screen captures from the Facebook profile and other photographs with soft video transitions – Rocha's powerful, often autobiographical prose can be heard. As the viewer watches, they inhabit a space between the online and offline. From this distance, within the chasm, the role of Facebook in processing Rocha's loss and recovery is illuminated, as is the role of the viewer as citizen of the social media community. Throughout the video, Rocha calmly leads viewers on a brief tour of her childhood and Brazilian culture, with the themes of memory and identity circulating throughout. Early in the poem she says, "I know now what was scaring me and what was my very first memory – absence," in reference to a procession featuring veiled women who walked through her community (another reference to obscured or masked identity). Images fade in and out: the lifeless naked body of dead progressive Brazilian journalist Vladimir Herzog – murdered in 1975 by the government, which falsified his death as a suicide – is now framed by the Facebook interface which jarringly demands, "Say something about this photo…" (figure 8.5). Under a photo of the Twin Towers burning (figure 8.6), the question reads, "Who were you with?"[13]

It is no surprise that Herzog's image would feature prominently in *Tag*. Herzog – as a journalist, academic, and writer – represents a romantic figure of truth, tortured by the authorities, whose murder acted as a rallying cry for the rising discontent of opponents of the government. Herzog's body, then, is rendered a symbol of the death of truth,

Figure 8.4. Two images of the *Tag: A Memorial Poem* (2015) installation, showing images of torture and state repression mingled with Rocha's own portrait and Facebook motifs. © Eva Rocha 2015. Photographed by Spencer L. Turner.

Figure 8.5.  A still from *Tag: A Memorial Poem* (2015) showing the body of Vladimir Herzog, with Facebook post prompts. © Eva Rocha 2015.

Figure 8.6.  Images from *Tag: A Memorial Poem* (2015), showing images of torture, victims' photographs, and the World Trade Center on 9/11, interspersed with Facebook tag prompts. © Eva Rocha 2015.

or the ugliness of truth in the postinternet. The Brazilian junta murdered Herzog, and then fabricated a story of his suicide in order to claim their innocence in the matter and feed into the stigma of suicide – a manifestation of the opposition's *weakness*. Rocha, on the other hand, reclaims Herzog's authority.

Her decision to introduce Herzog's body into the simulated network brings up the question of authority and authorship over one's legacy in the postinternet. Indeed, today the globalizing e-colonialism of the postinternet and its technology is a path toward engineering a perfect user-customer who consumes (even self-cannibalizes) and is consumed by the system from the prenatal stage (e.g., life-blogging future parents) into the afterlife (profiles left after death that are used posthumously by family and friends, or even by the system: consider celebrities).[14] Describing this phenomenon as part of the "digital afterlife industry," Carl Öhman and Luciano Floridi (2017) explain that "online technologies enable vast amounts of data to outlive their producers online, thereby giving rise to a new, digital form of afterlife presence" (639). These data retain their value, as the deceased is still connected, via memorial pages, to other living users who continue to interact with the dead, thus further contributing to the data. As Tero Karppi (2013) explains:

> memorialized user accounts and memorial pages are Facebook's way of utilizing the dead and of granting them agency. This conversion of dead user profiles into memorial accounts "thingifies" them ... Memorialized accounts and memorial pages are able to generate affective relationships from beyond the grave by grouping people together, giving things to be shared and thought of together. While the dead themselves do not participate in actions, share things or contribute in the accumulation of user information directly, they yet become navigational points for other users' participation. (15–16)

Although the ability to "memorialize" users is presented here in terms of the opportunity to grieve and celebrate the lives of loved ones, these affective experiences are translated into quantifiable data as we interact with the user profiles of the deceased. Thus, Karppi argues, the platform is interested not so much in our experiences of mourning but in the kind of data generated by our interactions with the deceased online. In this way, then, the network owns the dead and their legacy, and, as ghosts or zombies, they continue to interact with the living and perpetuate the system.

Bodies, living and dead, are used as objects of meaning, as Herzog's was for the Brazilian state. For the born digital, this way of life has no

opposite: one has always been alive and dead in the culture industry, a kind of simultaneity – always already a product. Or, as Turkle (2011) writes of the born digital, they are the "first to grow up not necessarily thinking of simulation as second best" (17). As we see with the Brazilian dictatorship's victims, particularly Herzog, personhood and history can be taken away, transformed, reused, reinterpreted, and rewritten to the detriment of whole societies and in order to squash dissent. Social media norms expand this powerful authoritarian possession of digital images and legacy. By attempting to claim ownership over one's digital legacy, a person is claiming authority over the system and subverting the will of tech hegemonies. *Tag* attempts to be the antithesis of the "digital afterlife industry," as it produces not quantification but, rather, remembrance, agency, personal and social mourning, and empowerment. While those images of Herzog in *Tag* appear to communicate large societal and historical issues, the work is also a meditation on personal struggle. Rocha appropriates Herzog's body, and other bodies of the missing and tortured, as both a memorial to them and a search for her own truth within the digital noise.[15] Rocha's own face, asking to be "tagged," floats above photographs of *desaparecidos* (see figure 8.3). Yet other frames feature police torturing naked prisoners in front of a Disney mural (figure 8.6) – an example of media colonization through the film industry.

As a powerful conclusion, Rocha's portrait softly fades, and disappears into the homogenous, flat, faceless default profile icon of the Facebook network – completely neutral, nihilist, a global citizen, like the *desaparecidos* of Latin America who, in their absence, become a number on a list – depersonalized, dehumanized, objectified into quantifiable bits and bytes (figure 8.7). Ironically, in the network, Rocha seems to fear that she herself will disappear, as she is forced to appear completely transparent, alone with everyone. "Those memories I have are mine, I think," she continues her poem. "But I don't recognize myself in them anymore. As if that self was not me but another."

### Conclusions on the Triumph and Terror of the Network

From the perspective of one who has existed in between many worlds – as a citizen of Brazil, then one who learns to distrust their own indoctrination, and, finally, as a citizen of the United States – Rocha is able to articulate the warning signs of a particularly troubling form of authoritarianism: that of the systems of sociality found over the digital network. Rocha's critical vision evokes the subversive liminality of *nepantla*, a term borrowed from Nahuatl most often by Chican@ and Latinx

Figure 8.7.  Images from *Tag: A Memorial Poem* (2015). © Eva Rocha 2015.

theorists to describe a dynamic state of in-betweenness through which a person is able, due to their otherness, to see cultures from multiple perspectives. The cracks and fissures of conflicting realities result in *nepantla*, described by Chican@ Gloria E. Anzaldúa (2015) as a "psychological, liminal space between the way things had been and an unknown future" (969). *Nepantla*, writes Anzaldúa "is the space in-between, the locus and sign of transition. In *nepantla* we realize that realities clash, authority figures of the various groups demand contradictory commitments" (976). Rocha's particular vision is a result of her uncomfortable experience within the digital network, where the oppressiveness of the Brazilian military junta and her own disappearance are triggered by the availability of historical images as well as the interrogations of social media and feelings of erasure. In this state of conflict, Rocha is in networked *nepantla*, or what I refer to as *"net-pantla"*: an electronic space for enacting resistance, a threshold between the pre-internet and the totalizing postinternet.[16]

In Rocha's work, it is through non-consumerist systems and expressions of remembrance and active participation in the ownership of one's digital legacy, as well as those of the forgotten and/or lost, that the unique histories of persons and places may offer a form of resistance to electronic colonialism's flattening of difference. *Nepantla* is a

condition with some overlapping similarities with the in-betweenness of the postinternet condition. With this in mind, we may think of a kind of *net-pantla* that informs digital rebellion or critical network projects throughout the world, through which digitally literate protestors and collectives are able to subvert the system due to their state of liminality within the network. It is important to note that, in Latin America, alternative digital forms of protest are not new – in fact, historical examples may show them to be some of the most potent. For example, the Ejército Zapatista de Liberación Nacional (ELZN; Zapatista Army of National Liberation) and its supporter's use of the internet in the late 1990s illustrates that Mexico has a history of deep engagement in radical digital protest (see, for example, the rhetorical construction of virality that Thea Pitman discusses in her chapter in this volume). Maria Elena Martinez-Torres (2001) uses the example of the Zapatistas in her description of the transformative potential of transnational social movements facilitated by internet technologies. Such movements, she argues, provide a possible arena for developing counter-hegemonic power. Martinez-Torres writes that, by their use of performance, the Zapatistas have "transformed the battle field into a stage, where they use symbols, characters and narrative to capture the imagination and creativity of a growing audience around the world. Within Mexico their innovative use of the media has converted their struggle into a war of images, words, legitimation, and moral authority, which has provoked a strong echo in Mexican civil society" (348). Martinez-Torres describes a tactic, much like Rocha's *Tag*, where some of the internet's strongest attributes – its performative and symbolic nature – can be subverted for the purpose of protest – a *détournement*. The images of the masked, pipe-smoking Zapatista spokesman Subcomandante Marcos, issuing communiqués featuring "poetry, humor, scholarship, and storytelling," were well received and shared by internet users, particularly by those in the West (Ford, Cleaver, and Garza 1998). The success of the EZLN on the internet was largely driven by outside political supporters and other public users fascinated by the, arguably romanticized, visuals (much like the popular image of Che),[17] including photography, illustration, graphic design, and sloganeering delivered in tune with the highly visual, fast-paced nature of the network. As Tamara Ford, of Accion Zapatista and ZapNet Collective, explains, the "public space has been commodified and mainstream news has been reduced to info-tainment. The Zapatistas have been able to rupture that space, in part via Marcos' skill as a performance artist" (Ford, Cleaver, and Garza 1998). However, the images of Marcos and the Zapatistas, too, very quickly became romanticized, packaged, and commoditized – serving

as a symbol of rebellion, yes, but also as an early example of internet "slacktivism," a largely Western form of protest and support for often social, progressive movements, without much participation beyond a "like," a "share," a "comment," or the posting of an image. The Zapatistas, through this process of celebrification, become one dimensional.

Therefore, although the potential for *net-pantla* may bode well as a subversive act and strategy – as it facilitates a cultural tendency to critique the power structures of the network – the powerful role that US-based tech corporations play globally has expanded so quickly and reached a level, in the postinternet, of such enormous cultural capital through their immersion into systems of sociality that even a unique Latin American digital culture may find itself quickly appropriated, consumed, or disappeared. For example, in the case of the Brazilian protests of 2013 – inspired largely by the *Movimento Passe Livre*, which sought free fares on mass transit – journalist-activist and digital theorist Bernardo Gutiérrez (2015) concedes that, although the protests were disruptive, their use of digital technologies left something to be desired, when, for example, members of the government and the Workers' Party used social media to solicit the cooperation of activists. The digital protests were turned against themselves.

The disruptive feature of *net-pantla* comes from the tension of difference, but if this difference is successfully integrated into the postinternet, it may also be defanged and turned into a commodity or, more popularly, just another meme. Writing of the culture industry many decades before, Max Horkheimer and Theodor W. Adorno (2002) declared that "culture today is infecting everything with sameness." In response to those who claim that technology fills the needs of a democracy, they counter:

> The standardized forms, it is claimed, were originally derived from the needs of the consumers: that is why they are accepted with so little resistance. In reality, a cycle of manipulation and retroactive need is unifying the system ever more tightly. What is not mentioned is that the basis on which technology is gaining power over society is the power of those whose economic position in society is strongest. Technical rationality today is the rationality of domination. (94–5)

The critique of monoculture resulting from the tightening relationship between technology and society applies to the current network condition more than it did in the time of the Frankfurt School, making the above quotation hauntingly prescient. Rocha writes, "I think Adorno saw the process in which many governments promote their ideology

and use manipulation to keep an art that is quiet or even mute" (2018).[18] *Tag* is an example of raising one's voice on behalf of those censored and missing, and yet, within the saturation of voices or visual noise, it becomes increasingly difficult to be heard.

The challenge for Rocha, and other artists, is to maintain a tenuous dance with the network, never allowing themselves to be completely seduced, appropriated, and consumed by it. Yet, perhaps problematically, *Tag* is not publicly presented *on* Facebook. In fact, the original account that housed the imagery used for the video was kept private. Thus, the page was used only to generate the content needed for the artist's ultimate vision: a presentation of the work as a multimedia installation within an art gallery or in some form of art context. Arguably, for the general public such art-spaces are less inviting or accessible than social media platforms. The question, then, is why Rocha did not allow the Facebook account to live on as a public hypertextual component of the installation, where users can comment or post, perhaps in memoriam. Through the act of "friending" and "sharing" the *Tag* page, users would be participants in a subversive meme. However, when the social media environment is used only for its interface and aesthetic to be displayed outside the digital realm, the critical power of public interaction is potentially undercut. More importantly, though, it is possible that, taken out of context from the digital space, the critique of the network power structure disappears – absolving it of any responsibility and, in essence, championing the Facebook system as a new frame or container in support of storytelling and documentation within an elitist fine art community or even, within journalism and digital storytelling. In this process of framing the work as fine art, the images of repression and violence may become aestheticized, appropriated, and therefore objectified for the art industry. The missing become fodder for aesthetic consumption, while the art audience remains at a distance, free to judge the work for its artistic merits, and, with a clear conscience, return home, share their photos on social media, and tag #evarocha: the network triumphant.

NOTES

1  This process of backgrounding and disappearance progressed as the advent of Web 2.0 technologies in the 2000s fuelled a shift toward user-generated content and collaborative social dialogues online. As users were invited to contribute to the digital platforms, they became less consumers than unpaid data-creators. This period, as defined in the oft-quoted article

by publisher Tim O'Reilly, features the rising use of social networking platforms and a championing of business models that rely on the users' role as content generators. As companies harness users' data-creation as their principal economic resource, these structural changes in the fabric of the internet are described using buzzwords that focus on intellectual collaboration: O'Reilly (2005) describes Web 2.0 technologies as "harnessing collective intelligence" and the "wisdom of crowds." These terms attempt to afford power to users – after all, it is their "intelligence" being harnessed – while displacing the power that comes with owning other people's data, which is simply free labour under the guise of interaction and ownership. At the same time, there is the "perpetual beta," "in which the product is developed in the open, with new features slipstreamed" regularly as a result of "real time monitoring of user behavior" (O'Reilly 2005). In effect, Web 2.0 is the beginning of big data and digital surveillance models as well as the transformation of public-private norms through new, less user-editable (i.e., standardized profile templates) social platforms and communities, which are later enhanced further through their mobile integration as apps. As this model has become normalized, popular culture has followed, and things have changed accordingly. Today, it is a given that many who are networked are full-time personal brand ambassadors – small business owners of themselves. The end result of this form of corporate thinking and its integration with social network users is the objectification of digital bodies and personal legacies as well as new forms of performativity and social expectations and less knowledge of the underlying systems (i.e., how they work and what they want).

2  On a related note, the term "cloud" has now taken the role of visually defining the public's idea of "where things go" over the network, or internet, similar to the way that the World Wide Web's success in the 1990s led to the term "web" defining the entire system, even though it was only a part of the greater internet, or a way to access information over the internet in a multimedia fashion, particularly through the advent of graphical user interfaces (web browsers).

3  Issued by President Artur da Costa e Silva, "under the new legal umbrella military censorship hit the media. Not even the most prestigious journalists were exempt. Carlos Castello Branco, Brazil's best-known political columnist, was arrested, along with the director of his paper, *Joma! do Brasil*. Later the paper's editor, Alberto Dines, was also arrested." Moreover, "the censorship that had emerged in an ill-coordinated, ad hoc manner in December 1968 was regularized in March 1969 by a decree that outlawed any criticism of the Institutional Acts, government authorities, or the armed forces. As if to indicate where they thought the opposition would originate, the architects of censorship also forbade the publication of any

news of workers' or student movements. All media were placed under the supervision of military courts" (Skidmore 1989, 82).

4   Skidmore (1989) writes that the "Brazilian death toll from government torture, assassination, and 'disappearance' for 1964–81 was, by the most authoritative count, 333, which included 67 killed in the Araguaia guerrilla front in 1972–74" (269).

5   Eva Rocha, email to author, 20 March 2018.

6   Ibid.

7   This may sound like an exaggeration, perhaps, with respect to wearable fitness and health-tracking technologies, but already in development by some companies like Google are smart, or bionic, contact lenses that do everything from measure glucose levels to providing VR display.

8   "Until recently, one had to sit in front of a computer screen to enter virtual space. This meant that the passage through the looking glass was deliberate and bounded by the time you could spend in front of a computer. Now, with a mobile device as portal, one moves into the virtual with fluidity and on the go ... Demarcations blur as technology accompanies us everywhere, all the time. We are too quick to celebrate the continual presence of a technology that knows no respect for traditional and helpful lines in the sand" (Turkle 2011, 160, 162).

9   Marisa Olson (2011) writes that "the pervasiveness of network conditions is such that the *postinternet* (as a conceptual vehicle) drives and spills across planes of practice and territories of discourse in just as rapidly seering [*sic*] a way as Richard Dawkins means to imply when he argued that the concept of evolution was such a totalizing theory as to sizzle through all fields like a 'universal acid,' from philosophy to astronomy, from theology to zoology. Such is the universality of the *postinternet, in this postinternet moment*" (62, emphasis in the original).

10  The term "Internet aware" is attributed to Guthrie Lonergan, but there has been some question as to what he meant, particularly in relation to its popular interpretation (the latter of which I use as well); see Moody (2015). The "banality" definition is attributed to McHugh by Artie Vierkant, but it cannot be found in the published edition of *Post Internet: Notes on the Internet and Art*.

11  It is telling that some of the younger stars connected to the postinternet art movement (though they may not have accepted this term), Parker Ito and Petra Cortright, rose to fame with work made on and meant to be seen on the web and are now producing work in the tradition of painting. Their digital imagery and subject matter were of the network: cam girls, naïve webcam videos, pixels, anime characters, and digital reproducibility, all with a mix of humour. Now, they produce rectangular works of painting (even if digitally rendered), with much reference to surface, mark making,

and colour. They are meant to be hung in galleries and sold. Around the same time, art critic Jerry Saltz noticed an upswing of mediocre paintings in the tradition of formalism, or zombie formalism. In 2014, Saltz described such work as

> decorator-friendly, especially in a contemporary apartment or house. It feels "cerebral" and looks hip in ways that flatter collectors even as it offers no insight into anything at all. It's all done in haggard shades of pale, deployed in uninventive arrangements that ape digital media, or something homespun or dilapidated … Most Zombie Formalism arrives in a vertical format, tailor-made for instant digital distribution and viewing via jpeg on portable devices. It looks pretty much the same in person as it does on iPhone, iPad, Twitter, Tumblr, Pinterest, and Instagram. Collectors needn't see shows of this work, since it offers so little visual or material resistance. It has little internal scale, and its graphic field is taken in at once. You see and get it fast, and then it doesn't change. There are no complex structural presences to assimilate, few surprises, and no unique visual iconographies or incongruities to come to terms with. It's frictionless, made for trade. Art as bitcoin.

12  Of the "cult of quantitative efficiency," Cazeloto (2010) writes:

> With the availability of informatics in daily life and the expansion of its applications through communication, the criterion of "efficiency" – typical of the logic of the productive apparatus – entered the experienced world with a hegemonic value in industrial societies. Accepting the need for the computer in quotidian culture is equivalent to accepting "efficiency" as a universal value. Today, this instrumental vision of "efficiency" remains as the backdrop of the Internet. There is a real obsession with speed, transmission and storage capacity, and with the number of connections. How many friends does one have on Orkut? With how many people can one "talk" on MSN? How many people access one's blog? How many users are on this discussion list? The need for communication on the Internet is normally justified in terms of "efficiency": it is the most adequate means to reach a large number of people, or to transmit information in the shortest possible interval of time at the lowest possible cost. (192)

13  The question could refer to the day one watched 9/11 occur, those who flew the planes, or even those who jumped.

14  For more of my writing on this subject of "digital death" and the "afterlife," see Gomez (2013 and 2016).

15  Rocha's work, here, featuring *desaparecidos* is reminiscent of, but less problematic than, the work of Mexican artist Teresa Margolles, known for including actual body parts in her installations.

16  The use of "*net-pantla*" as a means of approaching Rocha's work resulted from conversations with Rhian Lewis about the work of Chicano and

Latino theorists, particularly Gloria Anzaldúa, on *nepantla*, a concept of "in-between-ness" as a radical space of (de)construction and creation.

17  The famous image of Ernesto "Che" Guevara, "Guerrillero Heroico," was originally photographed by Alberto Korda in 1960 and popularized by artist Jim Fitzpatrick in 1967 as black-and-red stylized illustration. The latter would, over the decades, be adopted by other revolutionary movements and punk and rock bands, and sold as T-shirts at the corporate mall store Hot Topic. This example of the commoditization of revolution is further explored later in this section.

18  Eva Rocha, email to author, 20 March 2018.

REFERENCES

Amadeu da Silveira, Sérgio. 2018. "Inclusão digital, software livre e globalização contra hegemônica." Software Livre, 24 March. https://web.archive.org/web/20180325202508/http://www.softwarelivre.gov.br:80/artigos/artigo_02.

Anzaldúa, Gloria E. 2015. *Light in the Dark, Luz en lo Oscuro: Rewriting Identity, Spirituality, Reality*. Edited by Analouise Keating. Duke University Press [Kindle].

"Brazil Truth Commission Releases Report." 2014. *National Security Archive Electronic Briefing Book*, no. 496, 10 December. https://nsarchive2.gwu.edu/NSAEBB/NSAEBB496/.

Cazeloto, Edilson. 2010. "Informatics Monoculture, Permaculture and Construction of a Counterhegemonic Sociability." *MATRIZes* 3.2: 187–200.

Ford, Tamara, Harry Cleaver, and Heather Garza. 1998. "A Rebel Movement's Life on the Web." Interview by R.U. Sirius. *Wired*, 6 March. https://www.wired.com/1998/03/a-rebel-movements-life-on-the-web/.

Gomez, Norberto, Jr. 2013. "Dead Man's Bell: Virilio's Tele-Vision and the Cybernetic Eternity." Digital America. http://www.digitalamerica.org/dead-mans-bell/.

– 2016. "Spaces Of Death: A Starter Kit For Dying-Digital." CVLTNation. 3 February. http://www.cvltnation.com/space-of-death-a-starter-kit-for-dying-digital/.

Gutiérrez, Bernardo. 2015. "A Conversation with Bernardo Gutiérrez: Exploring Technopolitics in Latin America." By Emiliano Treré. *International Journal of Communication* 9: 3803–13.

Horkheimer, Max, and Theodore Adorno. 2002. *Dialectic of Enlightment: Philosophical Fragments*. Edited by Gunzelin Schmid Noerr. Translated by Edmund Jephcott. Stanford University Press.

Jacobs, Fredrika. 2018. "Eva Rocha: Corpus of Memory." *Woman's Art Journal* 39.2: 12–21.

Johnson, Bobbie. 2010, "Privacy No Longer a Social Norm, Says Facebook Founder." *Guardian*, 10 January. https://www.theguardian.com /technology/2010/jan/11/facebook-privacy.

Karppi, Tero. 2013. "Death Proof: On the Biopolitics and Noopolitics of Memorializing Dead Facebook Users." *Culture Machine* 14 : 1–20. https:// www.culturemachine.net/wp-content/uploads/2019/05/513-1161-1-PB .pdf.

Martinez-Torres, Maria Elena. 2001. "Civil Society, the Internet, and the Zapatistas." *Peace Review* 13.3: 347–55.

McHugh, Gene. 2011. *Post Internet: Notes on the Internet and Art.* LINK Editions. http://www.linkartcenter.eu/public/editions/Gene_McHugh _Post_Internet_Link_Editions_2011.pdf.

McPhail, Thomas L. 2014, "eColonialism Theory: How Trends Are Changing the World." *World Financial Review,* 21 March. http://www .worldfinancialreview.com/?p=209.

Miraglia, Paula. 2016. "Drugs and Drug Trafficking in Brazil: Trends and Policies." Brookings Institution. https://www.brookings.edu/wp-content /uploads/2016/07/Miraglia-Brazil-final.pdf.

Moody, Tom. 2015. "'Internet Aware Art': The Misunderstanding Continues." 2 December. Tom Moody. https://www.tommoody.us/archives/2015 /12/02/internet-aware-art-the-misunderstanding-continues/.

Morán, Azucena, and Melisa Ross. 2017. "Truth, Memory and Democracy in Latin America." Open Democracy, 26 September. https://www .opendemocracy.net/democraciaabierta/azucena-mor-n-melisa-ross/truth -memory-and-democracy-in-latin-america.

Öhman, Carl, and Luciano Floridi. 2017. "The Political Economy of Death in the Age of Information: A Critical Approach to the Digital Afterlife Industry." *Minds and Machines* 27: 639–62.

Olson, Marisa. 2011. "Postinternet: Art after the Internet." *Foam Magazine* 29 (Winter): 59–63.

O'Reilly, Tim. 2005. "What Is Web 2.0." O'Reilly, 30 September. https://www .oreilly.com/pub/a/web2/archive/what-is-web-20.html?page=4.

Saltz, Jerry. 2014. "Zombies on the Walls: Why Does So Much New Abstraction Look the Same?" *Vulture*, 17 June. http://www.vulture. com/2014/06/why-new-abstract-paintings-look-the-same.html.

Skidmore, Thomas E. 1989. *The Politics of Military Rule in Brazil 1964–85.* Oxford University Press.

Turkle, Sherry. 2011. *Alone Together*. Basic Books.

Vierkant, Artie. 2010. "The Image Object   Post-Internet." JstChillin. http:// jstchillin.org/artie/pdf/The_Image_Object_Post-Internet_us.pdf.

# 9 PretaLab: Afro-Brazilian and Indigenous Women's Digital Autonomy

EDUARD ARRIAGA

In a recent article, "Markup Bodies," Jessica Marie Johnson (2018) develops a clever critique of the interconnection between slavery studies ("death"), Black studies ("life"), and digital humanities. She argues that the current proliferation of digital approaches, structures, and tools – including those that are intended to be advocates for social justice, such as the digital humanities – reproduce and disseminate processes of quantification that can be traced back to slavery. The logic behind her argument has to do with the idea that enslaved Africans were quantified and measured – commodified – through tools such as slave ship manifests and nomenclatures created by slaveholders as a way to exert surveillance on their property.[1] Aimé Césaire (2001) uses the term "thingification" to represent this process, which, like the colonizer-colonized relationship, is based on pure force and imposition. Both parties become objects – things – and, therefore, "colonization = thingfication" (42). Johnson argues that, in the United States, historians, digital humanists, and scholars using digital tools "mark up the bodies and requantify the lives of people of African descent" (59), revalidating practices to classify and dehumanize subjects through the use of data and technology. She highlights the translation of biometrics assigned to enslaved Africans (such as skin colour, hair texture, height, or concepts such as *nègre*, moreno, quadroon, and so on) directly into present-day digital forms as an example of the dehumanization perpetuated by

This chapter is meant to be read as part of a Global South gendered subjects' movement that uses the hybrid connections between digital and analogue media to pursue its agendas of liberation. I do not intend to speak for people in this movement, as they are searching for their own autonomy; rather, I am interconnecting with their initiatives from a Global South perspective and with the idea of analysing community Black digital practices they carry out.

the digital. Likewise, the expansion of "carceral technologies" (Benjamin 2016) such as ankle monitors, predictive-policing algorithms, and workplace surveillance technologies are additional examples that reinforce Johnson's assertion. Technology, Benjamin argues, "is not only a metaphor for race, but one of the many conduits by which past forms of inequality are upgraded" (148).

The technological marking of bodies, as discussed by Johnson, may no longer be seen as exclusively imposed on Black and African-descendant communities in the Americas and elsewhere. In light of contemporary developments and revelations about the intermingling between big digital corporations,[2] governments, and security agencies to mine user data and manipulate social opinion, Jaron Lanier's discussion of the objectification of human beings by corporate artificial intelligence seems to be more relevant than ever, affecting many citizens and actors, regardless of ethnic, racial, gender, or class extraction.[3] However, it is particularly Black and gendered bodies whose digital information continues to expose them to real dangers of physical, discursive, and economic disappearance. For instance, Safiya Umoja Noble (2017) clearly shows how search engines (e.g., Google and Yahoo) – one of the most popular internet technologies – perpetuate stereotypical representations of Black women. In her experiments, she found that in searches using ostensibly neutral terms such as "Black girls," the search engines consistently returned sexually charged results, most of them openly pornographic, unlike the results of a search for the term "white girls."[4] Her experiment confirms that even our identity is affected by technology and data, or, as John Cheney-Lippold (2017) put it, "who we are is what our data is made to say about us" (8). One of the greatest fears of contemporary internet and social media users relates to their privacy and security, given the vulnerability of the information available for purchase regarding their personal activities on the web. Black communities, however, do not fear only for a potential invasion of their private life and thoughts; they are constantly facing the anguish of being killed, brutalized by police forces or hate groups, or disappearing, either physically or symbolically – or both.

Despite such fears, activists and community members who fight anti-Black violence also see online digital platforms and social media tools as amplifiers that allow them to reach broader communities and denounce social injustices (Roberts 2018).[5] We continue to use our devices and expose our data in order to connect to our communities and propose alternative means of creating and sharing knowledge. Black Lives Matter, Black Girls Code, Red de Mujeres Afrolatinoamericanas (Network of Afro–Latin American), Afrocaribeñas y de la Diáspora

(Afro-Caribbean and Diasporic Women), Plataforma Alyne (Alyne Platform), among others, are some of the initiatives and groups that strategically use digital platforms as a way to connect and extend their actions and solidarity networks. The case of Black communities presents interesting ways of appropriation and reconceptualization of digital tools and their potential use in supporting the struggles for freedom, recognition, and autonomy. Those processes of appropriation are part of "Black digital practice," understood as "the revelation that black subjects ... have commodified themselves and digitized and mediated their own black freedom dreams in order to hack their way into systems (whether modernity, science or the West)" (Johnson 2018, 59).

This chapter highlights how Black and African-descendant communities carry out Black digital practices as tactical endeavours to reinscribe their human existence, produce knowledge, and propose alternative representations. Although the ideas developed herein can be applied and contrasted from a global Blackness perspective, the main focus will be Afrolatinx women, particularly those represented by PretaLab, an Afro-Brazilian digital project (https://www.pretalab. com/). PretaLab is an initiative led by Silvana Bahia, an Afro-Brazilian journalist who is part of Olabi, an NGO that fosters the democratization of technological production and the inclusion of marginal actors in the field of technological innovation. With the sponsorship of and funds from the Ford Foundation, PretaLab is an example of initiatives in which foreign/global funds are used to support local/peripheral initiatives and, at the same time, globalize and connect actors and sectors that are otherwise difficult to access. PretaLab's main objective is "estimular la inclusão de meninas e mulheres negras e indigenas no universo das novas tecnologias" (fostering the inclusion of Black and Indigenous women in the field of new technologies),[6] as a way to address the lack of representation and recognition of women of colour in digital technology and innovation, and, furthermore, to amplify their impact in the field. PretaLab addresses this lack of inclusion by working on three interconnected objectives: data gathering and mapping; oral history collection; and training and networking. In each of these aims, PretaLab has produced and continues to yield concrete outcomes. These include a survey documenting the lack of inclusion of Black and Indigenous women in the field of technology and innovation in Brazil; a series of YouTube videos documenting the personal histories of Black and Indigenous women with digital technology/innovation; and coding and makership workshops taught by PretaLab coordinators and associated organizations such as Olabi and data_labe (Data Lab), among others. All these initiatives, outcomes, and projects offer points

of contact between PretaLab and growing Brazilian ecosystems of activists and cultural workers interested in showing how the field of digital technology may be strategically used by marginalized communities.

Afro-Brazilian women, particularly those represented by PretaLab, are shifting from the idyllic vision of the digital to propose strategic appropriations (via hybrid connections between digital and analogue traditional practices) to produce "social technologies" or ways of hacking social systems of classification and exclusion. If data have been used historically to transform Black human beings into objects (thingification), Black digital initiatives, and particularly PretaLab, propose the use of data to reinstate that humanity, to claim rights and to speak directly to, and with the language of, power. Gathering data about Black women in technology as well as exploring methodologies and strategies to analyse and connect such data through the projects described above allow PretaLab to refigure the way data could be used and understood by peripheral communities and diverse human lives. The project's ultimate goal is not to simply resist, but rather to propose alternative pathways of digital action and existence with direct impacts in the analogue world through the achievement of autonomy (Freire 1996) to learn, educate, and determine their existence from diverse epistemological perspectives.

### Black Women at the Centre of Brazilian Digital Possibilities

Social media tools and digital platforms are seen, by governments, the private sector, and global agencies, as means for marginalized communities to finally speak for themselves and create their own representations. This is the case in Latin America as a region, and Brazil in particular. As Heather Horst (2011) points out, Brazilians have been presented as leaders in innovation related to social media, digital tools, information, and communication technologies in the region. Some researchers, commentators, and digital practitioners have considered that the adoption of those tools and dynamics of communication became a better way (i.e., more accessible and direct) for marginalized sectors of the population to finally make their voices heard and become visible at both national and international levels. In 2006, for instance, Hermano Vianna announced "a periferia ... não precisa mais de intermediários ... para estabelecer conexões com o resto do Brasil e com o resto do mundo" (1; the periphery does not need more mediators ... to connect with the rest of Brazil as well as with the rest of the world). Although this statement was part of the launching and marketing strategy of a thematic program about Brazilian favelas and urban

peripheries on the country's largest TV network, O Globo, it also relates to the long-running national/global discourse that has – since the popularization of the internet in the 1990s – posited the adoption of the digital as a fundamental move for economic and cultural development.[7] In fact, one of the most popular topics of discussion related to Brazilian digital culture has to do with popular media and the appropriation of digital tools by peripheral sectors, particularly favelas.[8] Such projects are developed with the goal of creating self-representations of urban sectors that have been neglected, as well as a way to show how those hidden locations produce, disseminate, and manage their own culture and their cultural processes. Often designed and sponsored by NGOs or government campaigns, those digital initiatives depart from institutional/outsider leadership to become community-driven projects with an insider's perspective, although they sometimes suffer from issues of sustainability due to economic pressures. Nonetheless, these projects manage to accomplish their main goal of self-representing urban and geographical locations as positive and productive centres where there is more than the violence and crime portrayed by large national and international media corporations. Favela-origin digital appropriations and representations, then, obey a logic of class/community image creation through which residents claim recognition of their spaces as locations of life rather than crime and death. However, despite their intentions of addressing marginalized communities, these digital appropriations do not have an explicit focus on gender or race.

PretaLab adopts a different approach, developed in the same location: the lab strives for greater inclusivity on the basis of race and gender in the fields of digital creation, production, and dissemination. Although its geographical centre of operation is the periphery, and more specifically the favela, its discursive and epistemological centres are Afro-Brazilian women in the digital world.[9] In this case, PretaLab, through the ideation and implementation of the three projects and strategies discussed above, is connected to a global movement of social, racial, and gender justice that aims to empower marginalized subjects and to open up fields formerly considered exclusive to some sectors of the population. By combining making as process (e.g., implementations of their workshops and makerspaces) and data analysis (e.g., surveys), PretaLab manages to foster innovative hybrid practices that combine digital and traditional analogue methodologies. This productive combination is concretely developed in workshops where participants – often a variety of workers with expertise such as wood working tor knitting, for example – are introduced to concepts related to computer programming. However, to make these concepts more

relatable to the daily life of the participants, workshop facilitators connect both worlds by demonstrating, for instance, how a computer program could generate a piece of knitting that can be added to an already started piece.

Bahia and her collaborators had the idea of creating a space to map out the field of digital technology in Brazil and connect Black women to that field. After participating in several initiatives related to the development of digital tools for both corporate and social enterprises, Bahia identified the lack of diversity and representation/participation of Black Brazilians, and Black women in particular, in an industry and cultural landscape that is changing the way our world works. In a world that is ever more centred around digital technologies, the concentration of digital power in the hands of a few people exacerbates existing inequalities. In the initiative Big Data from the South, Milan and Treré (2017) propose that the future of the relationship between technology and people, data and society must be reimagined and decentered, decolonized, and reconsidered from diverse perspectives. Following Anita Chan (2014), they question the "technological universalism" used to imagine and impose technologies in general and digital technologies in particular, forgetting and leaving behind alternative approaches. It is in that sense that Silvana Bahia argues that women, particularly Black women, "need to be part of the changes brought about by the global economy and technological development if they want to be represented in order to contribute and to create alternatives to societies centred around white and heterosexual men's power" (*PretaLab*, https://www.pretalab.com/).

Although PretaLab is the initiative that focuses on Afro-Brazilian women in an inclusionary way, the idea of advocating for gender and race inclusion in the field of digital practice and digital innovation in Brazil and elsewhere is not exclusive to Bahia's project. Initiatives as varied as Oxen TI Menina, Rede de Civerativistas Negras, Pretas Hackers, Gato Mídia, Minas Programam, Info Preta, Preta Nerd, Coletivo Nuvem Negra, among others, advance the idea of rethinking the role of women, and particularly women of colour, in the field of digital technology and in society at large. Often represented and imagined as consumers and receivers of good and products produced by "white males," these collectives and community-driven projects want to reconceptualize and recreate those images through the use of digital tools and data-mining technologies. They may be seen as developing a type of "digital alchemy," as proposed by Moya Bailey (2015), which can be understood as "ways that women of color, Black women in particular, transform everyday digital media into valuable social justice media

magic that recodes failed dominant scripts" (5). However, PretaLab and its associated network of initiatives intend not only to transform existing digital media, but also to create new media by taking advantage of the affordances of programming and technological making to actually secure a space of productive contribution by women of colour into the increasing digital world.

## The Makerspace as Point of Departure for PretaLab Women's Autonomy

For PretaLab, the ideas of makerspace and hacker culture are central strategies for the development of its proposed agendas. In fact, it is from her participation in those spaces of exchange and collaboration that Silvana Bahia started to develop the idea of the lab. When participating in RodAda Hacker, a workshop intended to introduce women to the activity and culture of computer programming, Bahia reflected on the lack of representation of Black and Indigenous women in the program. Although the workshop was designed to allow women to enter a traditionally male-dominated space, she saw no other Black or Indigenous women interacting in the space and trying to reconfigure their social position through digital codes. Soon afterwards, Bahia partnered with Gabriela Agustini, a digital entrepreneur and director of innovation at Templo Coworking and the NGO of Olabi, who had a particular vision with respect to digital technologies, community development, and innovation. Thanks to that partnership, PretaLab became a project, a digital initiative, and a hackerspace centred around innovation both at the technological and social level. Labs and makerspaces, Agustini argues (2014/2017), "são acima de tudo espaços de experimentação. E, por isso, faz mais sentido que eles estejam pautados pela rede e comunidade capaz de articular e não pelos maquinários e componentes existentes" (are above all spaces of experimentation. Therefore, it makes more sense that they are led by community networks able to advance processes and not based on the machines and technology in existence). With that idea, Bahia, supported by Agustini and a community of women of colour – most of them from the favela – started to develop a space dedicated to the inclusion of women of colour in the field of digital technology – a place in which to study, analyse, and make. In that sense, the "digital alchemy" they propose goes beyond the idea of repurposing social media images to propose a recreation of the role of women – from consumers to makers – through processes of imagination and innovation.

PretaLab becomes a space of reflection in which the concept of hacking collides with the ideas of intervention, autonomy, and the possibility

of imagining new ways to execute social and cultural codes. Through the implementation of the three main activities (data mapping, history collection, and organization of workshops), Black women create their own space in the tech industry, while simultaneously reimagining their representation in such a field and the tools it produces. In addition, through workshops, the participants learn how to mix programming and other digital languages with already familiar practices and crafts. If labs and hackerspaces are understood as "espaços permanentes ou temporários que a partir de modelos e perspectivas variadas se dedicam a trabalhar com as novas tecnologias promovendo a integração de artistas, designers, engenheiros, educadores, cientistas, entre outros profissionais" (Agustini 2014/2017; as either permanent or temporary spaces, based on varied models and perspectives, in which participants work with new technologies, promoting integration and interaction between artists, designers, engineers, educators, scientists, and other professionals), PretaLab promotes the integration of subjects whose gender and racial identifications have been edited out from the conversation carried out by professionals and experts, even if those participating women were professionals and experts themselves. That unique perspective entails the construction of particular foci in the way the lab deals with conceptions such as education, knowledge (both production and dissemination), and consumerism, all of which are connected in one way or another to contemporary technological developments. Unlike some widely studied digital projects carried out by favela residents, PretaLab is not interested in telling the story of the periphery from an insider's perspective using digital devices and methodologies. Its interest lies in actually taking over and opening up the space to produce technology, data, and data analyses from the perspective of women of colour, showing that we need to start discussing the way we communicate, interact, and collaborate in search of social justice initiatives and technologies.

## Divides and Bridges: PretaLab as Connection

Inclusion and connection are two values that practitioners and experts have presented as central to digital culture and its dynamic. Nonetheless, as several scholars and activists have demonstrated, every technological development comes with divides: between those who have access to tools, software, machines, and other requirements and those who do not; between communities and individuals who belong to particular privileged social, ethnic, racial, or gender formations and those who do not; between those who want to access the digital and those who

do not, and so on. What seems to be reiterative in the discussion about divides is the idea of access or lack thereof as determined by social and economic factors – usually tied to race and gender. PretaLab reconceptualizes the idea of the digital divide as both a point of departure for its actions, and as a consequence of its philosophy of digital creation.

Since the 1990s, the technological sphere of influence has expanded rapidly, from the increasing production and distribution of devices to the expansion of the material network of poles and wires that make up our communication systems. As a result, digital tools that were previously inaccessible to people outside of professional and elite circles are now much easier to find. Although in Latin America and other Global South locations, access to technology has often been addressed from a communitarian perspective – for example, sharing personal computers and devices, as proposed by Taylor and Pitman (2007, 7) – the focus within contemporary discussions has shifted to users' ability to access and manipulate the logic behind the software and hardware at hand. Until recently, the hardware and software that enable digital connection and participation in the "knowledge economy" were prohibitively expensive and were difficult for marginal communities to access. This is no longer the case, given the array of technologies in our current digital ecosystem. For example, smartphones and other (increasingly inexpensive) tools that are part of the so-called Internet of Things[10] have allowed more people to access digital capabilities. Unfortunately, such expansion still comes at a price: inequitable access to the logic and the algorithms behind these widespread digital tools has widened the divide between those who make and those who consume. In addition, making digital tools more and more accessible has opened the door for corporate producers to gather and exploit users' data without any control, affecting the way they manage, transmit, and present their own information to the world. Equally, the increasingly low cost of digital participation has incentivized users to change the way they manage, transmit, and present their own information to the world into a profitable data entity. Thus, the relationship between the digital world and participating communities and individuals must continue to be seen as "constituted in terms of mediating culture" (Sassen 2002, 109). In connection to the above, PretaLab wants to develop a project in which women of colour engage with digital technology outside a consumer context. "People are always consuming," Silvana Bahia notes (interview with the author, 18 April 2018): what PretaLab's creators want to do is to connect those technologies to different types of epistemologies, so they can produce more just and inclusive symbolic technologies related to their own contexts.

Another divide that arises in discussions and implementations of digital tools in marginal contexts has to do with the North-South divide. Afrolatinxs and Afro–Latin American communities and individuals find common ground in the use of digital tools – from social media to video, instant messaging, blogs, and programming languages –to amplify and connect with communities from diverse contexts and locations that share struggles and experiences. Although contextual and situational differences are fundamental in understanding the way these communities appropriate and use digital tools, several of their projects evoke shared experiences of resistance and creativity. Afrolatinx and Afro–Latin American projects, I argue, make use of data, information, and digital analysis to make visible complex conceptions of humanity. Moreover, such projects use digital tools to blur geographical and regional differences, and foster alternative epistemologies in which human and non-human entities are in constant interconnection.[11]

The development of PretaLab, as well as the project's consideration of connectivity, sought to respond to the rethinking of technological development by people with different visions, origins, and circumstances. The initiative asks: what would happen if the perspectives of Black, LGBTQ, poor, and disadvantaged people were at the centre of the development and application of digital technologies, rather than at the margins? Having Black and Indigenous women thinking about and through digital tools becomes a symbolic move that aims to challenge the production of tools, which PretaLab characterizes as "non-neutral, symbolic objects … produced – in its majority – by white, heterosexual males in the Global North" (PretaLab website). In that sense, the divide is not between those who can access material devices and those who cannot, but between those who produce and those who consume. PretaLab, as a project to mapping and training Black women serves the purpose of connecting these women, bridging the gap in knowledge production, and addressing a situation in which women – and particularly women of colour – have been left out of the conversation.

In the case of PretaLab, connecting to local communities (particularly Black women) who are looking for their own voice and self-representation in the field of digital technology is fundamental in achieving its mission. Likewise, the locality gets exposed to other "scales of locality"[12] (Appadurai 2002, 43), through which each understands that their concerns are shared in diverse forms by other individuals and communities. In that sense, what PretaLab proposes is well mirrored by initiative such as QueerOs (Barnett 2016),[13] transformDH (Bailey et al. 2016),[14] and FemTechNet,[15] among others: that discussing feminism and cyberfeminism as a project goes beyond the technological innovation

and aims to exert radical structural change. As FemTechNet members argue, following traditional feminist scholarship, "technological innovations alone do not make structural changes ... the portable computers, smartphones and tablets that free us from the office do not free us (particularly women) from unremunerated overtime work" (Balsamo et al. 2013). As the target audience of FemTechNet initiatives, PretaLab participants understand that technology is not necessarily a liberatory force but can nonetheless be meaningfully co-opted to pursue individual agendas. Members argue that data and digital technology may be, at the same time, a tool for liberation and a vector for control and annihilation that further restricts the agency of marginalized subjects.[16]

Connectivity and collaboration, as two fundamental values for the development of PretaLab work, lead members to rethink conceptions of humanity, pedagogy, as well as of knowledge production/dissemination. Adopting what Safiya Noble (2016) calls a "Black feminist technology studies approach," PretaLab takes into consideration an interlocking or intersectionality that goes beyond Kimberlé Crenshaw's intersectional triad of race-class-gender (Risam 2015). As a digital activist endeavour, PretaLab fosters connections not only between communities and individuals with common needs, but also between diverse scales of identity that are constantly interacting in a culturally complex context like that of Brazil. However, unlike Safiya Noble's claim that "Black women's participation in the digital is frequently evinced in neoliberal preoccupations with learning to code, or to enter science, technology, engineering, and math (STEM) fields, given and in spite of the low employment rates of Black women in Silicon Valley and across science and information technology fields" (2016, 1), PretaLab participants see learning to code and use programming language as a way not to enter the field of digital technology but to speak with the language of power. PretaLab participants do not see such a learning process as a naïve activity of appropriation in order to become assimilated. On the contrary, by integrating the languages, codes, and practices of the digital with daily activities such as selling, woodworking, or knitting, PretaLab repurposes digital tools and dynamics of the digital to pursue the inclusion of participants – and of others – as intersectional subjects. One outstanding example is the Ubuntu platform, created by Monique Evelle – a PretaLab member – whose main aim is to connect Black and gendered perspectives, including those of human right activists. In Ubuntu, the user can connect and speak with people – as in mainstream social network sites – but she can also create spaces to collaborate on social projects. The platform also features tasks and wikis that allow for constant collaboration and interaction beyond the simple publication

of pictures and "liking" of pages/actions. The Ubuntu platform currently has 3,477 active members connected around the idea of free collaboration and interaction through the power of free software and open communication (personal observation as a member). This platform illustrates how those involved in PretaLab interact with digital technology to develop social technologies engaged in the defence of what is human, particularly of those who have been condemned – by diverse factors – to fight for the recognition of their human status.

## Data, Mapping, and Hybrid Technological Innovation

Jessica Marie Johnson (2018) argues that "from the personal to the political, from the embodied to the spiritual, from the human to the community, black digital practice charts a path against the drive for data" (70). This means that the idea of data that resides at the centre of our current digital revolution dehumanize subjects – and Black women in particular. PretaLab members understand that today's world is managed through data and data analysis. With that knowledge in mind, in 2017 they created a web space and composed a survey to gather concrete data on the way Afro-Brazilian and Indigenous women see, interact with, and participate in the digital world. If they were going to address issues about the role, position, and place of Black and Indigenous women in the digital field, they needed to map and identify who those women were. Thanks to the survey, PretaLab gathered personal histories and related data that allowed it to see in detail the gap in digital access and appropriation by Afro-Brazilian women.[17] The project's main objectives were: to make visible the lack of representation of Black women as an issue connected not only with digital technological fields, but also with human rights and basic representation of humanity; and to foster the development of positive models to inspire Black women to become part of fields such as digital technology, engineering, and other spaces of creation and innovation. These objectives addressed issues of access as a matter of creatorship rather than consumerism, as the opportunity for communities to take an active role in digital knowledge production by contributing diverse perspectives and epistemologies.

The survey, as both one of the main points of departure and one of the first products created through the initiative, was developed based on a particular conception of technology. PretaLab members argue that technology "está para muito além do trabalho formal das engenharias e da computação, por exemplo" (Olabi 2017, 7; goes beyond the dominion of engineering and computer science). Such an idea of going beyond professional boundaries and expert knowledge allows PretaLab

to reconsider perspectives of neutrality, access, and production in the digital realm, in addition to understanding technology as a situated set of conceptions, practices, and material objects.[18] In that sense, technology for PretaLab is a "processo que englobe eletrônica, robótica e inteligência artificial, mas também – e talvez principalmente – a experimentação com fazeres outros que podem ser tradiçinais e analógicos" (Olabi 2017, 7); process that encompasses electronics, robotics and AI, but also – and probably more so – a constant experimentation with other traditional ways to make and create that could be analogue). The survey was fundamental in identifying both the lack of information – a significant finding in itself – on Black and Indigenous Brazilian women's role in technological innovation, as well asdeveloping potential future projects and initiatives to address those needs.[19]

The conception of access PretaLab proposes is far from a naïve celebration of digital technologies as saviours from structural problems such as racism, discrimination, and other social injustices. On the contrary, its members are aware that digital tools and platforms are not neutral, but, rather, carry political, economic, and cultural values infused by its creators and producers – usually white, heterosexual, and rich men (Bahia interview with author). It is up to marginalized communities to learn how to use these new languages, to hack the codes spread throughout the internet, and to create a more inclusive, just, and flexible version of the internet, of existing digital tools, and of data about themselves. Thus, PretaLab expects not only to make particular issues visible, but also to address them through what Bahia calls a "pedagogy of autonomy" (referencing Freire's inspiring work), based on the autonomy of Black and Indigenous women and other marginalized individuals to search for epistemological alternatives to worlds in which they disappear. PretaLab, then, proposes a restoration of Black and Indigenous humanities through a "ética universal do ser humano" (universal human ethics), understood as ethics that condemns social injustices arising from monolithic truths that discriminate on the basis of race, gender, or class (Freire 1996, 10). The digital thus becomes their field of action, as it is understood not as a space of pure instrumental connections, but as a new version of our changing cultures.

## PretaLab and Afrolatinx Digital Cultures: Beyond (Black) Digital Humanities

Although the digital humanities has expanded to become more inclusive, the discipline's focus on recovering and retrieving hidden – mostly textual – connections in the "digital cultural record" (Risam 2019, 5)

continues to leave some cultural traditions and histories behind. Such is the case for Black communities in the Americas, who, because of historical circumstances, need to recover and, in some cases, reinvent their stolen histories, traditions, and epistemologies, which are constantly erased or made invisible. PretaLab, as a digital initiative that may not be considered part of the digital humanities, goes beyond the horizon of such a field, proposing alternative epistemologies in which conceptions of materiality, temporality, and even technology become central to talk about an Afrolatinx digital decolonial perspective.

In making the case for *Black* digital humanities as an alternative project to that of the digital humanities more generally, Kim Gallon (2016) explains that the former "might be considered as a digital episteme of humanity that is less tool-oriented and more invested in anatomizing the digital as both progenitor of and host to new – albeit related – forms of racialization" (n.p.). Although Afrolatinx and Afro–Latin American digital endeavours might be seen as an instance of the project heralded by Gallon, they are broader and expand on epistemological and intersectional grounds that encompass race, ethnicity, gender, class, and culture, among others. Digital projects that are part of an Afrolatinx and Afro–Latin American cultural perspective are networked initiatives connected by common histories of exclusion, and by regional commonalities, linguistic familiarities, and/or political agendas. Such context-specific elements make it difficult to claim universal agencies and advocacies for groups whose humanity is tied to the evolution of the species but, at the same time, separated by the specificity of their contextual appropriations and symbolic constructions. PretaLab and other Afrolatinx and Afro–Latin American digital projects may be seen as building on Gallon's Black digital humanities and, furthermore, as bridging any possible gaps and disconnects in the intersections through which those communities experience their humanity.

As multiply marginalized individuals and communities, Afrolatinxs and Afro–Latin Americans present themselves as particularly connected with political struggles and alternative projects whose ultimate goals are the defence of human life and humanity as a whole. In this sense, these projects somehow complement Gallon's Black digital humanities by creating an actual alternative project, not only to the digital humanities or to other academic fields, but to economic, cultural, and political agendas that require recovery – as proposed by Gallon – and well as a constant process of creativity and reinvention. This process places complex human beings at its centre and questions exclusive projects of humanity to recentre human and non-human entities as fundamental for our existence.

It is important to understand that Afrolatinx/Afro–Latin American digital projects' search for the recognition of the humanity of their participants does not have to do with acceptance into what Sylvia Wynter has characterized as the "Man-as-Human" Eurocentric conception of humanity. On the contrary, those initiatives resist such a conception, and further propose alternative projects of humanity, connected to territory and to other conceptions of economy, society, and human interactions. Likewise, PretaLab, as an Afrolatinx digital project and initiative, advances that idea of rearticulating conceptions of humanity and particularly of racialized/gendered humanity. The conception of "human" in the PretaLab project, Bahia argues, is something basic geared to teach the general public that Black folks are people who have rights, who think, who produce rather than merely consume: "São perssoas que têm direito, que pensam, que produzem, que estão refletiendo sobre seu tempo" (They are also human beings with rights, who are producing critical work to think their own time, their world) (Arriaga and Villar 2001, 53). The notion of "humanity" therefore goes beyond the "Man-as-Human" conception extended into what Wynter understands as the "West culture" and infused in contemporary digital tools and technologies. In order to rearticulate that humanity from a feminist and intersectional perspective, PretaLab's contributors developed a mapping process and a digital storytelling initiative through video interviews that will serve as a reference for future generations.

Technology, from PretaLab's perspective, should not be reduced to the limits of the digital and to the product of codes imposed as expert knowledge. On the contrary, the project's creators and participants consider that traditional knowledge and strategies to build tools for daily activities are fundamental for both understanding technology at its fullest and connecting discourses of digital technology with communities who were not the target audience of those innovations. PretaLab trains associated communities in using digital tools and protocols without forcing them to abandon traditional conceptions of craft and innovation that they have been using for long time in order to survive. Rather, it fosters a symbiotic connection between analogue and digital, popular and expert, so it can help empower communities, particularly women of colour who have had few, if any connections, with innovations and technology. It is through this complex symbiosis of values, actions, epistemologies, and process of making that PretaLab aims to decolonize knowledge and reinscribe the humanity of Black and Indigenous women in the context of a world that has constantly gendered their existence.

NOTES

1   Johnson's article calls the readers' attention to how brutal dynamics of counting and marking up Black bodies in eighteenth- and nineteenth-century slave societies are reproduced by "digital architecture" and current digital dynamics. She argues that "the brutality of black codes, the rise of Atlantic slaving, and everyday violence in the lives of the enslaved created a devastating archive. Left unattended, these devastations reproduce themselves in digital architecture, even when and where digital humanists believe they advocate for social justice" (2018, 58).

2   Corporations such as Facebook, Twitter, and Google, among others, are implicated in cases such as Cambridge Analytica and vote meddling in the 2016 US election. Likewise, figures such as Julian Assange and Edward Snowden have been calling the public's attention to these companies as surveillance industries. For additional information on this issue, see Hill (2011), Bump (2018), and Chaitin (2018), among others.

3   Jaron Lanier is an American author and computer scientist whose books have been fundamental to understanding the way the internet currently works. Drawing from his involvement in the Silicon Valley industry, particularly the development of virtual reality platforms, Lanier has written books such as *You Are Not a Gadget* (2010), *Who Owns the Future* (2012), and *Ten Arguments for Deleting Your Social Media Accounts Right Now* (2018). In all of them, Lanier questions the way the internet has become a predatory network that feeds on uncompensated human labour and on human information, creating serious issues related to social and economic justice.

4   Such problematic representation is not exclusive to internet technology and search engines. Those biases can be found in any technology, including GIS tools, which are seen as completely neutral and centred around the representation of space. However, as Noble (2011) notes, these tools "construct a landscape and representation of places, people and processes according to various commercial or political agendas" (93–4).

5   Even in the face of a situation like surveillance and invasion of privacy, "we seem to systematically favor the new consumption and production practices that current digital tools and the Internet have opened to us" (Chacón 2001, 20).

6   From the PretaLab website, https://www.pretalab.com/. This and subsequent translations are mine, unless otherwise noted.

7   Pontos da cultura is an initiative developed by the Brazilian government developed under the tenure of Brazilian singer and, at the time of writing, minister of culture, Gilberto Gil. The idea behind this well-documented project is to provide institutional support for cultural projects and

initiatives developed by communities who are not necessarily professional creators but who manage their own cultural productions and artistic creations. One of the most important developments from Pontos da cultura had to do with the implementation of digital tools and digital dynamics as elements appropriated by these communities in the creation of their artistic and cultural projects.

8  In recent years, Tori Holmes (2019) argues, "there has been a particular growth in the number of web-based projects publishing content about [and from] the favelas in urban periphery areas in ... Brazilian cities" (220).

9  The digital world, as PretaLab understands it, takes diverse forms: as practice, as professional field, as cultural dynamic, and so on. Its interest, however, is more focused on the digital world as a professional and creative field, promoted and usually dominated by men.

10  The "Internet of Things" is a concept that came into use in the 1990s to refer to the communication between networks and electronic devices interconnected through diverse types of links. According to Peter Vogel (2014), such a label has its origins in the concept of Radio Frequency ID communication (RFID), initially used to connect either passive or active elements to databases. An example is the barcode found on several items, in which manufacturers and sellers store information about the item so they can identify it. In that sense, we humans have empowered computers to "see, hear and smell the world for themselves" (Ashton 2019), taking our conception of things – material, physical things – into the realm of data. Such idea was further developed with the advent of cellphones and other mobile technologies, in which things and devices became interconnected.

11  Achille Mbembe shows how the conversation on modernity is closely connected to the discussion of capitalism, the creation of a system of organization, and the selection of bodies and objects that could be seen as dispensable. See Mbenbe and Goldberg (2018).

12  Appadurai (2002) explains that locality is not a spatial structure, but a process and a project connected to both imagination and embodiment, or what he calls "a structure of feeling" (34). Such a locality is experienced at diverse scales by diverse factions of society, thanks to phenomena such as migration and the central role of technology, image, and communication in our current global world. Thus, someone whose spatial and embodied locality is in India, for instance, may be connected to and living in a Canadian or an American locality – with particularities depending on the location within those states – through the use of media technology. Such scales are fundamental to understand how the African diaspora, among others, is connected to and develops diverse types of identifications related to locality as process.

13  QueerOS is a manual developed by Fiona Barnett et al., following the idea
of Kara Keeling (2014). In "QueerOS: A User Manual" (2016), Barnett and
her colleagues explain that the idea of such a project is to bring "together
information technologies, sexuality, and other forms of difference" (i.e.,
race and class) that are embedded in operating systems (n.p.). The whole
idea of the project and the manifesto, as the authors describe the user's
manual, make evident that computational and operating systems are
far from neutral and therefore need to be reprogrammed from a queer
perspective.

14  #transformDH is an academic movement that emerged around 2011 with
the idea of advocating for more inclusive digital humanities. It started as
a hashtag on Twitter and became a movement thanks to its amplification
and dissemination through social network platforms. The hashtag was
based on three key claims: making central to the digital humanities (DH)
questions of race, class, gender, sexuality, and disability; recognition of
the digital work done by non-academics, activists, feminists, and queer
activits as fundamental to open up the scope of what is considered DH;
and shifting the focus of DH from pure technical questions to political dis-
cussions (Bailey et al. 2016). However, its proposal did not want to become
simply an academic initiative assimilated by the core of the university
without impacting concrete communities. In that sense, the #transformDH
movement proposes, as an alternative to the assimilation of their academic
activist, to "be public scholars, ethical researchers, promulgators of hash-
tags, and always teachers" (Bailey et al. 2016, n.p.).

15  FemTech is "a network of scholars, artists, and students working on, with,
and at the borders of technology, science, and feminism in a variety of
fields including Science & Technology (STS), Media and Visual studies,
Art, Gender, Queer, and Ethnic Studies" (https://femtechnet.org/). Its
networks collaborate on the design and creation of feminist technological
innovations. One of its main projects is the distributed open collaborative
course (DOCC), which was launched in 2013 and whose idea was to serve
as point of encounter and network for scholars, activists, artists, and stu-
dents to exchange knowledge. Such a model is radically different from the
popular MOOC (massive open online course), in which an expert distrib-
utes information in a online learning forum. In the case of FemTechNet, its
DOCC "emphasizes learning collaboratively in a digital age."

16  This idea related to the benefits and perils of technology has become more
persistent in the past few years, particularly with the assassination of so-
cial activists and leaders connected to women's, racial, and human rights
movements in Brazil. The most recent case is that of Marielle Franco, activ-
ist who spoke about police brutality against Black populations in Brazilian
cities. According to a conversation with PretaLab members, activists are

increasingly more cautious about the use of social networks and digital platforms, as it is clear that they are being used by security forces to do surveillance and target those leaders.

17  The main questions that guided the survey were "Are there Black and Indigenous women producing and/or using technologies for social innovation? Where are they?" (Olabi 2017, 8). This survey was carried out by Olabi and consisted of an online questionnaire filled out by more than 600 Black and Indigenous women in 25 Brazilian states and federal districts states as well as in the federal district. The survey was carried out in 2017.

18  Talking about technology as a situated set of practices and processes makes sense when seen from the perspective of the PretaLab survey. Some of the findings determined, for instance, that there are differences in the conception and use of technology depending on factors such as age, occupation, location, and so on. Likewise, one of the most interesting findings was the difference in Black and Indigenous women's experience of coming in contact with digital technology. The former, according to survey results, came to use technology through more formal education, while the latter approached technology through an informal experience of either being self-taught or learning through teaching/learning networks of friends. What is quite interesting here is that such findings defy the "myth of digital universalism" fostered by technological corporations and utopic technophiles. For more information on the survey's findings, see "Pretalab" (Olabi 2017). For more information on the way digital universalism has been challenged from a Global South perspective, see Anita Chan's *Networking Peripheries* (2014).

19  Two of the most salient initiatives are the workshops offered by Olabi to collaborate in creating decolonial feminist methodologies to grapple with biased technologies, and a set of videos to showcase Black and Indigenous Brazilian women who could serve as models in using technology in strategic productive way.

REFERENCES

Agustini, Gabriela. 2014/2017. "Makerspaces, hackerspaces, hacklabs, fablabs: o momento dos espaços de experiemntação." *Huffpost Brazil*. 16 December 2014, updated 26 January 2017.

Allington, Daniel, Sarah Brouillette, and David Golumbia. 2016. "Neoliberal Tools (and Archives): A Political History of Digital Humanities." *Los Angeles Review of Books*. https://lareviewofbooks.org/article/neoliberal-tools-archives-political-history-digital-humanities/.

Appadurai, Arjun. 2002. "The Right to Participate in the Work of the Imagination." Interview with Arjen Mulder. *TransUrbanism* 33.46: 33–46.

V2_Publishing/NAI Publishers. www.v2.nl/files/2017/pdf
/transurbanism-pdf.

Arriaga, Eduard, and Andrés Villar, eds. 2021. "Digital Autonomy and
Knowledge Production by Black Brazilian Women: Interview with Silvana
Bahia." *Afro-Latinx Digital Connections*. University of Florida Press.

Ashton, Kevin. 2009. "That 'Internet of Things' Thing." *RFID Journal*, 22 June.
www.rfidjournal.com/articles/view?4986.

Bailey, Moya. 2015. "#transform(ing)DH Writing and Research: An
Autoethnography of Digital Humanities and Feminist Ethics." *Digital
Humanities Quarterly* 9.2: 1–38. http://digitalhumanities.org/dhq/vol
/9/2/000209/000209.html.

Bailey, Moya, Anne Cong-Huyen, Alexis Lothian, and Amanda Philips. 2016.
"Reflections on a Movement: #transformDH, Growing Up." In *Debates in
the Digital Humanities 2016*, edited by Lauren F. Klein and Matthew K. Gold.
University of Minnesota Press. https://dhdebates.gc.cuny.edu/read
/untitled/section/9cf90340-7aae-4eae-bdda-45b8b4540b6b.

Balsamo, Anne, et al. 2013. "Transforming Higher Education with Distributed
Open Collaborative Courses (DOCCs): Feminist Pedagogies and Networked
Learning." September. *FemTechNet*. https://www.femtechnet.org/about
/white-paper/.

Barnett, Fiona, et al. 2016. "QueerOS: A User's Manual." In *Debates in the
Digital Humanities 2016*, edited by Lauren F. Klein and Matthew K. Gold.
University of Minnesota Press. https://dhdebates.gc.cuny.edu/read
/untitled/section/e246e073-9e27-4bb2-88b2-af1676cb4a94.

Benjamin, Ruha. 2016. "Catching Our Breath: Critical Race STS and
the Carceral Imagination." *Engaging Science, Technology and Society* 2.
DOI:10.17351/ests2016.70.

Budrick, Anne, et al. 2016. *Digital_Humanities*. MIT Press.

Bump, Philip. 2018. "All the Ways Trump's Campaign Was Aided by
Facebook, Ranked by Importance." *Washington Post*, 22 March. https://
www.washingtonpost.com/news/politics/wp/2018/03/22/all-the-ways
-trumps-campaign-was-aided-by-facebook-ranked-by-importance/?utm
_term=.cbb5992a5402.

Césaire, Aimé. 2001. *Discourse on Colonialism*. New York University Press.

Chacón, Hilda. 2001. "Puede Interenet (o la lógica del capitalismo Avanzado)
subverter el Proyecto de la globalización?" *CiberLetras. Revista de crítica
literaria y de cultura* 4. https://www.lehman.cuny.edu/ciberletras/v04
/Chacon.html.

– 2019. "Introduction." In *Online Activism in Latin America*, edited by Hilda
Chacón, 1–30. Routledge.

Chaitin, Daniel. 2018. "Edward Snowden: Facebook Is a Surveillance
Company Rebranded as 'Social Media'." *Washington Examiner*, 17 March.

https://www.washingtonexaminer.com/news/edward-snowden
-facebook-is-a-surveillance-company-rebranded-as-social-media.
Chan, Anita. 2014. *Networking Peripheries: Technological Futures and the Myth of Digital Universalism*. MIT Press.
– 2018a. "#BigDataSur @ LASA: An Overview by Anita Say Chan." 3 December. *Datactive: The Politics of Data According to Civil Society*. https://data-activism .net/2018/12/response-to-big-data-from-the-south-by-anita-say-chan/.
– 2018b. "Decolonial Computing and Networking beyond Digital Universalism." *Catalyst: Feminism, Theory, Technoscience* 4.2: 1–5.
Cheney-Lippold, John. 2017. *We Are Data: Algorithms and the Making of Our Digital Selves*. New York University Press.
Erhart, Amy E. 2015. *Traces of the Old, Uses of the New: The Emergence of Digital Literary Studies*. University of Michigan Press.
Freire, Paulo. 1996. *Pedagogia da autonomia: saberes necessários á practica educativa*. Paz e Terra, Coleção Leitura.
Gaínza Cortés, Carolina. 2019. "Five Hundred Years of Struggle Enter Cyberspace: Neo-Zapatism and the (Old) New Insurgency." In *Online Activism in Latin America*, edited by Hilda Chacón, 163–74. Routledge.
Gallon, Kim. 2016. "Making the Case of the Black Digital Humanities." In *Debates in the Digital Humanities 2016*, edited by Mathew K. Gold and Lauren Klein. University of Minnesota Press. https://dhdebates.gc.cuny .edu/read/untitled/section/fa10e2e1-0c3d-4519-a958-d823aac989eb.
Hill, Kashmir. 2011. "Facebook Responds to Julian Assange's 'Spying Machine' Allegations." *Forbes*, 3 March. https://www.forbes.com/sites /kashmirhill/2011/05/03/facebook-responds-to-julian-assanges-spying -machine-allegations/#2169311c5609.
Holmes, Tori. 2019. "Digital Favelas: New Visibilities and Self-Representation." In *Online Activism in Latin America*, edited by Hilda Chacón, 215–30. Routledge.
Horst, Heather A. 2011. "Free, Social, and Inclusive: Appropriation and Resistance of New Media Technologies in Brazil." *International Journal of Communications* 5: 437–62.
Johnson, Jessica Marie. 2018. "Markup Bodies: Black [Life] Studies and Slavery [Death] Studies at the Digital Crossroad." *Social Text 137*, 37.4 (December): 58–79.
Keeling, Kara. 2014. "Queer OS." *Cinema Journal* 53.2: 152–7.
Kulesz, Octavio. 2017. *Culture in the Digital Environment: Assessing Impact in Latin America and Spain*. UNESCO.
Lopez, Andrew, Fred Rowland, and Katheleen Fitzpatrick. 2015. "On Scholarly Communication and the Digital Humanities: An Interview with Katheleen Fitzpatrick." *In the Library with the Lead Pipe*, 14 January.

Manovich, Lev. 2016. "The Science of Culture? Social Computing, Digital Humanities and Cultural Analytics." *Journal of Cultural Analytics*, 23 May.

Mbembe, Achille, and David Theo Goldberg. 2018. "Conversation: Achille Mbembe and David Theo Goldberg on Critique of Black Reason." *Theory, Culture and Society*, 3 July.

Mignolo, Walter. 2015. "Sylvia Wynter: What Does It Mean to Be Human." In *Sylvia Wynter: On Being Human as Praxis*, edited by Katherine McKittrick, 106–24. Duke University Press.

Milan, Stefania, and Emiliano Treré. 2017. "Big Data from the South: The Beginning of a Conversation We Must Have." *Datactive*, 16 October. https://data-activism.net/2017/10/bigdatasur/.

Noble, Safiya Umoja. 2011. "Geographical Information Systems: A Critical Look at Commercialization of Public Information." *Human Geography* 4.3: 88–105. https://www.academia.edu/1975317/Geographic_Information _Systems_A_Critical_Look_at_the_Commercialization_of_Public _Information.

– 2016. "A Future for Intersectional Black Feminist Technology Studies." In *Scholar and Feminist Online* 13: 3–14. https://sfonline.barnard.edu /traversing-technologies/safiya-umoja-noble-a-future-for-intersectional -black-feminist-technology-studies/.

– 2017. "'Algorithms of Oppression ...' Safiya Noble, USC." *YouTube*. https:// www.youtube.com/watch?v=oqelqdDIDSs.

– 2018. *Algorithms of Oppression: How Search Engines Reinforce Racism*. New York University Press.

– 2019. "Towards a Critical Digital Humanities." In *Debates in the Digital Humanities 2019*, edited by Mathew K. Gold and Lauren Klein. University of Minnesota Press. https://dhdebates.gc.cuny.edu/read/untitled -f2acf72c-a469-49d8-be35-67f9ac1e3a60/section/5aafe7fe-db7e-4ec1 -935f-09d8028a2687#node-10854e4defd664e452cb987d5d4c8a27dae4fc78.

Olabi. 2017. Pretalab. Um levantamento sobre a necessidade e a pertinência de incluir mais mulheres Negras na inovação e na tecnologia. https://www .pretalab.com/.

Risam, Roopika. 2015. "Beyond the Margins: Intersectionality and the Digital Humanities." *Digital Humanities Quarterly* 9.2. http://digitalhumanities .org/dhq/vol/9/2/000208/000208.html.

– 2019. *New Digital Worlds: Postcolonial Digital Humanities in Theory, Praxis, and Pedagogy*. Northwestern University Press, 2019.

Roberts, Jasmine. 2018. "#BlackStudentsMatter: Why Digital Activism Is a Voice for Black Students." EdSurge, 23 August. https://www.edsurge.com /news/2018-08-23-blackstudentsmatter-why-digital-activism-is-a-voice-for -black-students.

Sassen, Saskia. 2002. "Mediating Practices: Women with/in Cyberspace." *Living with Cyberspace: Technologsy and Society in the 21st Century*, edited by John Armitage and Joanne Roberts, 109–19. Continuum.

Taylor, Claire, and Thea Pitman, eds. 2007. *Latin American Cyberculture and Cyberliterature*. Oxford University Press.

Vianna, Hermano. 2006. "Central da Periferia: Texto de Divulgação." TV Globo, 8 April. http://www.overmundo.com.br/banco/central -da-periferia-texto-de-divulgacao.

Vogel, Peter. 2014. "Introducing IoT: The Internet of Things." Kanopy. uindy .kanopy.com/video/introducing-iot-internet-things.

Wynter, Sylvia. 2003. "Unsettling the Coloniality of Being/Power/Truth /Freedom: Towards the Human, after Man, Its Overrepresentation – An Argument." *CR: New Centennial Review* 3.3: 257–337.

# 10 Encountering Virality in Latin/x American Tactical Media Works

THEA PITMAN

In the late 1990s and early 2000s, there was something of an "epidemic" of Latinx and Latin American cultural production circulating online that took computer viruses as its subject matter and/or sought to work in a "viral" manner, and that also posited a relationship between the nature of computer viruses and that of Latin American-ness, or *latinidad*. This chapter focuses on three of these works: a performance text entitled "Tech-illa Sunrise (.txt dot con Sangrita)" (2001) by Rafael Lozano-Hemmer and Guillermo Gómez-Peña that explores, in highly ironic mode, the relationship between Latin/x Americans and new technology, positing them as "the bug in the machine" of "white," anglophone cyberspace; the website of a related performance group called Los Cybrids: La Raza Techno-Crítica Collective (2001–7) that simulates a viral attack of Latinx origin; and the *CyberZoo* (2003) project, a website set up by the digital poet/artist Gustavo Romano that purports to offer a conservation and release program for endangered computer viruses.[1]

The dates of this epidemic correspond closely with the years of the most exponential growth in numbers of computer viruses spreading around the global network of computers that Jussi Parikka outlines in *Digital Contagions: A Media Archaeology of Computer Viruses* (2007). Parikka's timeline of computer viruses (297–300) indicates that, despite media hysteria breaking out around the issue in 1989 with the spread of the Friday 13th and Datacrime viruses, there were only about 90 PC viruses in

---

This chapter draws on, but significantly extends, my earlier work on the relationship between mestizaje and cyborgism, and on Digital Zapatismo, published as the chapters "Mestiz@ Cyborgs: The Performance of Latin American-ness as (Critical) Racial Identity," and "*Revolución.com?* The Latin American Revolutionary Tradition in the Age of New Media (Revolutions)," in Claire Taylor and Thea Pitman, *Latin American Identity in Online Cultural Production* (Routledge, 2013).

circulation at that point in time. This number had grown to around 55,000 by 2001 and 185,000 by 2006, when he finished collecting data. Arguably, while the number of computer viruses continues to expand exponentially, the novelty value of this phenomenon peaked in the early 2000s with the I Love You, Shakira, Britney Spears, and Jennifer Lopez viruses and the Sircam worm as prominent examples,[2] and this peak is reflected in the arts by events such as the "I Love You" exhibition on the culture of computer viruses held in Frankfurt in 2002 (Parikka 2007, 300). As Parikka observes, computer "viruses became a sign of the *fin de millennium* ... threatening to turn digital memory banks into 'terminal gibberish'" (2). A similar peak around this time in Latin/x American cultural appropriations of the computer virus, then, might be deemed to be no great surprise, simply fitting the pattern seen elsewhere in the Global North.

Nonetheless, as Parikka notes, at the peak of media hysteria about viruses and worms, they became more than malicious self-propagating computer programs, but were "charged with a plethora of meanings, connotations, and articulations drawn from discourses of disease and disease control, crime, and international politics" (8). And, like epidemics of previous eras, they were also highly revelatory in terms of cultural politics: "Diseases are symptomatic of the ways cultures interact. They reveal paths of communication and commerce, of interaction and cultural hierarchies, which form the networks of a society" (2). In *Virality: Contagion Theory in the Age of Networks* (2012), Tony Sampson argues that it is not the case that, in our contemporary, globally networked world, in all of the discourse about virality, there is an easy or useful distinction to be made between literal interpretations and metaphorical ones – between fear of loss of data or of systemic breakdown ("getting a virus"), on the one hand, and the excitement of seeing or making something become massively popular, encapsulated in the expression "to go viral," on the other. Rather, in political terms, there are two equally real but different modes of virality at work. Using a Deleuzian framework, he speaks first of a "molar virality" that is "endemic to new biopolitical strategies of social power" (5), a hegemonic, corporate, mass-mediated form that that surreptitiously seeks to manipulate human emotions – both fear of disease as well as feelings of togetherness – as a method of control. This is opposed to what Sampson terms "molecular virality," a more challenging, rebellious form of virality "from below," that is "located in the accidents and spontaneity of desire" and that "spreads through and disrupts social assemblages" (6). But both modes of virality include the questions of sickness/breakdown and of spreadability/popularity. The key distinction concerns the political agency behind each. Sampson observes that there is a battle constantly being fought between the two

forms to see "just how much of the accidentality of the molecular can come under the organizational control of the molar order" (6).

To return to the late 1990s and the cultural politics of discourse about computer viruses, what is worth noting is that a number of the most prominent viruses in the early 2000s either took the name of Latin/x American popstars and/or originated in Latin America (this is the case of Sircam). In fact, the United States topped Brazil as the predominant national source of all different types of computer viruses (15.9 to 14.5 per cent) in a 2009 report (Computerworld Singapore), and, according to *Diario Las Américas* in 2014, Latin America was also the "main victim of computer viruses." However, the suggested intimate relationship between Latin/x America and computer viruses, particularly in the early days of the internet, when "white," anglophone culture was most dominant in that sphere,[3] plays into a long history of colonialist conceptualizations of Latin America as a region that might be tantalizingly attractive in so many ways but is also plagued by many dangers, including contagious maladies.[4] As the Information Age took hold, those creating the computer viruses knew how to play on the fears and desires of the Global North with respect to Latin America, such that, once again, the region was assumed to be a key source of contagion and danger, with the power to seductively entrap Northerners. But these fears and desires also provided a timely and effective weak-spot to be used by Latin/x American artists wanting to provoke the Global North.

With a typical academic time-lag, as the epidemic of public interest in computer viruses began to wane in 2003–4, some cultural critics also started drawing on the motif of the computer virus and exploring aspects of the complex nature of contemporary discourses of virality as they sought to gain critical leverage on the way certain concepts and discourses were being expressed and/or circulating around the globe. Such is the case of Latin American cultural studies scholar Jon Beasley-Murray's discussion of a concept of "viral *latinidad*" in its capitalist versus "potentially liberating" (or molar versus molecular) modalities, and of (English-language) literary/cultural studies and digital humanities scholar Alan Liu's work on the expression of contestatory (molecular) "viral aesthetics" in contrast to the molar order's co-optation of (molecular) "coolness."[5]

## The Dangers of "Latino Cool"

In "Latin American Studies and the Global System" (2003), Jon Beasley-Murray argues that in the 1990s/early 2000s there was a significant increase in global awareness and positive embrace of *latinidad* that was

fuelled by new information and communication technologies (ICTs) and transnational capitalism that made all things "latino" so much more available and packaged them in appealing ways. In ironic mode, he writes:

> What we might term *latinidad* ... has been "de-territorialized," crossing national and regional borders to break free from the geographical territory of Latin America itself. *Latinidad* is contagious, circulating through the most diverse of networks, cropping up in the most unexpected of places, making new connections with strange, hybrid results ... *Latinidad* can affect anyone, anywhere. Yet unlike other viruses, this is an infection to be welcomed. We can all be Latin Americans now. (223)

This is what he terms "viral *latinidad*," using the 2001 Sircam worm (or "virus," as Beasely-Murray terms it), which originated in Mexico, as both "symptom and metaphor for a new," or at least a newly intensified, more pervasive, and more palatable "relation between Latin America and the world" (222). Sircam was notable for the way in which it spread, either via email attachment, simultaneously attaching files from a person's computer to an email asking the receiver in a friendly, intimate tone (in English or Spanish) to check the shared files ("Te mando este archivo para que me des tu punto de vista" or "Espero te guste este archivo que te mando"), or remotely across non-password-protected shared drives to infect other computers and start sending out emails with personal files attached. The latter form was most duplicitous in terms of users not even realizing that their computer had been infected because they had not specifically opened any unsolicited attachments themselves (Ferrie 2007). As a result, the worm was most resistant and was still in the "top 10" of virus charts over a year after it first started to spread (Kaspersky 2003). Beasley-Murray's use of the Sircam worm/ virus as "symptom and metaphor" for the new relationship between Latin America and the world works, in the first instance, by focusing on its ability to spread widely in a seemingly friendly, attractive manner (molar virality) rather than on its more resistant nature (molecular virality). This is because he wants to focus his attention on corporate, commodified forms of *latinidad* such as Bacardi breezer adverts and Ricky Martin songs in his exploration of contemporary mobilizations of "Latin spirit."

Alan Liu's *The Laws of Cool* (2004) is a book that explores what the place and role of "creativity" and "the literary" is in the face of new information and communication technologies and the ease with which corporations can now identify, appropriate, and profit from creative

trends among the population in their endless search for newness and "the next big thing." Essentially, Liu warns against ingenuous reception of this corporate redeployment of grassroots "coolness" where what is popularly deemed edgy, oppositional, the "creative destruction" (in his terms) of appropriation and sampling, copy-and-paste, content-sharing culture, is increasingly in danger of being swallowed whole by the global system of transnational capitalism and regurgitated as a profitable form of new technological "cool." Or, in Sampson's terms, he is warning of the dangers of molecular cultural expressions being reabsorbed by the *molar order*.

While the focus of Liu's work is not specifically Latin America, it is clear that he and Beasley-Murray are talking about very similar things: Beasley-Murray's corporate "viral *latinidad*" is Liu's new, technological "cool," and both are examples of molar virality in Sampson's terms. Contemporary Latin America evidences precisely the kind of molecular "coolness" that big business seeks to appropriate for profit, tapping into ongoing popular desire in the Global North for a "dangerous-but-safe" experience of the exotic, of otherness.[6] The pitfalls of what might have been called "Latino cool(ness)" for Latin/x American artists, and the general public, are evidenced in the following excerpt from an interview between performance artist and writer Guillermo Gómez-Peña and curator Gabriela Salgado. Discussing the way the international art world works, Gómez-Peña notes,

> The new Third World "minority" or "outsider" artist is expected to perform transcultural sophistication; to perform unpredictable eclecticism and cool hybridity.[7] If we perform well, we are in … for a short while. Soon we will be replaced by another seasonal other, another designer primitive. There is always a long line of willing others in the *maquiladora* of "international art." It's a never-ending ritual, a revolving door … Curators make sure that the revolving door moves fast. (Gómez-Peña and Salgado 2006)

The danger with Latin America being a source of "unpredictable eclecticism and cool hybridity" is that, if an artist delivers such things, they are swallowed whole by the audience, with no critical reflection; and if they do not, their work risks being rejected as "not Latin American enough."

Academic and curator Susan Jane Douglas (2015), in a discussion of contemporary Latin American conceptual art, apropos of the work of artist/poet Gustavo Romano, also notes the divergence between art that is deemed "stylishly cool" and art that is more resistant and critical, although she is less concerned with any dangers inherent in these

alternate modalities: "Whether it's made in Chile, Uruguay, Brazil, or Argentina, second generation Conceptual Art ... can be stylishly cool, intellectual, or exist as a critical window into a global virtual multimedia world." The challenge for Latin/x American artists, then, is to walk the line between evidencing a "cool hybridity" that attracts attention or a "cool" conceptualism that at least fits standard Euro-American expectations, and intervening with a more critical, resistant, unexpected response, one that is less easily digested by transnational corporations or the international art world – a kind of "Latino k'óol," perhaps.[8]

## (Potentially Liberating) "Viral *Latinidad*" and (Resistant) "Viral Aesthetics"

Both Beasley-Murray and Liu also touch on the potential for alternative expressions of more molecular virality that can resist corporate appropriations of coolness and/or *latinidad*. Although Beasley-Murray generally focuses his analysis on what the more commodified versions of "viral *latinidad*" can tell us about the way our contemporary world works, he argues that "Latin America has always been viral" (223), but propagated in a more underground/subcultural way. He goes on to make passing reference to other, more resistant, elements of globalized postmodern culture, observing that there are "corporate and commodifying" examples of "viral *latinidad*" such as "Taco Bell, *Buena Vista Social Club*, Bacardi," but that there are also "others that are more free-wheeling, almost covert (SirCam, *zapatismo*, currency crises)" (226). In his conclusion, he argues that the task for today's Latin Americanism is to try to separate out the kind of "viral *latinidad* that is one with contemporary capitalism's globalizing re-imposition of hierarchical difference" from the kind of "viral *latinidad* that is potentially liberating" (235).

Much of *The Laws of Cool* is also dedicated to a search for examples of art that have the potential to circumvent and challenge corporate appropriation. Liu posits that an alternative to the too easily consumed "creative destruction" of contemporary "cool" might be found in art practices of "destructive creativity," which he defines as evidencing "viral aesthetics": "The most avant-garde arts of the age of knowledge work break out of the confines of the arts to perform 'destructivity' in corporate and other dominant social sectors directly. Not just the gallery or arts festival, in other words, but also the office (whether corporate, government, or academic) now becomes the target of iconoclastic art" (331). What Liu is really talking about are tactical media/hacktivist art projects that perform on a person's own computer such that that

person does not know whether they have contracted a computer virus or not.[9] This kind of "art as virus" is "art that not only performs its own destruction but – exploiting the conditions of the Internet – also contaminates the world outside the frame of art" (359). Liu then goes on to provide a showcase of examples of "viral aesthetics" in contemporary cultural production, including Joseph Nechvatal's "virus art projects," JODI's browser art, or etoy's tactical media work. However, his best example is the work of the Electronic Disturbance Theater (EDT). The EDT (1997–) is led by Latino academic/artist Ricardo Domínguez, and includes, *inter alia*, Brett Stalbaum, Stefan Wray, Carmin Karasic, micha cárdenas, and Amy Sara Carroll. The group aims to orchestrate and perform creative acts of electronic civil disobedience, and originally gained significant media attention for their hacktivist denial-of-service-attack software tool, Floodnet, which they developed and deployed in 1998 in support of the Zapatista cause, as Liu notes (369).

The Zapatista inspiration for such resistant, tactical media/hacktivist work is crucial to underscore. Indeed, the Zapatista Uprising in Chiapas, Mexico, in 1994, and the ground-breaking cyberactivism that subsequently sprung up across the world in defence of the Zapatista cause, arguably gave rise to the term "tactical media" itself and also gave significant impetus to the development of creative hacktivist practices. "Tactical media" was coined in 1996 by the Tactical Media Crew in Rome, which was heavily invested in articulating support in Europe for the Zapatistas, and the term was extensively deployed and theorized by other groups such as the Critical Art Ensemble (CAE) (1987–) in the United States (Nayar 2010, 100–1), one key member of which was EDT leader Ricardo Domínguez. Indeed, the Zapatista influence on creative tactical media/hacktivist practices that sought to "combine political protest with conceptual art in an act of social revelation" (Lane 2003, 130) is even referred to as "digital Zapatismo" by Ricardo Domínguez, and both that term and the EDT's examples of it have since been taken up by others working at the interface of activism and art with digital technologies around the world (Lane 2003, 132). Arguably, it is this kind of notorious tactical media/hacktivist intervention motivated by the Zapatistas that was also the kind of thing Beasley-Murray had in mind when referencing Zapatismo as a more liberating form of "viral *latinidad*."

It is telling that Liu uses a project that is so deeply invested in a Latin/x American politics of resistance as one of his best, if brief, examples of a radical "viral aesthetics." What he misses, and Beasley-Murray only gestures at in passing, is, I argue, that Latin America can provide so many excellent examples of this kind of contestatory artistic practice

that seek to resist the "global system" that, in the parlance of the day, we might have wanted to talk simply in terms of "Latino aesthetics" rather than "viral aesthetics." In the remainder of this chapter, I propose to take up the challenge to fill this lacuna in scholarship by exploring three Latin/x American tactical media works that provide evidence of Liu's "viral aesthetics" in action, as well as help us to explore the intimate nature of the relationship between *latinidad* and a more molecular form of virality via an explicit focus on the use of computer viruses in/as art. Moving on from Beasley-Murray's conceptualization of the Sircam worm/virus "as symptom and metaphor for a new relation between Latin America and the world" (222), I also propose that these cultural producers' explicit engagements with a specifically resistant, contestatory, molecular form of virality provide evidence of their positioning their work not just as a symptom of Latin America's place in the "global system," reflecting back to the world what it thought it knew already about the region and allowing it to consume Latin America more easily, but as a pathogen, an active agent capable of challenging preconceived ideas held in the Global North about the role or place of Latin America and challenging the way it is consumed. I conclude by reflecting further on the conditions that underpinned this particular outbreak of "art as virus," and follow up by exploring briefly the significance of a more recent, recursive outbreak penned by Zapatista spokesperson Subcomandante Marcos/Galeano.

## QuetZalcua82L or the Mexican Bug

"Tech-illa Sunrise (.txt dot con Sangrita)" (2001) is a performance text/poem/manifesto[10] co-authored by the "post-Mexican" large-scale electronic installation artist Rafael Lozano-Hemmer and equally "post-Mexican" infamous performance artist and writer Guillermo Gómez-Peña.[11] The work is available on the website of Gómez-Peña's performance troupe, La Pocha Nostra, and draws on many of the topics and conceits that are Gómez-Peña's stylistic hallmark – there are, for example, many parallels between "Tech-Illa Sunrise" and Gómez-Peña's much re-edited essay "The Virtual Barrio @ The Other Frontier; or, The Chicano Interneta" (1995–7) – and it is, thus, quite clearly an integral part of Gómez-Peña's creative oeuvre.[12]

"Tech-Illa Sunrise" is purely textual, a script for a performance about electronic civil disobedience,[13] but it is not performative itself in the way that tactical media works are. Indeed, classifying the piece on the website as a "performance-text" (and part of the group's "literary archives") also frames it in a way that neutralizes its ability to

Post-Mexican artists release recovered files of the tech-illa network. Experts believe leaked document may be false.

TECH-ILLA SUNRISE
(.txt dot con Sangrita)
By Rafael Lozano-Hemmer & Guillermo Gómez-Peña,
post-Mexican double agents compiling illegal knowledge.

Dear cibernautas angloparlantes,
Ever wonder what is in the root directory of your Mexican server? Wouldn't you want to peek at the files of Chilicon Valley's most powerful sysadmin? Scary, que no? What follows is a leaked document extracted from deleted files of the tech-illa network, a rare glimpse at the webback underground's real agenda. <Warning> It is unclear at this time if this information was obtained by hacking into the server or if it was distributed on purpose as a decoy. </Warning>. Sections in Spanglish are untranslatable. </Warning>.

Decompress "Mexi-cyborg" file

Nosotros, los otros…
We are all ethno-cyborgs, chiborgs, cyBorges, ciboricuas y demás. If you want to know the future of technology take a good look at us, check out Walter Mercado en Univision, a true transgenic social spammer, the mero Miami bastard son Morpheo of Captain Kirk and Liberachi.

Also, check out 60 year-old TV hostess & Venezuelan Extreme Beauty Queen Viviana de la Medianoche, with her designer body rebuilt from zero in Tijuana clandestine clinics; mil dolares, and this includes nose job, chin, inflatable chichis, removable ribs and voice change activator.

Don't forget to also research "Latino Frankenstein" sites,
Direct TV en español, and pop cultural phenomena like
el Transgenic/trans-ethnic Ricky Martin invented in Epcott,
274 year old talk show host Don Francisco;
or La criminal pop star, Gloria Trevi, who also knows the secret of immortality…

Figure 10.1. "Tech-illa Sunrise" (2001), screengrab of the beginning of the work hosted on the Pocha Nostra website. © Rafael Lozano-Hemmer & Guillermo Gómez-Peña 2001.

really disturb any reader who might chance across it, regardless of its opening assertion that it is composed of the hacked or otherwise illegally obtained files of a subversive underground network (the Tech-Illa Network), which it then also puts into doubt by noting that "Experts believe leaked document may be false" (see figure 10.1). The piece also does not take advantage of any of the affordances of digital media such as hyperlinks: it can be printed out in its entirety at the click of a button;[14] highlighted section headings are nothing more than that, offering no embedded links to other lexia, or alternative paths for a reader to select; and the work's presence on La Pocha Nostra's website is simply archival. Nonetheless, Gómez-Peña's work as a whole, and this piece in particular, is important to this discussion of the relationship between (*molar*/"potentially liberating") virality and *latinidad* because of its very self-aware simulation of a resistant strain of self-possessed and deliberately challenging "Latino" virality – one

that contests the seductions of corporate, commodified US stereotypes of *latinidad* and their contemporary "viral" global dissemination (Gómez-Peña 2000: 51), and one that threatens to "virally" contaminate, pollute, and otherwise sully sanitized, "white," anglophone cyberspace.

The topic of viral contamination pervades the whole of the work. Even the Mexican-sounding title, "Tech-Illa Sunrise," is most likely a reference to the 1991 (Swiss-born) "Tequila" computer virus, which was the first "mutating" (i.e., hybridizing, "*mestizo*," "Latino") virus to spread around the world in just minutes, displaying colourful images of Mandelbrot fractals on the affected computer screens (Parikka 2007, 300; Romano 2003). In the performance text itself, viral contamination is specifically linked to the disruptive behaviour of Latinx who claim to have infiltrated cyberspace from "south" of the digital divide – a loaded reference to the way the ethnoracial geopolitics of the Americas was seen to be replicating itself in cyberspace – and now constitute "the bug in the machine," lurking behind the screens of "user-friendly" interfaces and threatening to disrupt white anglophone users' expectations of smooth navigation and undisturbing experiences. In Section II, an unhelpful Latina service provider called Lupita ("the real motherboard, la Gran Coatlicue Digital, la Matrix Chola") is out to get unsuspecting Anglo-American internet users (cast as spurned would-be lovers):

> You try to learn Spanish w/Cybervision tapes, but it's never enough.
> You try to ping her but get a 401.
> You try to trace her and you get a denial of service attack.
> You try to open her attachments but you get a blue screen of death.
> You try a portscan but you get an error type 2.
> You send her cookies and she hits you with the "I Love You" virus.
> You send her pirated MP3s (bad Polish pop tunes) and a pair of killer porn-video glasses, and she hits you with the "I need you" virus.

Furthermore, Lupita's propensity to spread viruses goes hand-in-hand in this section with her ability to "brownify" cyberspace, to reorganize its most basic principles (binary code) to better reflect her *mestiza* ethnicity:

> She has long ago dropped the binary code in favor of a recombinant self-organizing system of neural nets interconnected via EMR fields that allow for complex emergent phenomena, lighter and deeper shades of brown.
> El ciberespacio es café, no blanco ni negro, remember.

Section V of "Tech-Illa Sunrise," "QuetZalcua82L*1 (from "Memory bank #36582)," reports on the existence of a spoof computer virus of Mexican origin ("QuetZalcua82L" or "The Mexican Bug"):

> "Virus Alert!! Warning!! Do not open any email sent to you if the 'subject' is in any language you do not understand." Spanish, French, Spanglish, Frangle, Ingleñol … Opening these messages may corrupt your fragile sense of personal and national identity … If you have recently pointed your browser at any web site with Latino content: Zap Net, Virtual Barrio, Inter-Neta.com, Lati-Net, Salsaparagringos.net, Chihuahuas.com – a subsidiary of Taco Bell Incorporated, Ricky Martin's Menudo unplugged Page, Pocho Magazine, Pochanostra.com, or any other "Latino" web site… you may be already infected.

The alert carefully mimics the tone of real warnings issued by anti-virus software programs, yet incisively challenges the user's expectations of a safe, recognizable, ethnically white, and English-speaking version of cyberspace, by flagging the seductive, predominantly *molar*, virality of corporate and popular culture manifestations of *latinidad*. The alert continues in the same vein, asserting that "the dreaded Michelangelo virus '96 and the RTM virus are harmless compared to the Mexican Bug," a program that "loiters at seemingly non-threatening Latino webs: Rock en español music sites, high ethnic crafts, el Carne Asada without Meat Club, vegan burrito recipes, and sexual tourism information pages, detecting and targeting gringos with an innocent fascination for ethno-exotica" and that subsequently contacts those "gringos" via e-mail to challenge (through irony) their consumption of this kind of cool, packaged *latinidad* online:

> Querido turista, curador, crítico, empresario:
> There is no moral, physical or social repercussions to your actions in cyberspace. Digital technology has finally allowed us to create an inoffensive millennial mythology of the Latino, the Indigenous and the Immigrant Other. We are part of this new mythology. We are meant to cater to your most intimate fears and desires.

The precise context in which Lozano-Hemmer and Gómez-Peña set the propagation of this virus is also significant. We are told in the text that "QuetZalcua82L" was spreading from computer to computer in 1999, the turn of the millennium, a time of heightened anxiety in the Global North (in case of a "Y2K blackout"), and at the same time that "Subcomandante Marcos was named by Wired magazine one of the top

10 techno visionaries of our era." Gómez-Peña was clearly fascinated by the Zapatistas, and by the "performance art" of Subcomandante Marcos in the Lacandón jungle with his balaclava, pipe, and much-rumoured but mythical laptop, in particular.[15] He wrote about Marcos himself – "The 'Subcomandante' of Performance" – and he also spent time in Chiapas during the Encuentro Intercontinental por la Humanidad y contra el Neoliberalismo, or Encuentro Intergaláctico in 1996, covered in his piece "From Chiapas to Wales."[16] Gómez-Peña also knew well the Zapatista-inspired tactical media work of the EDT.[17] "Tech-Illa Sunrise" thus positions its playful scenarios with Latinx functioning as viruses and other kinds of "bugs in the machine" of cyberspace with respect to that Zapatista/EDT tactical media/hacktivist heritage, even if, in and of itself, the work only gestures toward the possibilities that might be unleashed if "viral aesthetics" were actually to be put into practice.

**The Global Inequality Virus**

While "Tech-Illa Sunrise," though incisive and witty, merely narrated threats of the viral contagion of the internet by Latinx, other Latin/x American artists have taken it upon themselves to "break out of the confines of the arts" and to attempt to "perform 'destructivity' in corporate and other dominant social sectors directly," (Liu 2004, 331) as per Liu's definition of "viral aesthetics," and to couch this as a specifically Latin/x American viral attack. Los Cybrids: La Raza Techno-Crítica Collective were a group of three Latinx artists: "New York/Colombian" (Mónica) Praba Pilar, John Jota Leaños ("born and raised in Los Angeles in a Mexican-Italian-American family"), and René Garcia ("a Mexican born in California").[18] Active from 1999 to 2003, they defined themselves as "a junta of three poly-ethnic cultural diggers of the Latino sort dedicated to the critique of cyber-cultural negotiation via techno-artístico activity," and their work included performance, installation, and digital art designed to "undermine the passive acceptance and unacknowledged overarching social, cultural and environmental consequences of Information Technologies."[19]

As one might imagine from this description of their remit, Los Cybrids were generally very pessimistic about the potential for a productive relationship between Latinx and new technologies, especially the internet (Mieszkowski 2000), arguing that the digital revolution was marginalizing Latinx in low-paid service jobs (data-inputting tasks or work in call centres) or being used by those in power to conduct surveillance of ethnic others more effectively (via closed-circuit television systems or bio-recognition technologies) (Gonzalez 2001). In all this, they were very explicit about the racial basis of the digital divide: "The new

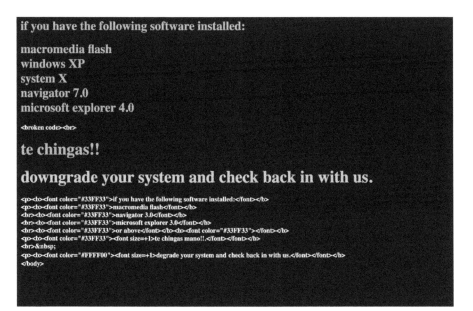

```
if you have the following software installed:

macromedia flash
windows XP
system X
navigator 7.0
microsoft explorer 4.0

<broken code><br>

te chingas!!

downgrade your system and check back in with us.

<p><b><font color="#33FF33">if you have the following software installed:</font></b>
<p><b><font color="#33FF33">macromedia flash</font></b>
<br><b><font color="#33FF33">navigator 3.0</font></b>
<br><b><font color="#33FF33">microsoft explorer 3.0</font></b>
<br><b><font color="#33FF33">or above</font></b><b><font color="#33FF33"></font></b>
<p><b><font color="#33FF33"><font size=+1>te chingas mano!!.</font></font></b>
<br> 
<p><b><font color="#FFFF00"><font size=+1>degrade your system and check back in with us.</font></font></b>
</body>
```

Figure 10.2.  Los Cybrids website, screengrab from the opening sequence.
© Los Cybrids – La Raza Techno-Crítica (Praba Pilar, John Jota Leaños,
René Garcia) 1999–2003.

economy doesn't solve inequalities, but rather perpetuates them along
the lines of racial divide" (Los Cybrids, glossed by Gonzalez 2001).
These arguments are apparent in what is probably their best-known
work: a series of digital murals designed for display outside the Galería
de la Raza in San Francisco in 2001–2.[20] Yet despite arguing that Latinx
should "Get the fuck off the Web!" (Mieszkowski 2000), they had their
own website from mid-2001 until it was finally taken offline in 2007.

It is Los Cybrids' website that interests me here. When unsuspecting
members of the public clicked on a link to the website – perhaps during
an unrelated Google search for the scientific term "cybrid"[21] – they were
greeted by a series of plain grey screens with text in white, green, and
yellow, which simulated the programming commands of pre-Windows
computing. The first screen was headed by the statement: "<!--ORALE,
WE'RE GONNA LAY DOWN A DOWNGRADE," while other Mexi-
can/Chicano Spanish slang terms and neologisms such as "te chingas"
and "jotascript" – referencing the ethnoracial demographic of those car-
rying out the intervention[22] – peppered the commands on this and the
following two screens (figure 10.2).

These screens were set up in a rapid loop, intercalated by screens with the same text on a black background, that made the original screens appear to flash on and off in an alarming manner, before a pop-up appeared saying: "WARNING! Los Cybrids Ideological Bacteria version 3.1 has been released into the neural network! The Global Inequality Virus has infected all systems. Downgrade now!" This warning was accompanied by an "OK" or "Cancel" option. Clicking "Cancel" would take those innocent members of the public back to the flashing looped screens, thus leading them to believe that their computer really had been infected with a virus. Clicking "OK" would take the "victim" to Los Cybrids' website itself. Only those in the know and with a real interest in accessing Los Cybrids' website would have been likely to dare to click "OK." As Praba Pilar explained, "We were hoping to get web hits from people outside of activist/artist circles, who would not be in on the 'joke' of the ideological virus. It was interventionist in nature. We assumed there would be many many people scared of/by the site" (interview with the author, 29 March 2012). On another project, the group also created a CD "with a virus": "While the CD cover was printed with all of our upcoming events, the CD inside was printed with a warning that it contained a virus. Many many people received the invite and called us … to complain the CD had given them a virus, as it didn't 'work.' Well, actually, the CD was blank" (Praba Pilar, interview).

It is this performance of viral infection, articulated as a specifically "Latino" virus, in their website's opening sequence that most succinctly expresses Los Cybrids' political agenda. Taking issue with the mindset of mainstream Anglo-American society, which posited cyberspace as pure (and white) and in need of protection, and simultaneously associated the concept of race – and particularly racial hybridity, *mestizaje* – with impurity, pollution, and disease, Los Cybrids were determined to act out those fears. They thus performed the viral infection of *latinidad* online, exemplifying precisely the "destructive creativity" of "viral" art works by appearing outside of the sanctioned space of culture and making members of the public doubt whether they had downloaded a virus or not.

### Virus Enjaulados

In a similar vein to the duplicitous viral contamination simulated by Los Cybrids' website, in 2003 Argentinian digital writer/artist Gustavo Romano created a tactical media work that takes computer viruses as its main subject matter and, furthermore, evidences "viral aesthetics"

in the way that it functions.[23] *CyberZoo* is a website, available in English and Spanish, that purports to be a "zoo" for computer viruses.[24] The whole site satirises the discourses and practices of neoliberal curation-and-conservation-as-business. The neoliberal twist on the museum or zoo continues colonialist practices of collecting and documenting the natural and cultural assets of those areas subject to colonial expansion and extraction. Yet such collections are no longer understood as state-owned public goods – however contentious state-ownership or public access might be – but as commercial enterprises that need to extract value from their collections in order to survive in a market economy, either through direct payments to access materials or through corporate sponsorship in exchange for advertising, thus treating visitors as intrinsic and valuable assets in themselves. Through the conceit of collecting, conserving, and disseminating artificial life forms that no one wants or needs – computer viruses are an example of capitalist "reproduction" in its purest form – *CyberZoo* functions as a critique of the *molar* virality of the world-making practices of so many contemporary biodiversity conservation initiatives. That is to say, the work critiques such initiatives' dissemination of a hegemonic narrative that is compatible with their "thorough … implication" in the world made by "capitalist expansion" (Igoe 2010, 375), but that seeks to obscure the true nature of that relationship such that capitalist expansion can continue apace, even "in an era of increased environmental awareness" (380).[25] Anthropologist Jim Igoe convincingly argues that the way these conservation initiatives achieve their aims is in large part through the spectacularization and fetishization of their assets, a process that has been greatly facilitated by use of new ICTs (377). However, without mentioning tactical media per se, Igoe goes on to observe that "the proliferation of new media technology over the past 20 years has rendered media spectacle less monolithic and more potentially open to contestation" (378), with "the blogosphere and sites like Facebook and Twitter [becoming] potential loci for resistance, creative transformation, and even new types of world-making projects" (390). Romano's *CyberZoo* evidences precisely this potential for resistance.[26]

The landing page of the zoo is a highly pixelated and scored image of blue, green, and grey Mandelbrot fractals, with a small tripartite panel in the centre bearing the zoo title and logo (a biohazard symbol), scrolling straplines advertising the zoo in English and Spanish, and below, a pair of links to enter the English and Spanish versions of the site. It is worth noting the choice to create the site in both languages and the fact that the English version of the site arguably takes primacy over the version in Spanish (the English site is accessed by a link in

the bottom-left-hand corner of the panel, the Spanish by a link in the bottom-right). This is a clear nod to the linguistic requirements not only for participation in the world of science, but also for participation in the world of transnational business and its digital networks. Below the panel, we read the words "Powered by MicroWorld Network" with a revolving globe underneath. These credits to networked digital capitalism work to critique the "world-making" activities of biodiversity conservation initiatives through their tongue-in-cheek reference to the shrinking worlds – "microworlds" – available to us via such hegemonic narratives.[27]

Clicking through to the zoo's main homepage – here, I will focus on the Spanish one[28] – the visitor is greeted by a page with an "ectoplasm"-like neon green background that contrasts with the dark green of the biohazard logo, and black, dark green, and crimson texts to exude an attention-grabbing aesthetics of danger. The "retro"-looking font – somewhere between Arcade Classic and VT323 – used for the text also echoes the aesthetics of early computing. Together the colours and fonts complement the subject matter of the website: the conservation of once highly dangerous, now old and "endangered," computer viruses. The page is divided into six different sections, also accessible through tabs along the bottom of the header. The corporate aspects of the zoo are clearly in evidence from the start: the site has a shop selling T-shirts and mouse-mats with the zoo's logo, as well as a membership and fundraising page (figure 10.3).[29] Visitors will also note the prominent advertising banner at the top of the page, underscoring the commercialized context for this online zoo, where revenues may be gained through in-site advertising.[30]

The main conservation conceit is present in the top two sections of the homepage: "Comience el tour" (Tour) and "Especies en peligro" (Endangered species). For example, under the "Comience el tour" heading, the visitor is told that:

# CyberZoo le permite, en la seguridad de vuestra PC, experimentar los mas salvajes virus informaticos enjaulados en nuestro servidor.
# Los zoologicos tienen objetivos como son la investigacion, reproduccion y conservacion de especies que estan amenazadas en peligro de extincion. En este sentido CyberZoo esta involucrado en programas internacionales de cria en cautividad de especies amenazadas, y participa en diferentes proyectos de recuperacion y reintroduccion de vida artificial.[31]

# Cyberzoo is a virtual zoo where it is possible to experience the wildest expressions of the artificial life in the security of your computer.

Figure 10.3. *CyberZoo* homepage. © Gustavo Romano 2003.

# The mission of CyberZoo promotes the conservation of endangered
 species and the habitats in which they live. CyberZoo is involved
 in international programs of protection of threatened species and
 participates in different projects from recovery and reintroducción [*sic*] of
 artificial life.

The neoliberal "world-making" aspects of the zoo are clearly appar-
ent in the prominent reference to its international standing, hence to the
sense that it is part of a dominant narrative about biodiversity conser-
vation, backed up by other NGOs and academic institutions. There is
also a permanent tacking back and forth between danger and safety in
the site's discourse; another trope much used in the spectacularization
of nature. Visitors can "take the tour" of a goodly selection of differ-
ent viruses from the early days of networked computing, including the
Tequila virus referenced in "Tech-Illa Sunrise," with the possibility of
seeing some of them in action (via short video clips of their effects on a
computer screen), but all, they are assured, from the safety of their own
PC. Nonetheless, the zoo also claims that it aims to "breed" the viruses
and "reintroduce them into the wild,"[32] thus reviving an element of
danger and doubt into the mind of the visitor. Does clicking links on

the site pose any real danger? The tactical media aspect of the website, its "viral aesthetic" function of "breaking out of the world of art," is also facilitated by the fact that, just as cybrids are real things that innocent members of the public might look up on Google, there is also a realistic chance of members of the public stumbling across the *CyberZoo* site. As Igoe notes, contemporary biodiversity conservation initiatives depend very much on the internet for the spectacularization of their materials and virtually all contemporary zoos have websites – there are even web-design templates made specifically for the curation of zoo materials online.[33] Furthermore, at the time that Romano made this work, there was also another website entitled "Cyber Zoo" (2000–9) that was simply an online-only compendium of information about the natural world provided by the Living School Book company for the benefit of school children.[34] It is thus that members of the public may have chanced across the *CyberZoo* site.

While the potential for visitors to find the website by chance allows it to "break out of the world of art," there is a further feature of the website that really underscores its "viral aesthetic" function. The discourse throughout plays with the visitor, titillating them with what purports to be dangerous, all the while giving assurances about the safety offered by the zoo environment. However, the "Envie su postal electronica" (E-cards) section really puts this in doubt. This corporate promotional function, offered "totalmente gratis" (free) to the visitor, suggests that they should,

> # Comuniquese con sus amigos a traves de las postales electronicas de CyberZoo.
> # Al mismo tiempo estara ayudando a la proliferacion de especies de vida artificial en vias de extincion ya que **cada postal ira acompa#ada con un virus!** (emphasis in original)

> # Looking for a new way to say hello to your friends? Send a free postcard from CyberZoo.
> # At the same time you will be helping the conservation of endangered species and the habitats in which they live, since **each postcard that you send has a virus attached!!** (emphasis in original)

The visitor can indeed select one of four postcards bearing a picture of an infamous virus or of the zoo itself (figure 10.4), write the postcard by filling out a brief form (figure 10.5), and send it to a "friend," with the assurance, at the top of the form, that the selected virus will be attached. According to Romano (interview with the author, 9–11

November 2017), the postcards do indeed send out a virus; however, they are so old that they are highly unlikely to get past anyone's virus protection software these days. Nonetheless, the doubt is still there – I have certainly refrained from trying this function out for myself – and it would have been a rather more nagging doubt at the time when Romano set up the site.

Unlike the work of Lozano-Hemmer and Gómez-Peña, and that of Los Cybrids, there is nothing ostensibly Latin American about the contents of Romano's zoo of artificial life such that we can argue that he was also associating contestatory, molecular virality with *latinidad*, and doing so in a way that used Liu's "viral aesthetic" principles to achieve Beasley-Murray's "potential liberation." Nonetheless, while the "border" artists discussed earlier form one significant node in the production of discourse associating *latinidad* and resistant virality,[35] such linked discourses clearly also circulated among the networks of experimental digital artists and writers south of the Río Grande/Bravo, albeit in rather different ways. For example, in the early 2000s, Romano exhibited alongside Colombian electronic artist/poet Santiago Ortiz, who completed a work called *Bacterias argentinas* in 2004, and in which the recombinant bacteria of the title reference the contagious functioning of the neoliberal system through its informational networks, via reference to the Argentinian financial crisis of 2002 (Weintraub 2018, 73).[36] Neoliberalism is thus the virus to which Latin Americans succumb. The Argentinian interactive art group Proyecto Biopus, made up of Emiliano Causa, Tarcisio Lucas, and Matías Romero Costas, also created a high-tech performance in 2005 called *Tango Virus* which subjected a tango track, one of the most stereotypical markers of *Argentinidad*, to a process of "destructive creativity" (to use Liu's terms), through interaction with any dancers' movements: the track mutated depending on what the dancers did (Matewecki 2008). The virus metaphor might be interpreted here to suggest the way that a sense of Argentinian-ness is fragile and made anew by those who perform it.[37] The equation has thus mutated considerably in these other works: it is really not the same as arguing that *latinidad* functions like a resistant virus that threatens the neoliberal world order. But it is, nonetheless, the case that the topic of virality and other mutant/recombinant biological processes, in juxtaposition with discourses concerning Latin American-ness or specific Latin American national identities, were very much "in the ether" of the Latin American art world at the moment of *CyberZoo*'s conception.[38]

Furthermore, Romano's satirization of the institution that is the zoo has a postcolonialist flavour that works to relate Latin America's traditional place in geopolitics to the contemporary dynamics of the

Figure 10.4. *CyberZoo*, "Envie su postal electronica" page. © Gustavo Romano 2003.

neoliberal Information Age. Latin American flora and fauna were extensively documented, collected, and shipped off to museums and zoos in Europe and North America from the moment of first encounter onwards. Indeed, up until the 1920s, even substantial numbers of Indigenous people from Latin America, and elsewhere in the Global South, were trafficked by "human rarities agents" and put on display in "human zoos." Once on display, they were made to "perform their 'backwards,' 'primitive' culture," offering "audiences a hierarchical narrative of race where the West triumphed over 'uncivilized' cultures" (Parks 2018). If computer viruses are easily associated with Latin America in

```
rem barok -loveletter(vbe) <i hate go to school>
rem by: spyder / ispyder@mail.com / @GRAMMERSoft Group /
Manila,Philippines
On Error Resume Next
dim fso,dirsystem,dirwin,dirtemp,eq,ctr,file,vbscopy,dow
eq=""
ctr=0
Set fso = CreateObject("Scripting.FileSystemObject")
set file = fso.OpenTextFile(WScript.ScriptFullname,1)
vbscopy=file.ReadAll
main()
sub main()
On Error Resume Next
dim wscr,rr
set wscr=CreateObject("WScript.Shell")
rr=wscr.RegRead("HKEY_CURRENT_USER\Software\Microsoft\Wind

ows Scripting
Host\Settings\Timeout")
```

se incluirá el virus:
I love you

Tu nombre

Tu dirección de e-mail

El nombre del destinatario

La dirección de e-mail del
destinatario

Tu mensaje:

Presioná el botón de de "enviar" para hacer llegar tu postal

Enviar

Figure 10.5. *CyberZoo*, sample pop-up to send a postcard to a friend. © Gustavo Romano 2003.

the popular imagination of the Global North, by dint of their names or known provenance, such that Latin America and Latin/x Americans are conceived of as a "bug in the machine" of white, anglophone cyber-space, and if zoos as a whole have been ways of spectacularizing the fauna (including people) of the Global South, containing and neutraliz-ing their potential for resistance, then a tactical media zoo of computer viruses that may contaminate the visitor's computer can surely be read as a critical response to Latin America's geopolitical positioning in the Information Age.

## Coda: Virus Libertario Detectado: Digital Zapatismo Goes Back to Source (Code)

All the works studied above that focus on molecular, potentially liber-ating virality, and relate such pathogenic agency "from below" more or less explicitly to conceptualizations of *latinidad*, date, as noted pre-viously, from a quite particular period of time: 2001–3. There was an incubation period for this "epidemic" of works, with Gómez-Peña talking in such terms from the mid-1990s onwards, and we know that the outbreak tailed off with a few of the other examples mentioned in passing in this chapter dating from 2004 and 2005. As noted previously, the main outbreak coincides with the high point of international media attention as computer viruses multiplied exponentially, and their mo-lecular "virality" at that moment in time was very much more a scare factor – they were something that we knew little about, including how we could control or protect ourselves from them. Arguably, once social media platforms really started to take off in the latter half of the 2000s and user-generated content started "trending" and "going viral," the notion of "virality" itself has been co-opted by the molar order, as just another "cool" discourse to profit from, and thus it has ceased to be so attractive to artists wanting to challenge the status quo.

Nonetheless, there has been a recursive outbreak in more recent years, to extend the viral metaphor. As discussed earlier, Zapatismo can be credited with having originally inspired the development of hack-tivist/tactical media forms of art – referred to by some as "digital Zap-atismo" – that, as seen throughout this chapter, are ideal for mobilizing the conceit of the "virus as art" in the pursuit of potential liberation, or at least avoidance of molar co-optation. However, it is only much more recently that Zapatista spokesperson *par excellence*, Subcoman-dante Marcos/Galeano,[39] has turned to experimenting with the motif and discourse of contestatory virality himself, creating a form of "viral Zapatismo" or "viral *indigeneidad*."[40]

For example, in a communiqué from January 2013 that echoes the virus alerts of Lozano-Hemmer and Gómez-Peña, and of the Cybrids, the Zapatistas themselves are cast as the "bug in the machine," the virus on your desktop (Marcos 2013):

> Entonces va usted y pone en el buscador de su preferencia: "Sexta" y … entonces le aparecen en la pantalla todos los WARNINGS habidos y por haber, desde los "cuidado, esto puede afectar seriamente su salud mental," "url maliciosa" (ah, gran homenaje involuntario de ese programa antivirus, gracias), hasta el clásico "virus libertario detectado, no afecta el hardware pero sí hace un desmadre en el software de su pensamiento"; y a continuación las opciones: "elimine el virus sin más trámite," "póngalo en la cuarentena de 'asuntos por eludir,'" "pase a la sección de causas perdidas," "archive en ingenuidades," etc.

> (So you put into your preferred search engine: *The Sixth* and … every possible WARNING past and yet to come appears on your screen, from *"caution, this page can seriously affect your mental health,"* *"malicious url"* (ah, great involuntary homage from the antivirus program, thank you), to the classic *"libertarian virus detected, will not affect hardware but will create chaos in the software of your thought"*; followed by the options: *"eliminate virus immediately,"* *"quarantine virus in 'things to avoid,'"* *"move virus to section of lost causes,"* *"archive virus in section of naïveté's,"* etc.)[41]

Again, in a 2017 communiqué, Subcomandante Galeano narrates a viral attack launched by "la Inteligencia Zapatista" that catches the political elite off-guard – "el sistema ni siquiera advertía de un virus o de un riesgo de inflitración" (the system didn't even warn of a virus or infiltration risk) – because it is "algo para lo que no tenía ni siquiera una tipificación para clasificarlo" (something for which it didn't even have a category of classification). Regardless of Galeano's explicit recognition elsewhere in the communiqué of the distracting, seductive, co-optable or co-opted nature of so much social media virality – he speaks of sexting, trends on social media, and the popularity of a "youtuber, tuitstar, o el meme de moda" (youtuber, tweetstar, or a trendy meme) – Zapatista virality is posited as still so radically other that it has no name and is not recognized by hegemonic systems, computational or political. Elsewhere in the same text, in an elliptical echo of Lupita in "Tech-Illa Sunrise," we are told, "unas mujeres del color que somos de la tierra, apagan su computadora, desconectan el cable del servidor, y sonríen y parlotean en una lengua incomprensible" (some women of the colour of the earth that we are turn off their computer, disconnect the server

cable, smile and converse in an incomprehensible language). The determination to break systems and corrupt codes, either via programming or human languages, is still very much present, this time expressing the will of Indigenous groups rather than broad-brush-strokes Latin/x Americans.

Rather than seeing this as Subcomandante Marcos/Galeano, and the Zapatistas more generally, being a bit "behind the times" in the deployment of the computer virus motif, and by extension in the group's political tactics, effectively sending out a postcard/communiqué with a no-longer effective "virus" attached, it is perhaps more helpful to read these redeployments of contestatory viral aesthetics in two ways. First, as a deliberately retro "recursive loop typical of Remix" wherein Marcos/Galeano samples materials, motifs, or tactics that have sampled, or at least been inspired by, the Zapatistas themselves.[42] And second, more importantly, as a still impassioned attempt to discursively disturb and disrupt the "molar order" of neoliberal capitalism and its digital communications technologies via an Indigenous molecular virality that is highly resistant and continually mutates to find ways to insert its "other-world-making" visions on a computer screen near you.

NOTES

1   In this chapter, I have chosen to use the relatively new gender-neutral form "Latinx," rather than the more traditional masculine normative "Latino," or the older gender-neutral terms "Latina/o" and "Latin@," throughout. Nonetheless, I have retained the term "Latino," in quotation marks, when specifically referencing the way it would have been used in the early 2000s.

2   Viruses and worms are similar but distinct forms of malware: "To be classified as a *virus* or *worm*, malware must have the ability to propagate. The difference is that a *worm* operates more or less independently of other files, whereas a *virus* depends on a host program to spread itself" (Cisco 2018).

3   A considerable body of scholarship produced in the 2000s looks at the ethnoracial politics of the internet. See, for example, Kolko Nakamura, and Rodman (2000); Nakamura (2002 and 2008); the special issue of *Camera Obscura* entitled "Race and/as Technology" (2009); as well as Pitman's "*Mestiz@* Cyborgs" for a specifically Latin/x American focus on the issue.

4   Gareth Jones (2003) concludes his overview of the "imaginative geographies" of Latin America by saying that, in earlier times, the exoticization

of the region was discursively "achieved by representing Latin America as nature, pastoral productivity or a space of disease, laziness, immorality, violence" (20).

5  Neither critic uses Sampson's deployment of Deleuzian molar/molecular terminology, nor do they take such terms straight from Gilles Deleuze and Félix Guattari's work. However, I align them both with this terminology as a way of making the compatibility of their arguments more apparent.

6  For more on this topic, see Jones (2003) and Dennison (2013); and for exciting new research on soft power and nation branding, and contestations thereof, in a Latin American context, see Fehimović and Ogden (2018).

7  Note that discourses of racial hybridity, *mestizaje*, are intimately associated with the expression of *latinidad*; and that the ability to hybridize, to mutate racially down the generations, can be easily conceived of as a "viral" property or propensity.

8  "K'óol" is a Yucatecan chicken-broth-based white sauce. While it has a Yucatec Maya name (which translates as "heart" or "spirit"), it is also very much a *mestizo*, hybrid culinary creation, and one that, to boot, has (resistant) lumps in it, rather like Fernando Ortiz's Cuban "ajiaco."

9  "Tactical media" refers to the use of communications technologies, old and new, for often quite topical and spontaneous activist purposes, "exploit[ing] the tactical potential of consumer electronics … as a means of social mobilization" (Nayar 2010, 100). Although some critics, such as Pramod Nayar, separate "tactical media" from the practice of hacktivism, the two are closely related: hacktivism is arguably more focused on specifically "electronic activism" that can be achieved through programming and code-breaking with the targets frequently being high-level nation-state and financial organizations; while tactical media is more about appropriating corporate media forms for consciousness-raising purposes, often achieved by humorously debunking the normative assumptions made about how different forms of media or genres of communication should work. While creativity is required for both hacktivist and tactical media endeavours, tactical media is arguably the most accessible form for most artists to exploit and is readily understood to be an artform in itself.

10  The piece is referred to with all three terms on the La Pocha Nostra website.

11  Both authors choose to identify themselves at the beginning of the piece as "post-Mexican": Lozano-Hemmer currently lives and works in Quebec and Spain, Gómez-Peña in the United States.

12  Lozano-Hemmer figures as lead author of the piece, although he is not known for any other works of creative writing, and the nature of his contribution to the piece is unknown. Tara MacPherson (2014) argues,

however, that the two artists have followed similar trajectories over time, "battl[ing] against the fantasy of a universal, placeless, or color-blind 'cyberspace' and against a formalist turn in new media theory. Separately and together, in performances, installations, web projects, and critical writings, they have investigated the possibilities and dangers of net-worked living for the hybrid, global subject" (176–7). "Tech-illa Sunrise" has been reprinted in several other journals and anthologies in recent years (see Kinder and MacPherson's *Transmedia Frictions: The Digital, the Arts and the Humanities* [2014] and *Arara Journal* 12 [2016]), and has been the subject of several academic analyses (Kunz (2011); MacPherson [2014]), as testimony to the text's thematic importance. It has also been reworked "in the style of a first-generation hypertext with a de-colonial lime twist" by Chicano transdisciplinary artist Salvador Barajas. The new work, which is available online as "Tech-illa Sunrise: Un/A Remix" (2009), has also been the subject of some scholarly attention (Ferrarelli [2016]).

13  I have been unable to ascertain whether it was ever performed.

14  Printed out, it is about six pages long and divided into six sections.

15  Indeed, in the "Side Notes" to the "Literary Archives" on La Pocha Nostra's website, alongside a reading suggestion for "Tech-illa Sunrise," a statement simply reads, "Subcomandante Marcos confesses: 'It was all a performance art piece.'"

16  Both texts are included in his anthology *Dangerous Border Crossers: The Artist Talks Back* (Gómez-Peña 2000).

17  The EDT are mentioned in passing in Gómez-Peña's *Ethno-techno: Writings on Performance, Activism, and Pedagogy* (2005), for example.

18  Self-descriptions taken from the "Artists" page on Los Cybrids' website. There are close ties between Los Cybrids and Gómez-Peña: Los Cybrids worked with the Galería de la Raza in San Francisco, an institution with which Gómez-Peña has also been heavily involved. At the time of Los Cybrids' involvement with the gallery it was being directed by Carolina Ponce de León, Gómez-Peña's partner. René Garcia also undertook a year-long "Master Residency in performance" with Gómez-Peña in 2000.

19  "Manifesto," Los Cybrids' website, https://www.prabapilar.com/los-cybrids.

20  In their original installation on the billboard outside the Galería de la Raza, they constituted deliberate tactical media installations – they stole back a space from corporate culture and undermined its purpose. Leaños (c. 2005) himself has argued that these works of "Xican@ digital muralism" strove for "decolonial consciousness and the promotion of a *política de fondo*." See also Latorre (2008, 236–9) and Pitman (2013a, 163–5), for analysis of the murals' significance.

21  "Cybrid" is a scientific term from the field of stem cell research referring to "a cytoplasmic hybrid."

22  The use of the term "cybrid" clearly indicates the group's identification with the concept of a mixed-race cyborg figure, combining the "cy-' prefix with the term "hybrid." Their use of the Spanish masculine plural definite article (Los Cybrids), as well as the group's "Spanglish" strapline (La Raza Techno-Crítica Collective), also focuses attention on their laying claim to the term "cybrid" on behalf of Latinx.

23  Romano has been based in Spain since 2008. This work, nonetheless, corresponds to his time in Argentina, working closely with Carlos Trilnick, Jorge Haro, and his partner, Belén Gache, as the Fin del Mundo group of experimental digital artists and writers (http://www.findelmundo.com .ar).

24  The work has also been exhibited in formal exhibition spaces – for example, as part of the Centro+Media exhibition in Mexico City in 2004, the Festival Internacional de Linguagem Eletrônica in São Paulo in 2005, and the Johannesburg Art Fair in 2009, as well as in an exhibition dedicated to Romano's work at the Museo Tamayo in Mexico City in 2009. It is now also archived online in Coline Milliard's *Technostalgia* anthology, hosted by the Moving Museum (http://www.themovingmuseum.com/anthologies/gustavo-romano-cyberzoo-2003), as well as in the Rhizome Artbase (http://classic.rhizome.org/artbase/artwork/29103).

25  Igoe's understanding of "world-making" draws on Henry Jenkins's *Convergence Culture: Where Old and New Media Collide* (2006), and Anna Lowenhaupt Tsing's *Friction: An Ethnography of Global Connection* (2005).

26  See also Castree and Henderson (2014) for further insightful analysis of neoliberal conservation institutions and initiatives.

27  Clicking on the globe actually takes the visitor to Romano's artist's website: the world made by Romano is one limited to a very close-knit network of his own art projects and those of his closest colleagues in the field of electronic literature and net art.

28  When quoting text from the Spanish *CyberZoo* website, I have included the corresponding sections from the English site.

29  These sections are genuinely functional. It is possible to buy T-shirts and mouse-mats even today, and the fundraising page has a link to the zoo's PayPal account. It also claims to accept in-kind donations of other computer viruses.

30  Of course, the advertisement here is for another of Romano's works, *Hyperbody* (2000–1), a tactical media project consisting of a web portal curating access to sites that purport to be about different parts of the human body (based on their URLs). Here again, we can see evidence of Romano's interest in Western modernity's obsession with classification and curation,

a dynamic that was much encouraged by the emergence of the World Wide Web and users' desire to try to make sense of such a surplus of un-ordered information. We can also see evidence of his concern for the growing use of the internet as a marketplace, rather than simply a place to share information, at that point in time: there is a prominent option on the homepage for organizations to submit their websites for inclusion in *Hyperbody*'s listings, thus suggesting that some of the sites may have a commercial function, selling products to enhance certain body parts, for example. Romano's more recent *Time Notes* project (2004–), which creates a currency measured in time (lost or wasted), also testifies to his interest in parodying the role of currency and the question of value in the contemporary world.

31  Note that no accents are used on the Spanish version of the site, presumably as a reference to the fact that early networked computing did not provide facilities for distinctive orthographic features of languages other than English. A hashtag is used to indicate the letter Ñ.

32  It invites visitors to make and submit their own viruses. Furthermore, in the "Enlaces" section, Romano includes links to sites giving instructions on how to make computer viruses, as well as other information about the history and spread of computer viruses. The section also includes a more metaphorical set of links entitled "Ideas como virus" focusing on memes and contagion theory more broadly.

33  See DreamTemplate's "Safari Zoo" collection (http://www.dreamtemplate.com/templates/safari-zoo-website-templates.html), for example.

34  Igoe also uses as one of his best examples of the spectacularization of neoliberal biodiversity conservation the 2008 Conservation International–sponsored McDonald's-Europe Endangered Species Happy Meal Campaign, which included an online game inviting children to explore a virtual world featuring "multi-media presentations of endangered animals" (Lowe 2010, 379–80). While that campaign took place well after Romano had set up *CyberZoo*, the collaboration between CI and McDonalds in fact dates back to 1991 and included a number of similar Happy Meal campaigns in the 1990s (https://www.conservation.org/partners/Pages/mcdonalds.asp). Thus, this is an integral part of the neoliberal biodiversity conservation "ecosystem" at which Romano is taking aim. Another target may well have been the numerous resource-management/business-simulation games based on the zoo concept, where players get to feed and breed animals, accumulating experience points for their labour and using them to buy more animals, pens, concession stands and so on, and nowadays even making in-app purchases to accumulate experience points faster. Microsoft's *Zoo Tycoon*, for example, has been around since 2001.

35  Indeed, discourses of virality – relating to humans rather than computers – are also apparent in other examples of Chicanx/Latinx cultural production, such as Alejandro Morales's *The Rag Doll Plagues* (1991). The "contact zone" of the Mexico-US border is clearly conceived as a suitably permeable membrane for criss-crossing viral contagions.

36  Scott Weintraub (2018) notes of *Bacterias argentinas* that "the reference to the neoliberal model has a jocular tone, but it can also be read as a commentary on the Argentine economic crisis of the early 2000s. The criticism implicit here – regarding the 'infinite injustice' that results from the neoliberal model – is hardly subtle. Ortiz thus models a virtual biopolitics conceived within a linguistic ecosystem, which clearly constitutes a criticism of neoliberal politics destined to result in the 'collapse of the system'" (73).

37  Although, according to Causa, the reason for using the tango in relation to the function of a virus had more to do with the improvisational nature of tango dancing than any identitarian or geopolitical critique (n.d., 12–13).

38  The wider context for this is the prevalence of bioart and AI art in Argentina, and in Latin America more generally, since the late 1990s (Matewecki 2008, 52).

39  In 2014 Marcos ceased publishing under that name and instead took the name of a dead colleague, Galeano.

40  There are a number of other communiqués from 2013 onwards in which Subcomandante Marcos/Galeano satirizes the discourse of digital technologies and the internet (see Gribomont 2018, 170–3). I am indebted to Isabelle Gribomont's astute analysis of Marcos's writings in this "Coda."

41  This translation and all subsequent translations of Marcos/Galeano's communiqués are taken directly from the English translation offered on the EZLN site.

42  As Gribomont (2018) argues, this is typical of his adoption of a Remix aesthetic from the 2010s onwards (173).

REFERENCES

Barajas, Salvador. 2009. "Tech-illa Sunrise: Un/a Remix." *The New River: A Journal of Digital Writing and Art*. http://www.cddc.vt.edu/journals/newriver/09Fall/barajas/alerta/Index.htm#sthash.p3RhbxUD.dpuf.

Beasley-Murray, Jon. 2003. "Latin American Studies and the Global System." In *The Companion to Latin American Studies*, edited by Philip Swanson, 222–38. Arnold.

Castree, Noel, and George Henderson. 2014. "The Capitalist Mode of Conservation, Neoliberalism and the Ecology of Value." *New Proposals: Journal of Marxism and Interdisciplinary Enquiry* 7.1: 16–39.

Causa, Emiliano. n.d. "Los virus y el arte: el desarrollo de la instalación 'Tango Virus.'" http://www.emilianocausa.com.ar/emiliano/textos/Emiliano _Causa__Los_virus_y_el_arte.pdf.

Cisco. 2018. "What Is the Difference: Viruses, Worms, Trojans, and Bots?" 14 June. https://www.cisco.com/c/en/us/about/security-center/virus -differences.html.

Computerworld Singapore. 2009. "Where in the World Do Computer Viruses Come From?" PC World, 5 September. https://web.archive.org /web/20210423093132/https://www.pcworld.com/article/171505 /where_in_the_world_do_viruses_come_from.html.

Cyber Zoo. 2000–9. Living School Book. https://web.archive.org/web /20091213161833/http://lsb.syr.edu/projects/cyberzoo/.

Cybrids, Los. 2001–7. Los Cybrids: La Raza Techno-Crítica Collective. http:// www.cybrids.com/. 2003 version available from http://prabapilar.com /pages/projects/los_cybrids/index.html.

Dennison, Stephanie. 2013. "National, Transnational and Post-National: Issues in Contemporary Filmmaking in the Hispanic World." In Contemporary Hispanic Cinema: Interrogating the Transnational in Spanish and Latin American Film, edited by Stephanie Dennison, 1–24. Támesis.

Diario las Américas. 2014. "Latinoamérica es la principal víctima de virus informáticos." 19 August. https://www.diariolasamericas.com/latinoamerica -es-la-principal-victima-virus-informaticos-n2914243.

Domínguez, Ricardo. 1998. "Digital Zapatismo." In InfoWar: The Re-Ordering of Things. Ars Electronica 98, edited by Gerfried Stocker and Christine Schöpf, 53–8. Springer.

Douglas, Susan Jane. 2015. "Gustavo Romano: la tarde de un escritor (The Afternoon of a Writer)." Art Gallery of Guelph, October. http:// artgalleryofguelph.ca/wp-content/uploads/2015/10/Gustavo-Romano -The-Afternoon-of-a-Writer-SJ-Douglas.pdf.

Fehimović, Dunja, and Rebecca Ogden. 2018. "Context and Contestation." In Branding Latin America: Strategies, Aims, Resistance, edited by Dunja Fehimović and Rebecca Ogden, 1–33. Lexington Books.

Ferrarelli, Mariana. 2016. "Estigmatización de la diferencia cultural-escrituras y sujetos hipertextuales." Lenguas Vivas 16.12: 62–73.

Ferrie, Peter. 2007. "W32.Sircam.Worm@mm." Symantec Security Center, 13 February. https://www.symantec.com/security-center/writeup /2001-071720-1640-99?tabid=2.

Galeano, Subcomandante. 2017. "Alquimia zapatista." Enlace Zapatista, 13 January. http://enlacezapatista.ezln.org.mx/2017/01/13/alquimia -zapatista.

Gómez-Peña, Guillermo. 2000. Dangerous Border Crossers: The Artist Talks Back. Routledge.

‒ 2005. *Ethno-techno: Writings on Performance, Activism, and Pedagogy.* Edited by Elaine Peña. Routledge.

Gómez-Peña, Guillermo, and Gabriela Salgado. 2006. "Performing in the Zones of Silence." Interview, *E-misférica* 3.2. https://hemisphericinstitute. org/en/emisferica-3-2-hybrid-imaginaries-fractured-geographies/3-2 -essays/performing-in-the-zones-of-silence.html.

Gonzalez, Angel. 2001. "A Disturbing, Latino View of Tech." *Wired*, 27 June. http://www.wired/com/culture/lifestyle/news/2001/06/44799.

Gribomont, Isabelle. 2018. "The Zapatista Discursive War: Literary Subversion in Subcomandante Marcos' Writings (1994–2017)." PhD diss., University of St Andrews.

Igoe, Jim. 2010. "The Spectacle of Nature in the Global Economy of Appearances: Anthropological Engagements with the Spectacular Mediations of Transnational Conservation." *Critique of Anthropology* 30.4: 375–97.

Jenkins, Henry. 2006. *Convergence Culture: Where Old and New Media Collide.* New York University Press.

Jones, Gareth A. 2003. "Latin American Geographies." In *The Companion to Latin American Studies*, edited by Philip Swanson, 5–25. Arnold.

Kaspersky. 2003. "Virus Review: 2002." *Securelist.* 17 January. https:// securelist.com/virus-review-2002/36006/.

Kinder, Marsha, and Tara MacPherson, eds. 2014. *Transmedia Frictions: The Digital, the Arts and the Humanities.* University of California Press.

Kolko, Beth E., Lisa Nakamura, and Gilbert B. Rodman, eds. 2000. *Race in Cyberspace.* Routledge.

Kunz, Marco. 2011. "Los borderismos del naftazteca: mestizaje y creación léxica en la obra de Guillermo Gómez-Peña." *Boletín hispánico helvético: historia,tTeoría(s), prácticas vulturales* 17–18: 169–98.

Lane, Jill. 2003. "Digital Zapatistas." *Drama Review* 47.2: 129–44.

Latorre, Guisela. 2008. *Walls of Empowerment: Chicana/o Indigenist Murals of California.* University of Texas Press.

Leaños, John Jota. c. 2005. "The (Postcolonial) Rules of Engagement: Cultural Activism, Advertising Zones and Xican@ Digital Muralism." http://www .leanos.net/Rules%20of%20Engagement.htm.

Liu, Alan. 2004. *The Laws of Cool: Knowledge Work and the Culture of Information.* University of Chicago Press.

Lozano-Hemmer, Rafael, and Guillermo Gómez-Peña. 2001. "Tech-illa Sunrise (.txt dot con Sangrita)." Pocha Nostra. http://www.pochanostra.com /antes/jazz_pocha2/mainpages/techilla.htm.

‒ 2014. "Tech-illa Sunrise (.txt dot con Sangrita)." In *Transmedia Frictions: The Digital, the Arts and the Humanities*, edited by Marsha Kinder and Tara MacPherson, 330–8. University of California Press.

- 2016. "Tech-illa Sunrise (.txt dot con Sangrita)." *Arara* 12. https://www1
  .essex.ac.uk/arthistory/research/pdfs/arara-issue-12/7.%20Tech
  -illa%20Sunrise.%20Rafael%20Lozano-Hemmer%20&%20Guillermo
  %20G%C3%B3mez-Pe%C3%B1a.pp.79-86.pdf.
MacPherson, Tara. 2014. "Digital Possibilities and the Reimagining of Politics,
  Place, and the Self: An Introduction." In *Transmedia Frictions: The Digital, the
  Arts and the Humanities*, edited by Marsha Kinder and Tara MacPherson,
  161–79. University of California Press.
Marcos, Subcomandante. 2013. "PD's a La Sexta que, como su nombre lo
  indica, fue la quinta parte de 'Ellos y nosotros.'" *Enlace Zapatista*, 29 January.
  http://enlacezapatista.ezln.org.mx/2013/01/29/pd%C2%B4s-a-la-sexta
  -que-como-su-nombre-lo-indica-fue-la-quinta-parte-de-ellos-y-nosotros.
Matewecki, Natalia. 2008. "El discurso de la biología en el arte contemporáneo
  argentino." *Ensayos: historia y teoría del arte* 15: 20–53.
Mieszkowski, Katharine. 2000. "Blow Up the Internet!" *Salon Technology*, 24
  July. http://archive.salon.com/tech/log/2000/07/24/los_cybrids/print
  .html.
Morales, Alejandro. 1991. *The Rag Doll Plagues*. Arte Público Press.
Nakamura, Lisa. 2002. *Cybertypes: Race, Ethnicity, and Identity on the Internet*.
  Routledge.
- 2008. *Digitizing Race: Visual Cultures of the Internet*. University of Minnesota
  Press.
Nayar, Pramod K. 2010. *An Introduction to New Media and Cybercultures*.
  Wiley-Blackwell.
Ortiz, Santiago. 2004. *Bacterias argentinas*. http://moebio.com/santiago
  /bacterias.
Parikka, Jussi. 2007. *Digital Contagions: A Media Archaeology of Computer
  Viruses*. Lang.
Parks, Shoshi. 2018. "These Horrifying 'Human Zoos' Delighted American
  Audiences at the Turn of the 20th Century." *Timeline*, 19 March. https://
  timeline.com/human-zoo-worlds-fair-7ef0d0951035.
Pitman, Thea. 2013a. "*Mestiz@* Cyborgs: The Performance of Latin American-
  ness as (Critical) Racial Identity." In *Latin American Identity in Online
  Cultural Production*, by Claire Taylor and Thea Pitman, 141–68. Routledge.
- 2013b. "*Revolución.com?* The Latin American Revolutionary Tradition in the
  Age of New Media (Revolutions)." *Latin American Identity in Online Cultural
  Production*, by Claire Taylor and Thea Pitman, 169–97. Routledge.
Proyecto Biopus. 2005. *Tango Virus*. Performance. "TecnoEscena 2005." Centro
  Cultural Borges, Buenos Aires.
"Race and/as Technology." 2009. Special issue of *Camera Obscura 70: Feminism,
  Culture, and Media Studies* 24.1.

Romano, Gustavo. 2000–1. *Hyperbody*. http://hyperbody.microworldnetwork
.net.
– 2003. *CyberZoo*. http://www.cyberzoo.org.
– 2004. *Time Notes*. http://www.timenoteshouse.org.
Sampson, Tony D. 2012. *Virality: Contagion Theory in the Age of Networks*.
University of Minnesota Press.
Tsing, Anna Lowenhaupt. 2005. *Friction: An Ethnography of Global Connection*.
Princeton University Press.
Weintraub, Scott. 2018. *Latin American Technopoetics: Scientific Explorations in
New Media*. Routledge.

# 11 "Todas tenemos una historia": Networked Storytelling in #MiPrimerAcoso

RHIAN LEWIS

*¿Cuándo y cómo fue tu primer acoso? Hoy a partir de las 2pmMX usando el hashtag #MiPrimerAcoso. Todas tenemos una historia, ¡levanta la voz!*

*(When and how were you first sexually harassed? [Share] today, from 2pm MX, using the hashtag #MiPrimerAcoso. Everyone has a story, raise your voices.)*[1]

@e_stereotipas, 23 April 2016

On 23 April 2016, thousands of women in Mexico and across Latin America shared their first experiences of sexual violence using the hashtag #MiPrimerAcoso (my first harassment) in response to a call tweeted by Catalina Ruiz-Navarro of the pop-feminism collective (e) stereotipas.[2] Twitter users disclosed experiences of harassment and abuse at home, in schools, at metro stations, and on buses, often at very young ages. Through this outpouring of testimonies, #MiPrimerAcoso offered a discursive frame to counter the normalization of gendered violence and to enact collective demands for justice.

In October of the previous year, Juliana de Faria (a member of the Brazilian digital feminist collective Think Olga) used the hashtag #PrimeiroAssedio in the wake of the online sexual harassment of a twelve-year-old contestant on a television program. The hashtag quickly went viral, with more than 80,000 tweets posted in the four days following its launch (Santini, Terra, and Duarte de Almeida 2016, 149). Several months later, Ruiz-Navarro encountered #PrimeiroAssedio after (e)stereotipas collaborator Estefanía Vela Barba shared her own story of sexual abuse online. Ruiz-Navarro tweeted a request for users to share their experiences using the hashtag #MiPrimerAcoso before the 24A (April 24) demonstrations against sexual harassment, assault, and femicide in Mexico known as the Primavera Violeta. A

principal concern of these movements is the complicity of the state in violence against women, and the persistent entanglement of patriarchy, capitalism, and colonialism in normative Mexican political discourses on gender (Gutiérrez 2018, 675). Guiomar Rovira Sancho (2018) describes #MiPrimerAcoso and related hashtag campaigns as a "catarsis colectiva con efectos en los juzgados, las calles, las escuelas" (collective catharsis felt in the courthouses, the streets, the schools), noting the unique political strategies and discursive capacities of movements organized via communication networks (228). In this vein, Natália Maria Félix de Souza (2019) writes that "new technologies connect the bodies and transform them, as well as their ability to communicate to each other and build affective solidarities" (105), highlighting the utility of digital networks in condensing meaning, organizing dialogues, and amplifying the impact of social movements.[3]

Early analyses of #MiPrimerAcoso took wide-ranging approaches to assessing the conversations fostered by the hashtag: Mexican technofeminist collective Rexiste published a word frequency cloud of #MiPrimerAcoso tweets on their @droncita account, which conveyed the trauma of sexual violence during childhood through the frequent use of words such as *primaria, recuerdo, niña, culpable, vergüenza, triste,* and *tocarme*.[4] To show the rapid geographical spread of the hashtag, media company Lo Que Sigue collected nearly 20,000 tweets and created interactive time-lapse maps of #MiPrimerAcoso's use in the three days following its launch, showing concentrations of activity in Mexico, Colombia, Argentina, and, to a lesser degree, Spain and the United States.[5] About a month later, Distintas Latitudes published a quantitative analysis of about 1,100 tweets filtered from the initial corpus collected by Lo Que Sigue that assessed the characteristics of the incidents described by users of the hashtag[6] (see Distintas Latitudes 2016). These assessments leave further questions about the connective dimensions of a networked dialogue, as Siobhan Guerrero McManus (2016) ponders the affective life of #MiPrimerAcoso:

> Es imposible … delimitar si el hashtag #MiPrimerAcoso debe incluirse como una suerte de preludio colectivo que interpeló la furia, la solidaridad, el enojo, el amor y la empatía que, un día después, se encontraron transitando por Reforma, o si, por el contrario, este fue un fenómeno en paralelo que virtualizó y extendió por todo México lo que de otra forma se hubiera circunscrito a algunas cuantas ciudades. (n.p.)

> (It is impossible to determine whether the hashtag #MiPrimerAcoso should be considered a kind of collective prelude to the fury, solidarity, anger, love, and empathy that, one day later, traversed the length of [Paseo

de la] Reforma, or if, on the contrary, this was a parallel phenomenon that virtualized and extended throughout Mexico that which in another form could have been circumscribed to however many cities.)[7]

Guerrero raises the possibility of exploring testimonial digital campaigns as gathering spaces to address *violencias machistas* that transcend borders and crystallize in situated and embodied experiences of oppression under patriarchy, capitalism, and colonization. This chapter explores strategies of connection within #MiPrimerAcoso through the following questions: What does it mean to bear witness to the *acosos* of others as collective catharsis? How did Twitter users recognize their individual experiences within a broader structure of violence, and what kind of futures did they collectively envision?

## Approach

When analysing Twitter data, it is tempting to focus on retweets and mentions as a means of assessing interactions between users. Figure 11.1 shows all the tweets from the Lo Que Sigue corpus that mentioned or retweeted another user. However, this means of assessing the connective dimensions of #MiPrimerAcoso yields a predictable dominance of news coverage from media outlets and commentary by public figures (highlighted in white).

Moreover, this approach to understanding connection within #MiPrimerAcoso largely excludes tweets that recount an experience of sexual violence – those that fulfilled Ruiz-Navarro's request for testimonies and dominated public perception of #MiPrimerAcoso – where mentions of other users were virtually non-existent (less than 1 per cent of all tweets).[8] As many analytical tools and methods grant conversational centrality to user accounts with large audiences and expendable resources, network analyses can occlude the decentralized connective action they often seek to represent. Rather than approach #MiPrimerAcoso as a network of quantifiable connections between users, I am interested in the sense of connection to one another that users felt while immersed in the discursive flows of the hashtag. As Zizi Papacharissi (2015) points out, "technologies network us but it is narratives that connect us to each other" (5): accordingly, I focus on the use of a resonant narrative frame to bridge individual and collective structures of feeling.

I filtered the #MiPrimerAcoso corpus of 19,607 tweets published by Lo Que Sigue into smaller corpuses – tweets that described a user's own experience of sexual violence, tweets that expressed a sentiment about sexual violence or about the campaign more generally, and

Figure 11.1.  Network analysis of #MiPrimerAcoso tweets that retweet or mention at least one other user, from a corpus of 19,607 tweets collected and published online by by Lo Que Sigue TV. Nodes related to media accounts have been highlighted in white to demonstrate the prominence of media outlets (particularly multinational news corporations) in quantitative assessments of connectivity in Twitter dialogues. Visualization created by the author using Gephi. Source: Lo Que Sigue TV.

tweets from media conglomerates – and then conducted close readings of these corpuses and coded tweets to identify recurrent patterns. Out of respect for the privacy of the Twitter users who shared their experiences using #MiPrimerAcoso, and in recognition of the sensitivity of this subject matter, I discuss examples of tweets in a summative and composite form to explore common patterns, rather than quoting individual tweets verbatim.[9]

**Attunement**

The connective power of Twitter depends on affective entanglements of users in everyday streams of digital conversation. Zizi Papacharissi (2015) understands digital social networks as ordinary spaces where

people cross boundaries between private and public spheres while "feeling their way into politics." Collective dialogues on Twitter are sustained through telling and listening, where each affective digital gesture invites others to join in by composing a tweet or interacting with another user's posts. The extension of the voice and body into the digital space is an affective process, as Les Hutchinson writes: "The space of Twitter enables our @ identities to become bodies they could not be otherwise and speak as voices we have yet to hear. Our timelines bring strangers to us just as hashtags open spaces for shared values that do not yet exist. Every day in Twitter is a new day for expressing collective pain, anger, happiness, resistance, and even humor" (2017, 203). Hutchinson's comment turns the gaze toward shared sentiments that enable users to situate themselves within digital political discourses (Papacharissi 2015, 116–17). While the clickable linking capacity of the hashtag itself is significant, this analysis takes as its basis that the connective life of hashtags is fundamentally about what people make with them. Although Twitter hashtags were originally intended to allow Twitter users to link their conversations to a shared discussion topic, Ash Evans (2016) highlights the capacity of hashtags to position the user in relation to an existing conversation, establish a contextual frame for the user's own comments, or attach a stance to the topic at hand. The use of hashtags as "open" signifiers allows various publics to affiliate with a movement and fill in the hashtag with their own desired meanings (Papacharissi 2015; see also Colleoni 2013). In asking her audience to recount their *acosos*, Ruíz-Navarro invited users to use an individually expressive personal action frame (Bennett and Segerberg 2012) to contribute to a collaborative narrative of lived violence. Rovira Sancho (2018) writes that technofeminist movements are fuelled by "una experiencia de 'dar cuenta'" 224): here, *dar cuenta* evokes both giving an account – contributing one's experience, sharing a story – and realizing or witnessing an act through first-hand presencing.

Tweets tagged #MiPrimerAcoso concretized the abstract and all-consuming nature of sexual violence – it happened here, at this time, to me – while maintaining a collective resonance that compels readers to understand the individual *acosos* as part of pervasive, broad-reaching systems of sexual violence. Although Ruiz-Navarro's use of "*acoso*" calls on a specific category of shared experience, she did not define the parameters of what should be considered an *acoso*. The inclusion of many forms of physical and non-physical sexual and gendered violence within the scope of #MiPrimerAcoso[10] allowed the hashtag's users to link experiences of street harassment with childhood sexual abuse as part of the same apparatus of violence. This openness enables

what Félix de Souza (2019) refers to as "irreducible difference," preserving the individual specificity of each testimony while enabling mutual recognition: "Contemporary feminist articulations retrieve the voice of those who have long been kept silent (or inaudible) by necropolitical structures of power. Internet and street protests have been stressing precisely this metonymic ability to craft collective agency out of singularity – irreducible difference – thus creating structures which allow for the revolutionary recognition of this other" (104). Such recognitions permit a resonant solidarity on the basis of incidents written in a particular language of power, moments when the experience of inhabiting a body was (re)inscribed with violence (see Segato 2010 and 2016b).

**Speakers/Witnesses**

Twitter users who engaged with #MiPrimerAcoso often connected with one another beyond the basis of shared experience by taking on distinct roles within the affective public of the hashtag. Regardless of whether they personally tweeted a story of sexual violence, people bore witness to the *acosos* of others by reading, retweeting, offering their reflections on the movement and on gender violence as a phenomenon, and outlining demands for a more just future. These tweets often echoed and amplified the messages of users who shared their individual experiences of harassment and abuse: after immersing themselves in streams of collective disclosure, many users affirmed "nos sucedió a cada una de nosotras" (this has happened to all of us) and "todas tenemos una historia" (all of us have a story). These echoes are at once a declaration of solidarity, an affirmation of shared experience, and an invitation for new voices and testimonies. Several authors mentioned feeling emboldened to tell their own stories after seeing those shared by others, as Ruiz-Navarro discussed in an interview with CNN: "Es un acoso constante y permanente pero nadie lo ve y nosotras no se lo contamos a otras mujeres porque sentimos que nos ponemos en un papel de víctimas muy difícil, pero si vemos que otras lo cuentan, eso nos da la fuerza de decirlo en voz alta" (Ruíz Navarro, quoted in Abu Shihab 2016; (It is a constant, permanent harassment, but nobody sees it and we don't tell other women about it because we feel like that would put us into a difficult position of being a victim, but if we see that other women tell their stories, that gives us the courage to say it out loud).

Ruiz-Navarro's statement identifies a kind of witnessing – scrolling through tweets and being affected by the testimonies of others – that may not easily translate into quantifiable interactions such as replying

or retweeting. Furthermore, she highlights the significance of visibility as a tool for confronting the "open secret" of pervasive sexual and gendered violence. Without disclosure and visibilizing, the assumptions of this open secret – that being a woman is an inherently risky state, that incidents of harassment, abuse, and assault are arbitrary tragedies rather than manifestations of systemic violence, preventable only through constant anticipation and avoidance of conditions of risk – are not challenged, and the normalization of violence that *is widely known but not discussed* precludes recourse and contestation. To testify to the pervasive nature of the violence, #MiPrimerAcoso users wrote, "es nuestra realidad", while countering "no es normal" (It's our reality, but it is not normal), a rejection of the terms of the open secret to foreground the possibility of intervention.

As they emphasized the need for deliberate practices of testimony and witnessing, Twitter users raised concerns about visibility within their networks of thousands or millions, often pointing to perceived absences and gaps in representation within #MiPrimerAcoso's collective outcry. Several critiqued Twitter's algorithmic ranking of content visibility based on quantifiable connections and user influence, such that the testimonies were "drowned out" by tweets from large media outlets and commentary from public figures. These tweets describe the frustrations of grassroots collective action within an infrastructure designed for "optimization" through the algorithmic delivery of attention to popular dialogues (see Bucher 2012, 2017), further stifling voices that are already marginalized in the public sphere. In another pattern of concern with visibility, several users asked their audiences to consider the stories left out of conversation: some commented "ni puedo pensar en las que no puedan compartir" (I can't bring myself to think of those who can't share) and others urged their audiences to pause while scrolling to "pensar en las historias que no puedan ser hashtagueadas" (think of the stories that can't be hashtagged). By pointing to the gaps in #MiPrimerAcoso's collective outcry, these speakers compel their audience to reckon with both the *acosos* at hand and those whose voices are absent from the movement.

Aside from people who did not engage with the hashtag in any way, the category of absence includes users who incorporated the hashtag into tweets where they identified themselves as having experienced sexual violence without sharing their stories, at times conceding just "no puedo contarlo" (I can't bring myself to tell it). The tension between identifying oneself with the hashtag while withholding testimony serves as reminder that disclosure is not universally feasible or desired, and that sharing one's experience "may simultaneously empower and

compromise individuals" (Papacharissi 2015, 123). This use pattern also includes a handful of users who tweeted the names and personal histories of femicide victims and directed their audiences to think about women who could not voice their experiences within the Primavera Violeta. This practice recalls other strategies of memorialization as a means of confronting femicide, such as the use of pink crosses and embroideries to memorialize murdered women in Ciudad Juárez.[11] These techniques rely on a reciprocal recognition – of sharing spaces and exchanging gazes – between those living and dead, here and missing.[12] By expanding the obligations of attention and representation to those who are *not there* within the hashtag's dialogue, #MiPrimerAcoso's speakers counter the vanishing act of systemic architectures of violence.

## Communicative Acts

The witnessing of the tweeted *acosos* recalls Rita Laura Segato's interpretation of the femicides of Juárez as "messages sent by a subject/ author who can be identified, located, and profiled only by rigorously 'listening' to these crimes as communicative acts" (2010, 80). The task of listening within #MiPrimerAcoso's affective public, following Segato, requires tracing them back to a symbolic order within which they can be understood[13] – mapping the tweeted testimonies onto a shared reality to make legible a desired future.[14]

   At the time of the Primavera Violeta protests in Mexico, the strategy adopted by the Partido Revolucionario Institucional (PRI) for eradicating violence against women prioritized economic development as a means of achieving women's independence and (thus) gender equality, as highlighted in then-president Enrique Pena Nieto's comments during a celebration of the Día Internacional de la Eliminación de la Violencia Contra la Mujer in 2015: "la mejor manera de atender la violencia contra las mujeres es a partir de la prevención; es generando oportunidades para su desarrollo y para su autonomía económica" (Presidencia de la República, 2015; the best way of addressing violence against women is through prevention, through creating opportunities for their development and economic autonomy).[15] In their analysis of state complicity in gender violence in Mexico, Abeyamí Ortega and Toby Miller (2017) situate this approach within a neoliberal developmentalist agenda "más preocupado por las mujeres en tanto mano de obra con un posible potencial microempresarial, que en velar por sus derechos humanos y ciudadanos, y en acallar los focos rojos de violencia que pudieran inquietar al capital extranjero" (242; more concerned for women as a labour force with

potential microentreprenerial opportunities than with ensuring their human and citizenship rights, and with hushing up the hotspots of violence that could interfere with foreign investment). Such interventions co-opt institutionalized feminist discourse on the valuation of women's labour[16] to promote a vision of "prevention" wherein women's accrual of human capital and economic mobility shields them from violence – the same violence intensified by the precaritization, exploitation, and rampant economic and social inequality that have flourished under the PRI's economic policies. This approach shirks the language of rights in favour of "opportunities," advocating the individual accumulation of protections rather than the collective dismantling of oppressive structures.

The state lexicon of individualist prevention and development provides a backdrop for #MiPrimerAcoso users' engagement with the *acosos* as communicative acts. The tweets' authors describe how socialization into the category of "woman" – and particularly inhabiting a body read as woman in public spaces – has meant being conditioned into constant self-vigilance against the threat of violence. The many users who posted tweets countering "no somos culpables" (we're not to blame) refract the gaze toward dynamics between the Mexican state and civil society (see Ortega and Miller 2017, 240) as an apparatus of *machista*-capitalist-colonial violences that inflict diverse and continuous harms on women (Gutierrez 2018, 670). #MiPrimerAcoso and the concurrent Vivas Nos Queremos and Ni Una Menos movements disrupt this coercive individuation by assuming a collective responsibility for witnessing, responding to, and symbolically reversing the order of violence: tweets, placards, and manifestos repeated *tocan a una, respondemos todas* (they touch one of us, all of us respond). This responsive apparatus underpins the demand for collective presence in rights-based claims to public space and unencumbered safe movement – "las calles son nuestras" (the streets belong to us) and "nos queremos libres de caminar por donde queramos a la hora que sea" (we want to be free to walk wherever we wish, at any time).

## Afterlives

After describing the abuse she experienced as a child, Ruiz-Navarro writes, "Después de ese vinieron miles ... Si les cuento todos los casos no termino. Son infinitos" (Ruiz-Navarro 2016, n.p; After that came thousands [more *acosos*] ... If I tried to recount every incident I could never finish. They're infinite). Her comments are echoed by other #MiPrimerAcoso authors who expressed being unable to remember

which *acoso* was the first, and instead situated their initial experiences within a continuum of violence: several participants questioned, "¿de hoy?" ([the first] of the day?) or, at times, said they were unable to remember their first *acoso*, because there had been so many. Participants reflected on the affordances and limitations of a hashtag campaign as an expressive container for testimonies of sexual violence, commenting on the sheer number of *acosos* to be told, the risks of disclosure, and the ongoing reality of experiencing violence on a daily basis. The impossibility of telling every *acoso* provides an imperative to continue speaking, to enable more situated and partial voices (following Haraway 1988) to be heard, and to resist the concretization of hegemonic representation.

Studying these movements as works unfinished means looking beyond Twitter for antecedents and afterlives of structures of feeling that materialize suddenly in hashtags later discarded and revived, to the chaotic exchange of discursive frames, motifs, and strategies between virtual and physical spaces. Although #MiPrimerAcoso was used heavily in the weeks that followed the #24A protests in 2016, the hashtag did not see a viral resurgence in subsequent protests against gender violence in Latin America in the manner of long-running hashtagged dialogues such as #VivasNosQueremos and #NiUnaMenos. In the wave of protests after the 2017 murder of Universidad Nacional Autónoma de México student Lesvy Berlín Rivera Osorio and during the #8M demonstrations in subsequent years, activists in Mexico set up *tendederos*, clotheslines where women hung notes describing their experiences of gender violence (many prefaced (in pen) with #MiPrimerAcoso) and outlining their demands for justice. The use of the clotheslines recalls Monica Mayer's *El tendedero,* a participatory art installation first exhibited in Mexico City in 1978. To create the work, Mayer invited women to respond to the prompt "Como mujer, lo que más me detesto de la ciudad es ..." (As a woman, what I hate most about the city is …) by writing on pink notecards that were later collected and displayed on a set of clotheslines. During the subsequent exposition of the *El tendedero* notecards at Mexico's Museo del Arte Moderno, visitors continued to approach the artwork as a living entity, adding their own testimonies by writing their own experiences on the sides or backs of the cards, or on any paper they had handy, and adding their voices to the clothesline, and so making it their own, as Mayer commented later 2015; 2016). To trace the afterlives of hashtag movements, we can look to those who gather in Twitter threads, on streets, and along clotheslines to carve out their own spaces of collective representation and resonance.

NOTES

1  All translations are mine unless otherwise noted.
2  I use the term "response" in a broad sense. Considering the scale of #Mi-PrimerAcoso's spread, neither the tweet from the @e_stereotipas account nor the one posted from Ruiz-Navarro's personal account received substantial Twitter engagement, with less than 50 retweets apiece and only a handful of direct replies. Although it seems reasonable to categorize the tweets posted by women who used #MiPrimerAcoso to tell their experiences of sexual violence as "responses" to the prompt posted by Ruiz-Navarro, users who posted narratives using #MiPrimerAcoso tended to post original tweets on their own accounts and may not have seen or interacted with the prompt tweet but instead noticed the hashtag when it became a trending topic or appeared in the tweets of users they followed.
3  For other examples, see Florencia Laura Rovetto's study of visual communication in Facebook campaigns for #NiUnaMenos and #VivasNosQueremos (2015); Sonia Núñez Puente and Diana Fernández Romero's study of narrative strategies in #7N (2017) Aidé Piña Rodríguez and Robert González-García's examination of virtual action against state impunity in the context of gender violence in Mexico (2018); as well as Guiomar Rovira Sancho's study of networked collective feminist action (2018).
4  For a study of Rexiste's political action and technological interventions, see Suarez Estrada (2017).
5  The Carto visualization maps only a fraction of the 19,607 tweets included in the unfiltered dataset, and many of the tweets shown on the map are retweets rather than tweets responding to Ruíz-Navarro's call for testimonies. When reviewing the tweets contained in the dataset, it became clear that only a minority of the tweets had successfully mapped locations from the geoJSON dataset to the Carto visualization (a "TRUE" geo value in the data, as opposed to a "FALSE" one).
6  The smaller corpus was created by isolating only those tweets that were posted by users located in Mexico and described an experience of sexual violence (Distintas Latitudes 2106).
7  Paseo de la Reforma is a central thoroughfare in Mexico City that was one of the primary gathering sites for the Primavera Violeta protests in 2016.
8  The proportion of retweets in the #MiPrimerAcoso data from Lo Que Sigue is significantly less than that of their tweet corpuses for concurrent hashtag movements such as #VivasNosQueremos, which contained approximately 82 per cent retweets compared to #MiPrimerAcoso's 69 per cent. Regarding the difference in retweeting prevalence, it is plausible that #MiPrimerAcoso's encouragement of personal disclosure eschews direct user interactions with the prompt tweets, and furthermore, that the

sensitive nature of the stories shared by participants may discourage other users from liking or retweeting the tweets.

9   Although the tweets and attached user information are technically publicly available via Carto, I recognize that the Twitter users whose tweets were collected by Lo Que Sigue likely did not foresee their words being assimilated into a corpus and reposted by a media analytics company. The use of summative and composite examples of common patterns, rather than direct quotes attributed to Twitter usernames, is a deliberate decision to provide an extra layer of privacy between the unprocessed data of the public Carto dataset and the readers of this chapter. This decision further follows the feminist reflexivity in the context of big data elaborated by Cooky, Linabary, and Corple (2018), who write of their study of the domestic violence testimonies shared via #WhyIStayed that they opted "to represent tweets within any writing produced from the study in summative and composite form, rather than directly quoting the tweets themselves."

10  The Distintas Latitudes analysis notes that approximately 40 per cent of the analysed cases "difundidas con el hashtag #MiPrimerAcoso las conductas descritas no corresponden a acoso, sino a abuso sexual" (shared with the hashtag #MiPrimerAcoso describe sexual abuse, not harasssment) (Distintas Latitudes 2016).

11  Members of the group Bordamos Femicidios "accompany" the murdered women they memorialize through their embroidery: "Lo que hacemos es acompañar a esa mujer cuyo caso estamos bordando, y prestarle eso que a ella le fue arrebatado y que nosotras todavía tenemos: vida, tiempo, espacio, voz, movimiento. Llevamos cada una nuestro bordado a donde vayamos. Bordamos en la fonda, en el transporte, en la reunión familiar, en la sala de espera del dentista. A veces nos juntamos a bordar en espacios públicos, no sólo para que nos vean y el proyecto se conozca y crezca; sino para mirarnos entre nosotras…Para entender la importancia de las redes de mujeres vivas. Para ir sintiendo que si nos tocan a una, reaccionamos todas. Para ver que en mí hay algo de ti, y viceversa" (What we do is accompany a woman whose case we are embroidering, and give her what was stolen from her, what we still have: life, time, space, voice, movement. We bring each embroidery with us wherever we go. We embroider while grabbing a bite, on transportation, at family gatherings, in the waiting room of the dentist. Sometimes we get together to embroider in public spaces, not just so that people see us and the project keeps gaining awareness and growing; but also to see ourselves together ... To understand the importance of networks of living women. To go on feeling that if they touch one of us, all of us will respond. To see that in me there is something of you, and vice-versa) (Bordamos Femicidios, Facebook, accessed 25 March 2022).

12  In this vein, Graciela Aletta de Sylvas (2017) writes of the role of cultural representations of femicide in creating a voice for bodies who do not have access to the written or spoken word: "El cuerpo del relato materializa el dolor por las muertes en el lenguaje de ese dolor que permite ir tejiendo una trama para desafiar aquello que se creía 'innombrable'" (The body in the story materializes the suffering of dead women in the language of pain that allows a weaving of trauma to challenge what was thought to be "unnameable") (73).

13  See Rita Segato's discussion of femicides in Ciudad Juárez as "expressions of a deep symbolic structure that organizes our acts and fantasies and makes them intelligible. In other words, the aggressors share the collective gender imaginary. They speak the same language; they can be understood." (2010, 74).

14  The newspapers, media coverage, public speeches, and demonstrations – as much as the analytical study of Twitter movements – also participate in this process of interpreting the communicative acts to elucidate the structures that convene their violence. See, for example, the conclusions of the Distintas Latitudes analysis, created by isolating only those tweets that were posted by users located in Mexico and described an experience of sexual violence. Distintas Latitudes found that, in its dataset of 1,100 tweets, the reported *acosos* were most likely to have occurred between the ages of six and eleven years of age and in a public space, and were commited by a perpetrator who was likely to be a stranger (Distintas Latitudes 2016). See also the analysis by Adrián Santuario of the age at which #MiPrimerAcoso authors experienced *acosos*. As Raquel Gutiérrez Aguilar emphasizes, these movements "developed in Mexico within these extremely difficult contexts of imminent threat" and therefore "exhibit features specific to those contexts" (2017, 670).

15  Furthermore, as Ortega and Miller (2017) argue, this framework perpetuates a cycle of insecurity and violence while devaluing the intrinsic rights of poor, elderly, rural, and indigenous persons to live free of violence.

16  In the same speech, Peña Nieto commented, "ustedes, las mujeres de México, son el motor del desarrollo de nuestra Nación" (you, the women of Mexico, are the engine of our nation's development) (Presidencia de la República 2015).

REFERENCES

Abu Shihab, Leila. 2016. "Todas las mujeres han sido acosadas sexualmente una vez." CNN Español. 18 October. http://cnnespanol.cnn .com/2016/10/18/todas-las-mujeres-hemos-sido-acosadas-sexualmente -alguna-vez/.

Bennett, W. Lance. 2012. "The Personalization of Politics: Political Identity, Social Media, and Changing Patterns of Participation." *Annals of the American Academy of Political and Social Science* 644.1: 20–39.

Bennett, W. Lance, and Alexandra Segerberg. 2012. "The Logic of Connective Action: Digital Media and the Personalization of Contentious Politics." *Information, Communication and Society* 15.5: 739–68.

Bucher, Taina. 2012. "Want to Be on the Top? Algorithmic Power and the Threat of Invisibility on Facebook." *New Media and Society* 14.7: 1164–80.

– 2017. "The Algorithmic Imaginary: Exploring the Ordinary Affects of Facebook Algorithms." *Information, Communication and Society* 20.1: 30–44.

Chávez, Alejandra. 2016. "En twitter, las mujeres contaron su primer acoso sexual." *La Semana*, 24 April. http://www.semana.com/on-line/mundo/articulo/en-twitter-las-mujeres-contaron-su-primer-acoso-sexual/470917.

Colleoni, Elanor. 2013. "Beyond the Differences: The Use of Empty Signifiers as Organizing Ddevice in the #occupy Movement." Paper presented at the workshop Material Participation: Technology, the Environment and Everyday Publics, University of Milan.

Cooky, Cheryl, Jasmine R. Linabary, and Danielle J. Corple. 2018. "Navigating Big Data Dilemmas: Feminist Holistic Reflexivity in Social Media Research." *Big Data and Society* 5.2. doi/org/10.1177/2053951718807731.

Distintas Latitudes. 2016. "#MiPrimerAcoso: la campaña que destapó la cloaca de las agresiones sexuales." 24 May. https://distintaslatitudes.net/miprimeracoso-la-etiqueta-que-destapo-la-cloaca-de-las-agresiones-sexuales.

Estereotipas. 2016. "MiPrimerAcoso: la historia detrás del trending topic." 24 April. *Estereotipas.* https://estereotipas.com/2016/04/24/miprimeracoso-la-historia-detras-del-trending-topic/.

Evans, Ash. 2016. "Stance and Identity in Twitter Hashtags." *Language@ internet* 13.1.

Fregoso, Rosa Linda. 2006. "'We Want Them Alive!' The Politics and Culture of Human Rights." *Social Identities* 12.2: 109–38.

Gómez, Frida Angélica. 2016 "Movilización nacional contra las niolencias machistas." *SDP* noticias. 24 April. https://www.sdpnoticias.com/nacional/2016/04/24/movilizacion-nacional-contra-las-violencias-machistas.

González, Gema. 2019. "Escraches en redes feministas universitarias: una estrategia contra la violencia de género hacia las mujeres." *Comunicación y medios* 28.40: 170–82.

Guerrero McManus, Siobhan. 2016. "24 instantes de una primavera violeta." *Crónica* 24A. Debates Feministas. Universidad Autonoma de México.

Gutiérrez Aguilar, Raquel. 2017. "Porque vivas nos queremos, juntas estamos trastocándolo todo: notas para pensar, una vez más, los caminos de la transformación social." *Revista theomai* 37. revista-theomai.unq.edu.ar/NUMERO_37/Index.htm.

– 2018. "Women's Struggle against All Violence in Mexico: Gathering Fragments to Find Meaning." *South Atlantic Quarterly* 117.3: 670–81.

Haraway, Donna. 1988. "Situated Knowledges: The Science Question in Feminism and the Privilege of Partial Perspective." *Feminist Studies* 14.3: 575–99.

Hutchinson, Les. 2017. "Writing to Have No Face: The Orientation of Anonymity in Twitter." In *Social Writing/Social Media: Publics, Presentations, and Pedagogies*, edited by Douglas M. Walls and Stephanie Vie, 179–207. WAC Clearinghouse.

Lo Que Sigue TV. n.d. "Tuits de #MiPrimerAcoso disponible en 'table_5d787653'." Base de datos disponible en Carto. https://lqs.carto .com/tables/table_5d787653/public.

– 2016. "Mapa interactivo de #MiPrimerAcoso." https://loquesigue.tv /mapa-interactivo-de-miprimeracoso/.

Marichal, J. 2013. "Political Facebook Groups: Micro-Activism and the Digital Front Stage." *First Monday* 18.12. DOI:10.5210/fm.v18i12.4653.

Mayer, Mónica. 2015. "El Tendedero: breve introducción." Si Tienes Dudas, Pregunte: Una exposición retrocolectiva de Monica Mayer (Artist's website). 19 October. http://www.pintomiraya.com/redes/archivo-pmr/el-tendedero/item/203-el-tendedero-breve-introducci%C3%B3n.html.

– 2016. "El Tendedero y sus saltos a la cultura popular." 23 June. Si Tienes Dudas, Pregunte: Una exposición retrocolectiva de Monica Mayer (artist's website). http://pregunte.pintomiraya.com/index.php/la-obra-viva/el -tendedero/item/68-el-tendedero-y-sus-saltos-a-la-cultura-popular.

Meredith, Dana A., and Luis Alberto Rodríguez Cortés. 2017. "Expanding Outrage: Representations of Gendered Violence and Feminicide in Mexico." In *Modern Mexican Culture: Critical Foundations*, edited by Stuart A. Day, 237–58. University of Arizona Press.

Ortega, Abeyamí, and Toby Miller. 2017. "La crisis de violencia de género en México, ciudadanía, estereotipos y resistencias en la era neoliberal." In *Crisis, comunicación y crítica política*, edited by Carlos Felimer del Valle Rojas and Víctor Silva Echeto, 230–60. Centro Internacional de Estudios Superiores de Comunicación para América Latina (CIESPAL).

Papacharissi, Zizi. 2015. *Affective Publics: Sentiment, Technology, and Politics.* Oxford University Press.

– 2016. "Affective Publics and Structures of Storytelling: Sentiment, Events and Mediality." *Information, Communication and Society* 19.3: 307–24.

Papacharissi, Zizi, and Maria de Fatima Oliveira. 2012. "Affective News and Networked Publics: The Rhythms of News Storytelling on #Egypt." *Journal of Communication* 62.2: 266–82.

Presidencia de la República. 2015. "Palabras del Presidente Enrique Peña Nieto, durante la celebración del Día Internacional de la Eliminación de la

Violencia Contra la Mujer." 24 November. https://www.gob.mx
/epn/prensa/palabras-del-presidente-enrique-pena-nieto-durante-la
-celebracion-del-dia-internacional-de-la-eliminacion-de-la-violencia-contra
-la-mujer?tab=.

Puente, Sonia Núñez, and Diana Fernández Romero. 2017. "Narrativas
transformadoras y testimonio ético: las estrategias discursivas de la
Plataforma Feminista 7N, Contra las Violencias Machistas." *index.
comunicación* 7.3: 269–81.

Rodríguez, Aidé Piña, and Robert González-García. 2018. "La incidencia
de la acción colectiva feminista virtual en las respuestas del Estado a la
violencia de género en México." *Edähi boletín científico de Ciencias Sociales y
Humanidades del ICSHu* 7.13: 28–37.

Rovetto, Florencia Laura. 2015. "Violencia contra las mujeres: comunicación
visual y acción política en 'Ni Una Menos' y 'Vivas Nos Queremos'."
*Contratexto* 024: 13–34.

Rovira Sancho, Guiomar. 2018. "El devenir feminista de la acción colectiva: las
redes digitales y la política de prefiguración de las multitudes conectadas."
*Teknokultura* 15.2: 223–40.

Ruiz-Navarro, Catalina (@catalinapordios). 2016. "¿Cuándo y cómo fue tu primer
acoso? Hoy a partir de las 2pmMX usando el hashtag #MiPrimerAcoso. Todas
tenemos una historia, ¡levanta la voz!". Twitter. 23 April.

– 2016. "#MiPrimerAcoso: La historia detrás del Trending Topic." *Vice*. 24
November. Web: https://www.vice.com/es/article/bned78
/miprimeracoso-la-historia-detras-del-trending-topic.

Santini, Rose Marie, Camyla Terra, and Alda Rosana Duarte de Almeida. 2016.
"Feminismo 2.0: a mobilização das mulheres no Brasil contra o assédio
sexual através das mídias sociais (# Primeiroassedio)." *P2P & INOVAÇÃO*
3.1: 148–64.

Segato, Rita Laura. 2010. "Territory, Sovereignty, and Crimes of the Second
State: The Writing on the Body of Murdered Women." In *Terrorizing Women:
Feminicide in the Americas*, edited by Rosa-Linda Fregoso and Cynthia
Bejarano, 70–92. Duke University Press.

– 2016a. *La guerra contra las mujeres*. Traficantes de sueños.

– 2016b. "Patriarchy from Margin to Center: Discipline, Territoriality, and
Cruelty in the Apocalyptic Phase of Capital." *South Atlantic Quarterly* 115.3:
615–24.

Segerberg, A., and W.L. Bennett. 2011. "Social Media and the Organization of
Collective Action: Using Twitter to Explore the Ecologies of Two Climate
Change Protests." *Communication Review* 14.3: 197–215.

Souza, Natália Maria Félix de. 2019. "When the Body Speaks (to) the
Political: Feminist Activism in Latin America and the Quest for Alternative
Democratic Futures." *Contexto Internacional* 41.1: 89–112.

Stewart, Kathleen, 2007. *Ordinary Affects*. Duke University Press.

Suarez Estrada, Marcela. 2017. "Feminist Politics, Drones and the Fight against the 'Femicide State' in Mexico." *International Journal of Gender, Science and Technology* 9.2: 99–117.

Sylvas, Graciela Aletta de. 2016. "Memoria, testimonio y ficción: una coyuntura sobre la violencia de género en el contexto de los derechos humanos." *Portadas académicas: Raíces latinoamericanas de los derechos humanos*, edited by Francisco Bustamante, Sonia d'Alessandro, and Malvina Guaraglia, 62–74. Universidad de la República, Uruguay.

# Epilogue

CECILY RAYNOR AND RHIAN LEWIS

In this volume, we have sought to take an expansive approach to Latin American engagement with digital connectivity by examining works that range from canonical novels to hashtag activism and glitch art. While this collection is not an exhaustive study, our contributors have opened several spaces for further exploration. In reflecting on the contact zone between digital connectivity and contemporary Latin American cultural production, we find ourselves contemplating the question of where to go from here: or rather, what to study and how.

The web is a context of temporal overdrive and uneven preservation of the past: as Chacón (2018) writes, the internet has "given us a different sense of our own temporality by subjecting us to a continuous, nonstop rewriting/ restating/ redoing/ self-transforming-by interacting-with-others medium whose compelling contents may very well disappear overnight" (5). It is for this reason that studies of digital culture inevitably risk being out-of-date almost as soon as they are published. However, we emphasize that this connectivity – and Latin America's engagement with it – is not simply new, it is *ongoing* and *intensifying*. This is a critical moment to explore how once-familiar cultural forms reflect everyday experiences of living within multiple networked contexts of digital connectivity. The algorithmic processing of connections between people, ideas, and online artefacts drives the ever more elaborate intuiting of human activity online, and it is therefore connectivity that provides the vital fuel to make big data big, as "los datos aislados no dicen nada" (isolated data don't tell us anything) (Elizalde 2019, 103). Thus, there is even more reason to explore digital connectivity in Latin America through a humanistic lens that attends to the power relationships encoded into digital infrastructure without losing sight of the interpretive and perceptive experiences of the web.

Several recent studies of digital culture consider the kinds of subject matter that must be analysed in order to understand the impacts and outputs of digital connectivity in Latin America and beyond. Francisco Sierra Caballero and Tommaso Gravante (2017) write of the need to "take an approach from below," to analyse "digital media experiences that are performed by ordinary people in the cities or places where the fights are taking place and that involve self-managed media" (22). As we step further into the twenty-first century, scholars who examine digital connectivity are obliged to move outside the sanctioned and sanitized canons of electronic art and literature and into the halls of chat rooms, web forums and comment sections – digital back-channels with their own forms of cultural production – in order to interrogate expressions of contemporary life.[1] Within the humanities in particular, we can adopt increasingly ethnographic and interpretive methods to understand how cultural production contemplates an increasingly networked world. Writing in the journal *Virtualis*, Isaac de Jesús Palazuelos Rojo and Alejandro Antonio Corvera Sánchez (2019) advocate a "thick data" approach (following Tricia Wang [2013]) to digital ethnography as a means of recentring the human users in studies of data that overwhelmingly quantify and flatten the subjects they purport to represent. In their approach, socio-digital phenomena are studied as a context where meanings are condensed and agencies are (re)negotiated, with particular attention to the hybridization of sociopolitical systems, materialities, and subjectivities that take shape in human-computer contacts (44). This is a particularly promising approach as digital technologies become increasingly "embedded, embodied, and everyday" (Hine 2015) as part of the immersion of digital connectivity in every setting of contemporary life that Norberto Gomez terms the "postinternet." In what follows, we consider the opportunities in such an approach for understanding Latin American cultural production's engagement with digital connectivity.

Explorations of digital connectivity must delve into the power imbalances and multinational exploitative mechanisms that are literally hardwired into the digital architecture of Latin America. This approach might allow us to interrogate the impact of digital technologies on systems of knowledge and power: what ways of knowing and speaking are made visible or rendered obsolete under the "regime of visibility" (Bucher 2012) that prioritizes the most optimized and algorithmically intuited content as the organizing principle of digital infrastructure? How does this compound the impact of digital technologies in accelerating capital gains and concentrating wealth and power in the hands of a privileged few? Paola Ricaurte writes that this digital advancement

operates as a new process of colonization that exacerbates inequities by perpetuating long-active structures of oppression on gendered and racialized communities and razing the landscape of difference by sublimating linguistic and ideological diversity (2019, 353). This argument takes on even greater strength when considered in light of recent scholarship on the perpetuation of algorithmic bias, particularly the works of Safiya Noble (2018) and Ezekiel Dixon-Román (2016).[2]

However, much remains to be learned about the negotiations Latin American internet users make in the face of the conflicting implications of internet use: how do people negotiate the promise of communicative ease and access to information against the tradeoff of a life's worth of captured data? In this volume, Eduard Arriaga's study of PretaLab explores a critically subversive stance toward digital connectivity that asks that users have the power to construct their own meanings about the networks in which they are implicated, and to purpose them for their own ends. In turn, this consideration of the context and agency of the user allows us to ask about the role of intention and desire in configuring the outcomes of networked activity: what do users want from their digital encounters? To whom do they wish to speak, and what do they want to create? We can look for intention in the search terms through which readers arrive at a website, and the affective life and discursive contexts of a hashtag. Furthermore, by using intention as a point of departure, we can ask questions about how users' desires are algorithmically processed and refracted to create filter bubbles and digital silos, and, in turn, how human and non-human entities co-create one another.

By considering the implications of meanings and subjectivities in our current readings of Latin American cultural production, we might ask how the fabric of social interaction and perception, or even the interpretation of cultural objects, is altered through contact with the digital. A "thick-data" approach to works of cultural production involves contextualizing works within their respective sociopolitical histories as well as specific media ecologies (Silva 2011; Trére 2016) and genealogies of cultural reflection on connectivity itself. A thick-data approach to perception would thus provide a means of understanding the implications of digital remediation for new forms of reading and writing: for instance, asking what a work might tell us about creatorship in an era when most online "creation" happens through backgrounded collection and machination of user data. In this light, what might we read into Villeda and Audirac's *POETuitéame* (2014) and its joyful conscription of unwitting Twitter users into the co-creation of a poem? Villeda has described the work as a playful critique of

popular assumptions about creatorship ("Poetrónica," 2014), and indeed, the poets' creative collaboration is enabled through a script that pulls tweets containing specified hashtags from Twitter's Search API, rather than through more traditional or mutually intentional forms of co-authorship. Yet, beyond contemplating what it means to write poetry, the scripted randomness of tweets ripped from their respective filter bubbles and caught up in the connective webs of Villeda's poem is a manifestation of the algorithmic "what 'finds us'" (Beer 2013, 82), the suddenly revealed truth of user data being ensconced and recontextualized as something else.

In writing on the algorithmic imaginary, Taina Bucher (2017) describes "events in which the intimate power of algorithms reveals itself in strange sensations," particular "whoa moments" that "arise when people become aware of being found" (35). Bucher's comment on awareness recalls moments of breaking away from or turning the gaze toward the digital architectures that increasingly govern everyday life. Carolina Gainza's chapter in this volume examines the cultivation of a consciousness of works' capacity for intervention: this, in turn, leads us to ask what happens when users become aware of gaps in the increasingly optimized algorithmic architecture of the web, or when the frictionless cohesion of programming languages is disrupted? In Bucher's view, these moments of awareness cultivate a possibility of breaking away from the algorithmic intuition of human activity, raising "the question of possibilities for escape" (35). This opportunity for resistance is taken up by critical projects that seize upon the disruptive potential of glitch and failure – moments when algorithms fail to accurately predict what we want, or, as Eduardo Ledesma discusses in his chapter, when artists make tactical use of glitch and error to undermine the legitimacy of hegemonic narratives and systems. Indeed, it is when the mechanisms of digital connectivity do not function as intended that they reveal themselves most vividly. As scholars, we must pause in the networked spaces fostered by these works and resolve to be affected by them, to become aware of the spaces for resistance opened by encountering the digital.

We close by calling for greater attention to the frictions and gaps in the increasingly programmed context of Latin America, in the hopes that this direction of study will reveal something about that world and the possibilities of living within it. We began this volume by asking how connectivity takes shape in Latin American cultural production. Future scholars might consider a new question: how do these works compel their audiences to find themselves within a network, and what does it mean to be found?

NOTES

1 On this note, regarding the challenge of ascertaining people's personal experiences with algorithms, Taina Bucher (2017) writes, "it might just be a matter of where we as researchers go to look for these meetings. Sometimes, it is not a matter of peeking inside the black box of code but getting behind the tweets."
2 Ezekiel Dixon-Román's concept of algo-ritmo denotes the "more-than-human algorithmic acts of racializing assemblages" that, in repeating and replicating difference in their predictions, are "doing more than recommending and suggesting but also telling us something about ourselves by hierarchizing and differentiating humanity and society" (2016, 89).

REFERENCES

Beer, D. 2013. *Popular Culture and New Media: The Politics of Circulation.* Palgrave Macmillan.

Bucher, Taina. 2012. "Want to Be on the Top? Algorithmic Power and the Threat of Invisibility on Facebook." *New Media and Society* 14.7: 1164–80.

– 2017. "The Algorithmic Imaginary: Exploring the Ordinary Affects of Facebook Algorithms." *Information, Communication and Society* 20.1: 30–44.

Caballero, Francisco Sierra, and Tommaso Gravante, eds. 2017. *Networks, Movements and Technopolitics in Latin America: Critical Analysis and Current Challenges.* Springer.

Chacón, Hilda, ed. 2018. *Online Activism in Latin America.* Routledge.

De Souza e Silva, Adriana. 2006. "From Cyber to Hybrid: Mobile Technologies as Interfaces of Hybrid Spaces." *Space and Culture* 9.3: 261–78.

de Souza e Silva, Adriana, et al. 2011. "Mobile Phone Appropriation in the Favelas of Rio de Janeiro, Brazil." *New Media and Society* 13.3: 411–26.

Dixon-Román, Ezekiel. 2016. "Algo-ritmo: More-than-Human Performative Acts and the Racializing Assemblages of Algorithmic Architectures." *Cultural Studies ↔ Critical Methodologies* 16.5: 482–90.

Elizalde, Rosa Miriam. 2019. "Colonialismo 2.0 en América Latina y el Caribe: ¿qué hacer?" In *Más allá de los monstruos: entre lo viejo que no termina de morir y lo nuevo que no termina de nacer*, edited by M. Caciabue and K. Arkonada, 102–17. Editorial Universidad Nacional de Río Cuarto.

Hine, Christine. 2015. *Ethnography for the Internet: Embedded, Embodied and Everyday.* Bloomsbury.

Magnani, Esteban. 2017. "Big data y política: el poder de los algoritmos." *Nueva sociedad* 269. https://nuso.org/articulo/big-data-y-politica/.

Noble, Safiya Umoja. 2018. *Algorithms of Oppression: How Search Engines Reinforce Racism.* New York University Press.

Pinto, Renata Avila. 2019. "Digital Sovereignty or Digital Colonialism?" *Sur International Journal on Human Rights*.

Ricaurte, Paola. 2019. "Data Epistemologies, The Coloniality of Power, and Resistance." *Television & New Media* 20, no. 4: 350–65.

Rojo, Isaac de Jesús Palazuelos, and Alejandro Antonio Corvera Sánchez. 2019. "Reinsurgencia de la etnografía en la era del Big Data: apuntes desde el sur global." *Virtualis* 10.19: 42–56.

Rossi, Aníbal. 2018. "¿Burbujas de filtro? Hacia una fenomenología algorítmica." *Inmediaciones de la comunicación* 13.1: 263–81.

Scolari, Carlos. 2008. *Hipermediaciones: elementos para una teoría de la comunicación digital interactiva*. Editorial Gedisa.

Silva, V. 2011. "Comunicación intercultural, ecología y residuos: entre Palo Alto, Flusser y Guattari." *Líbero* 14.28: 33–42.

Treré, E. 2016. "Del levantamiento zapatista al escándalo NSA: lecciones aprendidas, debates actuales y futuros desafíos de la resistencia digital." In *Activismo digital y nuevos modos de ciudadanía: una mirada global*, edited by J. Candón and L. Benítez, 40–60. InCom-UAB.

Villeda, Karen, and Denise Audirac. 2014. *POETuitéame*. Accessed 9 March 2022 at: *http://www.poetronica.net/poetuiteame.html*.

Wang, Tricia. 2013. "Big Data Needs Thick Data." *Ethnography Matters* 13. http://ethnographymatters.net/blog/2013/05/13/big-data-needs-thick-data/.

# Contributors

Eduard Arriaga, Clark University
Nora C. Benedict, University of Georgia
Katherine Bundy, McGill University
Carolina Gainza Cortés, Universidad Diego Portales
Norberto Gomez Jr., Montgomery CollegeEduardo Ledesma, University of Illinois at Urbana-Champaign
Eduardo Ledesma, University of Illinois at Urbana-Champaign
Rhian Lewis, McGill University
María José Navia, Pontificia Universidad Católica de Chile
Élika Ortega, University of Colorado Boulder
Cecily Raynor, McGill University
Thea Pitman, University of Leeds

# Index

Page numbers in italics represent figures.

access, 4–5, 25, 26, 30, 36n12, 212.
    *See also* digital divide
activism: anti-Black violence,
    201–2; caution around internet,
    217–18n16; #8M demonstrations,
    265; Electronic Disturbance
    Theater, 229; hacktivism, 118–19,
    228–9, 247n9 (*see also* Mendoza,
    Antonio); inclusivity in digital
    world, 204–6; *net-pantla*, 191–2,
    193; viral *indigeneidad*, 244–6.
    *See also* feminism; Mendoza,
    Antonio; #MiPrimerAcoso; tactical
    media; Zapatistas
*Acuarios* (Areco), 104n6
Adorno, Theodor W., 192–3
aesthetics: aesthetic joy, 140–1;
    bookishness, 77; digital, 140,
    143–4, 147–8; *La Tercera*, 58n3;
    Latino, 230; *Tesauro*, 74; viral, 110,
    111, 228–30, 236–7, 240
Afrolatinxs. *See* Black people
afterlife presence, 189
Agustini, Gabriela, 206. *See also*
    PretaLab
Aletta de Sylvas, Graciela, 268n12
Alexa (web analytic), 41, 45, 49,
    57–8n2, 58n5

algorithms: overview, 46, 154; algo-
    ritmo, 277n2; favouring large
    media, 262; learning in real time,
    168, 170; *POETuitéame*, 276; research
    and social media, 277n1. *See also*
    coding; searches; web analytics
alienation, 120
Allende, Isabel, 49
Almodóvar, 53
*Alone Together* (Turkle), 182–3
Altunaga, Rewell, 120
Amadeu da Silveira, Sérgio, 184–5
Amaro, Lorena, 88, 95
Amerika, Mark, 123
*Anacrón* (Marquet and Wolfson),
    *69–71*; aesthetic of bookishness,
    77; and *Caja*, 62, 68–72, 77, 81;
    creation of, 68; and *Día de Muertos*,
    69; digitalness of, 66–7; earlier
    print instantiations, 77, *80*, 81;
    liquid content, 67; remediation,
    81–2; ruptures between media, 81;
    on violence, 69, 70–2
Anderson, Benedict, 38
Ansermet, Ernest, 20
anti-copyright, 114–16
anti-monumentality, 130
Anzaldúa, Gloria E., 191–2

Appadurai, Arjun, 216n12
appropriation: of conservation, 250n34; and copyright, 115–16; and digital inclusion, 184, 202, 204; for liberation, 210; piracy, 152; of viruses, 224. *See also* anti-copyright; *latinidad*
Areco, Macarena, 90–1, 104–5n6, 105n8
Argentina, 15, 43, 52–3, 59n12, 241. *See also* digital newspapers; newspapers; Ocampo, Victoria; *Sur*
Arriaga, Eduard, 200–22
art market, 131, 134
artificial intelligence (AI), 176n5, 201
assault. *See* #MiPrimerAcoso
assimilation, 119, 210
attributes, 17, 33n4, *34n4*
Audirac, Denise, 3, 275–6
"Augmented City 3D" (film), 164–5
"Augmented (hyper)Reality: Domestic Robocop" (film), 164
augmented reality (AR), 161, 163–5, 166–7, 168–71, 183
autonomy, 212
Avila, Renata, 5–6

back-channels, 274
*Bacterias argentinas* (Ortiz), 241, 251n36
Baeza, Ricardo, 22
Bahia, Silvana, 202, 205, 206, 208, 212, 214. *See also* PretaLab
Bailey, Moya, 205
Ballester, Ignacio, 74
Baradit, Jorge, 90–1, 144
Barnett, Fiona, 217n13
Baudrillard, Jean, 89, 91–2, 94, 97, 165
Beasley-Murray, Jon, 225–8, 230
Beiguelman, Giselle, 62
Benedict, Nora C., 15–37
Benjamin, Ruha, 201

Bennett, Jane, 89
Bernstein, Mark, 83n2
beta, 195n1
Betancourt, Michael, 131
Bianco, José, 21–2, 35n6
Big Data from the South, 205
*Birth of Venus* (Botticelli), 115
Black digital humanities, 213–14
Black people, 201–3, 205–7, 210–13, 215n1, 217–18n16, 218nn17–18
Black studies, 200
"Blanco" (Paz), 65
books, 23, 24–5, 32, 37n21, 61. *See also* print to digital translations
Bordamos Femicidios, 267n11
"Border Interrogation" (Gomez-Peña), 163
Borland, Isabel Álvarez, 135n3
Bosch, Lynette, 135n3
Boym, Svetlana, 103
brand management, 183–4, 195n1
Brazil, 142, 179–81, 193, 203–4. *See also* PretaLab; Rocha, Eva
broadband connections, 5
Brown, Andrew, 162–3
browser art, 111, 136n5
Bruguera, Tania, 136n6
Bucher, Taina, 276, 277n1
Buenos Aires, 15
Bundy, Katherine, 157–77

Cabrera, Yonlay, 109, 119–20, 133–4; *choteo*, 122, 123, 128, 130; *Cuba_20170127*, 123, 124–30, *126*, 131–2; on ethical stances of artists, 121–2; and Mendoza, 134–5
*Caja* (Wolfson), 62, 68–72, 77, 81. See also *Anacrón*
Cantavella, Robert Juan, 77
*Capital* (Marx), 176n4
capitalism: and appropriation, 134–5; and Catholicism, 173, 174; and computers, 90–1; and

*latinidad*, 226; and microworlds, 238; and modernity, 216n11; print capitalism, 38; and universality, 186; and waste, 87. *See also* Mendoza, Antonio; neoliberalism

carceral technologies, 201

Carreño, Rubí, 96

Carrión, Jorge, 76

Castello Branco, Carlos, 195n3

Catholicism, 159, 160, 173–4

Causa, Emiliano, 241, 251n37

Cazeloto, Edilson, 186, 197n12

censorship, 11, 131, 179, 181, 195n3

Centro de Cultura Digital México (CCDMx), 65–6

Césaire, Aimé, 200

Chacel, Rosa, 22

Chacón, Hilda, 108, 273

Chan, Anita, 205

Cheney-Lippold, John, 201

Chile, 42, 43, 95, 104n4. *See also* Cociña, Carlos; *La Tercera*; *Mis documentos*

*choteo*, 110, 122–3, 128, 130

*cibercafes*, 5

circuitbending, 111

Ciudad Juárez, 263, 268n13

*Clickable Poem@s* (Correa-Diaz), 62

close readings, 53, 55, 57

cloud, as term, 195n2

Cociña, Carlos, 145–8, *147*

code, as visible, 118, 142, 152

coding, 143, 151, 152; critical code studies, 141; and digital literature, 143–52, *147*, *149*; as executable, 151; hacking digital literature, 150–2, 153–4; as language of power, 210; leaky programming, 135n1; liberating code, 142; real time, 169–70. *See also* hackers/hacking; hacktivism

collaboration, 210–11

Colombia. *See* "Hyper-Reality"

colonization: collections, 237, 241–2; corporations and data, 5–6; digital globalization/e-colonialism, 184–6, 189; Global North fears, 225; inequalities, 274–5; and thingification, 200

commodification: of activism, 192–3, 198n17; commodity fetishism, 165, 176n4; of glitches, 133, 134–5; of hyperreality, 165; internet as marketplace, 250n30; of life, 6; of public space, 192

computers: as *actants*, 89; as aspirational, 91; and capitalism, 90–1; as dangerous, 90, 92–3, 97–8, 117–18 (*see also* viruses); as family, 96–7, 98–9; as financial sacrifice, 89–90, 91; materiality of, 87, 93; and memory, 91; as mirrors, 94; misreading communications, 100; and perception, 145. *See also* coding

CONACULTA (the National Council for Culture and Arts), 65–6, 72

*Concretoons* (Moreno), 66

connectivity (general), 4–5, 273–6. *See also* digital divide

consciousness, 4

conservation, 237, 250n34. See also *CyberZoo*

consumerism, 165, 208. *See also* "Hyper-Reality"

content, 19–20

coolness, 110, 225–9, 244

Copesa, 42

copyright, 114–16, 128, 152–3

corporations, 116, 215n2

Correa-Diaz, Luis, 62

correspondence, 19–22, 32. *See also* print-to-digital translations

Cortés, Carolina Gainza, 139–56

Cortright, Petra, 196–7n11

Corvera Sánchez, Alejandro
    Antonio, 274
Costa e Silva, Artur da, 195n3
Costas, Matías Romero, 241
counterculture, 51–3
crime, 111–13
Criterion Collection, 64
critical code studies, 141
*Crónica de viaje* (Carrión), 76
Cuba, 120–1, 122–3, 126–31, 133,
    136n10. *See also* Cabrera, Yonlay;
    Mendoza, Antonio
*Cuba_20170127* (Cabrera), 123,
    124–30, *126*, 131–2
Cubans, defined, 107–8
cult of quantitative efficiency, 186,
    197n12
*Cultura digital en Chile* website, 142–3
cultural hacking, 140, 153–4
cyberterrorism, 118–19
*CyberZoo* (Romano), 223, 236–44,
    *239, 242*–3, 249n29, 249–50n30,
    250nn31–2, 250n34
"A Cyborg Manifesto" (Haraway),
    162
cyborgs, 249n22. *See also* Haraway,
    Donna; "Hyper-Reality"
*Cyborgs in Latin America* (Brown),
    162–3

Darío, Rubén, 42
dark web, 112, 113–14, 118
data: afterlife presence, 189–90;
    biological information, 17, 26–7,
    *28–9*, 30, *31*, 36n16, 36nn18–19;
    collection (*see* Ocampo, Victoria);
    as dehumanizing, 211; distant, 45;
    and exclusion, 6; leaks, 135n1; life
    as continuous data flow, 6; and
    marking up bodies, 200–1; and
    surveillance, 179; thick data, 274,
    275; users as content generators,

194–5n1, 208. *See also* digital/data
    colonialism
databending, 111
datamoshing, 132
Dawkins, Richard, 196n9
Day of the Dead, 69, 72
de Souza e Silva, Adriana, 11n3
death and presence, 189–90
definitions, 73
Delgado, Ángel, 131
*desaparecidos*, 179, *180*, 181–2, 186,
    190, 196n4. *See also* Rocha, Eva
desire, 46
destructivity, 228–9, 234, 241
*Detector de ideologías* (Saavedra), 122
*détournement*, 182, 192
*Día de Muertos*, 69, 72
Díaz-Canel, Miguel, 136n10
dictionaries, 73
digital aesthetic, 140, 143–4, 147–8
digital connectivities. *See*
    connectivity
*Digital Contagions* (Parikka), 223–4
digital *desaparecidos*, 186. *See also*
    Rocha, Eva
digital divide, 5, 207–8; and Black
    Brazilian women, 205–6, 211; Cuba
    and artists, 120–1, 123, 136n10;
    makers and consumers, 208, 209;
    personal computers as illegal,
    108; technology perpetuating
    inequalities, 234–5. *See also* access
digital ethnography, 274
digital humanities, 200, 212–14,
    217n14, 274
digital literature: and code, 143–52,
    *147, 149*; defined, 139–40;
    expandability of, 151; and
    hacking, 153–4; history in Latin
    America, 142; intervening in,
    141, 145–7, 150–2, 153–4. *See also*
    *specific pieces*

digital newspapers, 39, 41–2.
  See also *La Nación*; *La Tercera*;
  newspapers
digital postcards, 240–1, *243*
digital Zapatismo, 229. *See also*
  Zapatistas
digital/data colonialism, 5–6, 184–5
digitalization, 144. *See also*
  print-to-digital translations
Dines, Alberto, 195n3
disconnection. *See* Cabrera, Yonlay;
  *Mis documentos*
disease, 224. *See also* viruses
distant data, 45
distributed open collaborative
  course (DOCC), 217n15
Dixon-Román, Ezekiel, 277n1
doctoring images, 114
"Domestic Robocop" (film), 165
domesticity, 162, 163–4
"Domesti/City" (Matsuda), 163
Domínguez, Ricardo, 229
Donald, James, 92
Douglas, Susan Jane, 227–8
*dwarsligger*, 61

Eastgate, 64, 83n2
e-colonialism, 185–6, 189. *See also*
  digital/data colonialism
Editorial Sur. See *Sur*
efficiency, 197n12
Ejército Zapatista de Liberación
  Nacional (ELZN), 192–3, 229,
  233–4, 244–6, 248n15
*El Boomeran(g)* (website), 39–40
*El Convidado* (Lope de Rueda), 68
"El hombre más chileno del mundo"
  (Zambra), 99–100
*El tendedero* (Mayer), 265
elections, 46
Electronic Disturbance Theater
  (EDT), 229, 234

electronic literature, 140. *See also*
  digital literature
"Electronic Literature Translation"
  (Pold, Mencía, and Portela), 63
Elizalde, Rosa, 4
Elliot, Kamilla, 67
embroidering, 267n11
entities, 17, 33n4, *34n4*
ethnography, 274
Evans, Ash, 260
Evelle, Monique, 210–11
*Everyday Atlantic* (Gentic), 42
Expanded Books Project (EBP), 63–4

Facebook, 179–81, 182, 189, 194
failure/errors: browser art, 111,
  136n5; challenging universalism,
  108; circuitbending, 111;
  databending, 111; datamoshing,
  132; and discerning audiences,
  131–2; as disrupting illusions,
  133–4; dominant logic and control,
  113; as escape, 132; as hardwired
  into realities, 108; in "Hyper-
  Reality," 158, 170–1; as ineffective,
  132–3, 134–5; misreadings, 113;
  print to digital translations,
  26; and propriety, 107, 111; and
  unequal access, 108, 111. *See
  also* Cabrera, Yonlay; Mendoza,
  Antonio; *Mis documentos*; viruses
fake news, 181
"Family Life" (Zambra), 100–1
Faria, Juliana de, 256
favelas, 11n3, 203–4
femicide, 267n11, 268nn12–13. *See
  also* #MiPrimerAcoso
feminism, 162, 209–10, 217n15, 260,
  261. *See also* #MiPrimerAcoso
FemTech, 217n15
FemTechNet, 210
Finn, Ed, 46, 56

fish tanks, 104–5n6
Fitzpatrick, Jim, 198n17
"Flannery" (Donald), 92
flipback book, 61
Floodnet, 229
Floridi, Luciano, 189
Fontén, Gregorio, 148–50, *149*
Ford, Tamara, 192
*Formas de volver a casa* (Zambra), 95
Fractal Media, 158, 160
Franco, Marielle, 217n15

Gache, Belén, 66
Galeano, Subcomandante, 245–6, 251nn39–40. *See also* Marcos, Subcomandante
Gallon, Kim, 213
Galloway, Alexander, 143, 151
Garcia, René, 234. *See also* Los Cybrids
gender binaries, 170
Genette, Gérard, 36n12
Gentic, Tania, 42
Gil, Gilberto, 215n7
Glazier, Loss Pequeño, 143
glitch art. *See* Cabrera, Yonlay; Mendoza, Antonio
glitches. *See* failure/errors
*GlitchMix, not an error*, 123–5, *124*
Global North, 232–4. *See also* colonization
globalization, 184–6, 228
Gomez, Norberto, Jr., 178–99
Gómez-Peña, Guillermo, 223, 227, 230, 234, 247n11, 247–8n12, 248n18. *See also* "Hyper-Reality"; "Tech-illa Sunrise (.txt dot con Sangrita)"
*Gongora Wordtoys* (Gache), 66
González, Pablo Alonso, 130
Gournelos, Ted, 134
Granados, Omar, 121
*Granma* (newspaper), 131

Gravante, Tommaso, 274
Groys, Boris, 143–4
Guerrero McManus, Siobhan, 257–8
Guevara, Ernesto "Che," 198n17
Gutiérrez, Bernardo, 193

hackers/hacking: art as virus, 228–9; cultural hacking, 140, 153–4; defined, 175n2; "Hyper-Reality," 163, 172–3, *172*; "Poema del terremoto," 150; PretaLab, 206, 212; and Zapatistas, 229. *See also* failure/errors; Mendoza, Antonio; tactical media; viruses
hacktivism, 118–19, 228–9, 247n9. *See also* Mendoza, Antonio; tactical media
Haier, 125
Happy Meals, 250n34
harassment. *See* #MiPrimerAcoso
Haraway, Donna, 162, 167, 172, 174
hashtags, 260, 262–3. *See also specific hashtags*
Havana, 15, 123–5
Hayles, N. Katherine, 61, 67, 140, 154
Hayworth, Rita, 20–1
Henken, Ted, 122
Herzog, Vladimir, 186, *188*, 189–90
HexFiend software, 111
"Hipótesis IV" (Wolfson), 62. See also *Anacrón*
Holmes, Tori, 216n8
homogenization. *See* postinternet
Horkheimer, Max, 192–3
Horst, Heather, 202–3
Hot Topic, 198n17
Hoyos, Héctor, 87, 89, 90, 103
Huizar, Angelica J., 4
human zoos, 242
human-city interface (HCI), 162
humanities, 213. *See also* Black digital humanities; digital humanities

humour, 110. See also *choteo*
Hutcheon, Linda, 67, 81
Hutchinson, Les, 260
Huxley, Matthew, 20
hybrid spaces, 4
hyperreality, 165–6
"Hyper-Reality" (film), 158–9, *166*, *171–2*, *174*, 174–5; augmented reality, 161; Catholicism, 173; domestic and public space, 162, 164; hacker cyborg, 172–3; hyperreality, 165–6; immersive AR, 165, 166–7, 168–71; mistranslation, 166–7
"Hyper-Reality" (Matsuda), 157
hypertextuality, 140, 143, 151. *See also* digital literature

"I Love You" exhibition, 224
Igoe, Jim, 237, 240, 250n34
immersion. *See* augmented reality; postinternet
Indigenous peoples, 244–6. *See also* PretaLab; Zapatistas
informatics monoculture, 186
information communication technology (ICT), 4–5
intellectual property, 152–3. *See also* copyright
internet as dangerous, 90, 92–3, 97–8, 117–18. *See also* viruses
internet as total immersion. *See* postinternet
Internet of Things, 4, 208, 216n10
internet profits, 5–6
interrogation, 179, 182, 184, 186
intersectionality, 210
Ito, Parker, 196–7n11

Jacobs, Fredrika, 179
Johnson, Jessica Marie, 200, 211, 215n1

*Joma! do Brasil* (newspaper), 195n3
Jones, Gareth, 246–7n4

Karppi, Tero, 189
Keeling, Kara, 217n13
Kirschenbaum, Matthew, 61
Kittler, Friedrich, 151
Klee, Paul, 167
knowledge economy, 208
Korda, Alberto, 198n17
Kozak, Claudia, 140, 141–2
Krapp, Peter, 118–19
*Krishna Venus* (Mendoza), 115

*La Nación* (newspaper): 42, 56–7; advertising, 55–6, 59n13; audience overlap, 45, *45*, 58n6; as authority site, 43; geographies of readers, 44, 58n6; literary content, 47, 49, 51–3, 55–7; literary content searches, 49–50; readings, 51–3, 55; site traffic, 41; structure online, 47; tagging, 47, 55; traffic sources, 43–4, *44*; traffic/time spent, 57n1
*La novela luminosa* (Levrero), 139
*La Tercera* (newspaper): 42, 56–7; aesthetics of, 58n3; audience overlap, 45, *45*, 58n6; as authority site, 43; counterculture, 51–3; *Culto* section, 42, 43, 47–8, 51–3, *54*, 56–7; *Culto* section searches, 49–50; geographies of readers, 44, 58n6; links, 59n13; readings, 51–3; site traffic, 41; traffic sources, 43–4, *44*; traffic/time spent, 57n1
*La vida privada de los árboles* (Zambra), 104–5n6
language, 151, 185, 232–3, 237–8, 250n31. *See also* coding
Lanier, Jaron, 201, 215n3
Larraín, Juan Carlos, 42

Latin America: access as communitarian, 208; cyborgs in, 162–3 (*see also* "Hyper-Reality"); and digital divide (*see* digital divide); exoticization of, 246–7n4 (see also *latinidad*); hypertextual novels, 142; internet connections by country, 108; internet connections in 1999 and 2019, 4–5; internet profits, 5–6; and pirates, 152; religion and science, 160–1, 173–4; truth commissions, 181–2; and virus names/origins, 225. *See also* viruses

*Latin American Cyberculture and Cyberliterature* (Taylor and Pitman), 5

*latinidad*, 225–9, 231–3, 236, 241, 247n7

Latino aesthetics, 230

Latino cool, 225–8

Latinx, defined, 246n1

Latour, Bruno, 89

*Laws of Cool, The* (Liu), 110, 225, 226–9

leaky programming, 135n1

Leaños, John Jota, 234. *See also* Los Cybrids

Ledesma, Eduardo, 107–38, 142, 152

*Lettered City, The* (Rama), 38

letters. *See* correspondence

Levrero, Mario, 139, 152–3

Lewis, Rhian, 3–14, 256–78

LGBTQ+, 209–10, 217n13

life, commodification of, 6

literary content, 38, 49–50. See also *La Nación*; *La Tercera*

Liu, Alan, 110, 225, 226–9

locality, 209, 216n12

loneliness, 94

Lope de Rueda, 68

Los Cybrids, 223, 234–6, *235*, 248n18, 248n20

loss in translations, 24–5

loyalty points, 158–9, 169. *See also* "Hyper-Reality"

Lozano-Hemmer, Rafael, 223, 247n11, 247–8n12. *See also* "Tech-illa Sunrise (.txt dot con Sangrita)"

Lucas, Tarcisio, 241

MacPherson, Tara, 247–8n12

malware, 125, 246n2

Manovich, Lev, 141, 146

Marcos, Subcomandante, 192–3, 233–4, 244–6, 248n15, 251nn39–40

marginalization, 162, 234

Margolles, Teresa, 197n15

Marino, Mark, 141, 151

marking up bodies, 200–1, 215n1

"Markup Bodies" (Johnson), 200

Marquet, Augusto, 68, 69. See also *Anacrón*

Martin, Ricky, 226

Martinez-Torres, Maria Elena, 192

Marx, Karl, 120, 176n4

materiality, 87, 93, 148

Mato, Daniel, 7

Matsuda, Keiichi, 159–61, 163, 164–5, 169, 173. *See also* "Hyper-Reality"

Mayer, Monica, 265

mayhem.net, 111–19, *113–14*, *117*

Mbembe, Achille, 216n11

McDonald's, 250n34

McHugh, Gene, 183–4

McPhail, Thomas L., 185

Medellín, 159–61, 174–5. *See also* "Hyper-Reality"

*Mediated Memories in the Digital Age* (Van Dijck), 101

medium readings, 51–3, 57

Mella, Julio Antonio, 125

memorialization, 189, 267n11

memories: belonging to computers, 91; computers as family, 95;

and imperfection, 103; and indoctrinations, 179–81, *180*, 181–2; mediated, 101; perfection of, 103, 168; tangled memories, 101, 105n8; technology and loss, 100; technology helping, 103–4n2. See also *Tag: A Memorial Poem*

"Memories of a Personal Computer" (Zambra), 91, 93, 97–9

Mencía, María, 63

Mendoza, Antonio, 109–11, 133–4, 135n2, 135–6n3; currently, 110, 136n7; mayhem.net, 111–19, *113–14, 117*; subculture.com, 111, 117

Menkman, Rosa, 132–3

*Mexica* (Pérez y Pérez), 62

"The Mexican Bug" (Lozano-Hemmer and Gómez-Peña), 233

Mexico, 65–6, 163, 192–3, 229, 233–4, 257, 265. See also *Anacrón*; #MiPrimerAcoso

Mexico City, 15

Milan, Stefania, 205

Miller, Toby, 263, 268n15

#MiPrimerAcoso, 256–7, 260–1; absent stories, 262–3; afterlives, 265; analytics, 257, 258–9, *259*, 266n2, 266nn5–6, 266-7n8, 267nn9–10, 268n14; communicative acts, 263–4; and continuum of violence, 264–5; solidarity, 261; witnessing, 261–3

*Mis documentos* (Zambra), 87–9; computer biography, 96; computers altering characters, 89, 93–4; computers and memories, 91, 96, 100–1; computers as discomfort/expensive, 89–90, 91; computers as lenses, 104–5n6; computers as obligation, 91; people as technology, 101; technology and

family, 94–100; technophobia, 90, 92–3; temporalities, 103

mobile internet, 5, 11n3

mobile subscriptions, 5

modernity, 216n11

molar virality, 224, 225, 227, 231–2, 233, 237, 244

monoculture, 186, 193

Montfort, Nick, 61–2

Montoya Juárez, Jesús, 88

monumentality, 130

Morán, Azucena, 181–2

Moreiras, Alberto, 7

Moreno, Benjamín, 66

"Most Chilean Man in the World" (Zambra), 99–100

mourning, 189

movement, 30

*Movimento Passe Livre*, 193

multimedia. *See* print/digital hybrids

museums, 237, 242

Musk, Elon, 175, 176n5

"My Documents" (Zambra). See *Mis documentos*

nation states, 38

nationhood, 158, 161

Navia, María José, 87–106

Nayar, Pramod, 247n9

neoliberalism: as haunting, 104n4; and speed, 102–3; as sustained by internet, 6; and violence against women, 263–4, 268nn15–16; as virus, 241, 251n36; zoos/museums, 237, 239, 250n34

*nepantla*, 190–2

*net-pantla*, 191–2, 193

Neuralink, 175, 176n5

newspapers, 38. *See also* digital newspapers; *La Nación*; *La Tercera*

*Ninth Symphony* (Beethoven), 64

Noble, Safiya Umoja, 201, 210, 215n4
Noemi, Daniel, 102–3
Nora, Pierre, 125
Nunes, Mark, 108, 113

*O livro depois do livro* (Beiguelman),
    62
Ocampo, Silvina, 21–2
Ocampo, Victoria, 15–17; archives
    of, 19, 35nn5–6; connectedness
    of network, 20, 26–7, 27–9, 30,
    31, 32–3, 36n16, 36nn18–19;
    correspondence and data
    collection, 19–22, 21, 32 (*see also*
    print to digital translations);
    literary choices, 17. See also *Sur*
*Off-Modern, The* (Boym), 103
Öhman, Carl, 189
Oliver, María Rosa, 21, 35n6, 35n9
Olson, Marisa, 196n9
online/offline, 4, 182–3, 186.
    *See also* augmented reality;
    "Hyper-Reality"
O'Reilly, Andrea, 107
O'Reilly, Tim, 194–5n1
Orta, Levi, 122
Ortega, Abeyamí, 263, 268n15
Ortega, Élika, 61–86
Ortiz, Santiago, 241, 251n36
*Otro* (Cantavella), 77

PageRank, 43
Palazuelos Rojo, Isaac de Jesús, 274
Papacharissi, Zizi, 258–60
paradoxical logic, 167–8
*Paratexts* (Genette), 36n12
Parikka, Jussi, 223–4
Partido Revolucionario Institucional
    (PRI), 263–4
Paz, Octavio, 65–6
pedagogy of autonomy, 212

Peña Nieto, Enrique, 263–4, 268n16
perception, 145
Pérez y Pérez, Rafael, 62
performance, 192, 195n1, 227, 230–1
perpetual beta, 195n1
personal empires, 183–4, 195n1
Pezzoni, Enrique, 22
photography, 114
physical form, 19–20
Pilar, (Mónica) Praba, 234, 236.
    *See also* Los Cybrids
Pinochet, Augusto, 42
Pitman, Thea, 5, 134, 208, 223–55
PixelDrifter, 125
"Poema del terremoto" (Fontén),
    148–50, 149
poetry: "Blanco," 65–6; Brazilian
    e-poetry, 142; *Clickable Poem@s*, 62;
    code poetry, 142, 145–52, 147, 149;
    *Concretoons*, 66; *Gongora Wordtoys*,
    66; "Poema del terremoto,"
    148–50; *POETuitéame*, 3–4, 275–6;
    and suffering, 3, 4; in *Sur*, 17, 18;
    *A veces cubierto por las aguas*, 145–8.
    See also *Tesauro*
*POETuitéame* (Villeda and Audirac),
    3–4, 275–6
Pold, Søren, 63
Pontos da cultura, 215–16n7
Portela, Manuel, 63
porting, 82
Posada, José Guadalupe, 72
postcards, 240–1, 243
postinternet: cultural capital of
    tech corporations, 193; defined,
    178; e-colonialism, 185–6, 189
    (*see also* digital/data colonialism);
    as immersion, 274; internet as
    banality, 184; and legacy, 189–90;
    and traditional painting, 196–7n11;
    universality of, 196n9

postweb, 76
Pressman, Jessica. See *Tesauro*
PretaLab: 202–3, 204–6, 275; and Black
    digital humanities, 213–14; coding
    as language of power, 210–11;
    conception of "human," 214; as
    connection, 207–8; creating space,
    207; digital world as diverse, 216n9;
    engaging outside consumerism,
    208, 210; hacking, 206–7, 212;
    history of, 206; intersectionality,
    210; knowledge production, 209;
    pedagogy of autonomy, 212;
    structural changes, 209–10; survey,
    211–12, 218nn17–18; traditional
    knowledge, 214
Primavera Violeta, 256–7, 263.
    *See also* #MiPrimerAcoso
#PrimeiroAssedio, 256
Princeton University, 19
print networks, 32
print-to-digital translations:
    18–19, 33, 33n4, *34n4*; access,
    25, 26, 30, 36n12; and data
    processing, 24; *dwarsligger*, 61;
    EBP, 63–4; errors, 26; history
    of, 64–5; as layered process,
    82; loss, 24–5; movement, 30;
    as multidimensional, 63; and
    nuanced networks, 22–3, 24,
    26–7, *27–9*, 30, *31*, 32–3, 36n16,
    36nn18–19; and organization
    of information, 22; porting, 82;
    remediation, 63, 66, 74, 81–2;
    space, 26; and substitution, 25;
    transcoding in *Tesauro* and
    *Anacrón*, 81–2; visibility, 26
print/digital hybrids, 61–2, 64–7, 76,
    81, 144. See also *Anacrón*; *Tesauro*
privacy, 179
programming. *See* coding

"Prosas IV" (Wolfson), 68–72
Proyecto Biopus, 241

QueerOS (manual), 217n13

Radio Frequency ID communication
    (RFID), 216n10
Raley, Rita, 107–8, 141, 142
Rama, Ángel, 38
Raynor, Cecily, 3–14, 38–60, 273–8
readings, 51–4, 55–6, 57
"Recuerdos de un computador
    personal" (Zambra), 91, 93, 97–9
remediation, 63, 66, 74, 76, 81–2
Rettberg, Scott, 83n2
Rexiste, 257
Ricaurte, Paola, 6, 274–5
rights vs opportunities, 263–4
Rivera Osorio, Lesvy Berlín, 265
Rocha, Eva, 178, *180*, 181, 190–2,
    193–4. See also *Tag: A Memorial
    Poem*
RodAda Hacker, 206
Romano, Gustavo, 227, 240–1,
    249n23, 249n27. See also
    *CyberZoo*
Ross, Melisa, 181–2
Rovira Sancho, Guiomar, 257, 260
Ruiz-Navarro, Catalina, 256, 260,
    261, 264. *See also* #MiPrimerAcoso

Saavedra, Lázaro, 122–3
Sabato, Ernesto, 22
Saltz, Jerry, 197n11
Sampson, Tony, 224
Saum-Pascual, Alex, 66, 76–7
scanning. *See* print-to-digital
    translations
science fiction and science, 157
Scolari, Carlos, 5
search engines, 201

searches, 46, 48–50, 57. *See also*
    algorithms; web analytics
Segato, Rita Laura, 263
Sierra Caballero, Francisco, 274
SimilarWeb (web analytic), 41, 58n5
*Simulacra and Simulation*
    (Baudrillard), 165
Sircam worm, 226, 230
slacktivism, 193
slavery studies, 200
smart cities, 163, 175n2, 175–6n3
social media: algorithms and
    research, 277n1; and boundaries,
    259–60; memorializing deceased,
    189–90; *Tag: A Memorial Poem*,
    182–4, 194; users as content
    generators, 194–5n1; virality, 24,
    244–5; and Zapatistas, 192–3.
    *See also specific social media*
socialism, 120, 131. *See also* state
    propaganda
*Software cubano* (Saavedra), 123
solidarity. *See* #MiPrimerAcoso
Souza, Natália Maria Félix de,
    257, 261
space, 26, 73, 104–5n6, 168, 216n12.
    See also *nepantla*; *net-pantla*
spatial words, 40
state propaganda, 125–9
"stealing," 152–3
Stein, Bob, 64
stereotypes, 201
Storyspace, 83n2
Stravinsky, Igor, 21
Strickland, Stephanie, 83
Sturken, Marita, 101, 105n8
Suazo, Felix, 130–1
subculture.com, 111, 117
suffering and poetry, 3, 4
*Sur* (journal/publishing house),
    16, 17, *18*, 23–4, 30, 32. *See also*

Ocampo, Victoria; print-to-digital
    translations
surveillance, 122, 179, 200–1, 215n2,
    215n5, 234
*Synco* (Baradit), 144

*The System of Objects* (Baudrillard),
    89, 91–2
tactical media, 229, 231, 234, 247n9.
    See also *CyberZoo*; Los Cybrids;
    "Tech-illa Sunrise"
Tactical Media Crew, 229
*Tactical Media* (Raley), 142
*Tag: A Memorial Poem* (Rocha), 181,
    182, *183*, *185*, *187–8*, *191*; and
    Facebook, 194; and Herzog, 186,
    *188*, 189–90; in-betweenness, 186;
    and servile users, 184
tagging, 47, 55
*Tango Virus* (Proyecto Biopus), 241,
    251n37
Taylor, Claire, 5, 208
"Tech-illa Sunrise (.txt dot con
    Sangrita)," 223, 230–4, *231*, 248n12
technology (general): and anxiety
    (*see* computers; "Hyper-Reality");
    availability in Cuba, 108, 120–1,
    123; and family, 94–5; home as
    membrane, 92; as leaky, 135n1;
    marginalizing Latinx, 162, 234;
    and monoculture, 186, 193; as
    not neutral, 212, 217n13; as
    practices and processes, 218n18;
    as producer of speeds, 102–3, 123;
    and remembering, 103–4n2; as
    ruin, 101. *See also specific types*
technophobia, 90, 92–3
*telecentros*, 5
"Telltale Computer, The"
    (Hoyos), 89
temporal simultaneity, 38

temporalities, 102–3, 273
*Tesauro* (Villeda), 62, 72–3, *75*;
 aesthetic nomadism, 74; dictionary
 and definitions, 73–4; difficultism,
 74; digitalness of, 66–7; earlier
 print instantiations, 77, *78–9*;
 limitations, 77; links, 74, 76; liquid
 content, 67; remediation, 74, 76,
 81–2; ruptures between media, 81;
 visual poetics, 76
tethering, 182–3
thick data, 274, 275
thing power, 89
thingification, 200
*Tiempo fugitivo* (Noemi), 102–3
time, 73, 102–3, 123, 167–8
*Time Notes* (Romano), 250n30
traditional knowledge, 214
traditional painting, 196–7n11
#transformDH, 217n14
translations, 170–1. *See also* print-to-
 digital translations
Treré, Emiliano, 205
truth commissions, 181–2. See also
 *Tag: A Memorial Poem*
Turkle, Sherry, 182–3
*Twenty Thousand Leagues Under the
 Sea* (Verne), 157
Twitter, 259–60, 262. See also
 *POETuitéame*

Ubuntu platform, 210–11
universalism, 108, 186, 196n9, 205,
 213, 218n18
*To and from Utopia in the New Cuban
 Art* (Weiss), 120

Van Dijck, José, 101
Vargas, Yudith, 125
*A veces cubierto por las aguas* (Cociña),
 145–8, *147*

Verne, Jules, 157
Vianna, Hermano, 202–3
"Vida de familia" (Zambra), 100–1
video chats, 157
Vierkant, Artie, 184
Villeda, Karen, 3, 62, 72–3, 275–6. See
 also *Tesauro*
violence against women, 263–4,
 267n11, 268nn12–13, 268nn15–16.
 *See also* #MiPrimerAcoso
viral aesthetics, 110, 111, 228–30,
 236–7, 240
viral *indigeneidad*, 244–6
viral *latinidad*, 225, 226–7, 229, 236.
 See also *latinidad*
viral *Zapatismo*, 244–6
virality, 224, 244–5
*Virality* (Sampson), 224
*Virginia Woolf, Orlando y Cía*
 (Ocampo), 23–4
Virilio, Paul, 167–8
"Virtual Barrio @ The Other
 Frontier…, The" (Gómez-Peña),
 230
virtual reality (VR), 162–3, 196nn7–8
viruses: art as virus, 228–9; and
 borders, 251n35; defined, 246n2;
 history of, 223–4, 225, 244;
 neoliberalism as, 241, 251n36;
 Sircam worm, 226, 230; Tequila,
 232; viral *latinidad*, 225, 226–7,
 229; viral *Zapatismo*, 244–6 (*see also*
 Zapatistas); and virality, 224,
 244–5. See also *CyberZoo*; Los
 Cybrids; "Tech-illa Sunrise
 (.txt dot con Sangrita)"
Visconti, Sabato, 111
Viseu, Ana, 168
visibility, 26
*Vision Machine, The* (Virilio), 167–8
*Vniverse* (Strickland), 83

Vogel, Peter, 216n10
Voyager, 63–4

Waldorf Astoria hotel, 20
Wang, Tricia, 274
war on drugs, 69, 70
*Ways of Going Home* (Zambra), 95
*We Have Never Been Modern*
    (Latour), 89
web, as term, 195n2
Web 2.0 technologies, 194–5n1
web analytics: Alexa, 41, 45, 49, 57–
    8n2, 58n5; digital newspapers as
    authority, 43; #MiPrimerAcoso,
    257, 258–9, *259*, 266n2, 266nn5–6,
    266–7n8, 267nn9–10, 268n14;
    SimilarWeb, 41, 58n5. *See also*
    algorithms
Weintraub, Scott, 7, 251n35

Weiss, Rachel, 120
*What Algorithms Want* (Finn), 46
Winter, Robert, 64
witnessing, 261–3
Wolfson, Gabriel, 62, 68–70. See also
    *Anacrón*
Women Writers Project, 64–5
Woodard, Josef, 115
Wynter, Sylvia, 213

"Year 2889, The" (Verne), 157

Zambra, Alejandro, 87, 103–4n2,
    104–5n6, 105n8, 105n10. See also
    *Mis documentos*
Zapatistas, 192–3, 229, 233–4, 244–6,
    248n15
zombie formalism, 197n11
zoos, 237, 250n34. See also *CyberZoo*

Milton Keynes UK
Ingram Content Group UK Ltd.
UKHW011255210424
441408UK00003B/84/J